PREHISTORIC
ROCK ART
IN THE NORTH YORK MOORS

PREHISTORIC ROCK ART

IN THE NORTH YORK MOORS

PAUL BROWN

GRAEME CHAPPELL

The
History
Press

I would like to dedicate this book to Jayne and our son Alexander. G.C.

To Barbara for her commitment in finding new sites and the many hours spent
checking through field notes and text documents; without her help this book
would not have been possible. P.M.B.

First published 2005

This revised and updated edition published 2012

The History Press
The Mill, Brimscombe Port
Stroud, Gloucestershire, GL5 2QG
www.thehistorypress.co.uk

British Library Cataloguing in Publication Data.
A catalogue record for this book is available from the British Library.

ISBN 978 0 7524 6877 8

Typesetting and origination by The History Press
Manufacturing managed by Jellyfish Print Solutions Ltd

Contents

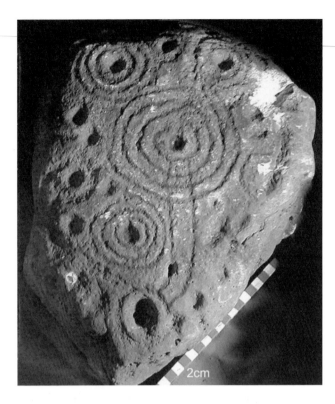

1 Left Standing Stones Rigg, Tissiman 1852. *Scarborough Museum Collection*

2 Below Fylingdales linear marked stone

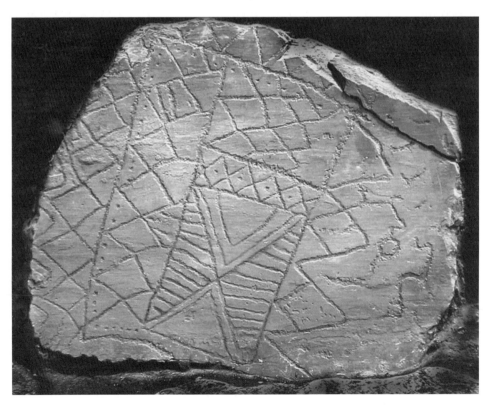

Foreword

The area covered in this book is vast. I take one area of many as an example: Fylingdales CP is rich in rock art, burial mounds and other prehistoric features, many of which were revealed dramatically in 2003 by moorland fires which burnt off the deep heather. I walked this area with Paul, Barbara and Graeme in November 2004 to see panels that are so beautifully illustrated in this book. Few people appreciate the effort and time that are expended on bringing rock art to the notice of others, or the conditions often encountered in high winds, cold, and wet. Their work, spanning many years of walking and recording, had already teased out from among the heather, rocks which had been lost and many new ones. The fire revealed even more, and these had to be added to the book at the last minute by people who have jobs and lives other than in rock art research. There are no great stretches of decorated outcrop, as in Northumberland or Argyll, for example, for most are glacially-scattered, earthfast boulders with motifs that are only revealed in strong oblique sunlight: elusive, difficult to find. Slide photography, digital pictures and photographs are not enough as a recording system – the authors rely upon time-consuming wax-rubbing as a basis for drawing, for the drawings and the exact locations enable us to consider what kinds of motifs are used and the significance of their distribution in the landscape. Location has been made more accurate and easier to record by the use of GPS, but there is no way other than hard walking to locate rocks.

All their research has been done in their own time, at their own expense. It frees them from institutions and shows that they are doing this work for the love of it. Consider what their work would have cost the nation's taxpayers; it would run into thousands of pounds. The tradition of independent archaeology is alive and well in Britain; researchers have kept links with each other for many years. As an example of what this means, the sites are well over 100 miles return journey from their homes; the cost of photography is enormous. They have developed an uncanny knack of sensing where new rock art is to be found – something that can come only from experience in the field, of familiarity with the known. This also brings a close sense of the relationship of people in the past and present with

landscape. They pursue clues to 'lost' rock art, leading them to dark corners of museum stores and to people's gardens – at times this reads like a detective story.

The book is a result of many years of part-time work, with an immeasurable value to studies in Britain that have accelerated over the past 20 years or so. Others are going to build on this work. The world of professional archaeology has missed out this component of our history, and it is only now that institutional time and resources are being given to it. Fortunately there is now a considerable archive to build on, and a tradition of cooperation between professional and independent archaeologists. The North York Moors, although sharing symbols and motifs with other sites in Britain, has its own characteristic style too. As we see elsewhere, there is a manipulation of basic cups and grooves that shows that people have been free to create individual designs. This book graphically demonstrates these variations. The link between rock art, burial, and other ceremonial monuments, emphasised here, is an area for further research, for it may be possible to establish a more satisfying chronology within its long use. This is a book to be proud of for the authors now take their places among the best of the rock art recorders. Their work had made a considerable impact in northern Britain long before this survey was completed. They will be financially poorer as a result of their efforts, but will be better informed, closer to the people of the past and fitter than most who are only now beginning to follow them. There is now a great opportunity to build on their work with skilled excavation and survey that can make use of new technology, but there is no getting away from the demands made by tough terrain and all kinds of weather. The study of rock art will continue to be firmly based in the field, for that is the beginning of real understanding.

Stan Beckensall

Acknowledgements

We are indebted to the following without whom this book would not have been possible:

Ms Bastow, Field Monument Warden, for her help and information on the Maiden Grave site.

Stan Beckensall, author and independent archaeologist, for help and advice in getting the project started.

Mr & Mrs Bishop of Pickering for permission to record the Kendall stone.

Professor Richard Bradley, information research on Maes Howe Cairn, Orkney.

Craig Hutchinson, archaeologist at the Dorman Museum, Middlesbrough.

Chris Evans, Scarborough Archaeological Society.

The late Stuart Feather, independent rock art researcher.

Paul Frodsham, archaeologist, Northumberland National Park Authority.

Mr & Mrs Richard Harland, Grassington, for historical information.

Frank James, Staintondale Post Office, for information regarding the stone at Raven Hall Hotel.

Liz Vine, Kirkleatham Museum, for help and permission to record the Kilton Stone.

Mrs Sue Lane, independent rock art researcher for information on Near Moor.

Tim Laurie, independent researcher, for help with the assessment of flint assemblages and information on burnt mounds.

Graeme Lee, Archaeological Conservation Officer, North York Moors National Park Authority, for help and updates regarding Fylingdales Moor fire and survey reports.

Gavin Parry, for information on random flint finds on Fylingdales Moor.

Andrew Morrison, Curator of Archaeology, Yorkshire Museum, for research information from archive.

Karen Snowdon, Rotunda Museum, Scarborough, for permission to record and publish material within the museum's collection.

Staff at the Dorman Museum, Middlesbrough, including Ken Sedman, Senior Curator, and Louise Harrison for their help and permission to record and publish archive material.

Peter Rowe, Tees Archaeology, for his assistance in the recording the department's rock art collection, and for permission to publish information from archive and private research papers on the Upleatham Hills.

The Ryedale Museum, Hutton le Hole, to Helen Mason and staff for kind assistance and permission to photograph and record their prehistoric collection (Lingmoor barrow stones).

Steve Sherlock, archaeologist, for his help and advice on Fylingdales Moor.

David Macleod, Aerial Survey Team, English Heritage, York, for his help in obtaining photographs of the Fylingdales Moors and permission to publish.

Neil Redfern, Ancient Monuments Inspector, English Heritage, York, for permission to publish information on the English Heritage Survey, Fylingdales Moor.

Brian Smith, independent rock art researcher, for information on the Wain Stones Sites, Near Moor and Fylingdales.

Chris and Ann Tiffany, Standing Stone Farm, Cloughton.

Blaise Vyner, for help, advice and permission to publish information on the Street House Cairn and Wossit and the remarkable aerial photographs.

Whitby Museum, The Whitby Literary and Philosophical Society, Messrs Graham and Roger Pickles, Joint Hon Keepers, and Mr Les Sythes, for assistance and permission to record and publish archive material from the Museum collection.

Allan Walker, independent rock art researcher.

Mrs Carol Cook, for information on the Near Moor cup-and-ring stones.

Kate Wilson, English Heritage, for her support and encouragement.

The Yorkshire Archaeological Society, for help and assistance towards the purchase of GPS equipment.

We would like to thank the following Estate Owners and Land Agents:

Reuben Williams, Gilling and Skelton Estates.
Snilesworth Estate; Near Moor.
Bransdale Estate; Urra Moor.
Carter Jonas, land agent, Thimbleby Estates.
Peter Cornforth, farmer and landowner, Dimmingdale.
Mr Ward of Dunsley Moor Hotel, Ramsdale.
Fylingdale Moor Bailiffs – Mr Lol Hodgson, present Moor Bailiff.
Harry Green, previously a Moor Bailiff.
Sir Frederick Strickland, Constable landowner.
Frank Hall, land agent, Council Garth Land Aislaby.

Our sincere apologies to anyone we may have inadvertently omitted.

All drawing, maps and photographs by Paul Brown; others as acknowledged.

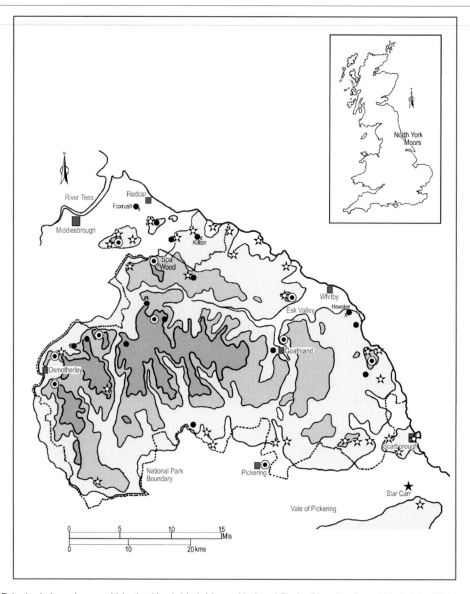

Principal sites shown within the North York Moors National Park, Cleveland, and Yorkshire Wolds

Site Maps and information is based on 1st edition and later Ordnance Survey Maps, updated with ground survey and aerial photography. With permission of the controller of Her Majesty's Stationery Office NC/01/27 Crown Copyright

KEY to all Maps	● Cup Marks and other motifs	☆ Barrow or Cairn	→ Site Position
	◉ Cup and Ring Stone	X Stone removed from site	f or fs Flint or Flint scatter
	▲ Standing Stone	------ Footpath	All other features as marked

The following Ordnance survey maps can be used in conjunction with the published maps Explorer OL26, OL27, 301.

3 North York Moors sites distribution map

1

Introduction to rock art

Prehistoric rock art in the cup-and-ring tradition in the British Isles spans the Late Neolithic into the Early Bronze Age, 3200-1500 BC. It is present in many countries of the world including those of our European neighbours of France, Spain, Norway, Sweden and northern Italy and in some it is considered to have originated earlier than the Late Neolithic. Rock art is symbolic, abstract and diverse, in contrast with the imagery of traditional and earlier art forms such as the famous Palaeolithic cave paintings at Lascaux and Altamira that depict animals and hunters of the period. Despite the symbolism there is little doubt that many display artistry, dexterity and imagination in their creation. There has been controversy about the ambiguity in categorising it as 'art', but it appears that the term has become established and is universally recognised. Carvings were 'picked' or 'pecked' onto the rock surface with a sharp tool and symbols or motifs can range from simple cup marks to elaborate and decorative carvings. A cup mark may be etched on a small stone such as a cobble that is portable and larger complex arrangements may be found on outcrop panels or rock-sheets. There are, of course, exceptions and the opposite can occur with the application of a single cup mark on a large rock or panel and a complex carving applied to a small stone. We do not know why a particular rock was chosen for marking in preference to another, when there appear to be many equally suitable surfaces in the same area that are not selected.

Use of rock art in the prehistoric appears to be multi-functional; it occurs at random and significant places in the landscape such as spring sources and viewpoints. It also features within the burial practices and has a place in the ceremonial and ritual monuments of the time. It rarely occurs in isolation and is more frequently found in clusters or groups, particularly in relation to the landscape surrounding burial monuments. The markings are almost certainly symbolic but this symbolism has become lost through time. Interpretation of symbols is difficult, numerous theories have been proposed and discussed; few are feasible and many are subjective and extreme. Since we no longer share a common mindset with our prehistoric ancestors there are many elements that

will probably remain a mystery. We now live in an urban environment and share the expectations of a modern society that, with the spread of education and knowledge, has come to expect answers to everything. We may have to accept that we might never have an answer to the question everyone asks about rock art: what does it mean? From our own research and reference to other studies we have put together much of the who, when and where, and even speculated on part of the why, but the what remains elusive!

Rock was marked by people who journeyed through the prehistoric landscape; the temporary or seasonal hunters; drovers or early farmers; travellers passing through the area. Throughout the early stages of prehistory up to the Late Neolithic people were not settled, they moved around the landscape on a seasonal basis following and hunting the animals of the time. Numerous trackways are evident throughout the moors area and many are reputed to have their origin in the prehistoric. By the Late Neolithic, although farming had begun, animal husbandry was not fully practised and people took their animals to graze on land outside their home territory and continued to hunt. Archaeologists consider that the marking of rock began in the Late Neolithic and continued into the Early Bronze Age. Rock art exists in other countries, but long distance travel and communication in the prehistoric was not as easy as it is today so how and why did it spread throughout the world? Did the symbols have the same meaning universally? We cannot answer all of these questions, but we can discuss what we currently know.

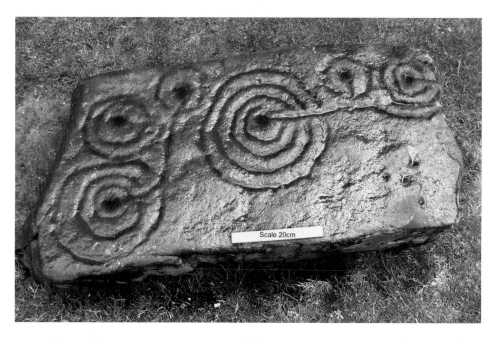

4 Panel from Peak Moors near Ravenscar. *Yorkshire Museum Collection*

Rock art in the landscape can be found at approximately 230-300m OD on outcrop rock, rock-sheets, earthfast slabs, boulders, rocks, stone scatter and, as a consequence of being moved from its original position, frequently in settlement walls. Rock with a softer composition such as sandstone is generally favoured, but in some areas of Britain markings appear on schist outcrop and, as recent discoveries in the Lake District show, even dense volcanic tuff can be carved. Rock art may have marked places in the landscape that would be vital for people at the time, such as sites of springs and water sources, near to ancient tracks or territorial routeways, places that could have been observed by those passing through the area. Viewpoints on high ground were also favoured, possibly providing the viewer with the opportunity to check sites of settlement or to seek good hunting territory such as river plains or marsh ground. Animals are known to follow specific routes through the landscape and would probably gather at these spots to drink, graze and rest. There are probably many logical reasons for its presence in the landscape, but its existence undoubtedly marks human presence and activity in a variety of places and situations.

It shares a common landscape with burial monuments of the time; for example, random marked stones lie close to cairns and howes at Allan Tofts, near Goathland, Fylingdales and Near Moors. The archaeological record indicates that many ritual monuments have been cup marked and rock art has an association, too, in the ceremonial and burial practices of the time. Though the population count within the later Neolithic and Early Bronze Age was considered to have been high in our area, it's unlikely that all individuals were buried with full ritual honour or venerated with the inclusion of cup marked stones within the burial mounds. Quite possibly only the individuals who had status in their group or community would have been honoured. Placement and orientation of stones in burial mounds appears deliberate and excavation reports show that marked stones have been placed with cup marks or carvings facing inward toward the burial. The amount of marked stones within a mound can vary; for example, the Hinderwell Beacon site above Port Mulgrave contained over 150 marked stones, but at other sites only one or two have been retrieved.

Rock art has been recorded in many parts of the British Isles including mainland Scotland, Wales, Derbyshire, West Yorkshire, County Durham, Northumberland, Cumbria, Galloway, Argyll and Ireland. A variety of motifs have been recorded and most are repeated universally though some remain unique to particular areas. The cup mark is the basic recurrent feature but there are many variations, such as cup-and-ring; cups with concentric circles; cups with multiple concentric circles; rosettes, where cups are formed in a ring that resembles an old telephone dial; 'domino-style' with cups carved in alignment and a cup and penannular (an incomplete circle). Features also include keyhole-shaped motifs, grooves, chevron, linear and curvilinear marks. The permutation and variety of carvings is phenomenal and they occur at sites all over the country and abroad. The North York Moors area can now take its place in that record with a diversity of rock art that has many of the features mentioned above and some unique to its own (5).

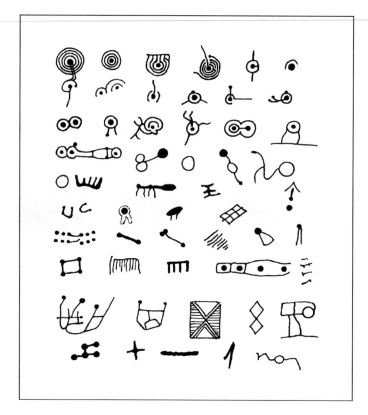

5 Main elements of rock art on the North York Moors

During our research two of the most extraordinary stones were discovered following the devastating fire on Fylingdales CP in September 2003. One of the stones exhibits linear and lozenge markings in the style of Late Neolithic Grooved Ware or Early Bronze Age 'Beaker' style pottery. Although the stone is distinctive, we do have comparison in other areas of Britain and Ireland. Its decoration appears surprisingly fresh and contemporary and appears to be in pristine condition. The stone's exposed upper edge had been damaged and suffered much erosion. The clarity of the markings on the other stone is equally stunning. It has a 'pecked' groove around its circumference, two neatly cut intersecting grooves and an arrangement of cup marks. Though other stones on the moors exhibit 'enclosure' patterns and cup marks, despite much research we have not found any parallels to this stone (6). The stones are further discussed in Chapter 2.

We cannot match the number of large panels of rock art recorded in other areas such as West Yorkshire, Northumberland, Galloway and Argyll, simply because the geology doesn't contain the large exposed rock-sheets of those areas. The moors area is quite literally strewn with stone and rock boulders, the residue or debris from the receding glaciers that covered part of the moors area. In plotting the location of rock art we discovered that the major open-air rock

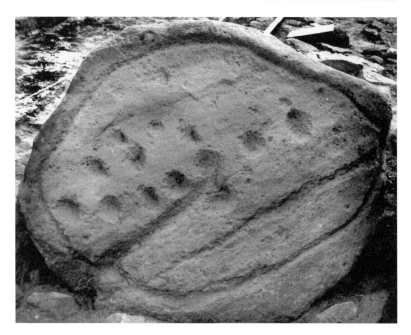

6 The
curvilinear
stone from
Fylingdales
Moor

art sites, including Fylingdales and Goathland, are situated along the periphery
of the moors where the Devensian ice sheets finally retreated from the area. The
majority of rock art has been carved on the dogger-series sandstone that has a
'softer' composition than other rocks and is relatively easy to cut or carve. The
geology of the North York Moors area includes sedimentary Jurassic rock such
as the dogger-series sandstone and ganister, a silica-rich sandstone. The scarp
from Scarborough to the Howardian Hills is rich in limestone, which is useful
for building but not suitable for carving, and the coastline contains deposits from
an earlier geological period that include alum, mudstone shales and sandstones
that are exposed in areas such as Robin Hood's Bay. Ironstone and jet from the
lower Jurassic have been much exploited in the past and halite salts buried deep
in the Permian rocks at Boulby on the Cleveland coast continue to be exploited
today.

Areas that contain larger outcrop rock include West Yorkshire, which also has
a diverse geology containing sheet outcrop sandstone with igneous intrusions
as well as coal shales and limestone. Here, much of the entire surface of the
sheet outcrop has been carved, as has the millstone grit series sandstone of
Northumberland. Achnabreck in Argyll has impressive carved panels on its schist
outcrop, and carvings that appear to superimpose others are considered to be
the work of a number of different carvers possibly during different periods of
prehistory. The site, above marshland, overlooks Lochgilphead and lies close
to Mhoine Mhor, an important marsh and wetland area in the prehistoric.
The ceremonial ritual complexes within the Kilmartin Valley are also in close
proximity.

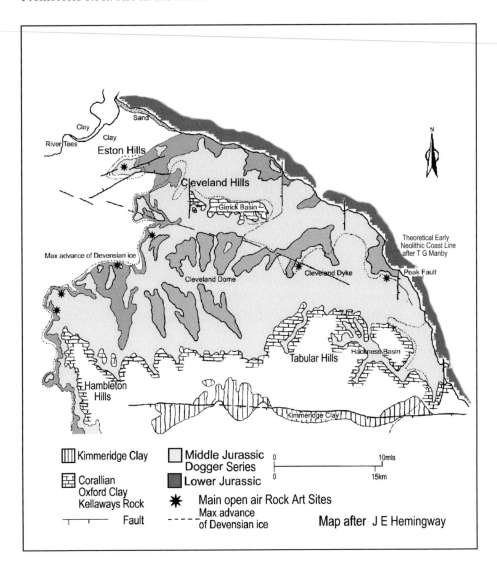

7 Geology of the region

ROCK ART WITHIN THE LANDSCAPE

After many years of research and fieldwork the authors firmly believe that rock art should not be considered in isolation from its position and situation within the landscape. In locating a new site it is important to get the 'feel' of its position in that landscape. There are questions in its discovery that can be answered instantly. Is it an isolated find or part of a cluster? What, if anything, can be seen from the rock? Does it lie close to a prehistoric monument or burial ground? Is it close to a source of water? What is its position in the landscape? We have used

GPS for greater accuracy in recording site locations; providing precise data is probably of more importance than recording the details carved on the rock.

Ordnance survey maps prove a great asset in gauging the contours of the land and they contain much information about known prehistoric sites. Yet understanding the landscape comes only with getting to know your area, preferably through fieldwalking during different seasons of the year. The landscape, however, has changed considerably over the millennia, not only through the natural processes of time but also from man's interference. The Enclosures Acts of more recent centuries changed the nature of the entire British landscape. Farming and the effects of industrialisation have totally altered the North York Moors area; for example, there were thought to have been more than 20 significant barrow sites in the Wilton area of Cleveland but these no longer exist. Stones and boulders may well have been moved from their original position to be reused for building, cleared for farming or broken up for field walls. Fieldwork in locating sites can be difficult; they are seldom obvious, being buried beneath peat or earth over the centuries or hidden by thick vegetation such as bracken or heather, as was the case on Fylingdales Moor, a situation that seriously hampered our research over a number of years.

Weather conditions also play a part in the search for new sites. While rainwater can enhance cup marks, the oblique lighting effect that often accompanies bad weather can shroud carvings and strong sunlight almost renders them invisible, particularly on eroded stone surfaces. Researching sites in relation to burial monuments can be difficult, particularly in relation to the changes in our landscape over the centuries. While much information can be obtained from the local Sites and Monument Records (SMR) at local council offices, regrettably, with the spread of agriculture and industry, many mounds and cairns have since been destroyed and little evidence remains. Robbery from monuments was a regular occurrence in earlier centuries and with no records made of excavations much information has been lost. The majority of funerary monuments of the time were generally sited in prominent positions in the landscape and the view of the surrounding countryside from them is normally panoramic. For example, Mount Pleasant Howe, Ormesby, at 217m OD, has stunning views to the west across farmland to Roseberry Topping and to the east; Teesmouth and the Eston Hills. Many are considered to share intervisibility, though we cannot say for certain as the tree line in the Early Bronze Age is not known (8).

In the following chapters we look more closely at the sites in detail and in an attempt to put the region's rock art in context it may be useful to look at the area's past. The separation of Britain from the Continent heralded a change of climate and increased the ratio of coastline to inland eventually bringing about an expansion of hunting communities in the Late Palaeolithic. People who existed in the Palaeolithic and Mesolithic (Old and Middle Stone Ages) or the Neolithic (New Stone Age) would not have recognised these terms. They are archaeological 'labels' used to distinguish and identify the change and

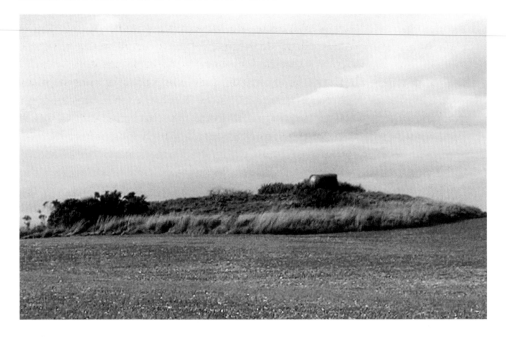

8 Mount Pleasant Cairn

development in time of polished stone tool technology. The time span of the Palaeolithic and Mesolithic ages is vast and most archaeological tables suggest different dates and transition periods; for ease of reference we have split these into three chronological stages: the Lower, Middle and Upper, and we will look at the latter stages in each time span (*9*). In the Late Upper Palaeolithic people lived in small groups following and hunting the herds of large slow-moving grazing animals such as giant reindeer and bison. Bone assemblages from the time suggest that the wild horse too was as important or even more important than reindeer for food and raw materials.

It is generally acknowledged that prehistoric people respected and revered the spirit of the animal that they killed. In the earlier Palaeolithic animals featured in the cave art of the time and antler and bone tools had animals depicted or carved on them. People hunted on a seasonal basis and set up temporary camps on gravel terraces above lowland rivers and with the onset of adverse weather they took shelter, living in caves. Tubers, seeds and berries would also have been eaten, but vegetation that exists at low temperatures has a short growing season and would not have been easy to exploit on a large scale. The archaeological record presents clear evidence that the area was used extensively throughout the prehistoric period, though there appears to be no tangible evidence from the Palaeolithic other than animal bones and flint tools. The art of the Palaeolithic is evident in many countries but until recently it was thought that there was no art from that time in Britain. Its absence had

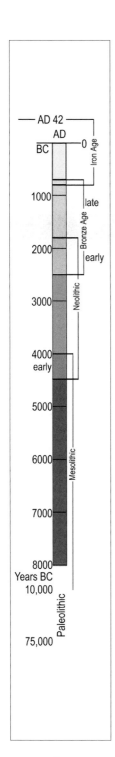

9 Time chart

been attributed to our subsequent wet climate due to our island setting. However, cave paintings have recently been discovered in the Derbyshire area, although unfortunately sites are not easily accessible. The hunter-gatherers of the Mesolithic shared a similar lifestyle to that of their Late Palaeolithic ancestors living in groups or communities, but were perhaps more territorial and nomadic.

Much of the evidence of the earlier periods in prehistory comes from flint finds and most of this came from the Yorkshire Wolds, it was not available locally. Archaeologists suggest that people did not occupy the moors, they exploited it for hunting purposes only, and microwear analysis, the study of patterns of wear on the edges of flint, indicates that most were used in the processing of meat, bone, wood, antler and hide. Early Mesolithic flint finds mostly consist of microliths, tiny sharp flints used in hunting, and a variety of blades and flakes have been recovered throughout the area from Guisborough to Flixton near Filey, including Stokesley, Greenhowe, Egton and Urra Moors, Scugdale, Bransdale, Bilsdale and Seamer Carr.

The archaeological detail of Mesolithic occupation, however, was obtained from the famous site at Star Carr in the Vale of Pickering. The site, above a gravel terrace, provided an insight into the lives of the people. The environment and climate had changed from the Palaeolithic and the increase in temperature and spread of birch woodland did not suit the large animals that grazed the open landscape and they disappeared. Warmth-loving animals that were smaller and speedier took their place and hunters had to adapt their hunting techniques and flint technologies. The bone assemblages of animals from Star Carr included the dog that had probably been tamed for hunting purposes, red deer, wild ox or aurochs, hare and the wild boar that thrived beneath the forest canopy. A pollen analysis of soil indicated that birchwood, pine and willow existed above the site and there had been minimal land clearance. A fragment from a wooden oar provided evidence that boats were being used, and that they were probably skin-covered coracles or dug out canoes. While there is no evidence of art from the Mesolithic, it does not mean that it did not exist; it may have been practised on material that did not survive the millennia, such as

wood, leather, hides or skin. Elaborate 'head-dresses' were recovered from the site, these had been fashioned from the skull plates of the red deer complete with antlers attached. It is not known whether these were used in stalking or hunting animals or reserved for ceremonial or ritual practices. The Later Mesolithic flint find sites covered the entire area from Upleatham, Eston Nab, Ingleby Barwick, Osmotherley, Kildale, Farndale and Hawnby through to Scawton Moor near Cold Kirby.

The transition between Mesolithic and Neolithic was probably gradual. There was no Neolithic revolution and no sudden disappearance of Mesolithic communities but there is evidence of coexistence in the pattern of early Neolithic flints found within Mesolithic flint areas on both high and low ground in the area. Six thousand years ago the way in which human communities existed in Britain changed; the origin and spread of farming is difficult to pin down but it was thought to have started in Turkey and the Near East a millennium earlier. The catalyst that sparked the change is believed to have been a general widespread willingness to adopt these new ideas and an acceptance of the change from one way of life to another. Quite possibly Mesolithic people did not disappear – it is most likely that they 'became' Neolithic. Agriculture started with the use of plants and seeds but farming had not begun in earnest, territories had probably been established, but man was not settled and hunting was still of great importance.

Animals that had previously been hunted were domesticated, horses were no longer eaten, the dog was tamed and hunter eventually became herdsman. These early farmers were drovers who moved their cattle around the landscape to graze suitable land, setting up temporary camps at significant places in the landscape from which they could hunt and watch over their animals, and this way of life continued until the Late Neolithic. Archaeologists suggest that the population in the Neolithic was high and most of the area was occupied. There is, however, no obvious evidence of cereal cultivation on the high moors but cereal and crops were cultivated in the Tabular Hills, a known area of Neolithic settlement near Helmsley. Saddle querns used in the Late Neolithic for grinding grain were found together with evidence of the weeds that come with cultivation such as ribwort and plantain. The peat cover and the pollen analysis from buried soils beneath Bronze Age barrows indicated that there were some areas of open country in the Neolithic. The assumption is that any land clearance had been for pasture and this resulted in an increase in hazel and grassland. Grass and shrubs were maintained in woodland clearings to feed animals that were now sheltered and nurtured by the people who once hunted them. Palaeobotanists suggest that this was a contributory factor in preventing the natural regeneration of wildwood and the native elm fell victim. The Elm Decline is a defining period in the environmental prehistory of Britain that began with the change to a sedentary way of life, an increase in population and the clearance of land for pasture. With the onset of farming it would have been necessary to establish

size and limit in the development of houses. The landscape was probably divided into separate properties in each communal territory and further sub-divided into separate holdings of particular families. Settlement provided time to work and progress technologies and build new forms of social and material culture that could not have been developed by a community that was always on the move. Trading networks had probably been established in the Mesolithic; evidence of cross-Pennine exchange was found in the number of Lake District axes that were recovered in East Yorkshire and quality Yorkshire Wolds flint was found in the Lake District.

With the regular movement of people through the land it is suggested that this is the period in which rock art began. Evidence for settlement is confined to polished stone axes, storage pits and ditches, field systems, settlement walls, flint sites and, of course, the numerous funerary monuments of the time. We have very little evidence of the domestic life in the Late Neolithic. This may be due in part to evidence of occupation being removed or destroyed by later reuse of a site in prehistory, or perhaps the structures were simply not substantial enough, being round stake-built houses covered with wattle and daub. The lack of evidence of Neolithic homes appears to be at odds with the amount of memorials to the dead that have survived the millennia, an indication perhaps of the strength of their beliefs surrounding death.

There are hundreds of round and long barrows and howes and thousands of cairns in the area, though not all contained burials; many were thought to have been territorial markers. Human remains or interments were sometimes buried in or under barrows or howes that were constructed from mounds of earth, or cairns that were largely made of stone.

An interment can consist of either cremations or inhumations. Cremation entailed the burning of human remains, inhumation involved placing the body to be buried in a grave in the ground without a covering mound. In later stages of prehistory cremated remains were deposited in a container such as a beaker or a pottery urn and placed as secondary burials in mounds barrows and cairns; that is, they were inserted at a later date. This too was the age of monument builders and many ceremonial and ritual complexes were established, the nearest to the area was Rudston in the Yorkshire Wolds. Communities and groups would have visited the ceremonial complex at particular times of the year to trade, discuss new developments, agree contracts and strike up partnerships. Archaeologists believe this was a major centre of intensive ritual activity, possibly unequalled in any other part of Britain. The famous cup marked Rudston Monolith is the tallest prehistoric standing stone in Britain. Its geological source is thought to have been the Jurassic grit at Cayton Bay between Filey and Scarborough. The easiest route is considered to have been by sea around Flamborough Head, but this remains an incredible feat and one that would have entailed much physical effort.

The transition to the Early Bronze Age brought major developments in stone tool technology with polished stone tools eventually replacing flint. With the

10 Hole of Horcum

control of fire, kilns were developed and pottery produced. Throughout the early part of the Bronze Age land was cleared not only for pasture but also for barrows that continued to be built. By the Late Bronze Age people had adopted the sedentary lifestyle. There was much greater clearance of land for farming and livestock. The production of bronze tools and the expansion of trade and exchange networks brought wealth to some communities. Disputes over ownership of territories and boundaries led to a need to protect or defend possessions and land. Defensive hillforts were constructed and hierarchies evolved within groups. The former nomadic way of life had been replaced, survival no longer depended on hunting animals that roamed the landscape. The way of life had changed by the Late Bronze Age and very possibly the need to carve rock was no longer important. In later periods of prehistory, however, marked stones were recovered from the remains of hillforts, settlement walls and in the hearths and floors of farmsteads, perhaps in recognition of its tangible link with ancestors.

The North York Moors richly deserves its modern day status as a National Park. It is an area of outstanding natural beauty that attracts thousands of visitors each year. It has wide areas of open moorland, hills, valleys and rivers, limestone vales and dales and a stunning coastline that contains classic areas of geology and a unique fossil record.

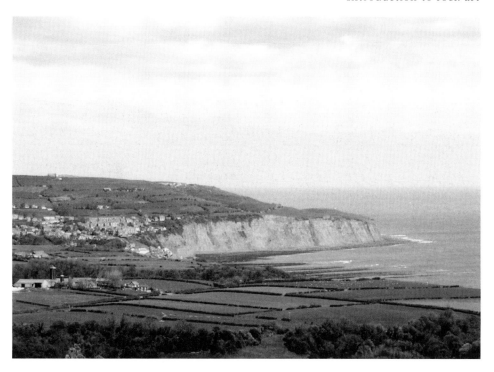

11 Robin Hood's Bay

Over 200 million years of earth history has had its effect – the land was flooded by oceans, deluged by huge river deltas and partially covered in ice sheets. These great forces of nature created a landscape that was folded by glacial activity to form a plateau or tableland that rises to 360m OD. Erosion has produced an impressive landscape with streams and rivers that cut into the land. The River Esk runs east to the coast and the Derwent River, together with its tributaries, drains to the south. The land to the north of the Tabular Hills is thick sandstone and thin, impure limestone and meltwater from the retreating glaciers cut into the limestone to create the gorge-like dales of Newtondale and the Forge Valley. Rocks of alluvial and deltaic origin occupy the moorland and form the dramatic scarp that rises sharply to shape the sheer cliffs that sweep the coastline from Kettleness to Scarborough. The Eston Hills and Roseberry Topping are Lower Jurassic outliers and the effect of latter-day industry has shaped these hills, and the landscape, with the extraction of ironstone, coal, shales, alum and jet. The North York Moors has a fascinating history and a prehistoric landscape laden with burial monuments and rock art sites. In the following chapters we present for the first time full details of all known sites as well as the many new discoveries that we have made. We start our journey with the sites at Fylingdales Moor and those of the East Coast, finishing at West Heslerton, a site that lies close to the Rudston Monolith, the focus of the major ritual complex in the Neolithic.

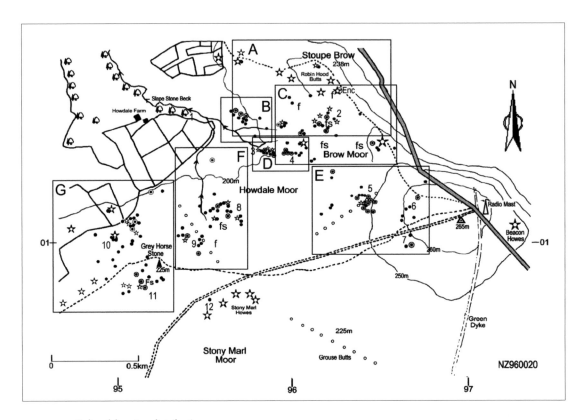

12 Fylingdales sites distribution map

2

The Fylingdales Moor rock art

In Stoup Brow, in Stoup Brow a fair maid did dwell,
She loved a young sailor and he loved her well.
He promised for to marry her when back he did turn,
but mark what hard fortune all on them did run.

These lines form the opening verse to a popular folksong, which relates the tragic story of a young woman finding her drowned lover on the sands of Robin Hood's Bay. The song was current in the mid-nineteenth century at a time when the first references to the prehistoric rock art around Robin Hood's Bay were also being noted by the antiquarian barrow diggers of the day.

Stoupe Brow Moor, Howdale Moor and Stony Marl Moor are located on the east coast, 6 miles to the south of Whitby. These adjacent moors form part of a larger area of land held common to the parishes of Fylingdales and Hawsker, the whole area being designated the Fylingdales Moor. Brow, Howdale and Stony Marl moors are situated on the high ground alongside Robin Hood's Bay and Ravenscar, with the prominent ridge of Stoupe Brow being closest to the sea. Today the village of Ravenscar stands somewhat isolated on the headland to the south of the bay; however, the wealth of recorded archaeology in the vicinity of the village and on the moorland around the bay suggests extensive activity dating back into prehistory. These prehistoric sites include a large number of burial mounds, cairns, earthworks and standing stones. A further indication of this prehistoric activity can be seen in the concentration of rock art located in the area. Even before the authors' survey work, the number of exposed rock carvings exceeded the total recorded for the rest of the entire North York Moors region. Additional fieldwork over the last 10 years has altered this bias slightly, with new discoveries being made in other parts of the moors, but the large concentration of cup-and-ring marked stones around Ravenscar still remains intriguing. Such a focus of prehistoric activity around the bay suggests that this coastal location

had some, as yet unrecognised, significance and importance during the Late Neolithic/Early Bronze Age period.

The main spread of rock art is located 1 mile to the west of Ravenscar village, where Stoupe Brow, Stony Marl and Howdale Moors form an unbroken tract of heather moorland covering an area of approximately 2 square miles. The cup-and-ring marked stones are grouped in a dozen or so discrete clusters across this area and are often associated with prehistoric remains such as earthworks and cairns. This whole area of moorland is rich in prehistoric sites, prominent among which are the Robin Hood's Butts and the Old Wife's Howe barrow groups. A closer inspection also reveals clusters of small cairns, cairn circles, standing stones, linear stone banks, ditched enclosures and other earthworks. A number of barrows containing rock art also existed on the cultivated land to the south-east of Stoupe Brow Beacon (anciently called the Peak), suggesting a continuation of the prehistoric activity around this high point over looking Robin Hood's Bay.

ANTIQUARIAN AND LATER INVESTIGATORS

The first reports of rock art in this area derive from the activities of nineteenth-century antiquarians, who were attracted by the numerous burial mounds around Ravenscar. The wealth of prehistoric monuments in this district were investigated by the likes of Thomas Kendall, Samuel Anderson, Canon Greenwell, John Mortimer and, in all likelihood, a host of unrecorded diggers. As Greenwell noted when writing about this area in the late 1800s:

> Nearly all the barrows have been opened, and many of them in quite recent times, but no account of these examinations has been recorded. (Greenwell 1890, 39)

These early barrow diggers were mainly looking for 'collectables' such as funerary vessels, stone axes, flint and jet objects. However, during their explorations, they also uncovered cup-and-ring marked stones and it was soon realised that these 'curious figured stones' (Anderson MSS c.1850) were of ancient origin too.

Probably the earliest reference to the rock art in this area dates to 1849, when the Scarborough antiquarian John Tissiman dug into the Raven Hill barrows near Ravenscar. In these mounds he noted several cup marked stones and a cist slab carved with concentric circles. Tissiman also recovered a number of cup-and-ring marked stones from the ruined cairn circle on Cloughton Moor, 2 miles to the south (Tissiman 1851). Thomas Kendall was another 'pot hunter' from this era, who assembled a very large collection from the barrows he dug, mainly around the Pickering district (Elgee 1930, 13). As part of this collection, Kendall had a section split off from a cup-and-ring marked outcrop on the moor above Robin Hood's Bay. This decorated slab was shown to Sir James Simpson (president of the Society of Antiquaries of Scotland) who later illustrated the

stone in an article for the society's journal (Simpson 1866, 51). The whereabouts of this slab remained a mystery for well over a century until September 1998, when Chris Evans (Scarborough Archaeological Society) inspected a carved stone in the garden of a house in Pickering. This stone was later identified as the 'Kendall stone' from the illustration in Simpson's article.

During the summer of 1852, George Marshall (a London 'gentleman') visited Ravenscar and stayed as a guest at Peak House (Raven Hall). During his stay he 'explored' a small barrow near the Hall and found a cist slab carved with three concentric circles (possibly the same stone reported by Tissiman). Marshall also found several more stones in the area, including one decorated with four cup-and-ring marks.

Canon Greenwell excavated a number of barrows on the Fylingdales Moor, including one of the Old Wife's barrow group (Stony Marl Howes). While in this area he noted the presence of cup-and-ring marked rocks, and reported that eight carved stones were to be found in the gardens at Raven Hall. Enquiring after these stones, he was informed that they had been collected from several sites within the area (Greenwell 1890, 39). At least one of the decorated stones is still located in the hotel gardens.

J.R. Mortimer, a contemporary of Canon Greenwell, also visited this area during a day's ramble over the Peak Moors in the summer of 1890. He observed several boundary stones bearing cup marks and 'other ancient mystic sculpturing', which he speculated were decorated cist slabs removed from the burial chambers in nearby barrows (Mortimer 1890, 146). The 1934 publication of an article by Arthur Raistrick, entitled 'Cup-and-Ring Marked Rocks of West Yorkshire' (Raistrick 1934), inspired Hugh Kendall to make a search for similar rock carvings on the moors around his hometown of Whitby. This search bore fruit in the spring of 1936 when he discovered a cup-and-ring marked stone on Stoupe Brow Moor. In the following year the Whitby Naturalists Club organised a field trip in order to view this new discovery, and while in the area, the club found a further six carved rocks (Browne 1940, 65). Hugh Kendall's discovery became the first published account of a decorated stone from the Fylingdales Moors and it was to be another 30 years before any further examples were reported. At this time, the first indications began to emerge that the Fylingdales Moors contained a wealth of prehistoric rock art, this being a direct result of the extensive fieldwork carried out by Stuart Feather during the early 1960s.

STUART W. FEATHER (1927–2002)

Stuart Feather's name will be familiar to those who have studied Britain's prehistoric rock art in any detail, his name appearing in reference to many sites across northern Britain (Boughey & Vickerman 2004). From the late 1950s onwards, he did a prodigious amount of pioneering fieldwork, discovering significant new sites

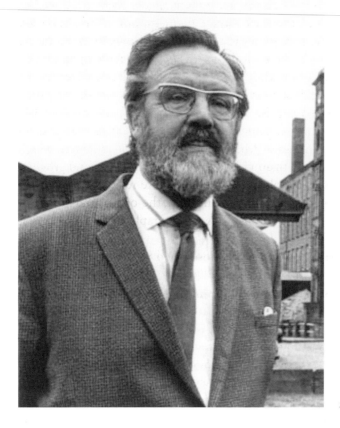

13 Stuart W. Feather

and reporting details from many others in North and West Yorkshire, Derbyshire, Teesdale, Northumberland and Scotland etc. The results of his work were mainly published in the *Yorkshire Archaeological Journal* and the Bradford and Cartwright Hall Archaeological Group Bulletins, where the detailed pencil drawings of the Ilkley Moor rock carvings in their moorland setting are particularly memorable. Having already highlighted the rock art at several new and little known sites around the Yorkshire region (Middleton Moor, Gayles Moor, Appletreewick etc.) Mr Feather then turned his attention to the North York Moors and the Fylingdales Moors in particular. Following up on Kendall's 1936 discovery, he made an extensive search of Stoupe Brow, Howdale and Stony Marl Moors during the mid 1960s, camping in the area while undertaking this work. Evidently, the conditions on the moors at that time were favourable and he was able to report approximately 30 carved stones, the details of these discoveries appearing in the *Yorkshire Archaeological Journal* (Feather 1966, 557; 1967,3).

During this time, Mr. Feather worked for the Bradford Museum Services, and in the early 1970s; he took charge of a project to create a Museum of Industrial Heritage for the area. This huge task required a focus and commitment to the industrial archaeology of the region and, consequently, this left less time for

his rock art interests. However, his continued interest in the subject did lead to occasional reports in a number of journals. Stuart Feather's rock art research took place at a time when there was little professional or academic interest in this aspect of Britain's prehistory. The indifferent response to his fieldwork reports, along with his own increasing professional workload, were no doubt not conducive to the full publication of all his research and discoveries. Had this not been the case then his contribution to the study of British rock art would have been more widely acknowledged. In 1987, Mr Feather retired from his position as First Keeper of Technology at the Bradford Industrial Museum, Eccleshill. This museum, which he helped create, is still one of the main visitor attractions in the area and provides an educational programme for schools in the West Yorkshire region.

At a late stage in the preparation of this publication, the opportunity arose to inspect Mr Feather's photographic archive. The photographs and slides relating to the Fylingdales Moor indicate that he had covered the whole of the area and made further discoveries in addition to those listed in the 1966/67 reports. The future availability of his archive will no doubt provide useful information regarding the Fylingdales sites along with the numerous other sites where he carried out fieldwork.

During the 1970s, the Ordnance Survey visited the Fylingdales Moor area, but they were unable to locate any of the previously reported carved stones. This was in part due to the extensive vegetation cover, which is understandable given how quickly the blanket heather can obscure the low stones. Subsequent research has also shown that it is virtually impossible to provide an accurate grid reference for the sites on the open moor, without the aid of a GPS receiver or some other surveying system. These items were not available to Mr Feather in the 1960s and it is to his credit that he attempted to plot the locations in this environment. The Ordnance Survey did plot the position of five carved rocks at this time, being unaware that these included one of the stones reported by Mr Feather and the stone found by Kendall in 1936. Three other marked stones plotted in the same area are likely to be among those discovered by the Whitby Naturalists Club in 1937.

In the early 1990s the authors noted that Hugh Kendall's 1936 report still remained the only detailed account of a marked stone from the Fylingdales Moor. In an effort to rectify this situation, they decided to investigate the area with the aim of making a detailed record of the previously reported rock art. This survey work proved to be quite a task, as it soon became apparent that conditions were far from ideal. Most of the moorland areas were covered by deep heather, effectively cloaking the decorated surfaces and making access difficult. Fortunately, patches of heather were burnt off from time to time, and one of these areas was found to contain a cluster of carved stones, which were identified as a group reported by Mr Feather. Further systematic fieldwork on the moors located most of the previously reported carved stones, and a significant number of unrecorded examples came to light during the process.

In September 2003 a roadside fire spread onto Stony Marl Moor, and in the dry conditions, it burnt across the entire survey area. Although the fire had a disastrous effect on the ecology of the area, it also revealed a mass of buried archaeology and provided an opportunity for the authors to carry out a second phase of detailed survey work. This resulted in more than 200 marked stones being recorded in the area, covering both the burnt and unburnt parts of the moor. The results of this work are covered in the following chapters.

STOUPE BROW, HOWDALE AND STONY MARL MOORS

The underlying geology in this area comprises the Ravenscar Group of alternating shale and sandstone layers, overlying a band of dogger (orange sandstone). This structure is reflected in the topography of the moors, with the land to the north dropping in a series of steps and plateaux from the high point at Stoupe Brow Beacon (265m OD). Stony Marl Moor is located on the west side of the survey area and this section of the moor has been extensively quarried for the tough, high silica sandstone known as ganister. Moving further east towards the coast, softer, medium grit sandstone predominates, which would appear to be more suitable for carving and may explain why the majority of the rock art is to be found in this area. Although this softer sandstone seems to have been the preferred medium for the rock art its less durable nature has resulted in the very eroded condition of many of the carvings. The extensive erosion suggests that the motifs have been exposed for significant periods since their creation; however, in the current moorland environment, low stone slabs can become totally overgrown within a few years.

An example of this can be seen with the stone found by Hugh Kendall in 1936. This stone has a flat surface (over 1m square), which must have been exposed when the Ordnance Survey noted it during the 1970s. By the early 1990s, this surface was totally overgrown, and remained buried even after heather burning in the area. The stone was finally relocated in 2002 and at that time the surface was entirely covered by a 20mm-thick 'carpet' of peaty root material. Ironically, this type of covering layer, whilst providing protection from weathering by the elements, could be creating an acidic environment on the surface of the stone and thereby contributing to the erosion of the carvings. Moorland heather requires an acidic medium in which to grow, and researchers in Scandinavian countries have also measured acidic Ph levels at the interface between rock art surfaces and covering vegetation. In these circumstances, the covering root layer could act as a damp, acidic 'blanket', slowly dissolving the mineral cements holding the sandstone grains together, leading to the disintegration of the stone's surface.

THE ROCK ART

As noted previously, the area surveyed by the authors also includes a number of large, visually prominent burial mounds; however, the rock art does not appear to be associated with these more conspicuous monuments. Instead, it was noted that individual cairns or groups of small cairns were often located near many of the decorated stones. Several clusters of these mounds are marked as 'tumuli' on the first edition OS maps (*c.* 1853), but the later edition maps either omit them or mark them as cairns. The cairns are composed of stone and earth, and range in size between 1-6m in diameter and up to 1m in height. The survey found that the majority of the cairns have been dug into, suggesting antiquarian probing, whilst others appear to have been robbed for their stone or otherwise cleared from the moor.

At present, the generally open aspect of the moorland means that several of the areas with rock art are intervisible, although this may not have been the case in the past due to differing vegetation. In addition to this, much of the rock art is located on low stone surfaces, which are easily obscured by light ground cover.

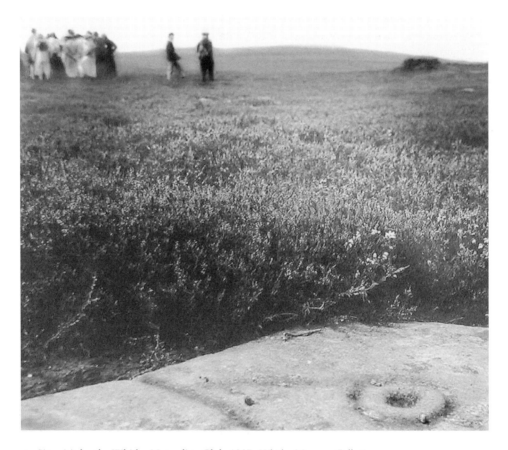

14 Site visit by the Whitby Naturalists Club, 1937. *Whitby Museum Collection*

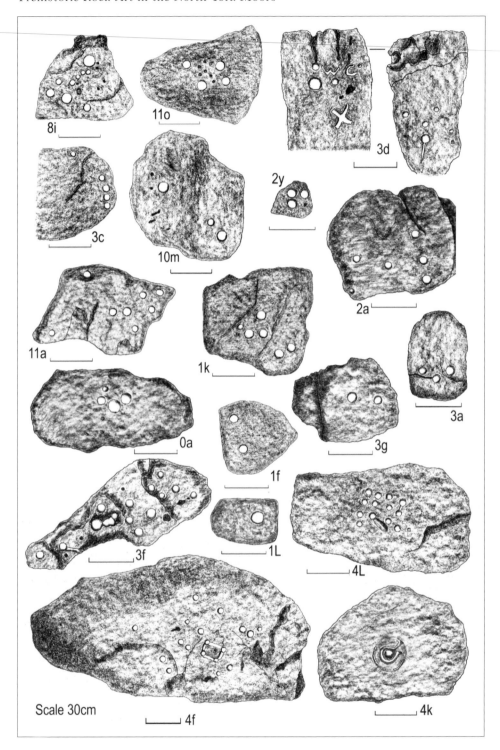

15 Selection of rock art panels from Stoupe, Brow, Howdale and Stony Marl Moors

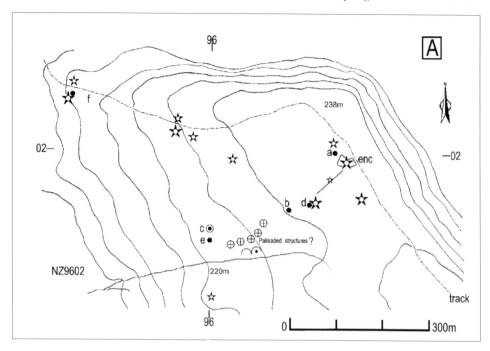

16 Stoupe Brow (Area A) map

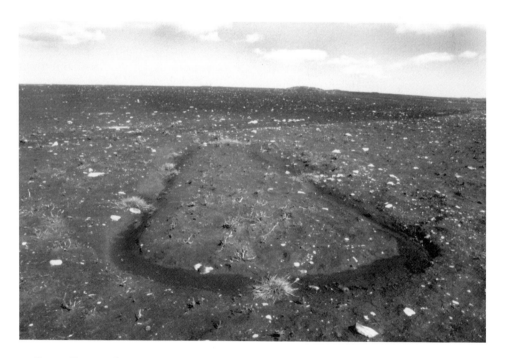

17 Stoupe Brow enclosure

In common with the rock art in other regions of Britain, the cup mark forms the predominant motif among the carvings in this area. Other, more complex motifs are present and these include cup-and-ring marks, multiple concentric rings, grid-like patterns, serpentine channels and pecked lines. The combination of these motifs provides a unique character to the rock art located on these moors. This range of marked stones, from those with simple cup marks to those with more elaborate carved surfaces can be found in each of the areas containing rock art (see *12*), and is illustrated by the marked stones recorded on Brow Moor, in the northern sector of the survey area.

Brow Moor – (Area A)

An isolated stone on the ridge of Stoupe Brow appears to mark the north-easterly limit of the rock art in this area. Beyond this point the land drops away steeply into Robin Hood's Bay. This low stone is simply marked, having just three cup marks located midway along the stone (*16a*). A very large cairn (one of the Robin Hood's Butts barrow group) is located 50m to the south; however, there are traces of several small cairns within a few metres of the stone, and these, perhaps, are more likely to be associated with it. Moving west across Brow Moor, another larger slab has its upper surface covered with large cup marks, shallow depressions and a series of grooves and channels (*16b*). There is a possibility that this marked stone and a cup-and-ring marked boulder located 150m further to the west (*16c*), define an area occupied by a series of ring ditch features.

The 2003 moorland fire revealed a number of oval or D-shaped ditched enclosures, spread in a line between these two decorated stones. The shallow, peat-filled ditches (*17*) enclose small areas (a maximum of 8 x 3m) but their function is currently unknown. Pieces of worked flint were noted within two of the ring ditches and there appears to be traces of two large circular features to the immediate south. Suggestions as to the purpose of these small rings have ranged from relatively recent tent sites, to prehistoric hut platforms or some form of small, palisade enclosures.

Stoupe Brow West – Site 1 (Area B)

Moving further west across Brow Moor there is a step in the terrain as the land begins to drop down towards the Slape Stone Beck ravine. A number of carved stones are located along this step, and it could be argued that this cluster forms the most elaborately carved group of stones on the whole North York Moors. One outcrop on the bank side is over 3.5m in length and carved with multiple cup-and-ring marks, channels, grooves and pecked areas (*18, 1a*). Three more stones in this group (*18, 1b, c, 1c*) have cup-and-ring marks enclosed by channels, and a further 10 stones have arrangements of cup marks.

This cluster may complement another group of elaborately carved stones located on the enclosed spit of land on the opposite side of the beck ravine (Site 3 – Howdale Moor). The choice of these two locations for the carving of

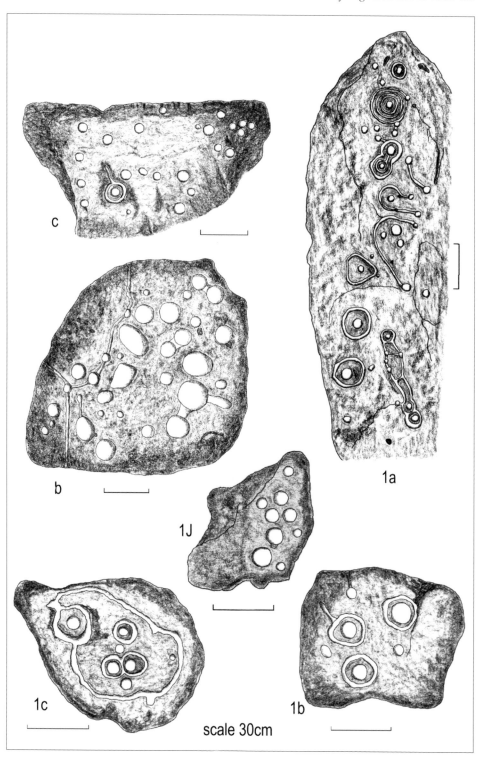

c

1a

b

1J

1c

1b

scale 30cm

18 Stoupe Brow, motifs from Areas A and B

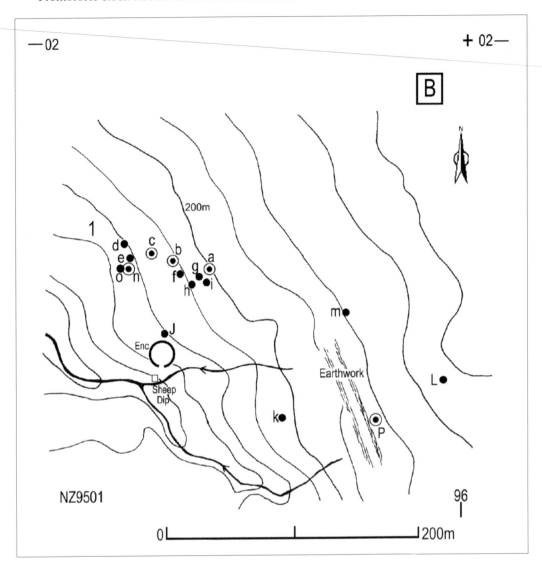

19 Stoupe Brow West, Site 1 (Area B) map

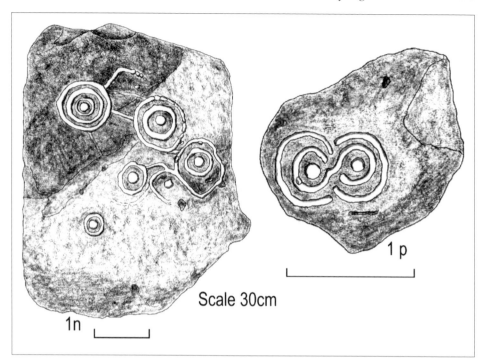

Scale 30cm

1 p

1n

20 Above Stoupe Brow West, Site 1n and 1p (Area B) motifs

21 Right Stoupe Brow, Site 1a (Area B)

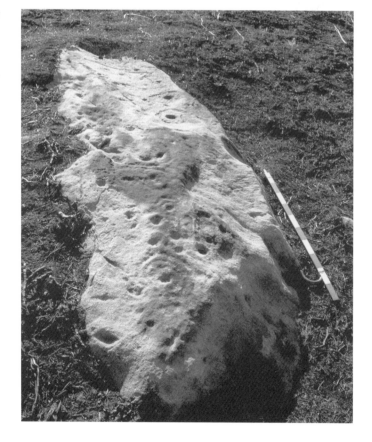

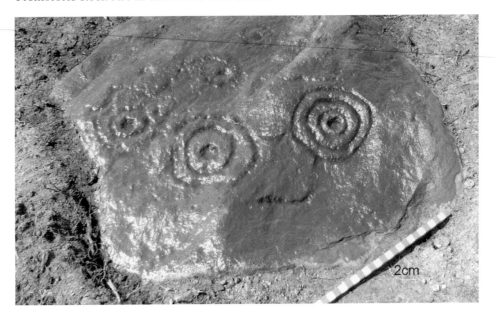

22 Stoupe Brow, Site 1n (Area B)

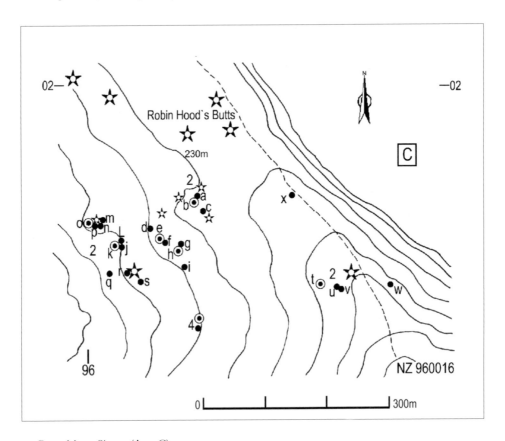

23 Brow Moor, Sites 2 (Area C) map

complex motifs might suggest that the upper section of Slape Stone Beck held some significance to the people carving the stones. It is also worth noting that a prominent circular banked earthwork (15m dia.) is located between the two sites, this enclosure being positioned above the steep bank on the east side of the beck. The date and function of the earthwork is unknown, but it may relate to a sheep-wash structure in the beck below, although as a holding pen this would seem rather extravagant and may therefore be an earlier structure.

Brow Moor – Site 2 (Area C)

A stony area on a slight ridge in the middle of Brow Moor provides another focus for a cluster of carved stones. Amongst the scatter of outcropping stones and boulders there is a flat slab marked with three concentric rings around a central cup mark (25, 2b). A robbed-out cairn is located a few metres to the north-east of this marked slab and there are traces of several more small cairns in the vicinity. A further nine stones in this area are marked with cup marks, whilst one tilted slab has a series of channels dividing its flat surface into a style similar to that of a gaming board, with a single cup-and-ring mark also incorporated into the design (25, 2h). A large barrow is located 150m to the south-west of this cluster, but once again the rock art does not appear to be connected with this

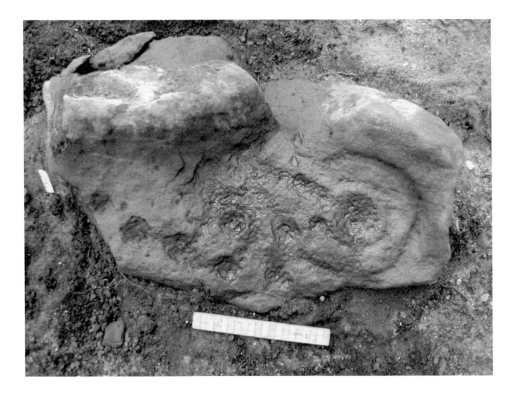

24 Brow Moor, Site 20 (Area C)

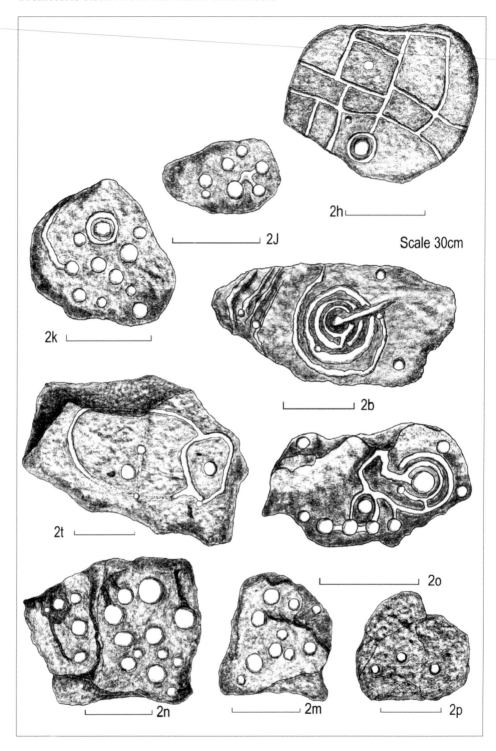

2h

2J

Scale 30cm

2k

2b

2t

2o

2n

2m

2p

25 Brow Moor, Site 2 (Area C) motifs

conspicuous feature. Instead, 100m to the north of the barrow there are two cup-and-ring marked stones (*25, 2k, 20*) and five cup marked stones, located alongside what appear to be denuded cairns.

Brow Moor – Site 3 (Area D)

A group of seven marked stones are located on a spit of land enclosed by the two substantial stream gullies at the head of Slape Stone Beck. The significance of this naturally demarcated site is perhaps underlined by the fact that it harbours two of the most elaborately carved stones found on the Fylingdales Moors. Access into the area is restricted to the south-east corner, where it is possible to cross over one of the boggy, peat-filled stream channels. A large decorated boulder is located near this 'entrance' point and the stone is unusual in that it has distinctive carvings on the vertical (west) face of the rock (*27, 3h*). The motifs include linked cup-and-ring marks, channels and two comb-like patterns of parallel lines. The second elaborately marked stone in this area is located 80m to the north-west, where a flat slab has its upper surface decorated with cup marks; some with concentric rings and intercon-necting grooves, plus two deep 'basins' and areas of peck marking (*28, 3b*).

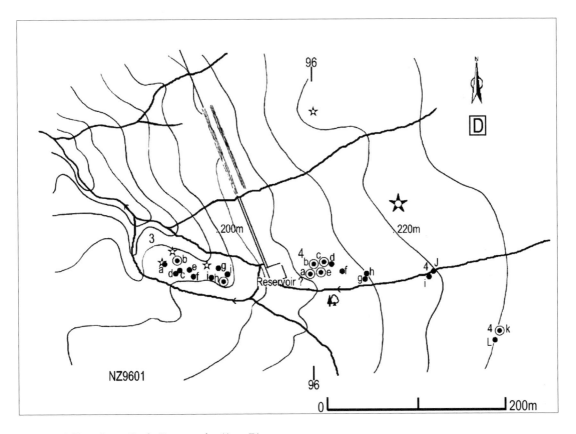

26 Slape Stone Beck, Sites 3 and 4 (Area D) map

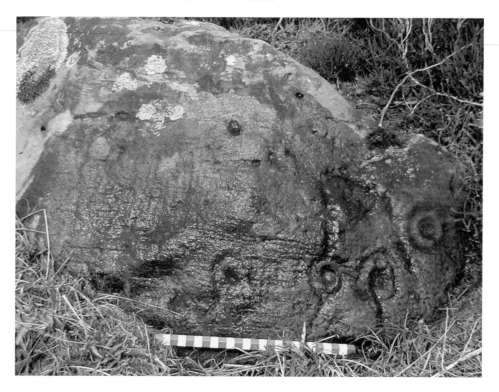

27 Brow Moor, Site 3h (Area D)

Two cairns are located a few metres to the north of this impressively decorated slab and again this highlights the association between cairns and carved stones. A further six cup marked stones are also located in the area enclosed by the stream gullies and as noted above, the choice of decorating the stones at this location may relate in some way to the adjacent watercourse.

The comb-like patterns on stone 3h were first noted by Stuart Feather in his 1966 report. The two motifs consist of a series of parallel pecked lines (7 lines and 9 lines), which increase in length from right to left, resembling, perhaps, a set of panpipes rather than a comb. Mr Feather also noted that a section of one comb pattern was cut into by a deeply pecked cup–and–ring mark and suggested that the comb motif was therefore an earlier feature on this decorated boulder. Close inspection of these superimposed motifs reveal that the cup-and-ring mark is relatively unweathered with pick marks visible, whilst the underlying comb pattern appears quite eroded. This could be another indication that the comb motif is significantly older than the superimposed cup-and-ring mark. Further examples of this comb-like motif occur in a group of carved stones located 500m to the south-west, in Howdale Moor, Site 8. A similar set of parallel lines have also been noted on a stone from the kerb of a barrow at Hutton Buscel, located 9 miles to the south (See chapter 4).

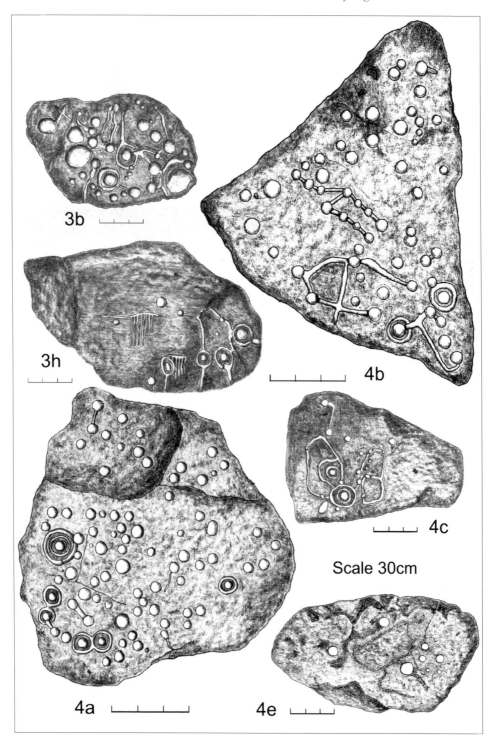

3b

3h

4b

4c

Scale 30cm

4a

4e

28 Brow Moor, Sites 3 and 4 (Area D) motifs

Howdale Moor – Site 4 (Area D)

Most of the stones recorded in Site 3 on Howdale Moor were discovered by
Stuart Feather and listed in his 1966 report. He also reported a second cluster
of carved stones located slightly to the east, but these stones were so heavily
overgrown that they did not come to light again until after the 2003 fire. The
marked stones in this group are located alongside a small, choked-up watercourse,
which carries water from a spring located on the low ridge to the east. The
markings are located on low outcropping surfaces or large stone slabs, three of
the larger stones having numerous cup marks spread across their surface (28, 4a,
b, c). Several of the cup marks have concentric rings, while others are connected
by short channels. One particular stone has a rectangular motif made up of four
cup marks linked by channels. Another smaller stone in this group was noted to
have several cup marks and a pattern of fine pecked lines, creating an enclosure
motif linked to a cup mark and a small, faintly pecked ring mark (28, 4e). The
surviving detail on this stone suggests that it was covered over soon after the
carvings were made, the fine pecking perhaps being the preliminary layout for
later carving work. Further to the east, a cup marked boulder sits at the edge of
the watercourse, while two more marked stones are located on a slight rise in
the moor just to the south of the stream. Again, these are low stone outcrops or
buried slabs, one having a single cup mark surrounded by a penannular ring (15,
4k). The other stone has a 'domino' arrangement of 12 cup marks arranged in
three rows of four (15, 4l). Another example of this domino pattern can be found
300m to the south, at Site(31, 5v, East Butts Area E).

Brow Moor – Site 5 (Area E)

The open moorland to the south-east of Slape Stone Beck rises gradually towards
the high point of Stoupe Brow Beacon. A step in the moor creates a slight plateau
around this area of higher ground, and from its northern edge there are extensive
views across the moors to the west and to the north with Robin Hood's Bay in the
distance. This plateau area provides the location for another cluster of 25 marked
stones, and again the association with cairns is apparent. A small cairn marks the
southern limit of this group, with its position being noted on the first edition
OS map, along with 10 more 'tumuli' located amongst the decorated stones just
to the north. It is interesting to note that another banked enclosure is located
on the western edge of this group of cairns and marked stones. The rectangular
earthwork is described as a sheepfold on the first edition OS map; however, 500m
to the south-west a similar enclosure has been identified as part of a prehistoric
field system. The proximity of this enclosure to a cluster of marked stones, along
with the circular enclosure noted at Site 1, may be a coincidence, but a possible
link cannot be ruled out without further investigation.

As with the rock art elsewhere on these moors most of the carvings in this
group are located on low outcrop rocks and boulders. One example is a roughly
rectangular outcrop over 3m in length that has three concentric rings around a

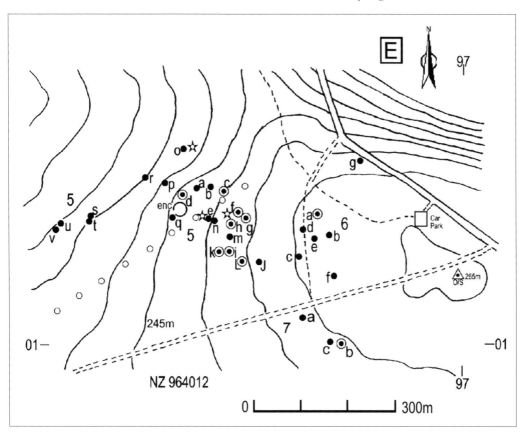

29 East Butts sites, Brow Moor, Site 5-6-7 (Area E) map

cup mark at the western end of the stone, and two concentric rings around a cup mark at the eastern end (*30, 5i*). A pecked channel crosses the rock midway along its length, as if to separate the two motifs. A tilted slab has its flat surface quartered by pecked lines, forming a cross (*30, 5g*). Three of the quartered sections have a single cup mark, while the fourth sector has an irregularly-shaped ring mark. Another flat stone has a tight cluster of 16 small cup marks enclosed by a channel fig (*30, 5b*) This group of marked stones also contains the cup-and-ring marked slab discovered by Hugh Kendall in 1936 (*30, 5f*), and some of the other marked stones in this group are likely to be among those seen by the Whitby Naturalists Club in 1937.

Brow Moor – Sites 6 & 7 (Area E)

A smaller group of marked stones are located 200m to the east of the Site 5 cluster. This group is spread out in a curving line around the western edge of the Stoupe Brow Beacon plateau, although this high point is not particularly pronounced. Several low cairns and stone scatters were also noted in this area,

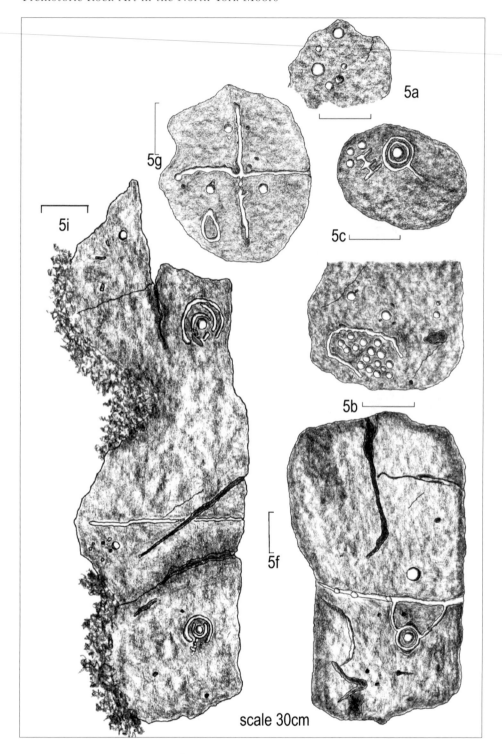

30 East Butts, Site 5 (Area E) motifs

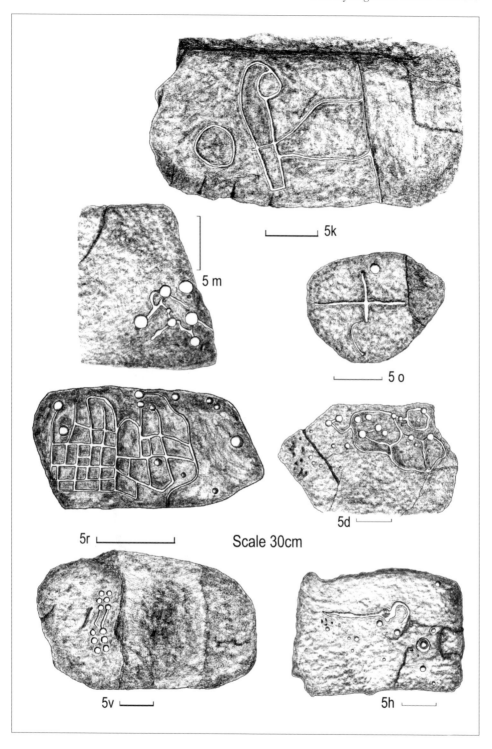

5k

5 m

5 o

5r

Scale 30cm

5d

5v

5h

31 East Butts, Site 5 (Area E) motifs

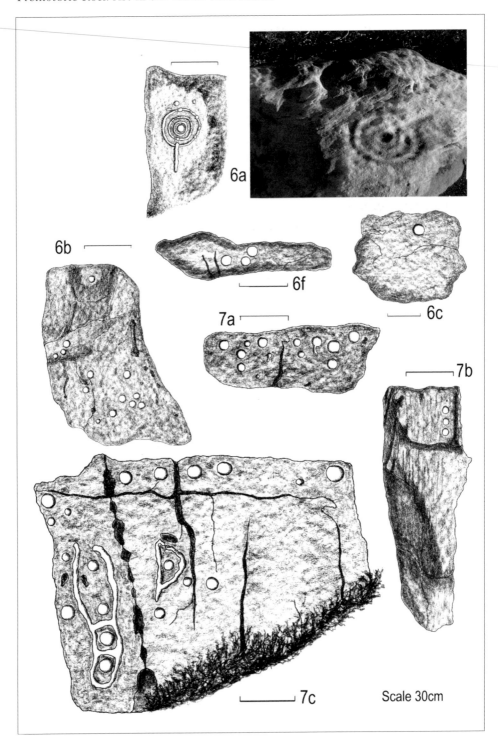

32 Brow Moor, Sites 6 and 7 (Area E) motifs

but the dispersed nature of the marked stones make any association less apparent. This section of Brow Moor appears to have suffered disturbance due to its proximity to the modern road and the route of the Lyke Wake walk. Tracks have been made into the area and there is evidence of stone quarrying, plus levelled areas with concrete construction platforms, all of which may have disturbed or destroyed prehistoric remains.

Most of the stones in this group have just a few cup marks; however, one low boulder has a very eroded motif consisting of three concentric rings around a central cup mark (32, 6a). Unfortunately, the markings are so faint that they are only visible in good light. A further group of three marked stones are located to the south of the Lyke Wake Walk track (32, 7a, b, c), but these are likely to be a continuation of the group mentioned above. A large section of stone on one of the carved rocks in this group has been quarried (32, 7b). On its surviving part there are traces of eroded cup marks enclosed within wide channels, but the rough surface of the stone makes the motifs unclear. A search of the moorland to the south of this group did not locate any more carved stones. This may be due to quarrying activity, or the nature of the stone. This heavily overgrown area may yet reveal further examples.

Howdale Moor – Sites 8 & 9 (Area F)

The lower section of Howdale Moor immediately to the west of Slape Stone Beck is often wet and boggy as a result of water draining from the higher ground to the south. Moving further west the land rises again to form another plateau area, which provides the location for another extensive group of marked stones. Stuart Feather noted several of the marked rocks in this area, but an inaccuracy in the reported grid reference placed the site further to the east. Traces of cairns and linear stone banks had already been noted in this area prior to the 2003 fire, which later revealed the full extent of these features.

Several larger cairns were exposed at this time and it could be seen that very small examples were also present, these being made up of just a few stones piled together. This denuded condition could be the result of stone robbing or may have been the actual size of the original cairn. The now familiar pattern of carved stones and small cairns is repeated across this area with around a dozen low mounds located in the vicinity of the marked rocks. At one location stones had been placed around a cup marked boulder, in another, a cup marked stone was found amongst the cairn stones (34, 8o).

One of the more elaborately marked stones in this area is a low outcrop with numerous cup marks on it is upper surface, whilst a lower step on the edge of the stone has three cup-and-ring marks, alongside four short parallel lines (34, 8a). On the same part of this outcrop there is a rectangular depression pecked into the surface. This pecked area appears to have obscured a previous carving and there are indications that this underlying motif may have been another comb-like pattern. If this was the case, then it has parallels with the cup-and-ring mark pecked over the top of a comb pattern (28, 3h) in Area D.

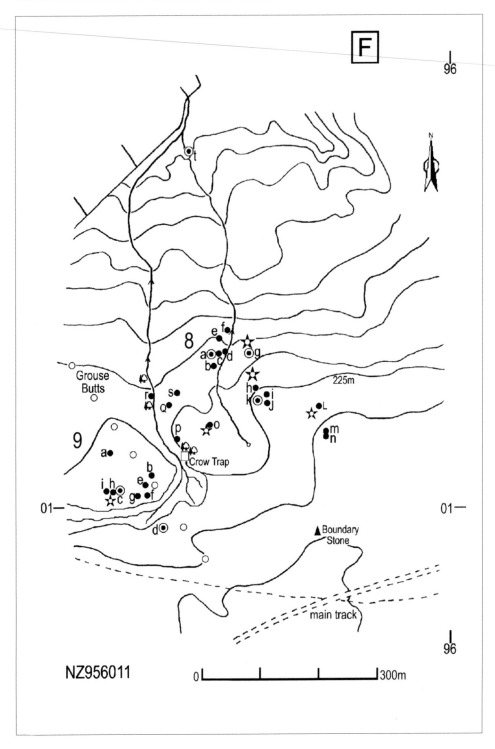

33 West Butts, Sites 8 and 9, Howdale Moor (Area F) map

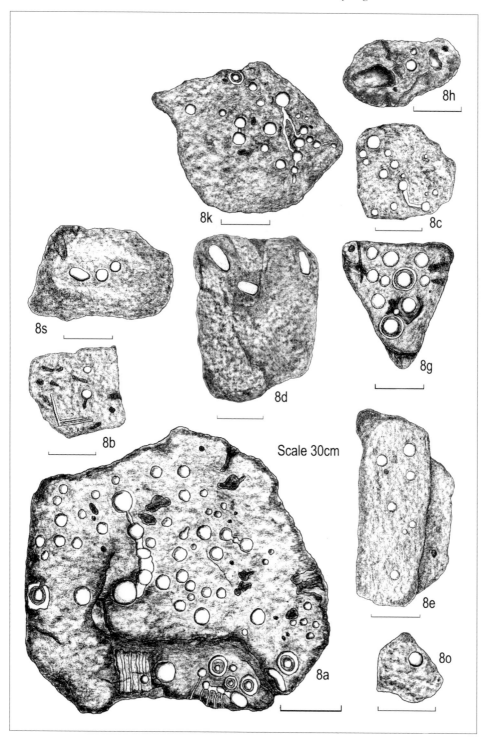

8h

8k

8c

8s

8d

8g

8b

Scale 30cm

8e

8a

8o

34 West Butts, Sites 8 (Area F) motifs

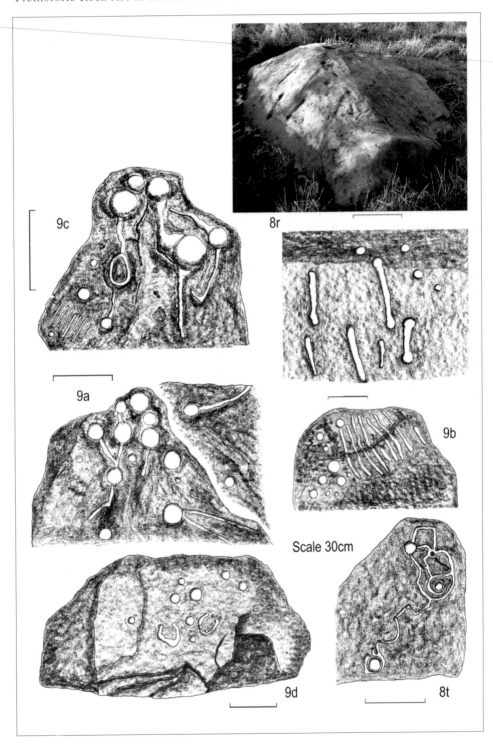

9c

8r

9a

9b

Scale 30cm

9d

8t

35 West Butts, Sites 8 and 9 (Area F) motifs

A stream channel passes through this group of marked stones, taking water from an intermittent spring source, located just to the south. An isolated marked stone was discovered on the edge of this watercourse, at a point 300m downstream from the main group of carved stones (35, 8t). The flat surface of this slab has two cup-and-ring marks linked by a meandering channel crossing the face of the stone. No other marked stones have been noted in this area but the adjacent land has been enclosed and turned over to agriculture.

To the west of Site 8, a second stream channel has to be crossed before reaching another group of nine marked stones. Stuart Feather reported a large cup marked boulder (35, 9d) in this area and although the Ordnance Survey later noted the stone, the markings were reported as being natural. This would appear to be an error, as there are a series of cup marks and two horseshoe-shaped ring marks on the sloping side of the stone as reported by Mr Feather. This boulder is located on the south side of the stream channel mentioned above, while on the north side, another boulder is located alongside a prominent cairn (35, 9c). This site more than any other on the moors serves to illustrate the apparent association between the cairns and the carved stones. In this case, the size of the cairn and the adjacent boulder leave little doubt that the positioning was intentional. The upper surface of the boulder has a number of cup marks and eroded grooves in addition to which there are a series of eight parallel lines, located on the east side of the stone. A second stone is located 70m to the east, and this low slab has another arrangement of parallel lines, but erosion and damage to the surface makes the precise layout unclear (35, 9b). A further five cup marked stones are located in the vicinity of the stream and the cairn while a larger cup marked boulder is located 30m to the north.

Howdale Moor – Site 10 (Area G)

Immediately to the west of the stones in Site 9, there is a low ridge with a trackway passing along the southern side. To the north of the ridge, the moorland is relatively flat and featureless, stretching northwards to a farm track and the enclosed fields beyond. A preliminary search of this area did not reveal any carved stones; however, the presence of several large barrows and robbed cairns provided the impetus to carry out a more detailed search that led to the discovery of another 22 marked stones. The majority of these stones were cup marked, and again there are several cairns in the vicinity of these marked boulders and stones. One example worth noting in this group is an outcrop located on the side of a bank, overlooking the enclosed fields and lower ground to the north (37, 10u). The flat upper surface of this large stone has traces of a few eroded cup mark grooves but a better-preserved section has cup marks with connecting channels and an axe-shaped depression. The stone also has a rare motif not seen anywhere else on the moors comprising a cup mark with a short channel positioned between a splayed V-shaped groove. There are traces of several more of these shaped grooves on the stone and it is interesting to note that this type of arrow-like symbol has fertility associations in other cultures around the world.

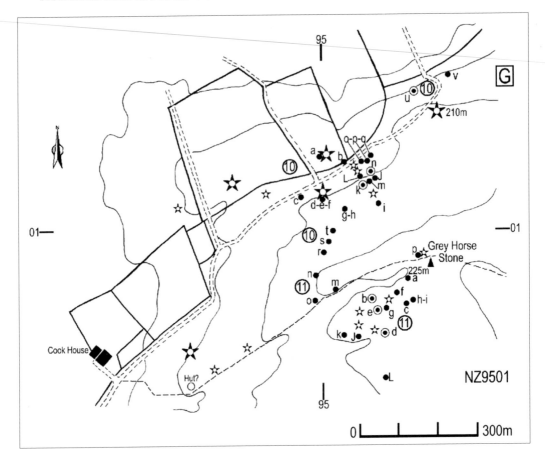

36 Cook House and Grey Horse Stone map (Area G)

Moving back across the moor to the south, the land gradually rises up to a low ridge (mentioned above), and on its southern side, there is a trackway passing the Grey Horse Stone. This large standing stone is located at the northern edge of a small cairnfield and is the location for the final cluster of marked stones noted on these moors.

Stony Marl Moor – Site 11 (Area G)

The Grey Horse Standing Stone is located approximately 200m to the south-west of the cairn and cup marked boulder described in Site 9, with the top of the standing stone just visible from this site. This large eroded stone stands 1.5m in height and is thought to have been erected in prehistory, a fact perhaps supported by its location on the northern edge of another cairnfield containing over 30 small cairns. Writing in the early 1800s, Robert Knox thought the stone marked a 'Druid's Station' noting that the standing stone formed an acute triangle with two smaller 'Druid-stones' nearby (Knox 1855, 182). In 2003, a local farmer told

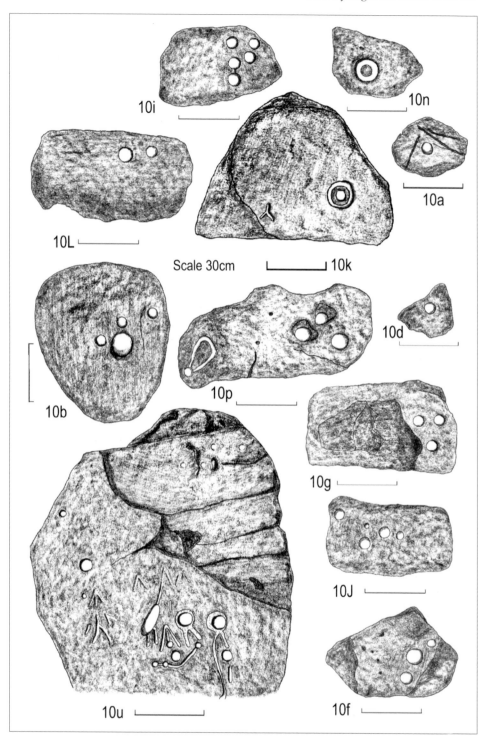

10i

10n

10a

10L

Scale 30cm

10k

10b

10p

10d

10g

10J

10u

10f

37 Cook House, Site 10 (Area G) motifs

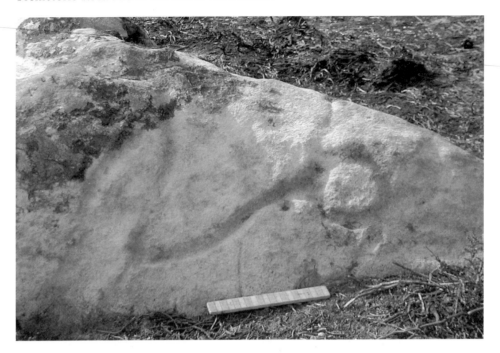

38 Grey Horse Stone, Site 11b (Area G)

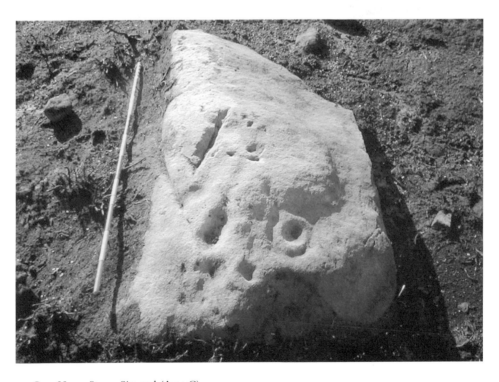

39 Grey Horse Stone, Site 11d (Area G)

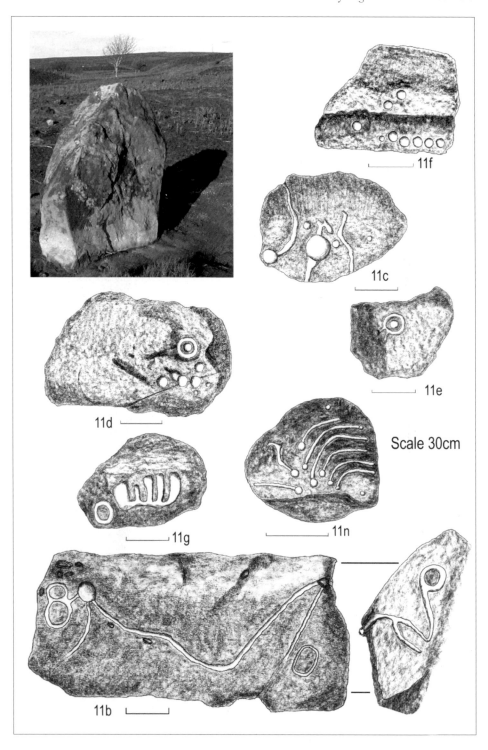

11f

11c

11e

11d

Scale 30cm

11g

11n

11b

40 Grey Horse Stone, Sites 11 (Area G) motifs

one of the authors (GC) of a tradition that a giant threw the Grey Horse Stone from the Hole of Horcum (*10*), located 8 miles to the south-west. The story accounts for the marks and cracks on the stone as being caused by the giant's fingers as he gripped it. A very similar story is recorded for a lost standing stone that once stood alongside Swarth Howe barrow, near Aislaby (see Chapter 3).

The Whitby Museum archive has photographs of two marked stones listed as being 'Near the Grey Horse Stone'. These stones were originally photographed in 1936, but their exact location was unknown until the authors relocated one of the stones in 2002 (*40*, 11b). The 2003 fire revealed the location of the second stone, along with another 15 marked stones and the spread of cairns located across this area. A check of Stuart Feather's photographic archive indicates that during 1967 he made a record of at least four marked stones in this area, including the cup-and-ring marked stone (*40*, 11d). Stone 11b is a low, ridged boulder with a ring marking on the north side of the stone. This ring mark is connected to a channel, which travels the length of the stone to connect to a spectacles-shaped motif made up of two adjacent ring marks. Midway between stones 11b and 11d there is a smaller, earthfast rock with a single cup-and-ring mark on its sloping west side (*40*, 11e).

The other stones in this group are mainly cup marked, although it does appear that grooves and channels occur more frequently on the carved stones on this western side of the moors (i.e. Sites 7, 8, 9, 10, and 11).

The group of cup-and-ring marked stones located around the Grey Horse Stone appear to mark the western limit of the rock art on the Fylingdales Moors. A search of the areas further to the west did not reveal any more carved stones and it could be seen that the type of stone in this area is of a different character. This ganister stone is lighter in colour and has a hard, reflective surface. The stone also appears to break or shatter into angular pieces and there are piles of this stone dotted around Stony Marl Moor. Some of these mounds look like prehistoric cairns, but a local farmer suggested that they might relate to more recent quarrying, where the ganister had been piled up ready for removal from the moor. Further investigation would be required to establish the origins of these mounds, however no carved stones were found in the vicinity.

THE MOORLAND FIRE 2003

During September 2003, the local news carried reports of a large fire on the Fylingdales Moor to the south of Whitby. The fire originally started on the west side of the A171 Scarborough to Whitby road but the prevailing wind soon carried it across the road onto Stony Marl Moor, where it took hold and burned fiercely for several days. The fire quickly spread over a large swathe of moorland, including the Howdale and Brow Moor survey area, before eventually burning itself out on the ridge overlooking Robin Hood's Bay. The extent of the blaze

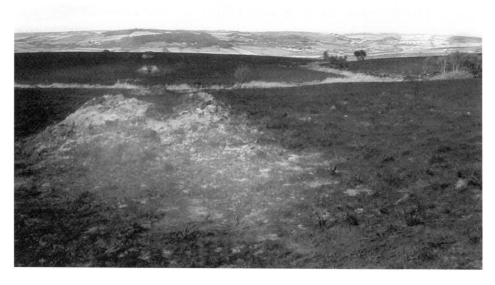

41 Fire ravaged landscape, September 2003. West Butts, Howdale Moor

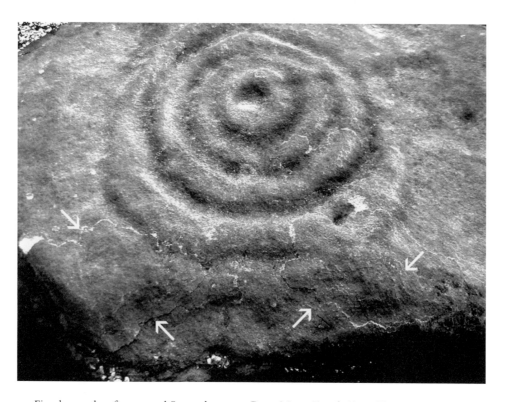

42 Fire damaged surface around September 2003. Brow Moor, Site 2b (Area C)

required over 100 firefighters to attend the scene, where it took several days to get the fire under control and to prevent it spreading to adjacent areas.

Soon after the main fires were extinguished, the authors visited the area to check for damage to the previously surveyed rock art. It was something of a shock to view the devastation left by the fire and difficult to comprehend a landscape so utterly changed (*41*). The carpet of heather that once stretched across the moors had gone, to be replaced by a vast expanse of charred and blackened earth. Virtually everything that could burn had been incinerated, leaving only a thick layer of soot and ash under which even the soil had been charred red in places. Walking across this burnt terrain caused the wind to whip up the black ash and swirl it across the landscape like a scene from some alien planet.

A check of the carved stones revealed that the intense heat had damaged a small number of them. This damage was characterised by thin sections of the stone surface having detached from the main body of the rock, perhaps as a result of trapped moisture or expansion stresses within the stone. This, combined with the effect of jets of water spraying directly on to the red-hot surface of stone, would have added to the damage. This type of visible damage can be assessed and recorded; however, the extent of any hidden damage within the stone will only come to light after exposure to winter frosts and other environmental factors (*42*).

Although some of the carved stones had suffered as a result of the fire, it was also clear that it had uncovered a significant number of unrecorded carved stones, along with many other archaeological features previously hidden by the blanket heather. In some areas, the fire had stripped the vegetation and peat layer back to the underlying soil surface, to reveal flint tools and the unusual ring-ditched enclosures, plus numerous other features, possibly unseen for millennia. Traces of this 'buried landscape' had been noted by the authors on many occasions during their fieldwork over the previous decade, but to see this landscape uncovered like some vast open area excavation was a revelation.

The authors conducted a systematic search of the burnt areas during the weeks following the fire and were able to identify over 100 previously unrecorded carved stones, along with numerous cairns and other features. It also became apparent that even though the fire had burnt away most of the vegetation, many of the stone surfaces remained covered by a layer of dead root material. This root-mat adhered to the stones when dry, but when damp it could be lifted up and the surface checked for carvings. Many of the marked stones discovered by the authors were found in this way and these covered motifs would no doubt have been overlooked by a less rigorous survey. After recording these new discoveries, the sites were then marked with a white tag to assist the English Heritage survey that was planned for early 2004. At this stage, the authors were able to provide the National Parks, Survey and Conservation Coordinator with a database printout listing details of over 120 marked stones on the Fylingdales Moors. This data provided the first real indication of the amazing extent of the

rock art on the Fylingdales Moor. It also provided evidence of the authors' long-term fieldwork and research in the area.

The English Heritage funded work on the moors included a broader based survey, which aimed to identify and plot the location of all the multi-period features exposed by the fire. This walk-over survey had an added urgency, in that it had to be completed before the extensive conservation work started in spring 2004. The survey was undertaken by a professional team led by Blaise Vyner and Steve Sherlock (Tees Valley Archaeology), and took place during the winter months, which on the exposed North York Moors can be real test of character! Additional rock art finds came to light during the walk-over survey, and continued fieldwork by the authors has seen the total number of marked stones rise to over 200. The details of all these sites have been incorporated into the authors' rock art database, which covers the whole of the North York Moors region.

SUMMARY

Even before the moorland fire in 2003, the Fylingdales Moors rock art presented something of an enigma: why did this area contain so many rock carvings in comparison to the rest of the North York Moors? The sheer number of carved stones that came to light after the fire served only to emphasise this question. The fire revealed a clearer picture of the areas where stone surfaces had been selected for decoration and provided further evidence for the deliberate siting of cairns in these same areas. The sites seem to suggest a preference for marking stones near watercourses, exemplified by the focus of elaborately carved stones at the head of Slape Stone Beck. This stream serves as the main watershed on the north side of the moors, and after flowing past several clusters of rock art, the stream drops dramatically into the Slape Stone Beck ravine, via a series of waterfalls set between sheer rock faces. Similarly, the site at the Grey Horse Stone is located at the head of two stream channels arranged in a distinctive manner.

The first edition OS map marks this area as 'Thorn Key Wath', indicating a crossing point between the streams and though these two watercourses are likely to have a common spring source, one channel flows westwards, the other to the east. The stream flowing to the east passes the carved stones and cairns in Sites 8 and 9, before eventually joining the Slape Stone Beck. The ridges and raised plateaux in this moorland area also appear to have been sites favoured for marking stones. The siting of rock art in this type of location has been noted in other parts of northern England with the suggestion that areas of higher ground were chosen to provide views over the surrounding landscape. This may indeed have been the case, but the groups of carved stones located on relatively low ridges and scarps might also indicate that this type of topographical feature held some significance, regardless of height. Carved stones located in these

areas generally cluster along the sloping scarp edge or upper hill slopes of these landscape features. This 'preferred zone' perhaps defines more closely the area of significance where it was appropriate to decorate the stone surfaces.

The rock art in this area follows the general pattern found at other British sites where cup marks predominate, with a range of more elaborate motifs present in smaller numbers. The rock art also appears to incorporate a relatively high proportion of channels and grooves, which link and enclose other motifs, as well as the use of linear markings to create individual motifs like the arrangements of parallel lines and grid-like patterns. In each of the discrete groups of carved rocks, there are generally two or three stones marked with complex motifs (cup-and-ring marks etc.). These elaborate carvings tend to be dispersed across the area, but also appear to provide a focus for the other stones marked with simpler arrangements of cup marks and channels.

Perhaps the most intriguing aspect of the Fylingdales rock art is the apparent association between the carved stones and cairns. This pattern has been identified during survey work at other sites in northern England, such as Chatton Sandyford and Ray Sunniside in Northumberland. Given the nature of the carved surfaces (outcrops and large boulders etc.) then it is clear that the cairns were placed in the vicinity of these stones and not vice-versa. The question is, were the stones decorated prior to the cairns being built? The positioning of the cairns would suggest that these stones already held some significance, in all likelihood due to the decorated surfaces, but it cannot be ruled out that the carvings were added when the cairns were built, or even at a later date.

Recent work at Hunterheugh in Northumberland indicated that the rock art associated with a cairn predated the structure by a significant period of time (Waddington, 2005 in press). On Fylingdales Moors Site 8n may be relevant to this point. Here a robbed cairn still has a few stones placed around an earthfast cup marked boulder suggesting that the markings could pre-date the cairn. This is just one aspect of the Fylingdales rock art and its environment that requires further research. At present the area provides a unique opportunity to carry out this kind of work, which could establish a chronology and context for the sites revealed by the fire. Hopefully the opportunity will not be allowed to pass and this ancient landscape left to disappear once more beneath the heather.

THE FYLINGDALES LINEAR MARKED STONE

The intense fire that spread across the Fylingdales Moors in September 2003 uncovered numerous archaeological features and led directly to the discovery of a fascinating and unique prehistoric carved stone. This decorated stone received substantial media coverage when English Heritage announced the details in December 2004, although the stone originally came to light in the previous April when Graham Lee, North York Moors National Park, arranged

a visit for archaeologists from other National Parks Authorities; Paul Frodsham, Northumberland park archaeologist, noticed the triangular patterning across the exposed top edge of the stone. Realising the significance of the markings and the vulnerability of the site, it was proposed to English Heritage that the site should be excavated as part of the survey work taking place in the area. However, during the intervening period an inquisitive member of the public also noticed the markings and partially uncovered the carved face of the stone, exposing more of the intricate design. This prompted the official excavation to be brought forward, and a team led by Blaise Vyner (Tees Valley Archaeology) excavated an area around the stone to reveal the full extent of the carving and in the process also uncovered several more carved stones nearby. While the stone was exposed the carved face was laser scanned by Archaeoptics Ltd in order to record a highly detailed image of the design, with this stored digital information also making it possible to create a replica of the stone if required in the future.

After the excavation the decision was made to rebury the stone in situ, and as a consequence the exact location and other details about the site were not made public due to the real threat of theft or vandalism. Given the unique importance of the discovery, the decision to rebury the stone received some criticism from archaeologists and local groups, who suggested the stone should have been removed to a museum, but English Heritage expressed the view that the stone had been part of the local landscape for several millennia and any decision to remove it from that context should not be taken lightly.

The decorated slab formed part of a stone setting which had become buried beneath the moorland peat and heather. The stone (measuring 1 x 0.8 x 0.2m) stood on edge with its carved face towards the north-west, while an adjacent large stone was also marked with a series of cup marks enclosed by a groove around the edge of the stone. These two marked stones were separated by an unmarked slab and several smaller stones were also uncovered, these being marked with single cup marks and pecked lines. The damage around the edge of the linear marked slab might indicate that the stone had been reused and 'trimmed' to fit the site, perhaps having originally being part of a larger carved stone. However, close scrutiny of the markings show that in several places they has been adjusted to fit the space available up to the edge of the slab, so the visible damage may be the result of transporting and setting up the stone, which may also account for a broken section from the top edge being found at the base of the slab.

One noticeable feature of the stone is its flat and relatively smooth surface which has provided an ideal canvas for the elaborate design. This surface may be a natural feature of the stone, perhaps created by glacial action, or alternatively the surface may have been abraded and smoothed by human activity as there are examples of this occurring on sections of stones found at other sites in the region e.g. Hinderwell Beacon and Hutton Buscel. (Such stones with abraded surfaces, perhaps used for grinding and polishing appear to have had some significance which possibly extended to the fragments of broken saddle quern

found at some sites.) A further explanation could be the local geology which includes relatively soft sandstones and beds of harder, silica rich, ganister stone. A surface layer of this harder material may have been chipped through to create the sharp edged markings.

From the photographs (*2, 6*) and figure *43* (1m) it can be seen that virtually the whole face of the slab has been decorated with a pattern of linked triangles and lozenge shapes, along with dots and hatched areas, in order to create an intricate and quite complex design. This type of decoration is of a totally different character to the cup-and-ring style of rock art found on the rest of the Fylingdales moors, where approximately 200 marked stones have now been recorded.

There is, however, a possible link between the two styles through the small rings and serpentine grooves located along the right edge of the stone, as this motif does occur on a small number of marked rocks on the surrounding moors. The linear markings on the stone have drawn parallels with those found on Bronze Age Beaker pottery, a striking similarity being noted with Beaker (*4, 44*) from Brantingham Yorkshire. A recent find from the Ringlemere Barrow excavation in Kent was a later Neolithic Grooved Ware vessel decorated with triple lozenge motifs and grooves.

Some elements of the decoration on the Fylingdales slab are also to be found within the Passage Grave style of rock art and on a small number of stones from other prehistoric sites in the Britain and Ireland. These include a stone from the Neolithic enclosure at Lyles Hill, County Antrim, Northern Ireland and a decorated slab from the chambered cairn at Barclodiad-y-Gawres in Anglesey.

Further examples worth noting are the Badden cist slab from Lochgilphead, Argyll, and a cist cover from Stenness, Orkney, and stones from Skara Brae (not illustrated) with lozenge and geometric shapes; these are now part of the collection of the Royal Museum Scotland, Edinburgh. All these carved stones exhibit some similarities with the markings found on the Fylingdales Stone.

The small number of comparable sites highlights the rarity of finding these types of motifs and designs carved on stone surfaces; however, finds from a relatively local site provide another comparison in the form of the 'Folkton Drums'. These small engraved chalk cylinders were found accompanying a burial in a barrow at Folkton Wold on the Yorkshire Wolds, 25km to the south of the Fylingdales Stone. The markings on the cylinders consist of linear and geometric patterns, including triangles, lozenges, hatched areas and an intriguing 'eyebrow' motif, while the tops of the 'drums' are marked with multi-concentric circles. Although on a smaller scale, there are similarities with the markings on the Fylingdales Stone and again comparisons have been made with the markings on the drums and those found on Grooved Ware and Beaker pottery dating to the Late Neolithic and Early Bronze Age period. It has been proposed that all these markings were part of a common set of motifs in use during this early period, surviving in the archaeological record mainly on pottery vessels and occasionally

on other objects such as the sheet goldwork plaques decorated with concentric lozenge shapes and triangles from the Bush Barrow in Wiltshire and Clandon in Dorset. It has also been suggested that these markings and designs are purely decorative, perhaps replicating patterns found on textiles, leather or carved wood. However, it should also be noted that even a brief study of ethnographic literature provide examples where similar motifs and designs have been used in different cultures to represent artefacts, elements in the natural environment or topographical features. For example, the striking and complex design found on one particular Aboriginal bark painting incorporates very similar elements to those found on the Fylingdales Stone. In this case the painter explained that the composition had several layers of symbolism, depicting the clan's mortuary rituals and the spatial layout of a burial ceremony and at the same time illustrating the connection with coastal features in the local landscape and the ancestral beings who were believed to have created them (Carauna 1993, 74).

The discovery of this carved stone raises many questions, including, why such an extraordinary piece of rock art should be located on an isolated moor on the east coast of Yorkshire. Part of the answer may lie in the concentration of prehistoric remains in this area, which suggest that a well established community lived in the vicinity, perhaps utilising the natural harbour and resources of Robin Hood's Bay, which also raises the possibility of contact and influences from other regions via the extensive network of sea routes that are thought to have spread along Europe's Atlantic coast in the Neolithic and Bronze Age.

CURVILINEAR STONE

When the markings on the linear stone were first noted and brought to the attention of the National Park Authorities and English Heritage, the authors were invited to visit the site. They noted that a stone close to the linear stone was also marked and subsequently reported their findings. Following excavation the decoration was clearly revealed. It has truly unique decorative markings and these features are quite different from any other stone that the authors have seen and recorded over the last 20 years. This presented much difficulty when trying to draw parallel or reference with other marked stones and, despite intensive research, they have been unable to reference another. Although the stone is essentially of the cup-and-ring tradition, the placement of the motif on the stone is so unusual that we consider it to be unique. The stone is a circular slab and a ring has been pecked around its circumference, this pecked ring is intersected by grooves and above the grooves cups have been carved in a linear formation (see *43, 2m*). There are many examples of enclosure patterns, enclosing cups and cup-and-rings at Fylingdales (*18, 1c; 25, 2t* and *30, 5g*) and at Allan Tofts Site 2b, yet none exhibit the bisecting grooves. As discussed in Chapter 1 the symbolism of carved rocks is unknown, and this stone is no exception.

OTHER MARKED STONES

Within the limited excavation area seven further marked stones were uncovered. Some of the small stones were cup marked as in figure 43 (stones 5-9); these small stones are frequently associated with burial rituals. A polishing stone was also found, and stone 3 (*43, 3m*) appears to have had its polished surface obliterated by peck marks and linear incisions, perhaps with a possible intention of removing its function from the living world. It is interesting to note, however, that both these were placed face-downward, close to the linear stone setting. It has been noted that quern stones also feature in a burial or ritual context, these are often found broken or defaced and placed with the working surface placed face-downward (Pryor 1998, 61).

During the excavation a square-shaped block of sandstone (stone 4) was unearthed; this too showed faint linear lines forming linked rectangular shapes and integrated within the overall motif are three small cups. There are distinct parallels with stone 4 at other sites within the North York Moors such as the linear-pecked or incised lines found on Fylingdales Moor (*25*, 2h; *31*, 5r and 5k; Hutton Buscel, barrow 2 stone C and at Allan Tofts Site 5c). Many of these grooves form rectangles, squares and enclosures, and these are integrated with cups or cup-and-rings; unfortunately the symbolism here is not fully understood. Although the linear stone site covers a limited flat area of the moor no burial context was found during excavation and concentrations of marked stones are common in archaeological sites. The creation and use of the site may well have been ritual and the marked portable stones deposited as votive offerings.

FLINT ASSEMBLAGES ON FYLINGDALES MOORS

Though we must consider that rock art within the landscape is not in isolation, some of the lithic artefacts discovered can be dated from the later Neolithic to the Early Bronze Age 3200-1500 BC, the period when the carvings are considered to have been created.

Before the moorland fire of September 2003 we were aware of well-documented barrows, random cairnfields and small sections of prehistoric walling within our survey area. Small worked flakes of undiagnostic flint were also apparent in isolated erosion patches. The intense heat of the fire stripped most of the vegetation cover including the peat that had been laid down on the prehistoric land surface. This revealed many more flint artefacts on the surface and other previously unrecorded features.

While surveying for new rock art sites prior to the English Heritage survey, we noted a number of flint artefacts among the new sites; these were recovered and their location plotted. Other undiagnostic flakes and spalls were also recorded but left in situ. We were concerned that public awareness of the prehistoric

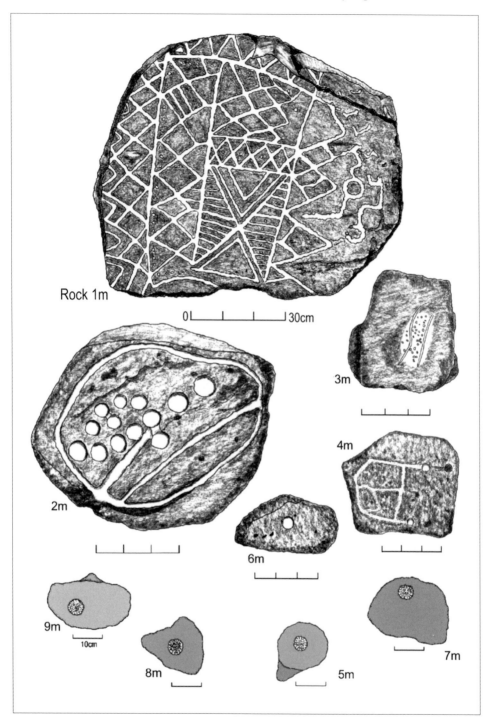

Rock 1m

0 ⌞ _ ɪ _ ɪ _ ⌟ 30cm

3m

2m

4m

6m

9m

10cm

8m

5m

7m

43 Linear marked stone site

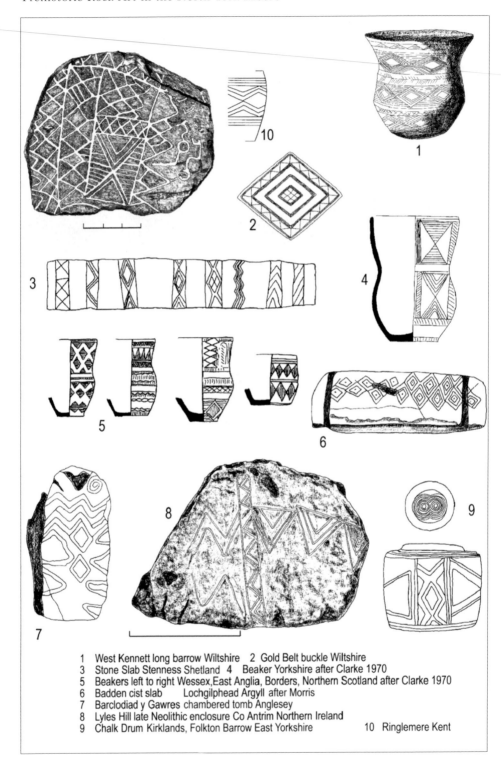

1 West Kennett long barrow Wiltshire 2 Gold Belt buckle Wiltshire
3 Stone Slab Stenness Shetland 4 Beaker Yorkshire after Clarke 1970
5 Beakers left to right Wessex,East Anglia, Borders, Northern Scotland after Clarke 1970
6 Badden cist slab Lochgilphead Argyll after Morris
7 Barclodiad y Gawres chambered tomb Anglesey
8 Lyles Hill late Neolithic enclosure Co Antrim Northern Ireland
9 Chalk Drum Kirklands, Folkton Barrow East Yorkshire 10 Ringlemere Kent

44 Linear marked stone parallels

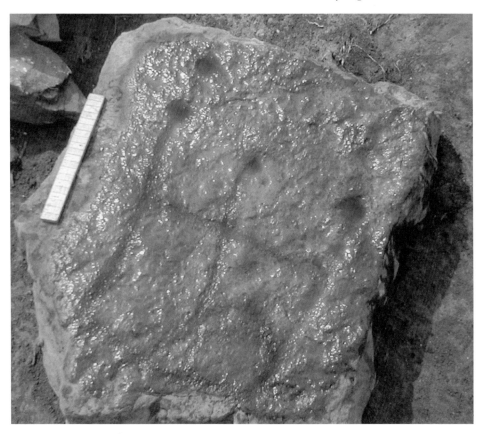

45 Linear stone site rock 4

aspect of the moors was probably highlighted with media coverage of the fire, its vulnerable open aspect perhaps attracting the undue attention of flint collectors. Unfortunately this detracts from the final analysis of the flint assemblage and consequently affects the true picture of prehistoric activity on the moorland.

Museums in the area have a number of fine flint artefacts and this information was included in our report. In all we examined over 60 pieces of flint, in general it appears that flint had been located randomly over the entire burn areas; some were small, fractured flint pebbles and other struck pieces that had been fractured by the heat from the fire and shattered into small spalls. Most of the worked flakes were waste material, the majority of diagnostic flakes have been identified as scrapers and these were discovered close to the rock art clusters.

The flint artefacts recovered during our survey and the positioning finds are plotted on the site distribution map (12) indicating (f) as a single flint or (fs) as flint scatter. This illustration shows various tools and arrow points; scrapers appear to be the dominant tool. It is difficult to assign a definitive time period to the worked flints as this type of scraper was used over all periods within the

prehistoric. However, two end scrapers were discovered in our assemblage; a double-ended scraper (46, h) has been attributed to the Early Mesolithic and the smaller, single-ended scraper (46, i) to the later Mesolithic.

Two transverse arrowheads were recovered. One was located in the West Butts area of Fylingdales and the other in the area of Stoupe Brow Moor. Both show the same characteristic of a small imperfection (dot) within the flint fabric, clearly indicating that they have been struck from the same nodule. These wedge-shaped arrowheads were designed to bring down larger prey and they can be attributed to the Neolithic period. One Bronze Age barb and tanged arrowhead was shown to us; unfortunately the tip was missing, but it is quite possible that it was the result of a failed shot and non-recovery. It was found lying on the blackened land surface around the Cook House area (see 47).

THE ENGLISH HERITAGE SURVEY

English Heritage-funded survey of the moor in spring 2004 recorded an assemblage of over 179 lithic artefacts and a further 18 pieces were recorded around the linear stone site. The lithic artefacts were inspected and summarised in a report compiled by Peter Rowe, this to be integrated and submitted in a final report to English Heritage. The following is an abridged version of the report:

> The raw material as consistent with this report consists of a few red pieces, grey and light brown and various shades with further examples of Wolds Flint, light-grey in colour. A number of beach pebbles, some of glacial origin, many of these have little cortex left and this may well have been worn away by wave action indicating that some flints were struck from beach pebbles.
>
> The majority of the flint recovered show signs of being badly burnt in the moorland fire of 2003, some of the examples have sooting and resin glazes, others with pot fractures and spalling. Some artefacts were shattered into numerous fragments. A number of fire-altered flints were discovered from previous moorland fires, and their surfaces show cracking and exposure producing a white opaque surface. The assembly consists of the following tool types.
>
> Arrowheads, barbed and tanged, leaf and retouched pieces, scrapers, a single barb and tanged Sutton-type attributed to the Beaker period or early Bronze Age date. Of the 179 lithic pieces recorded, the scraper appears to be the dominant tool (20).

The lithic evidence indicates that the moorland area has seen multi-period activity ranging from the Early Mesolithic hunter-gatherers into the Bronze Age when many of the large round barrows and low field walls were constructed. The recovered flints that are attributed to the periods of Late Neolithic to Early Bronze Age consist of leaf-shaped, transverse, barb and tanged arrowheads and

46 Flint assemblage, Fylingdales Moor

47 Arrow point from Howdale Moor. *Photograph: A. Walker and B. Smith*

scrapers. All have association in the form of hunting of game and the processing of hides, activities that had continued over a long period of time. It is possible that throughout these periods the area had special significance, judging by the number of rock art panels, small cairns and large round barrows within the area. It is possible that the area was used for the trading of stock and goods, feasting or ritual ceremonies that possibly accompanied the passing of the dead. Whatever activities were practised the moorland remains a special place within the landscape. Man's activities here have continued throughout history with stone structures and other features associated with the past Alum industry, as well as stone quarrying; it was also used in the recent past by the military. Grouse butts have also been constructed for the shooting season and there are numerous features constructed by the local farming community such as field walls, sheep dips and folds.

3

Allan Tofts and eastern sites

ALLAN TOFTS (NZ 830 030 AREA)

For many years the concentration of carved stones on the Fylingdales Moor has stood out conspicuously when set against the limited distribution of rock art around the rest of the North York Moors region. This disparity (now even more apparent since the 2003 fire) led Don Spratt to joke that the Fylingdales area must have been home to a cup-and-ring hobbyist (Spratt 1982, 134). Allan Tofts, near Goathland, is perhaps the one site that can stand some comparison with the Fylingdales Moors, admittedly with far fewer carvings, but still having something of the character of the coastal site. This is perhaps not surprising given the proximity of the two areas; Allan Tofts lies 8 miles to the west of Howdale Moor and less than half a day's walk across country.

Located 1 mile to the north of Goathland village, Allan Tofts is situated on the gently sloping hillside overlooking the hamlet of Beck Hole. The site also overlooks the confluence of Eller Beck and the Murk Esk River, which flows along the valley to the west of Allan Tofts before joining the main Esk River, 2 miles to the north. The site is spread across a series of wide terraces on the hillside, which provide open views across the valley to the north, south and west. The land to the east of Allan Tofts continues to rise to the higher moorland areas of Goathland and Sleights Moors, where the group of standing stones known as the High and Low Bridestones are located. Today, Allan Tofts is mostly given over to rough grazing and some enclosed pasture; however, the tofts name records an early settlement hereabouts, and in more recent times, quarrying has taken place in the area.

Across the rough, open ground at Allan Tofts there are a series of low, stony earthworks, many of which are linked together and thought to be the remains of a prehistoric field system. These low banks (composed of stone and earth) are

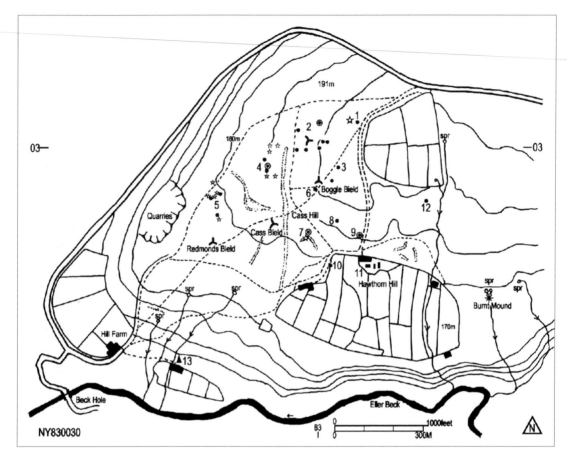

48 Allan Tofts site distribution map

laid out in an irregular pattern across the site, although one noticeable section runs for 500m in a north–south direction and incorporates large boulders along its course. In addition to these earthworks, the first edition OS map marks 120 small cairns in this area, but the actual total is well over 200 cairns. Many of these stony mounds can still be seen today, along with the remains of several larger cairns and barrows. The majority of these mounds show evidence of disturbance, probably as a result of antiquarian digging, a likely candidate being James Ruddock who is known to have dug barrows in the Goathland area during the 1850s (Manby 1995, 98).

Raymond Hayes and Mrs A. Hollings visited the Allan Tofts site in 1939 and discovered two cup-and-ring marked stones amongst the cairns and earthworks (54, 7, 9). In the early 1970s an Ordnance Survey team relocated these stones and noted a third marked rock (50, 2f) nearby (TSDAS 1972, 39). Stuart Feather visited Allan Tofts in 1968 and his photographic archive contains several photographs of marked stones from this area. These include a large boulder,

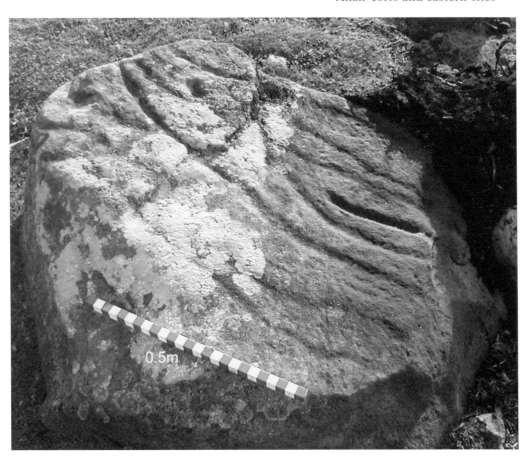

49 Allan Tofts, Site 2c

marked with cup marks and channels (*54*, 5c) and a smaller cup marked slab (*54*, 8). Fieldwork by the authors has highlighted further examples in the area, raising the total to 25 marked stones. From the current survey work carried at Allan Tofts, it would appear that a relatively high proportion of the carved stones are marked with cup-and-ring and linear motifs etc. as opposed to simple cup marks, which tend to predominate at many rock art sites. This bias may alter if more carved stones are found in the area, however, it could also relate in some way to Allan Tofts proximity to the 'mega-site' on the Fylingdales Moors. The Allan Tofts distribution map (*48*) also reveals an apparent association between the decorated stones and cairns, repeating the situation found on Howdale and Brow Moors, 8 miles to the east. Virtually all the carved stones at Allan Tofts were found in areas where cairns were also located, and the following examples serve to illustrate this point.

A group of seven marked stones are located toward the northern end of the Allan Tofts site, in an area containing a number of cairns (*50*, 2a–g). Stone

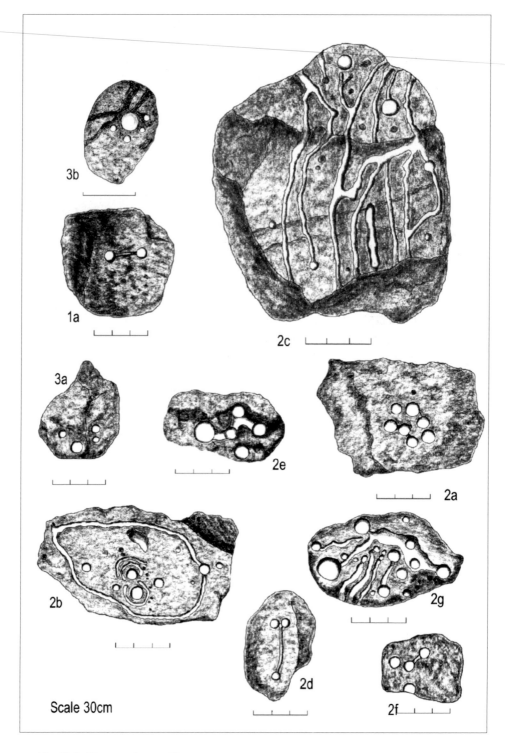

50 Allan Tofts, Sites 1 and 3 motifs

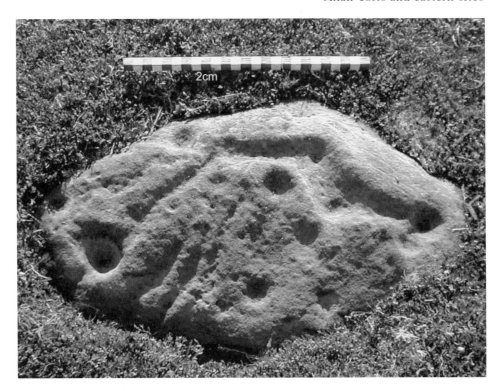

51 Allan Tofts, Site 2g

2b is a low earthfast slab with traces of two cup-and-ring marks on its upper surface, along with several cup marks and an irregularly-shaped depression. A channel running around the outer edge of the slab encloses the motifs and this arrangement is reminiscent of a stone on the Fylingdales Moor. A further six stones in this group are cup marked, but in each case there are channels linking some of the cups.

One of the marked stones discovered by Raymond Hayes in 1939 is located 200m to the south of the cluster in Area 2. This low slab has three large cup marks or 'basins' cut into its upper surface, with each basin enclosed by a single concentric ring (54, 7). An arrangement of channels also links the three cup-and-ring marks. This stone is located 10m to the north of a prominent cairn, which appears to have been excavated, raising the possibility that this decorated slab may have been removed from the cairn.

A group of five small cairns are located in an open area between two sections of the linear banked earthworks, on the west side of the site. The original search of this area did not reveal any decorated stones; however, during a period of hot, dry weather, patches of vegetation began to die back, suggesting that there were stones just below the surface. Lifting the thin layer of vegetation revealed several marked stones located between the cairns, including one stone with a cup mark

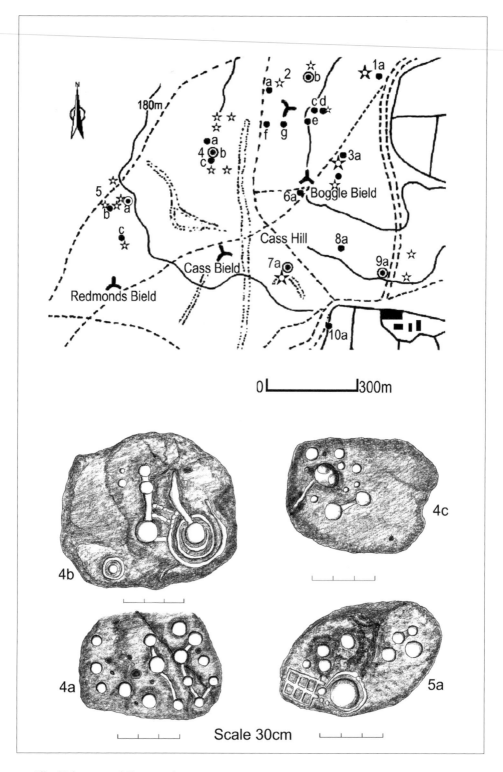

52 Allan Tofts map and Sites 4 and 5

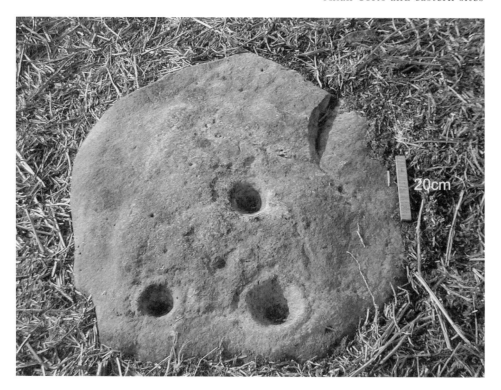

53 Allan Tofts, Site 10a

enclosed by multiple concentric rings (*52*, 4b). A second cluster of carved stones were found in a similar situation near another cairn group, located 200m to the south-west of Area 4 (*52*, 5a; *54*, 5b-c). Stone 5a was almost totally covered by a layer of vegetation which, when lifted, revealed a large cup mark/basin, adjacent to a rectangular grid pattern divided into 6 sectors.

The Pennock Puzzle Stone (NZ 8253 0234)

The Pennock Puzzle Stone stands alongside Lins Farm Cottage, 500m to the south of the main group of carved stones at Allan Tofts (*48*, Site 13). This rough block of sandstone stands nearly 1m in height and has an eroded grid pattern on its sloping north face. The name attached to the stone derives from a local farming family, the Pennocks, who were the tenants at Lins Farm in the 1850s (Peirson 1985, 13). In a further report it was noted that John Pennock was a man of many skills: farmer, mason, fiddle player and clock repairer. He was especially known for his skill at cutting stone sundials and he died in 1904 aged 84. The 'puzzle' part of the name apparently refers to the grid pattern being reminiscent of a gaming board (Whelan 1990, 4). However, the shape of the grid and the steep angle of the carved surface would make this a rather impractical pastime. Another example of a grid-like motif has been recorded among the prehistoric

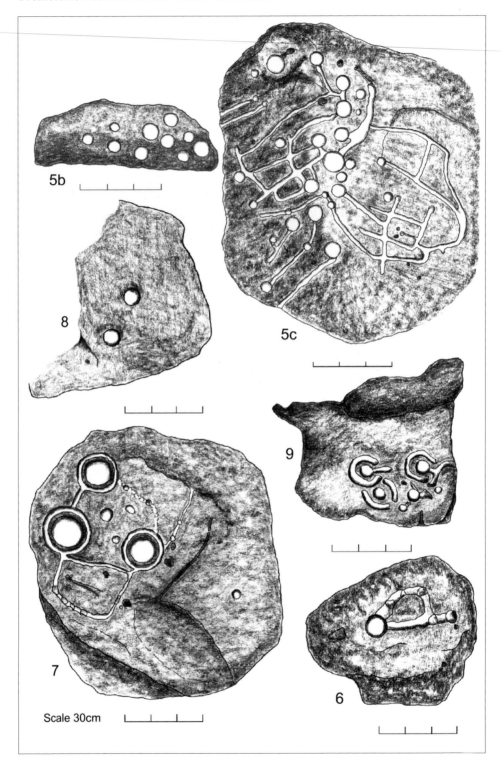

54 Allan Tofts, Sites 5-9 motifs

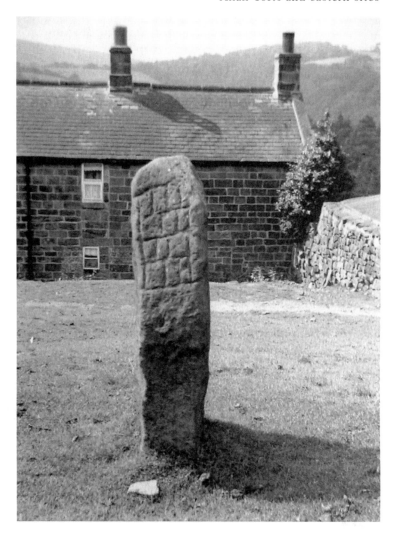

55 The Pennock
Puzzle Stone,
Allan Tofts Site 13.
*Whitby Museum
Collection*

carvings located to the north (52, 5a), and given the proximity of the Pennock
Stone to this group, it is at least possible that the two carvings are part of the
same tradition. The grid-marked stone may have been brought to the farm
as a curiosity, or it may have been discovered during one of the numerous
barrow openings that appear to have taken place on Allan Tofts during the mid-
nineteenth century.

Boggle Bield (NZ 8300 0290)

There are several sheep shelters or 'bields' located at Allan Tofts. These structures
take the form of a Y- or T-shaped arrangement of drystone walling, which
act as a simple windbreak behind which animals can find some cover during
foul weather. It is perhaps worth noting that the ground plan of these bields
is reminiscent of the tri-radial cairn structures identified at sites such as Ray

Sunniside in Northumberland. These cairns have stones and boulders piled up in a Y-shaped arrangement in order to create a structure shaped like a three pointed star. The example at Ray Sunniside is located near a group of round cairns that are associated with cup marked stones, while the tri-radial cairn itself had a saddle quern and a cup marked stone incorporated into the eastern arm of the structure. The location of the bields at Allan Tofts has parallels with the Northumberland site, but at this stage there is no evidence to suggest that they may have been built on top of prehistoric features. However, a local example of the reuse of a prehistoric site has been suggested for Temple Beeld on Lealholm Moor, 6 miles to the north-east of Allan Tofts.

One of the bield structures at Allan Tofts is known as the Boggle Bield, perhaps connected with Boggle House, located 1 mile to the north. In the north of England a 'boggle' was the name given to a supernatural being, often connected in folklore with a particular location or family. Another north-country name for this type of spirit was the 'brownie', and a real belief in their existence continued, particularly in rural areas, throughout the 1800s and into the early 1900s (Morris 1967, 53). The North York Moors has several traditional stories describing how a benevolent brownie would provide invaluable assistance around a farm, usually when most needed, at harvest time etc. In return for long hours of work and prestigious feats of labour, the brownie would only expect a saucer of cream as payment. Raymond Hayes referred to a similar story in connection with the cup marked stones he uncovered in the Lingmoor Barrow near Hutton-Le-Hole (see Chapter 4). In this case, Hayes highlighted the story of a highland farmer who would leave a portion of cream on a cup marked stone for the local brownie spirit (Hayes 1978, 31). In this respect, it is perhaps worth noting the proximity of the Boggle Bield to the cup marked stones at Allan Tofts.

Purse Moor (NZ 8095 0162)

Chris Evans (Scarborough Archaeological Society) provided valuable assistance on several occasions with regard to the survey of the North York Moors rock art, including work at Allan Tofts. In February 2000, he also discovered a cup marked stone located 1 mile to the south-west of Allan Tofts (56). This new site was located on Purse Moor, on the opposite side of the Murk Esk valley, but intervisible with Allan Tofts. The stone is a triangular-shaped slab, with seven well defined cup marks on it uppers surface. The stone was found in a pasture field, and alongside the medieval Park Dyke earthwork, which encloses Julian Park, to the west of Goathland. The remains of several cairns were noted in the vicinity of the earthwork, raising the possibility that the cup marked stone may have come from a cairn that had been quarried to provide material for the Park Dyke.

Gate Posts and Bridestones

Several stones with unusual markings came to light during the fieldwork at Allan Tofts, including an isolated stone located on the eastern edge of the site.

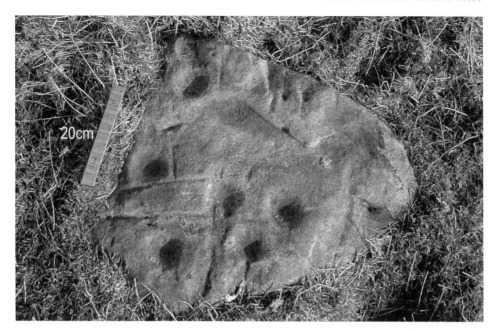

56 *Above* Purse
moor, cup marked
stone

57 *Right* Purse
Moor, cup marked
stone motifs

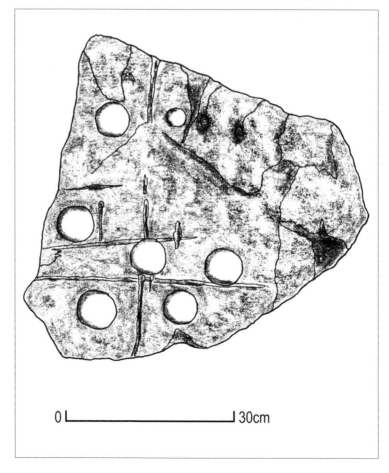

0 ⊢————————————⊣ 30cm

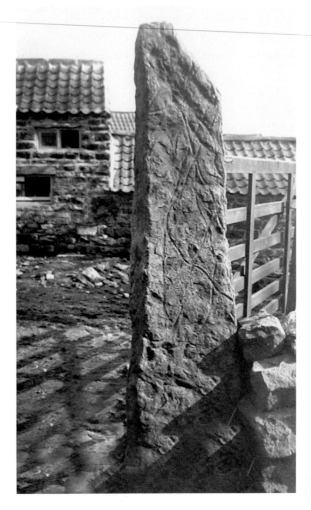

58 Allan Tofts, gate post with linear lines. *Whitby Museum Collection*

This earthfast slab has a series of faint linear markings, consisting of four short parallel lines set at right angles to a longer baseline running across the face of the rock (Site 12). The authors could not decide if these markings were a natural feature on the stone, but it was also noted that a small cairn was located 20m to the east.

Another stone was identified from a photograph in the Whitby Museum archives, which showed a roughly shaped pillar set up as a gatepost on Hawthorn Hill Farm at Allan Tofts (*58*, Site 11). One rough side of the stone has a series of meandering lines criss-crossing the face of the stone and running along most of its length. The details written on the photograph state that this is an incised gatepost, but similar patterns are to be found on rock outcrops near the High Bridestones on Sleight Moors, 2 miles to the north-east. These markings have been a curiosity for many years and there are old photographs in the Whitby Museum archive showing long curving lines cutting across the flat surface of

these stone slabs. A visit to Sleight Moors found this group of stones located approximately midway between the High and Low Bridestones (NZ 8464 0470). The area shows signs of extensive quarrying, with numerous detached blocks of stone laid amongst the heather, including the slabs with the unusual markings. These stones have grooves and channels forming arcs, circles, loops and meandering lines on their surfaces, but a close study of the marks suggest they are likely to be trace fossils. This type of fossil marking is known as an Ichno-type, meaning the imprint of a track or burrow made by a worm-like creature. One of the marked stones was also noted to have a rippled surface similar to that found on sandy beaches, perhaps indicating that a marine creature produced the fossil. Without specialist knowledge, it is difficult to positively identify these kinds of markings, as there are similarities with the linear markings found on some prehistoric carved stones. Further possible examples of these Ichno-type fossils have been noted on Little Hograh Moor above Baysdale, and the lost stone from Hawsker.

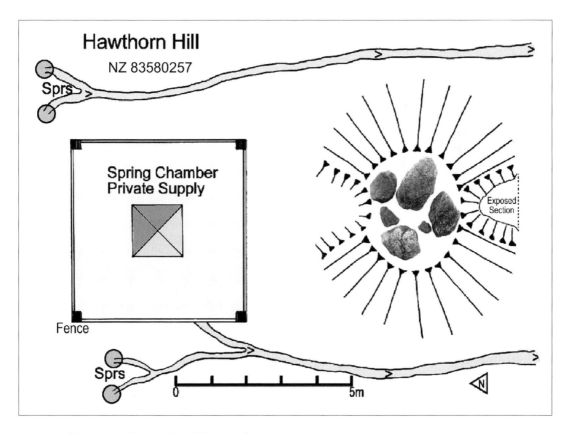

59 Burnt mound site at Allan Tofts, site plan

The burnt mound site at Allan Tofts

During our rock art survey of Allan Tofts the authors noted many other features including a number of small cairns, robbed-out barrows, linear walls and a small mound at the confluence of a spring-head. From the exposed burnt and shattered stone the mound was instantly recognised as a burnt mound.

As indicated in Chapter 1, while rock art is generally not found in isolation in the prehistoric landscape it may be difficult to assign other features to the same period; perhaps only excavation and C14 dating can provide that evidence. Some burnt mounds have been C14 dated to the Neolithic onwards, but they continue to be subject of debate within archaeology and the research continues. Although this mound has not been excavated and no dating evidence is available it is feasible to assume it falls within the above time scale and it was decided to present this as part of the possible Neolithic/Bronze Age landscape in evidence at Allan Tofts.

Journal entries of Lewis and Clark's famous Corp of Discovery expedition in the early nineteenth century included notes of 'ritual cleansing processes' practised by North American Indians – these were referred to as 'sweathouses'. It was also understood that tribal medicine men used them in an attempt to rid the body of fever and other ailments. Lewis and Clark 's fascinating journals did not provide many details of the origins of this ritual, but a similar form of sweathouse or sauna (that had possible origins in the Late Neolithic) was practised in this country and continued throughout the Bronze Age into the Iron Age. In Great

60 Burnt mound at Allan Tofts

Britain and Ireland these ritual places are known as burnt mounds. Stones were preheated in a fire and placed within a clay-lined pit or wooden trough and a tepee or tent of skins was placed over the top. In some areas, box-type structures were used in place of tepees or tents. The stones were splashed with water to produce steam and it is possible that herbs were also placed on the hot stones. Research on burnt mounds has increased and a number of sites have been discovered in the Northumberland, Teesdale and Yorkshire Dales area. Following an investigation of the current archaeological records and the SMR, the authors can confirm that the burnt mound at Allan Tofts appears to be the first discovered within the North York Moors and in the north-east Yorkshire region.

This example is close to a spring source with a pure water supply but in other areas of the North East mounds have been located close to temporary sites of settlement. The mound measures 7.5 x 6 x 1m high and is formed by the gradual accumulation of stone; following numerous cycles of heating and cooling the large sandstone cobbles fracture and disintegrate into compacted fist-sized pieces of sandstone that are discarded on a heap nearby, thus forming the burnt mound. Over a considerable time period these mounds can accumulate several cubic metres of stone; identification of stone used in a burnt mound is relatively easy since it exhibits extensive reddening and fracturing due to intensive heat. The present-day spring at Allan Tofts has been tapped for a private water supply and is now within a fenced enclosure. The authors consider that the site is contemporaneous with the rock art and Bronze Age barrows on the moor. Mounds can be singular but can occasionally be in clusters and one of the authors located the site of three large mounds at Sturdy Springs, Whashton (near Richmond), Yorkshire, NZ 135052. One of the mounds measured 15 x 12 x 2m and all three mounds were situated on the same spring source.

The site in Allan Tofts may not be isolated. Further spring sources were checked by the authors but much of the area has been quarried and cleared. No other evidence has been found, though some of the water tables have been altered over the years and the position of spring sources may have been altered. On the first edition OS maps, a mound is marked close to a spring source. Unfortunately, many mounds have been removed and a modern day pipe has been placed at the spring source and only excavation or geophysic survey would determine if this was the site of a burnt mound. Mounds have characteristic shapes, mostly in the form of a crescent or horseshoe-shape. More often they are circular in shape and they hold either a rectangular trough or circular pit capable of containing water. Other processes that would involve the heating of such substantial amounts of water include the fulling and dying of cloth or making and brewing of beer.

In a recently published paper (Laurie 2003) Tim Laurie suggests that burnt mounds can be composed of three or four mounds surrounding a central pit where the stones were placed in a trough. Orthostatic rocks occasionally protrude through the turf to indicate the presence of the hearth or other structures. Large sites often have a levelled surface, or a level circular interior and in general

mounds are situated at 250m OD or above. Without exception all are situated on the banks of small streams or dykes, either above or just below the spring, though occasionally the spring has been diverted or moved to a different level for a farm or public water supply. Radiocarbon dates of 2000 BC have been given for the timber trough linings and Laurie suggests that the mounds were sweathouses or bathing places and unlikely to be cooking places. The basis for his interpretation and that of other researchers was the total absence of domestic debris, pottery or bone that would be expected on a cooking site. However, burnt mounds in Ireland are believed to be ancient cooking places and are known in the Celtic as Fullacht Fiadh. It is suggested that it was the method used for cooking deer in the medieval period.

EASTERN SITES

Aislaby and Swarth Howe

Eskdale forms the main east–west watershed across the North York Moors region, with the River Esk eventually flowing into the North Sea at Whitby. The village of Aislaby is situated 3 miles to the south-west of Whitby, and its location on the north side of the Esk Valley provides extensive views across Eskdale and the moorland to the south. An unenclosed section of Aislaby Moor still exists to the west of the village; however, on Galley Hill to the north, the original moorland has been turned over to rough pasture and cultivation. Evidence for prehistoric activity in the area can be seen in the surviving barrow group around Swarth Howe: a large and prominent burial mound located on the hilltop ridge adjoining Aislaby Moor. In addition to these barrows, the Revd George Young, writing in the early 1800s, noted the existence of a long line of smaller barrows extending from Swarth Howe down towards Aislaby village (Young 1817, 664).

Aislaby Moor (NZ 850 088)

During 1969, Stuart Feather discovered two cup marked stones on Aislaby Moor at an approximate grid reference NZ 850 088 (Feather 1967, 387). Numerous visits to this area by the authors have failed to relocate the reported stones and it is presumed that they are buried beneath the dense vegetation on the moor. In relation to this area, it is worth noting the site of a cairn (NZ 8456 0888), which appears to have been part of the line of small howes noted by Revd Young. In 1935, Hugh Kendall and E. Simms excavated the remains of this cairn, which was located by the roadside on the northern edge of the moor. The mound had been robbed for its stone and also cut by a drainage channel. However, the excavators located two deposits of cremated bone, one being associated with a flat stone covering an inverted collared urn (Kendall 1935, 243). The proximity of this burial mound to the cup marked stones reported by Mr Feather raises the possibility that the stones may have been associated with this cairn.

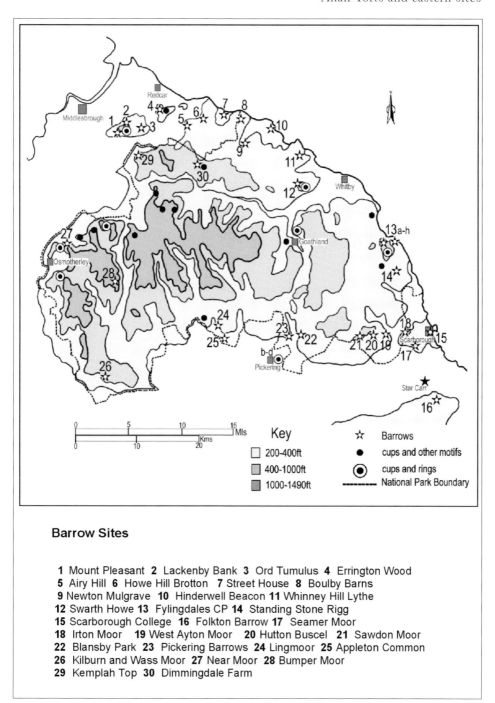

Barrow Sites

1 Mount Pleasant **2** Lackenby Bank **3** Ord Tumulus **4** Errington Wood
5 Airy Hill **6** Howe Hill Brotton **7** Street House **8** Boulby Barns
9 Newton Mulgrave **10** Hinderwell Beacon **11** Whinney Hill Lythe
12 Swarth Howe **13** Fylingdales CP **14** Standing Stone Rigg
15 Scarborough College **16** Folkton Barrow **17** Seamer Moor
18 Irton Moor **19** West Ayton Moor **20** Hutton Buscel **21** Sawdon Moor
22 Blansby Park **23** Pickering Barrows **24** Lingmoor **25** Appleton Common
26 Kilburn and Wass Moor **27** Near Moor **28** Bumper Moor
29 Kemplah Top **30** Dimmingdale Farm

61 Barrow sites distribution map

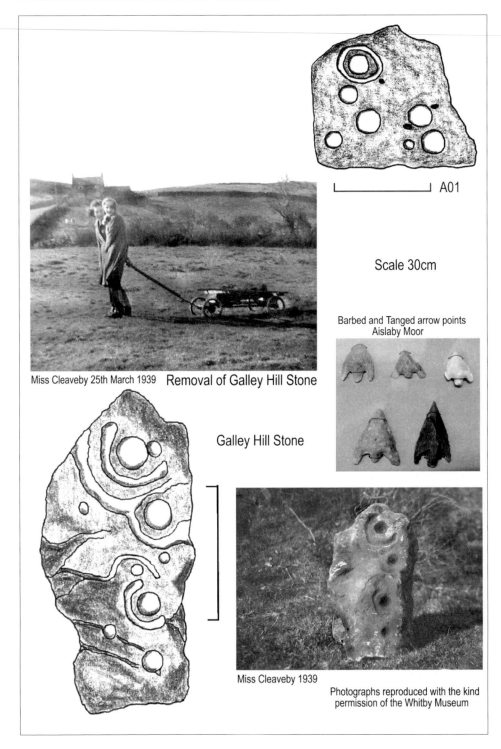

A01

Scale 30cm

Barbed and Tanged arrow points
Aislaby Moor

Miss Cleaveby 25th March 1939 Removal of Galley Hill Stone

Galley Hill Stone

Miss Cleaveby 1939

Photographs reproduced with the kind
permission of the Whitby Museum

62 Aislaby Moor and Galley Hill

Galley Hill (NZ 9275 0420)

In the winter of 1939 Mr P. Burnett of the Whitby Naturalists Club discovered a large cup-and-ring marked stone on Galley Hill to the north of Aislaby village (*62*) (Browne 1940, 65). The stone was built into a field wall, and noted as being one of the larger stones in the walling, perhaps suggesting that it had not travelled too far from its original location. The unweathered state of the carving also indicated that it had not been exposed to the elements for any significant period. Given these facts, it seems likely that the stone had originally been incorporated into a barrow or cairn on the hill, before the land was cleared for agriculture. This stone is now on display in Whitby Museum.

Moorcock Farm (NZ 8427 0836)

Much of the valley side to the west of Aislaby village is precipitously steep, due to the extensive sandstone quarrying in the area. No examples of rock art have been noted on the remaining exposed outcrops, although the scale of quarrying has, in places, removed several metres from the valley side. An unmarked footpath leads westward along the top edge of the escarpment, and in November 1996, one of the authors (GC) found a cup-and-ring marked stone in this area (*62*, A01). The stone is located alongside a small quarried outcrop in a field on Moorcock Farm, this farm being located on the enclosed land adjacent to Aislaby Moor. The markings on this block of stone are very eroded and the shape of the stone might suggest that it was originally part of the nearby outcrop. The fact that this carved stone has been preserved on the quarry site while several tons of sandstone were removed would suggest that the carvings were viewed as significant and worth preserving. If this is the original site of the stone then its location, only a few metres from the edge of the escarpment, provides impressive views along the Esk Valley.

Swarth Howe (Penny Howe)(NZ 8430 0891)

In the early 1850s, the Whitby antiquarian Samuel Anderson organised the excavation of at least four barrows in this area, including the large mound of Swarth Howe. A short account of this barrow opening appeared in the Proceedings of the Society of Antiquaries (Anderson 1853, 58), where Anderson described a kerbed mound covering a rectangular arrangement of walling, and a cist. The report also mentions finding cremation and inhumation burials, plus a food vessel, an accessory cup, jet rings and worked flint. Anderson's account also noted the existence of a line of large stones located between Swarth Howe and a smaller barrow 130m to the west. Unfortunately, by the 1850s this stone alignment had been reduced to just two boulders, the result of 'Modern Goths' pilfering the stone for road mending etc. Anderson reported that both the surviving stones had markings upon them, but he was unsure if the marks were manmade or natural. However, he did note: '... some of the marks correspond with those on a stone found in the barrow which has evidently been done by the parties forming it.'

Here Anderson is referring to a cupstone found within the cist in Swarth Howe (Spratt 1982, 146). The two boulders in the alignment still exist today; standing approximately 1m in height. However, the tops of the stones are deeply eroded with pits and grooves. Although the markings do appear to be the result of natural weathering, some are sufficiently cup-like to lend support to Anderson's observations.

By the mid-1800s there was a growing interest in cup-and-ring rock carvings, particularly in Northumberland and Scotland, whilst in this region the Scarborough antiquarian John Tissiman was also reporting cup-and-ring marked stones as significant features in his barrow explorations, during the early 1850s. At this time Anderson seems to have been unaware of this wider interest, although he observed and noted the markings at Swarth Howe, and at another barrow on Newton Mulgrave Moor he mentions a 'curiously marked stone' covering a cremation, plus 'a variety of curious figured stones' in the central area of the mound (Anderson Mss. c.1850).

Wade's Stone – Swarth Howe (NZ 843 089 Area)

In his history of Whitby, the Revd Young records the local tradition that a large stone near Swarth Howe was known as 'Wade's Stone'. This stone had an 'impression' upon its surface, which was created when the stone struck a giant named Bell (Young 1817, 666). Several locations around the North York Moors are connected in legend with the Giant Wade and his wife Bell. On one occasion, the giantess Bell was milking her cow near Swarth Howe, having left her infant son at play on Sleights Moor. However, when the child became hungry and wanted to attract his mother's attention, he picked up a large boulder and threw it across the Esk Valley towards her. The stone caught the giantess unawares, and struck her a hard blow, before bouncing off to land near Swarth Howe: '... And her body made an impression on the stone which remained indelible, till the stone itself was broken up, a few years ago, to mend the highways.' (Young 1817, 725).

This story appears to record another marked boulder near Swarth Howe which, before the stone's removal, possibly formed part of the alignment noted by Anderson. Details regarding the form of the 'giant's impression' are not related in the tale, so unfortunately we have no clues as to whether this was another example of this area's prehistoric rock art.

Foulsike, Kirkmoor, Ramsdale and Hawsker

The cup-and-ring marked stone found on Galley Hill at Aislaby can be seen in the Pannett Museum in Whitby along with several other marked stones from the Whitby area. These stones form part of the diverse collection held by the museum, which admirably sticks to the philosophy of presenting a large selection of interesting items, displayed in a traditional layout.

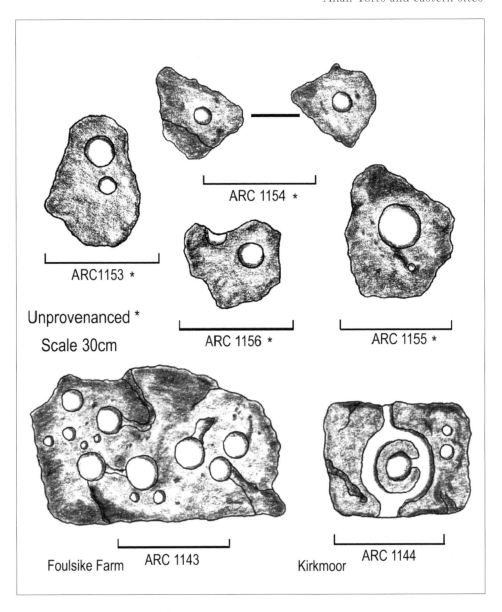

ARC 1154 *

ARC1153 *

Unprovenanced *

Scale 30cm

ARC 1156 *

ARC 1155 *

Foulsike Farm ARC 1143

Kirkmoor ARC 1144

63 Whitby Museum rock art collection

Foulsike Farm (NZ 918 020 Area)

The marked stones in the Whitby Museum collection were mainly donated by local landowners, but in most cases there are few details on record regarding the finds. This lack of information exists because the stones had already been removed from their original context many years ago. The examples from Foulsike Farm are typical of this, one having been found in a drystone wall on the farm (63), whilst another was found as a loose stone in the vicinity of a cairn

group to the south-east of the farm. Foulsike Farm is located in the gap between two watersheds, and in the past this area may have provided a dry route from the higher moorlands to the west, down into Robin Hood's Bay on the coast. There are extensive earthworks to the west of Foulsike, and a number of barrows and cairns to the north and south, so the carved stones found on the farm may relate to this phase of prehistoric activity in the area.

Kirkmoor Farm (NZ 9236 0295)

Kirkmoor is located immediately to the east of Foulsike, and the owners of Kirkmoor Beck Farm also donated a cup-and-ring marked stone to Whitby Museum, this stone having been found in a field wall around an enclosed part of the Kirk Moor (63). Interestingly, the name 'Kirk' may provide a clue to the prehistoric remains in this area, as it can be associated with stone circles in northern Britain. In 1965 a small circle was excavated on Kirkmoor Beck Farm, and although originally described as a stone circle, this site (NZ 9253 0306) is now recognised as the remains of a kerbed barrow or cairn (Smith 1994, 91). The site of this robbed barrow is located 200m to the east of the drystone wall where the cup-and-ring marked stone was found, so there is a possibility that the marked stone was associated with this barrow, or perhaps another mound cleared from the moor.

Ramsdale (NZ 9275 0420)

The Ramsdale Standing Stones (NZ 921 038) are situated 0.5 miles (800m) to the north of the Kirkmoor site. Their location, on the higher ground of Standing Stones Rigg, overlooks Ramsdale, Robin Hood's Bay and the seascape beyond. The three large stones are arranged in a triangular setting, with a 'recumbent-like' boulder on the longer axis facing out towards the distinctive escarpment of Stoupe Brow, visible to the south-east. The lower, south-facing slopes of Standing Stones Rigg have been turned over to pasture land, and it was here in April 2004 that the authors found four cup marked stones in an old boundary wall enclosing the fields (64). The first edition OS map marks the site of several 'tumuli' in these fields; again there is the possibility that these cupstones may originally have been incorporated within the mounds before they were cleared from the land. These marked stones have also been donated to Whitby Museum.

The Hawsker Stone (NZ 925 075 area)

Research in the Whitby Museum Archive brought to light an old photograph of an unusual marked stone from Hawsker, near Whitby (65). The only information relating to the stone is written on the back of the photograph: 'Plate number A91. Celtic Stone from Hawsker. A. Smith'. The image shows an irregularly-shaped stone (size unknown, as there is no scale) with a series of grooves or linear marks on one face. These lines form a triangle, alongside an oval shape connected to three parallel lines, while a further line encloses this group of markings. There are

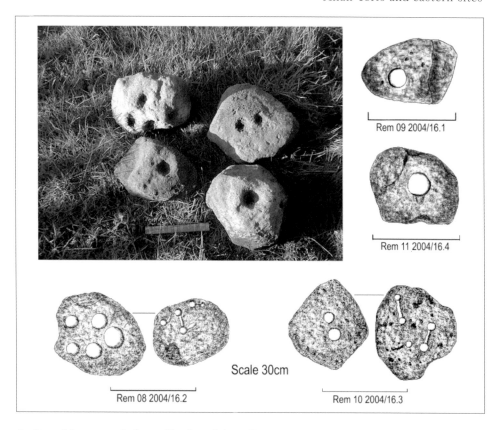

Rem 09 2004/16.1

Rem 11 2004/16.4

Scale 30cm

Rem 08 2004/16.2

Rem 10 2004/16.3

64 Ramsdale, cup marked portables from dyke wall

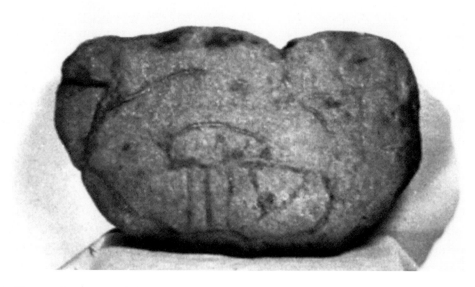

65 The Hawsker Stone. *Whitby Museum Collection*

possibly other marks on the stone but the image is very blurred, making it difficult to study the markings in any detail; however, they do not appear to resemble any style of 'Celtic' art. Enquiries made in Hawsker village, and a check of possible locations such as the village church, have not revealed the whereabouts of this stone. Given the poor quality of the photograph, and without the opportunity to study the markings, it might be suggested that they are the result of an Ichno-type trace fossil. The surface of the stone also appears to be smooth and rounded, possibly water-worn, and its location at Hawsker on the coast might explain this. If this is the case, then the action of the sea on the fossil markings may have given them a more manmade appearance, leading to the Celtic reference.

RAVENSCAR AND RAVEN HILL

Raven Hall Hotel (NZ 9805 0195)

Canon Greenwell visited Ravenscar around the time of the publication of his monumental work *British Barrows* (Greenwell 1877). The purpose of his visit was to excavate barrows on the Fylingdales Moor, including one of the Stony Marl Howes. In his report covering these excavations, he noted that several cup-and-ring marked stones had been found on the moorland, adding that eight examples were also to be found in the gardens of Peak House. Greenwell was informed that the Peak House collection had been removed from barrows and other sites in the neighbourhood (Greenwell 1890, 39). Peak House is now the Ravenhall Hotel, impressively located on the high cliffs at Ravenscar, overlooking the scenic Robin Hood's Bay.

Although a century had elapsed since Greenwell's report, there were no current records of any carved stones at the hall. So, in the mid-1990s the authors decided to check up on Greenwell's reference. This research paid off when enquiries made by Frank James at Staintondale and Steve Hesketh at Ravenscar, led to the reporting of a fine cup-and-ring marked stone (67). This stone had been built into a wall in the hotel garden, and with its rediscovery it is hoped that further examples may come to light in the future. The motif on the stone has been produced by shallow pecking, creating a small central cup mark surrounded by three concentric penannular rings. The ends of the rings link together to form a pattern similar to the comb-like motifs found on Howdale Moor, 1.5 miles further inland.

The Raven Hill Barrow – A tale of two barrows? (NZ 9795 0104)

Canon Greenwell indicated that some of the carved stones at Raven Hall came from burial mounds in the neighbourhood of Ravenscar. Today, a number of barrows still exist in the area, but these are likely to be just a small fraction of the total that were removed by agricultural activity during the nineteenth century. Robert Knox records that when a small field to the south of the hall was brought into cultivation, the plough uncovered the remains of 32 tumuli (Knox 1855, 183).

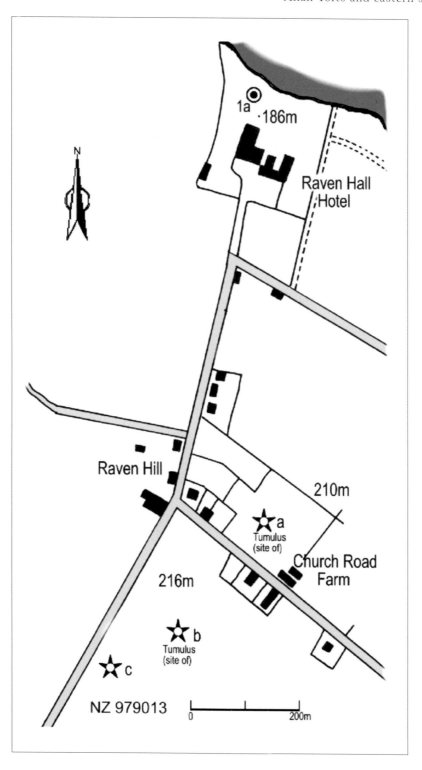

66 Ravenscar area map

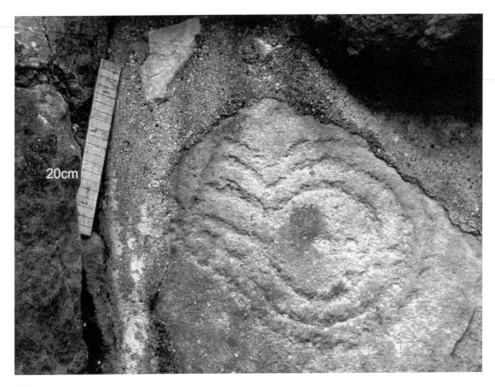

67 Raven Hall hotel cup and ring stone

In August 1849 the Scarborough antiquarian John Tissiman opened a barrow known as the 'Raven Hill Tumulus' located just to the south of Ravenscar village. He later published an account of his digging (Tissiman 1851, 1), noting that this barrow was one of three mounds to be found alongside the road leading to Raven Hall. The barrow covered a substantial kerb and a number of collared urns associated with cremations. Also associated with these funerary vessels were at least five marked stones, one with five cup marks and one with two cup marks; another stone had a spear-shaped cavity and a chevron-like arrangement of lines, whilst another had an oval depression on one face and a single cup mark on the opposing side.

The Raven Hill Cist Stone (NZ 9809 0121)

A large stone slab marked with three concentric circles is currently on display in the Rotunda Museum, Scarborough (68). This carved stone originally formed the side slab of a burial cist and was discovered in a barrow at Ravenscar by John Tissiman. In his account of the Raven Hill Tumulus (see above), Tissiman does not mention finding a cist, although he states that the whole mound was turned over at that time. The only reference to the cist stone is in a letter dated November 1851, where Tissiman describes the cup-and-ring marked stones

found in the Cloughton Moor Cairn Circle. (Tissiman 1852, 448). This letter also includes a sketch of the 'Raven Hill vault stone' and a brief note indicating that he intended to further excavate the intact 'vault' (cist) in the spring of 1852. It has been assumed that the cist slab came from the 'Raven Hill Tumulus' dug in 1849, but the letter of 1851 does not appear to support this assumption. Instead, it would seem to indicate that Tissiman returned to Ravenscar in 1851 to excavate another barrow in the Raven Hill group, this second barrow being the more likely site of the decorated cist slab.

This scenario is, perhaps, confirmed by another Scarborough antiquarian Robert Knox, who records that a Mr George Marshall 'explored' a small barrow to the south of Raven Hall, during a stay there in the summer of 1852 (Knox 1855, 197). Marshall reported that a cist within the mound had a side slab marked with three concentric rings, this cist being the same orientation and approximate dimensions as that reported by Tissiman. Further support can be found on the first edition OS map, which plots the position of the three 'Tumuli' alongside the road to Raven Hall, as noted by Tissiman. All three mounds can be described as being located on Raven Hill. However, the current OS map now marks two of these barrows as 'Site of'. One of these will be the barrow dug by Tissiman in 1849 when he was 'desirous to turn the whole of it over'. This barrow was described as being on moorland at that time and can therefore be identified as the barrow site at NZ 9795 0104. The other 'Tumulus – Site of' is located at NZ

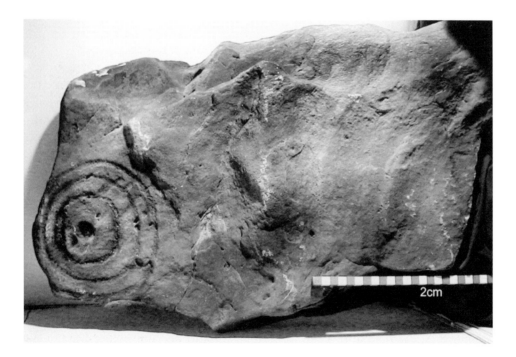

68 The Raven Hill Cist Stone

2cm

69 Cup marked slab from Raven Hill Barrow

9809 0121, and this is the suggested site for Tissiman's second barrow excavation at Raven Hill. Interestingly, the early OS map also records a circular feature alongside this barrow, which matches the site description given by Marshall for the mound he 'explored' in 1852. If this situation is correct then it appears that both men were describing the same barrow and cist slab.

How this situation arose can perhaps be explained by the fact that Tissiman (a local farmer) would not have been digging the barrows in this area without the permission of the landowner, William Hammond, at the nearby Raven Hall. Indeed, it is quite feasible that Tissiman, as an experienced barrow digger, may have been carrying out the excavations on behalf of the landowner with some arrangement regarding any of the finds from the sites. From Tissiman's letter it would appear that he had already found the cist in the autumn of 1851, perhaps having driven a trench into the mound and noting the cist before leaving the site over winter with the intention of returning to it in the spring of 1852. Mr Marshall also visited Ravenscar in 1852, at which time he was described as a

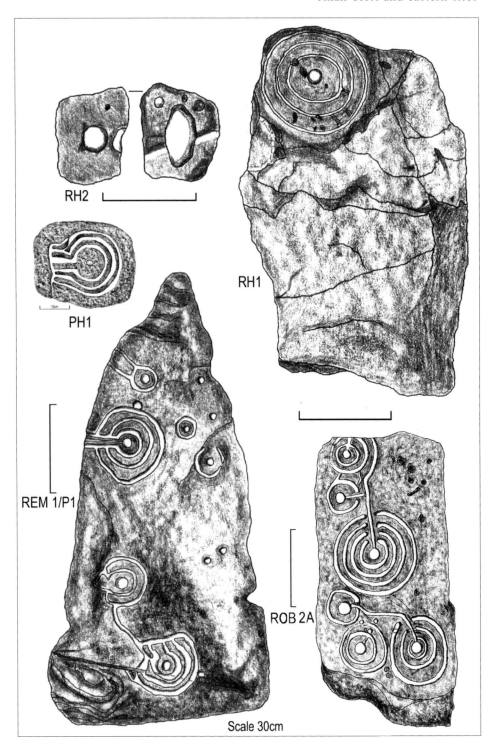

70 Rock art panels from the area of Raven Hill and Peak Moors

'gentleman' residing at Raven Hall, and therefore a guest of the landowner. With the arrival of Mr Marshall, who appears to have taken a keen interest in the local archaeology, Tissiman may have been obliged to complete his excavations under the direction or scrutiny of Mr Marshall.

These snippets of information raise more questions than answers, but perhaps provide a rare glimpse of the activities of these early barrow diggers in an era when few records were made. Indeed, Tissiman claimed to have opened 'numerous barrows in the district', but only brief details of two excavations are on record. George Marshall's correspondence with Robert Knox has preserved some information regarding this barrow. Knox also noted additional finds from the site:

> Hereabout Mr Marshall also found another stone, marked with a circle, crossed with a horizontal and perpendicular line. And subsequent to 1852, the same gentleman found in that vicinity another particular stone, marked with four of the same kind of hieroglyphics, differing only as follows; viz., one consisting of four concentric circles with a dot in the centre – one of three circles and dot in the centre – one of two circles and dot in the middle and one of only one circle and centre-dot. (Knox 1855, 198)

From the above description it seems likely that this multiple cup-and-ring marked stone is now located in the gardens of the Yorkshire Museum in York. In the late 1800s, the Yorkshire Philosophical Society purchased two cup-and-ring marked stones from the neighbourhood of Robin Hood's Bay (Y.P.S. 1886), and the Society's collection later passed to the Yorkshire Museum, which still holds one of these marked stones. For many years, the carved surface of this stone was face down and no record existed of the motifs. Fortunately, just prior to the publication of this book the stone was turned over to reveal a series of cup-and-ring markings, which closely match the description given by Knox (*70*, ROB2A).

CLOUGHTON MOOR

Cairn Circle, Standing Stones Rigg (SE 9825 9698)
In 1851 John Tissiman exhibited a set of drawings to the Society of Antiquaries of London. These drawings illustrated two cup-and-ring marked slabs from the cairn circle on Cloughton Moor, 2 miles to the south of Ravenscar (*71*). Robert Knox had marked this site as a 'Druids Circle', on his map of the area published in 1820, and gave further details of the site in his subsequent book (Knox 1855, 164). Apart from his speculations regarding victims being bound to a sacrificial stone seat, while they were 'immolated' by Druid priests, Knox also describes the circle as it stood in the early 1800s, noting that even at that time standing stones and cairn material were removed for road mending and

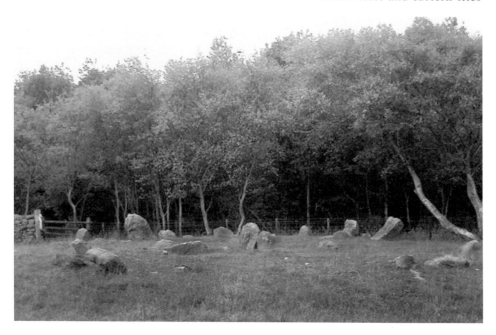

71 Standing Stones Rigg

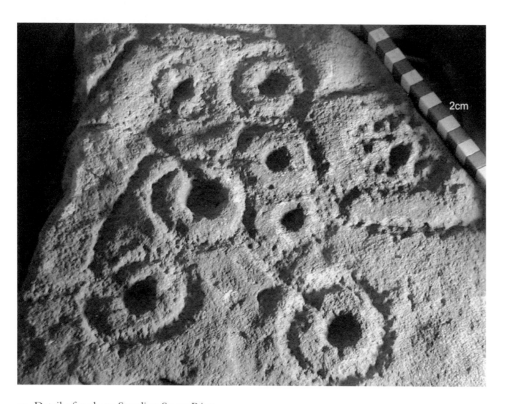

72 Detail of rock 2c, Standing Stone Rigg

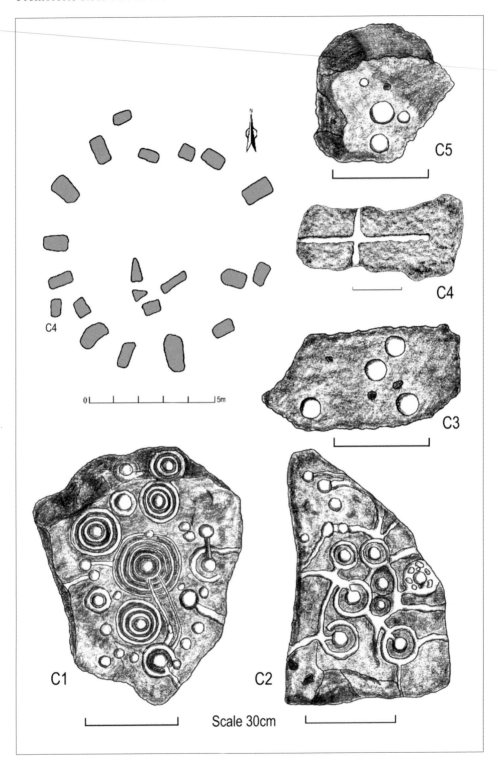

73 Standing Stone Rigg, cairn and motifs

wall building. Knox's illustrations show the circle (16m in diameter) with an outlying stone, 90m to the north-west. His description mentions other stones within the north-west sector of the circle forming the remains of an 'avenue' to the centre, where a flat, altar-like stone had existed prior to its removal sometime after 1830.

This large, flat stone (approximately 1.1 x 0.75m) may in fact have been the cover to a cist, which was later fully exposed when more stones were removed for the building of a field wall adjacent to the circle. At this time John Tissiman was on hand and noted the cup-and-ring marked stones, which he was in no doubt had 'formed a part of a sepulchral chamber of a cairn' (Tissiman 1852, 447), and, fortuitously, he removed the carved stones from the site (73). Tissiman's own sketch of the circle shows an arrangement of large stones at the centre, which he speculated might have been the remains of a cist, and near which he found a third stone with six cup marks. The drawing also shows two cup marked stones at the edge of the circle and a stone marked with a cross. This cross-marked stone is still in situ and may relate to the site being a boundary point of Whitby Strand, as recorded in the Whitby Abbey register. Tissiman also noted the circle's location on a ridge commanding extensive views, but today modern forestry obscures much of the outlook from the site. The first edition OS map also shows approximately 100 'tumuli' to the west and south of the cairn circle, and although these were likely to have been small cairns it indicates that the circle was part of a much larger spread of prehistoric remains.

The two cup-and-ring marked stones from this site can rightly be regarded as amongst the best in the region. The elaborate decoration includes cup marks, grooves, channels and multiple concentric rings, which are spread across the whole face of the stones; a feature often associated with passage grave art. In this respect, it is interesting to note Knox's reference to the remains of an 'Avenue' within the mound, which might suggest a chambered cairn structure, similar perhaps to the site on Great Ayton Moor, 25 miles to the north-west.

The four marked stones from this site are now part of the Scarborough Museum collection, and although they are now grey with 150 years of dust, and have suffered some damage during storage, these fine examples of rock art have been preserved, instead of ending up as broken fragments in a dry stone wall.

RUDDA HOWE AND CASTLEBECK FARM

Rudda Howe (SE 9768 9975)

During the year 1850, John Tissiman also carried out excavations at Rudda Howe, a large cairn located 1 mile to the south of the Raven Hill barrows (Tissiman 1852, 446). In this mound he uncovered a cremation burial and fragments of a large urn, below which he also found a smaller collared urn associated with

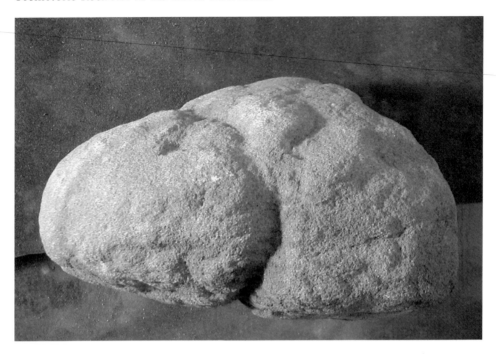

74 Net sinker from Hinderwell Beacon similar to the ones described

two worked stones. These two items, although not strictly examples of rock art do illustrate the point that certain utilised stones were considered to have some significance in relation to burial practices. The small, irregularly-shaped stones (maximum length 35cm) were each encircled by rough grooves, the form of which indicated to Tissiman that they might have been prehistoric anchor weights. This seemed a reasonable inference given the burial mound's coastal location and outlook, and perhaps suggests that placing the anchor stones within the cairn had some symbolic association with those interred there.

One of the authors (GC) noted similar stone anchor weights in the Te Papa Museum of Maori Culture in Wellington, New Zealand (some of the stones being carved with linked spirals). These stones highlight the concept among traditional cultures whereby utilitarian objects can take on an added spiritual dimension. To the Maori people the anchor stones symbolise the long sea journeys made by their ancestors to reach the islands and a sense of permanence once they finally let down the anchor stones, before going ashore to settle in a new land. These kinds of beliefs attached to apparently everyday objects could go some way towards explaining the occurrence of stone weights and pieces of broken saddle querns etc. that have been found in burial mounds. Examples have been noted at Seamer Moor, Eston Nab, Wilton Moor, Hinderwell Beacon, the Street House Wossit, and a cup marked quern fragment from the Lingmoor Barrow at Hutton-Le-Hole.

Castlebeck Farm (SE 9500 9765)

In an article by Richard Harland (Harland 2001, 5), there is a passing reference to a cup-and-ring marked stone and 'pit dwellings' near Bloody Beck in the Scarborough district. These sites were apparently discovered by a local antiquary, Joshua Rowntree (1844-1915); however, it appears that few details were recorded about the sites, their exact location, for example, is not noted. In the course of the authors' research an intriguing photograph came to light among the Scarborough Museum records, showing a large stone slab with three rings carved on its flat surface. The only details connected with the photograph were the words 'Taylor 1922 Castle Beck Harwoodale'. Harwoodale is situated 6 miles to the north-west of Scarborough, and in this area there is a Castlebeck Farm located near the junction of Bloody Beck and Jugger Howe Beck. In the fields to the north of the farm there are a series of shallow pits which are thought to be the result of ironstone extraction. In the past, however, these type of pits were believed to be the remains of dwellings created by prehistoric people. Enquiries made at Castlebeck Farm also led to the farmer's son identifying the large stone slab in the photograph, and pointing out its location at the edge of Scar Wood to the west of the Farm (SE 9500 9765) (75). On examining the stone, it was found that the carved circles were very large

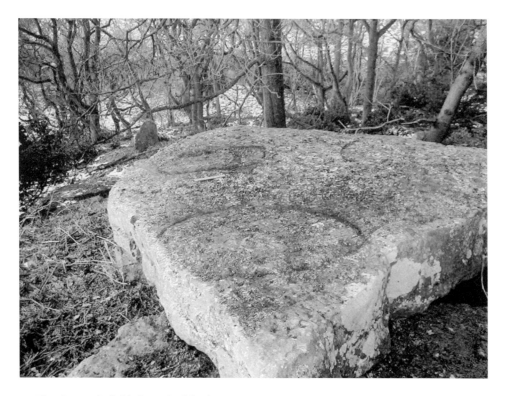

75 The ring marked slab from Castlebeck Farm

(1.5m in diameter), and although very eroded, they were probably the marking out stage for millstone quarrying. This stone, and the pits to the north, would appear to be the sites noted by Joshua Rowntree, who apparently had some connection with Castlebeck Farm. Although the report of a cup-and-ring stone was not confirmed, this research has hopefully shed some light on the reference to these sites.

4

North York Moors – southern and western sites

SOUTHERN SITES

The Tabular Hills to the west of Scarborough define the southern edge of the North York Moors region, this range of limestone foothills dropping gradually into the Vale of Pickering. During the prehistoric period the low lying land within the vale formed an extensive area of marsh, lakes and waterways, which were utilised by the early inhabitants in the region as evidenced by the site of a Mesolithic camp at Star Carr. Across the vale to the south the land rises again to form the upland area of the Yorkshire Wolds, where extensive Neolithic activity has also been recorded.

Corallian limestone and calcareous sandstone make up the main underlying geology along this southern flank of the moors and it would be unlikely that any exposed prehistoric carvings will have survived on these relatively soft sedimentary rocks. This is perhaps borne out by the fact that all the recorded examples of rock art from this area have been discovered during barrow excavations carried out over the last 150 years. These barrow sites form a chain along the fertile slopes on the southern fringe of the moors, starting near the east coast with the site at Wheatcroft then stretching inland along the foothills to the barrows dug by Canon Greenwell on Byland Moor, at the southern end of the Hambleton Hills.

Wheatcroft Barrow – Scarborough (TA 0460 8645)
In the summer of 1910, the extension to a cricket pitch in the grounds of Scarborough College led to the removal of a burial mound on the site. The mound was found to cover three cists, one of which had previously been opened in 1835. Two cup marked stones were found near this earlier excavation, one being identified as the covering stone from the cist (Crossley 1911, 111). The current location of these stones is unknown.

Barrow 1 – Seamer Moor (TA 0194 8617)

On the high ground immediately to the west of Scarborough town there are numerous burial mounds and earthworks. In 1966, the excavation of a plough-damaged barrow in this area revealed a kerbed cairn built over several cremation pits, together with evidence for earlier Neolithic activity on the site. This earlier phase centred around a hearth radiocarbon dated to 3310 BC (Brewster & Finney 1995, 25) while the cairn mound material also contained Neolithic Towthorpe Ware, Beaker sherds and flints. A small block of limestone (approximately 12 x 10cm) was also found in the western section of the kerb and this rough stone had an encircling groove crossed by another groove on one face, suggesting its use as a weight or net sinker (76) The location of this stone has not been traced, however it may have parallels with the grooved stones from Rudda Howe and a stone from Hinderwell Beacon.

Barrow 2 – Irton Moor (TA 0065 8768)

Irton Moor adjoins the concentration of barrows and earthworks already noted on Seamer Moor, and this whole area has been enclosed for agriculture for many years. During the early 1970s, a number of rescue excavations took place in this area in order to record the details of several disturbed and damaged burial mounds. In 1971, the excavation of a plough-damaged barrow on Irton Moor uncovered a cairn built over two pits. A large stone marked with abraded grooves had been placed over one of these pits and apart from this stone the only finds

76 Seamer Moor Barrow 1, net sinker. *After Brewster and Finney*

were flints (Brewster & Finney 1995,10). The current location of this stone could not be traced, but the excavation report suggested that the grooves might have been tool sharpening score marks. This stone may have parallels with the grooved stone from the Hutton Buscel site (see below).

Barrow 5 – Irton Moor (TA 005 876)

The excavation of a second disturbed barrow on Irton Moor took place during 1973 and, in this case, the mound was found to cover two concentric kerbs and a central setting of boulders (Simpson 1974, 32). A cup marked stone was found within the cairn along with deposits of cremated bone, a plano-convex knife, sherds of Bronze Age pottery and a food vessel urn. The current location of this stone could not be traced. The Bronze Age cairn overlay an earlier Neolithic site, which included a central pit (1m in depth) surrounded by two concentric ditches. Cremated bone, Neolithic pottery, and a leaf shaped arrowhead were associated with this earlier phase and it is interesting to note the possible continuity of a theme on the site, with the two Neolithic concentric ditches and the two concentric kerbs during the Bronze Age.

Barrow 6 – Irton Moor (TA 0068 8755)

The remains of a third disturbed barrow on Irton Moor were also excavated in 1973 and this particular mound was found to cover three concentric kerbs, with a cup marked stone in the north-east section of the outer kerb. The central grave had been robbed but food vessel sherds and worked flint were found in the mound material (Coombs 1974, 31-32). The current location of this stone is unknown.

Way Hagg Barrow – West Ayton Moor (SE 9657 8840)

A group of earthworks and barrows are located on West Ayton Moor, 2 miles to the north of Ayton village. Today, the area is covered by forestry but during the autumn of 1848 John Tissiman excavated one of the burial mounds finding an Accessory Cup and a large collared urn, which stood upon two large stones. Three cup marked stones were also located near this urn, one stone had an oval depression and three cup marks, another stone had four cup marks, and a third had 13 cup marks along with three parallel lines on the edge of the stone. A fourth stone, with five cup marks on one side, stood nearby (Tissiman 1851, 1) (77). The current location of these stones is not known.

Barrow 2 – Hutton Buscel (SE 9595 8720)

In 1965 the excavation of a plough-damaged burial mound took place on the hill slopes to the north of Hutton Buscel village. This area contains numerous prehistoric sites including extensive groups of barrows and linear earthworks. However, many of the sites are now covered by the modern Wykeham forest. The excavation revealed a kerbed barrow with an inner mound built over an area of limestone paving which, in turn, covered an inhumation. The excavation also

77 Cup stones from
Way Hagg Barrow.
After Tissiman 1848

uncovered food vessel pottery and Beaker sherds, plus a small stone-lined pit to
the east of the platform. This pit, covered by a capstone, contained charcoal and
hazelnut shells thought by the excavators to have some ritual significance. The
outer capping layer of the barrow also covered four cremations, and in a final
phase of construction 60 stones were placed in a kerb around the mound. Of
these kerbstones nine bore cup marks, one had incised lines and cup marks, two
had incised lines only, one a 'human face' and a shield-like motif and one other
had two drilled holes. The marked stones were located at points in the east, south
and west sectors of the kerb with a marked concentration in the northern sector
(Brewster & Finney 1995, 6).

Stone 16 (*78, 80*) was found to be marked with a comb-like arrangement of
incised parallel lines, alongside a smoothed shallow depression, perhaps created
by grinding. This comb-like pattern is a rare motif in British rock art, although
a remarkably similar example occurs on a large boulder on Brow Moor, 9 miles
to the north. Stone 42 was originally described as 'anthropomorphic' from the

78 Hutton Buscel Barrow 2. *After Brewster and Finney*

face-like arrangement of two cup marks above a curved groove, resembling a mouth and two eyes, along with two indentations as possible nostrils. This arrangement is reasonably convincing; however, the 'mouth' groove unfortunately continues across the face of the stone. Alongside this 'face' a pecked groove defines a circular area (a 'shield'), and encloses six ill-defined clusters of pick marks: possibly an attempt at a rosette of small cups on an unsuitable stone surface? Several of the carved stones from this site were deposited in the Scarborough Museum.

79 Hutton Buscel Barrows Sites 1 and 2 location

Barrow site – Hutton Buscel (SE 9492 8908)

In 1972, an Ordnance Survey field officer (Mr D. Smith of Pickering) found a cupstone on the site of a barrow in Wykeham Forest, 1 mile to the north-west of Hutton Buscel Barrow 2. The small limestone block had two cup marks on opposing sides). The stone was later deposited in Scarborough Museum (TSDAS 1972, 40).

Barrow site – Wykeham Moor

A footnote in Canon Greenwell's book *British Barrows* mentions that Colonel A. Lane Fox (Pitt Rivers) has two cup marked stones from a barrow on Wykeham Moor (Greenwell 1877, 342). No further details have been found regarding these stones and enquiries to the Pitt Rivers Museum in Oxford confirmed that the marked stones are not part of the Colonel's collection held there. Wykeham Moor is located in the same general area as the Hutton Buscel, Sawdon Moor and Way Hagg sites, which have all contained carved stones and the Wykeham barrow finds would seem to be part of this tradition.

Barrow 1 & 2 – Sawdon Moor (SE 9350 8590)

In 1966 two barrows on the higher ground to the north of Sawdon village were excavated in response to plough damage. The barrows were located approximately 100m apart and the excavations uncovered cremation pits and

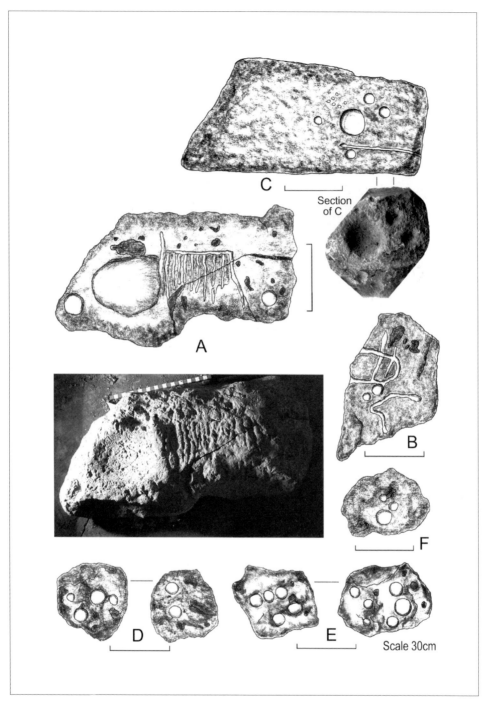

80 Hutton Buscel Barrow 2 motifs

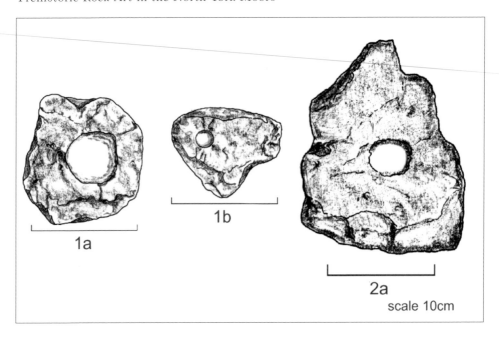

1a

1b

2a

scale 10cm

81 Sawdon Moor Barrow Sites 1 and 2. After Brewster and Finney

collared urn burials in each mound. Both barrows were also found to have kerbs constructed from limestone and sandstone blocks. Barrow 1 had two marked stones, one being a small piece of limestone with a single cup mark and pecking on one face, the other a small piece of sandstone with a small cup mark on one face. Barrow 2 also had a small limestone block with a single cup mark on one face. In both barrows, the marked stones were located in the eastern sector of the kerb. The excavation also uncovered several pits around and under the barrows that contained Grimston and Peterborough Ware pottery, indicating Early Neolithic activity on the site, possibly connected with the strong flowing Halley Keld Spring to the east of the site (Brewster & Finney 1995, 11) (*81*).

West Farm Barrow – Blandsby Park, Pickering (SE 8141 8652)

The 1961 excavation of this low mound was prompted by a number of bones being ploughed up on site and taken to the Police Station in Pickering. The barrow was found to cover approximately 10 burials, mostly in a central hollow. Pottery sherds from a Corded Beaker and other fragments (possibly Peterborough Ware and collared urns) were found associated with the burials. A small stone with a single cup mark was found in the burial pit while a second stone with two cup marks on opposing faces was found on the surface of the barrow. The marked stones were deposited in Scarborough Museum (Rutter 1973, 16-19).

James Ruddock – The Pickering Antiquarian (1813-1859)

James Ruddock of Pickering was a prolific barrow digger, opening at least 90 barrows on the moors around Pickering during the mid-nineteenth century. Thomas Bateman, a wealthy gentleman living in Derbyshire, paid for most of the excavations. Finds from the sites were forwarded to him for inclusion in his extensive antiquarian collection. Bateman published an account of these barrow openings using the brief site notes made by Ruddock, and details are often lacking or rather vague e.g. the barrow site being '4 miles NE of Pickering'; at least in this case some kind of record was made of the excavations (Bateman 1861).

Barrow – '4 miles NE of Pickering'

In February 1851 James Ruddock dug a barrow located 4 miles to the north-east of Pickering. He uncovered an urn and cremation deposits along with a flint dagger and a knife. At the top of the mound he found a small, rectangular sandstone (approximately 20 x 15cm), which had a circular cavity in the middle of each side: 'the use of which we are not able to determine, although several of the same kind have been found in the barrows' (Bateman 1861, 224).

Cross Dyke – Earthwork (SE 838 879)

A suggested location for the barrow dug by Ruddock (see above) can perhaps be pinpointed by following the main road from Pickering to Whitby. This road leaves the town in a north-easterly direction and approximately 4 miles along the road there are several barrows in the vicinity of a cross-ridge earthwork known as the Cross Dyke. Don Spratt found a cup marked stone on the surface of this earthwork, which now runs across cultivated land, so the marked stone may have been field clearance from a ploughed out barrow (Spratt 1982, 261).

Barrow site – '6 miles north-east of Pickering'

This vague reference describes yet another of Ruddock's sites where he had previously noted several large stones in a grassed area. This led him to dig the site in July 1851, where he uncovered a grave pit containing an inhumation, a cremation and a collection of flint tools. In the gravel fill of the grave pit he found two cup marked stones, one a small rectangular stone with two cup marks on opposing faces. The other stone was 'an irregularly-shaped sandstone, near six inches long, with neatly-wrought round holes in it' (Bateman 1861, 230).

Barrow – 'Two miles north of Pickering'

In April 1850, James Ruddock dug a stony barrow located to the north of Pickering, and found a small iron knife associated with an inhumation near the centre of the barrow. In the northern part of the mound there was 'a large sandstone, with a cup shaped cavity, 2.5 inches diameter, worked in it' (Bateman 1861, 213).

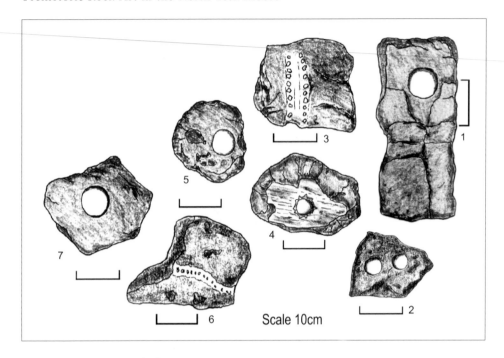

82 Lingmoor Barrow, marked stones

Lingmoor Barrow – Hutton-Le-Hole (SE 713 883)

During 1969-70 Raymond Hayes excavated a burial mound on Lingmoor Farm to the south of Hutton-Le-Hole village. The mound covered a kerb of stones encircling a central cairn, which covered three cremation pits. Single cup marks were found on two kerb stones while two stones found near the cremation pits each had a pecked surface and a single cup mark. Another stone found over the pits had a pecked outline, thought to possibly represent a phallus. A stone axe and worked flint were also found in the mound and part of a saddle quern marked with a single cup mark was also found alongside the barrow (Hayes 1978, 31). The cup marked stones were deposited in the Ryedale Folk Museum, Hutton-Le-Hole (82, 83).

Low Common Barrow – Appleton-Le-Moors (SE 7256 8604)

Several barrows still exist on the slopes of Low Common to the south of Appleton-Le-Moors village, this barrow group being located approximately 1 mile to the south of the Lingmoor Farm site detailed above. The excavation of one of the larger mounds in this group took place during the late 1940s, and an unpublished report in the YAS library notes that the mound covered an inner kerb of 85 stones with a gap in the circuit to the ESE. One of the kerbstones was marked with a straight groove and a cup-and-ring mark, while possible cup marks were also noted on two other stones in the kerb (Smith 1994, 117).

83 Lingmoor Barrow,
cup stone

Barrow 1 – Byland Moor (SE 5429 8056)

In 1869, Canon Greenwell excavated three barrows located on Byland Moor to the north of Byland Abbey. In one barrow the cairn material contained over 20 cup marked stones (some having up to six cup marks), and others with cup marks connected by grooves. One particular stone found on the east side of the cairn had been marked with two grooves forming a cross (Greenwell 1877, 341). This 'cross' stone is one of three stones from the site that are now in the British Museum (Smith 1994, 109).

Barrow 2 – Byland Moor (SE 5432 8064)

A second site dug by Canon Greenwell is located approximately 50m to the north of CXXXI (see above). The mound material of this kerbed barrow contained a small cupstone with two cup marks located on opposing faces (Greenwell 1877, 340). More recently, a stone with a single cup mark was noted in the hollow left by Greenwell's excavation (Smith 1994, 109). The cupstone found by Greenwell is now in the British Museum.

The following unidentified barrow sites have been included because they provide further examples of marked stones and other stone objects from the area.

Barrow Site – '11 miles east of Pickering'

In 1852 James Ruddock investigated the site of a ploughed out barrow at Scamridge, where he uncovered a deep grave pit containing a skeleton with a bronze dagger. A number of stone objects were associated with this burial, including a small piece of sandstone with encircling pecked lines and two small stone balls. In addition to these items, he also found a flat piece of sandstone (19cm long) with one face 'divided into a number of small squares, as a draught board' (Bateman 1861, 225). This marked stone may have parallels with the Pennock Puzzle Stone and other grid-like carvings found on the moors.

Barrow – '3 miles from Pickering'

In April 1850 James Ruddock dug a barrow near Pickering in which he uncovered the skeleton of a large dog. Below this animal burial, there were three inhumations and a number of 'peculiarly shaped stones' associated with them. Some of the odd-shaped stones were thought to be natural while others had been worked with a tool, one apparently having peck marks around a natural hollow in the stone (Bateman 1861, 213).

Barrow – '6 miles north of Pickering'

In February 1851 Ruddock dug into a barrow in this approximate area and found two flint spearheads associated with a cremation. He also found a stone ball alongside an inhumation, the ball being 10cm in diameter, with a pecked surface (Bateman 1861, 224).

During his barrow digging in 1851 Ruddock collected a number of items from the general area of his activities around Pickering. Among these finds were 'several examples of stones, with artificially worked cavities in one or both of their sides; in one case, five such cavities are drilled into a single stone.' (Bateman 1861, 231). Unfortunately, location details for these marked stones were not recorded. In 1856 Ruddock moved from Pickering to Whitby, but then died suddenly in 1859 at the age of 46. At the time of his death there were two cup marked stones in a collection of items from the barrows dug around Pickering during 1854 and 1855. However, location details were not recorded for these stones either (Bateman 1861, 239).

SUMMARY

This chapter has provided details of the rock art located across the southern region of the North York Moors. All the carved stones in this area have been noted in connection with burial mounds; no examples of open-air rock art

had been recorded, possibly because of the 'softer' limestone-based geology in the area. It is interesting to note that among the southern sites all the recorded markings consisted of simple cup marks, grooves and linear channels, there being only one reference to a cup-and-ring mark, from the Appleton-Le-Moors barrow, which Raymond Hayes thought a 'doubtful' example (Smith 1994). The significant numbers of carved stones found in the Byland Moor and Hutton Buscel barrows are not repeated elsewhere among the relatively small number of recorded barrow excavations in this southern region. However, the detailed excavations of more recent times have uncovered what could be seen as 'token rock art', e.g. a single cup mark on a kerbstone or a small, portable cupstone, features which may have been overlooked by antiquarian diggers, and thus the barrows subjected to less rigorous excavation.

The Byland Moor barrows complete the list of sites along the southern edge of the North York Moors where carved stones have been recorded in burial mounds. From this point on the Hambleton Hills head northwards and there is a gap of 7 miles before reaching the next reported site at the cairn circle on Bumper Moor. This gap may simply be the result of fewer barrow excavations in this area or a lack of targeted fieldwork, as there are extensive prehistoric remains recorded across the Hambleton Hills.

WESTERN SITES

The steep slopes of the Hambleton and Cleveland Hills form the western edge of the North York Moors upland area, overlooking the Vales of York and Mowbray to the west. The belt of limestone located along the southern edge of the moors now gives way to the sandstone which dominates the geology in the north of the region, and it can be no coincidence that examples of rock art on exposed stone surfaces are in evidence once again. The barrows dug by Canon Greenwell on Byland Moor were the last noted rock art sites located to the south, and moving northwards along the west side of the moors there is a gap of 7 miles before the next reported site at Bumper Moor.

Ring Cairn – Bumper Moor

Bumper Moor and Hawnby Moor are located on the higher ground to the north of Hawnby village. This area of moorland sits between two river valleys: the Seph running through Bilsdale to the east, and the River Rye to the west. A number of field systems, cairns and larger barrows have been identified in this area and the Bumper Moor Ring Cairn forms part of a large field system on this moor. In the book *Moorland Monuments*, Don Spratt made a passing reference to a 'carved stone' being found in this cairn (Pearson 1995, 164), which prompted the authors to investigate further. The ring cairn was excavated in 1967 by Andrew Fleming, as part of his research into Bronze Age agriculture in upland

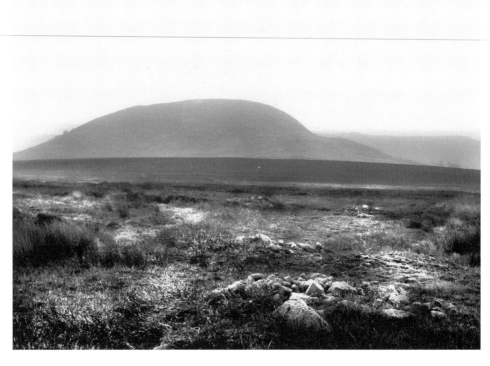

84 Bumper Moor, view towards Hawnby Hill

areas; however, work on the site remains unpublished and attempts to trace details of the marked stone and the site in general have failed. The authors visited Bumper Moor but could find no trace of the ring cairn although the remains of the excavation trenches on the site were visible. This would suggest that the excavation was total and that the cairn was not reinstated after the work. The site is located on an open and level area of the moor, where numerous low-banked earthworks and mounds are also evident. Raymond Hayes produced a plan of these features, plotting over 200 cairns, with the ring cairn being located towards the centre of this concentration. The discovery of a marked stone in this cairn would be in keeping with the generally accepted opinion that these structures featured in the ritual life of prehistoric peoples. In this respect, it is worth noting that the site's location provides a view that is dominated by Hawnby Hill (*84*), an isolated 'hump-backed' hill, 1.5 miles to the south-west. It is hoped that further details of this marked stone may come to light in the future.

Thimbleby Moor

Thimbleby Moor is located at the northern end of the Hambleton Hills, approximately 5 miles to the north-west of Bumper Moor. This relatively small area of enclosed moorland is covered by deep heather with the land rising to

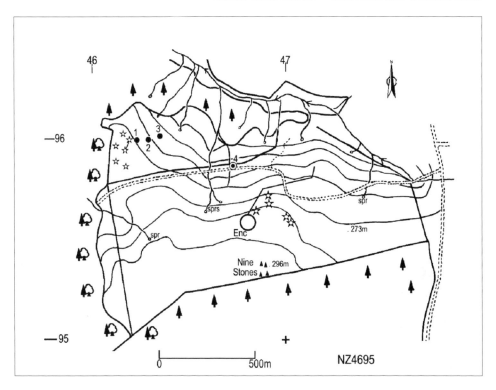

85 Thimbleby Moor site map

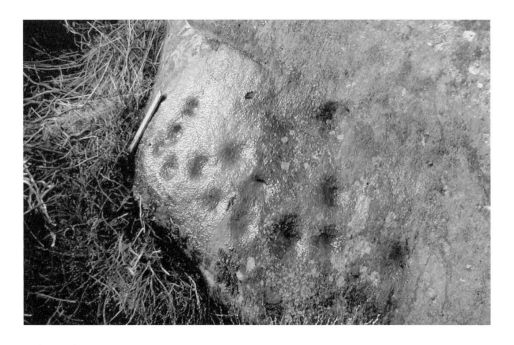

86 Thimbleby Moor Site 2

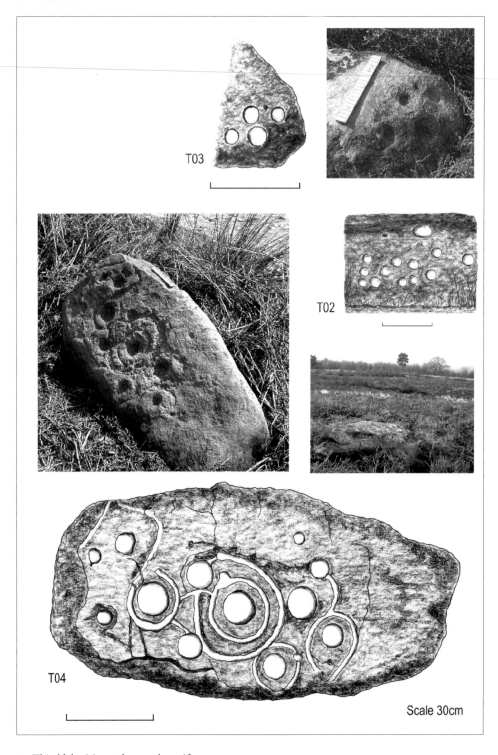

T03

T02

T04

Scale 30cm

87 Thimbleby Moor, plates and motifs

the south to an area of higher ground hidden within a large forestry plantation. Located near this high point there are a group of standing stones known as the Nine Stones, possibly the remains of a stone row which would originally have stood on the open moor. Aerial survey work carried out during the 1970s identified an extensive field system of cairns and walling on the north side of Thimbleby Moor and a smaller cairnfield on Over Silton Moor, 1 mile to the south-west (Brown & Spratt 1977, 4). These discoveries were reported in the YAJ Archaeological Register, where reference is also made to a prominent group of boulders and a large cup marked rock, the report giving the impression that the marked stone was located near the Over Silton cairnfield. Visits to this area failed to locate the cup marked rock or the cairnfield and it was assumed that the forestry plantation now covered the site.

In February 2003, the authors investigated the cairnfield on Thimbleby Moor and noted a large cup marked boulder at this site. It soon became apparent that the original report had confused the two areas. Further cup marked stones were also found in this area and a short distance away Barbara Brown discovered an impressive cup-and-ring marked boulder (*colour plate 24*). This carved stone is arguably one of the best examples of rock art to be found on the North York Moors, although its location alongside a modern farm track suggests recent disturbance. The boulder may have been pushed to one side during construction of the track and it is possible that associated prehistoric features lie buried in the surrounding deep heather. Whatever the case, the stone's location on the upper hill slopes over looking Oakdale would not be out of character for the siting of such an elaborately carved stone.

NEAR MOOR AND SCARTH WOOD MOOR

Three miles to the north of the Thimbleby Moor, the western edge of the North York Moors makes a turn towards the north-east and follows the more prominent peaks of the Cleveland Hills. Scarth Wood Moor and Near Moor occupy this 'corner' location and this scarp edge provides extensive views out over the Vale of Cleveland and the Tees Valley. The area around Near Moor appears to have been a particular focus for activity during the prehistoric period, perhaps due to the presence of an ancient north–south routeway which runs along the Hambleton Hills and down into the Cleveland Plain. This trackway passes through a gap in the hills known as Scarf Nick and Scarth Wood Moor and Near Moor are located on either side.

Near Moor Whorlton
Osmotherley and Thimbleby are situated at the edge of the Hambleton Hills to the north-west of the North York Moors. A further 2km north of Osmotherley the source of Crabdale Beck rises at the Holy Well spring, flowing from its

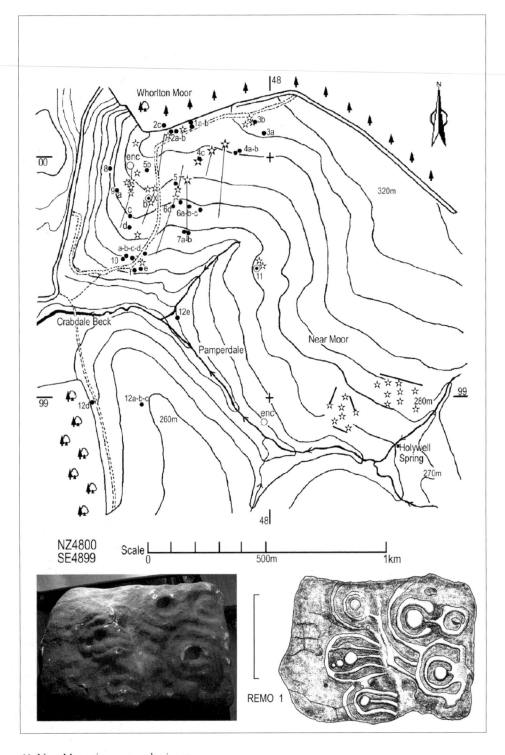

88 Near Moor sites map and cairn stone

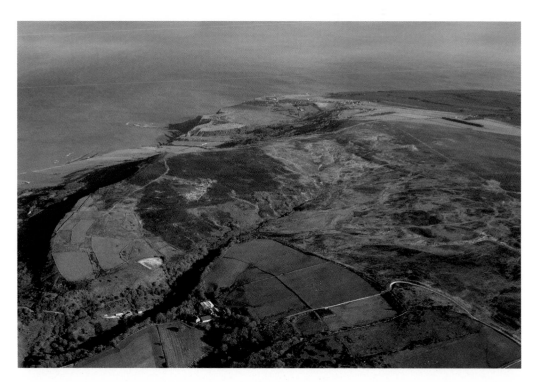

1 Fylingdales moor. *English Heritage 20175_002*

2 Robin Hood's Bay from Raven Hall Hotel Ravenscar

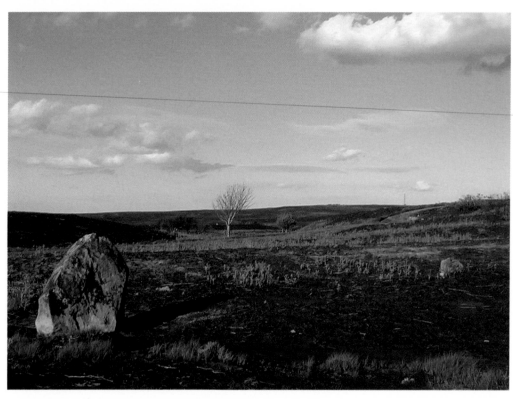

3 Grey Horse Stone Fylingdales regeneration after the fire

4 Fylingdales moor and alum workings

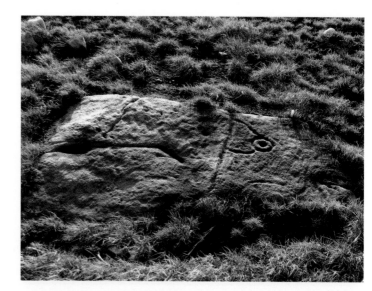

5 Fylingdales Hugh Kendal stone
site 5

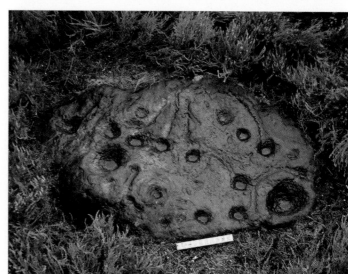

6 Fylingdales site 3b

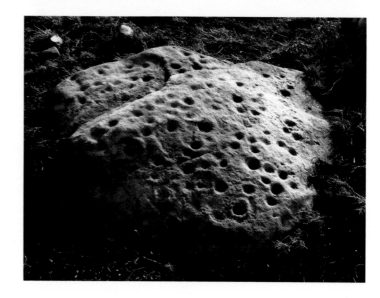

7 Fylingdales site 4a

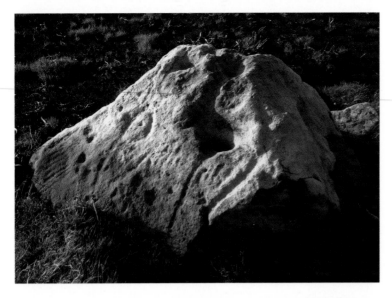

8 Fylingdales site 9c

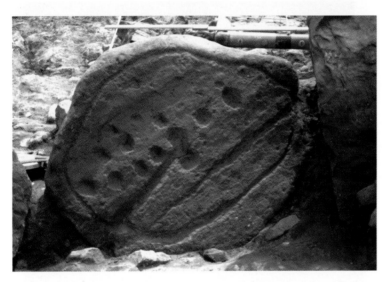

9 The Curvilinear Stone during excavation, 2004

10 Laser scanning the 'Linear Marked Stone'. *Blaise Vyner*

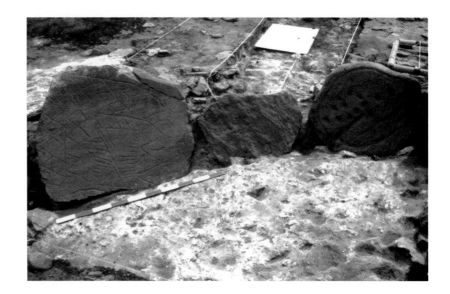

Right: 11 Fylingdales excavation, 2004

Below: 12 Hinderwell Beacon Barrow

Above: 13 Double rainbow over Allan Tofts

Opposite top: 14 Allan Tofts site 4b

Opposite middle: 15 Allan Tofts site 5c

Opposite bottom: 16 High Bridestones

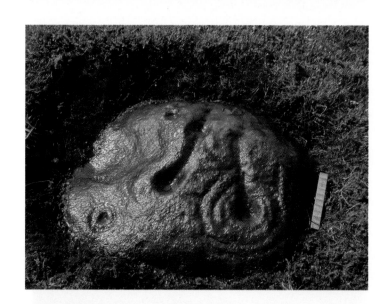

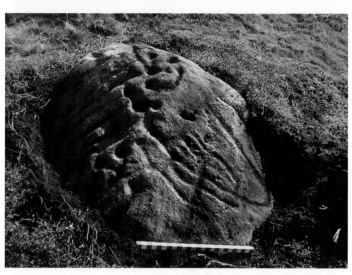

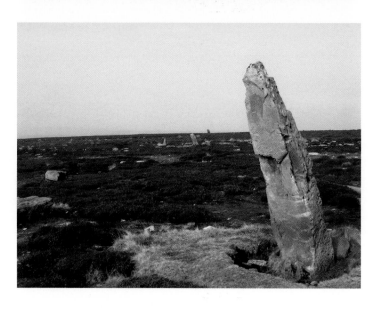

17 Aislaby cup and ring stone site A01

18 Street House Cairn excavation. *Tees Archaeology*

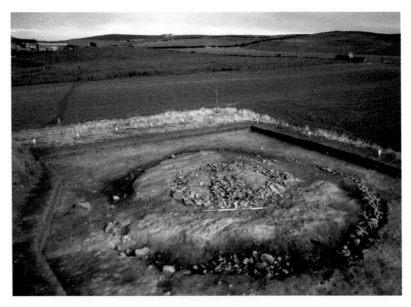

19 Street House Wossit excavation. *Tees Archaeology*

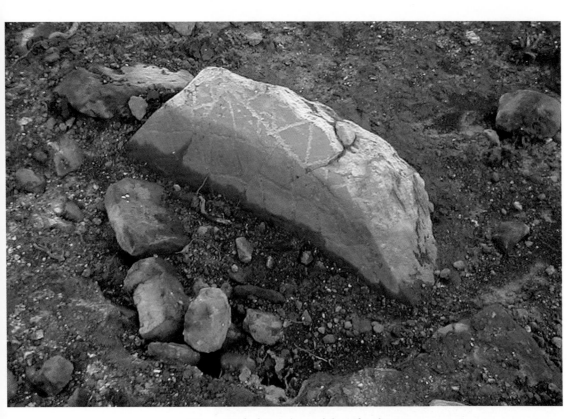

20 'Linear Marked Stone' several days after discovery

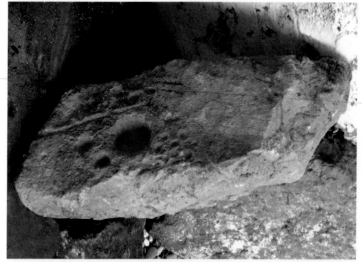

21 Hutton Buscel Barrow stone HUT 1A

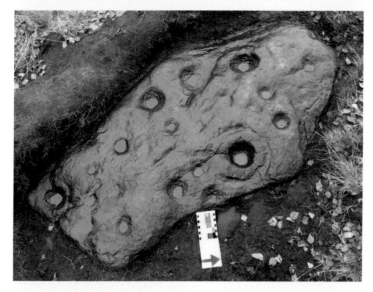

22 Eston Moor Moordale Bog
site MOR 1

23 Eston Moor

24 Eston moor, central moor site 3b

25 Wainstones from Whingroves site WAI 9

26 Bilsdale view from the Wainstones

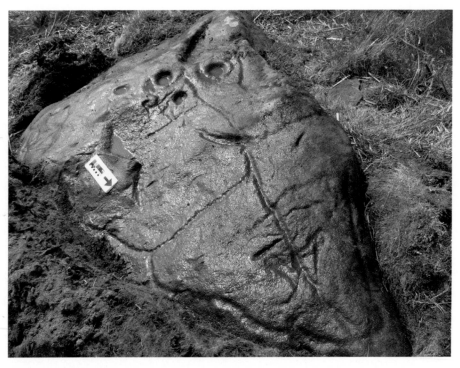

27 Wainstones site WAI 8a

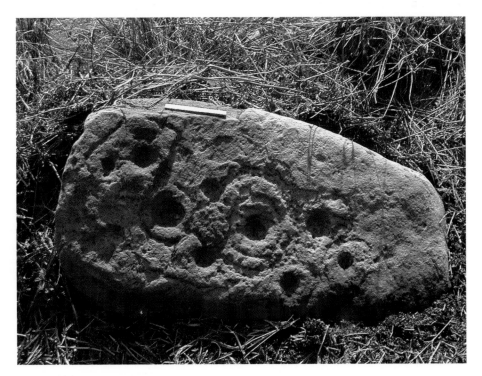

28 Thimbleby moor site T04

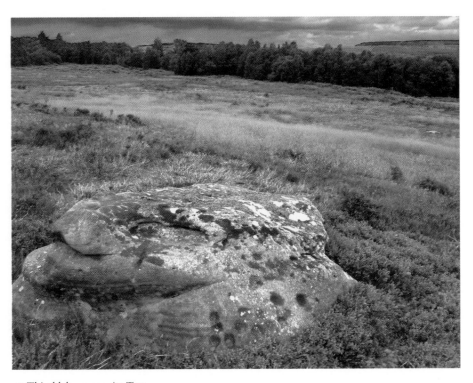

29 Thimbleby moor site T02

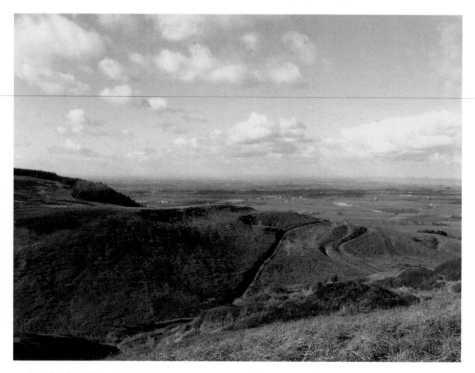

30 Scarth Moor from Near Moor

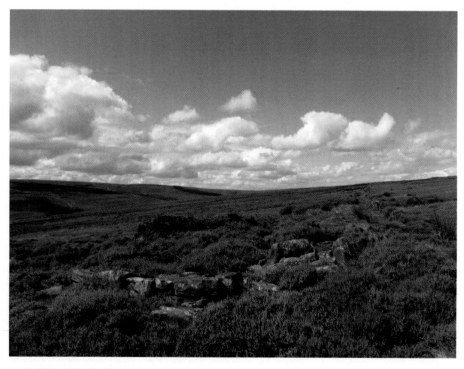

31 Holliday Hill, far distance

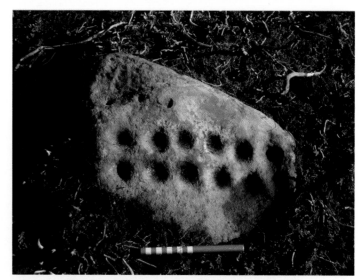

32 Linear cups Near Moor site 10f

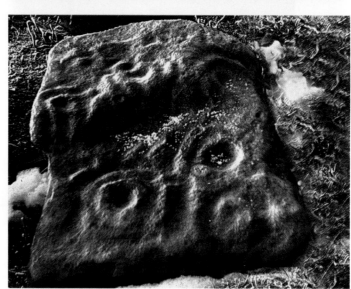

33 Near Moor site NEA9b before removal. *Carol Cook*

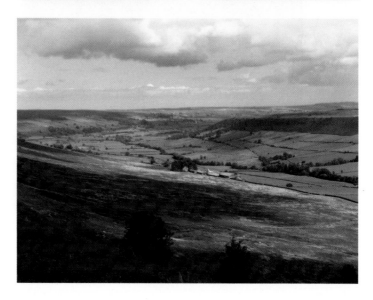

34 Little Fryup Dale

35 Wainstones site WAI 5 and Cold Moor

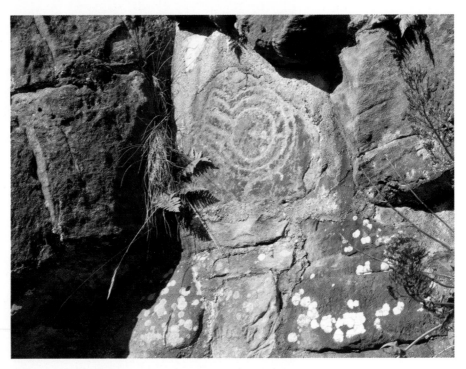

36 Raven Hall Garden Site PH 1

source into Cod Beck reservoir and continuing south to join the tributary of Oakdale Beck at Thimbleby Hall. An area of rough heather and bracken covered moorland rises to a height of 310m OD and is fringed by a forest plantation before dropping away to the Tees Valley to the north. The area contains four moors: Scarth Wood, Whorlton, Pamperdale and Near Moor.

The rock art here first came to light in 1978 when Mrs Carol Cook discovered a cup-and-ring marked stone on a small cairn in this area. The reporting of this stone led to a survey of the moor in 1980 by Goddard Inman and Spratt (YAJ 1980, 181). They conducted a series of archaeological investigations into the area, plotting extensive linear walling and cairnfields; during this survey an earthfast cup marked boulder was recorded among the features. Included in the sites discovered by C. Cook, a large cairn at SE474998 that contained the cup-and-ring stone and a further example built into a small cairn and a linear field wall were found. Due to the poor condition both stones were removed and deposited with the landowners at Snilesworth Lodge and subsequently donated to the Dorman Museum, Middlesbrough (museum ref. 1982.866 and 1982.866.2).

In 1992 a controlled burn over the area in the survey of Goddard et al. was made, exposing areas not previously visible, and in the mid-1990s one of the authors visited the area to look at the cup mark stone reported by the survey and discovered a further nine unrecorded examples of rock art within the area. Further fieldwork by the authors over the last decade has located further marked stones in this area including a number of portable cupstones associated with the remains of low cairns. Cup marks were favoured on these earthfast panels, although a further panel decorated with cups and rings has been discovered at SE4793 9950. The site consists of two cairns and a small square structure that abuts the cairns close to an angular linear field wall. A few metres south is a small panel; although eroded it bears three cups and in low angle lighting conditions a ring can be clearly seen around one cup. A curving groove appears to enclose a second cup and returns back to the ring edge.

Further to the east around Holy Well Spring are a number of cairnfields and a linear wall at SE48447 99082 cuts across the moor. On a downward slope, one appears to be arranged with sufficient space to accommodate arable crops. Another cairnfield 0.5km to the west of the map location given above is made up of larger piles of stones and random linear walls; this area has not been cleared as earthfast stone is scattered over the area. It would have been unsuitable for the planting of crops but it may have had possible use as enclosures for animals. A small stone enclosure has also been noted at SE47948 99096, the entrance to the south overlooking Crabtree Beck.

The distribution of rock art on the moors is illustrated on figure 88. This includes a large cluster around Oak Bank Gill and a further cluster near to Raindrip Well. Close to the linear field walls are smaller marked stones; some are incorporated within the wall structure, or within small adjoining cairns and these may have been deposited ritually or by random clearance. The cairn with the cup-and-ring

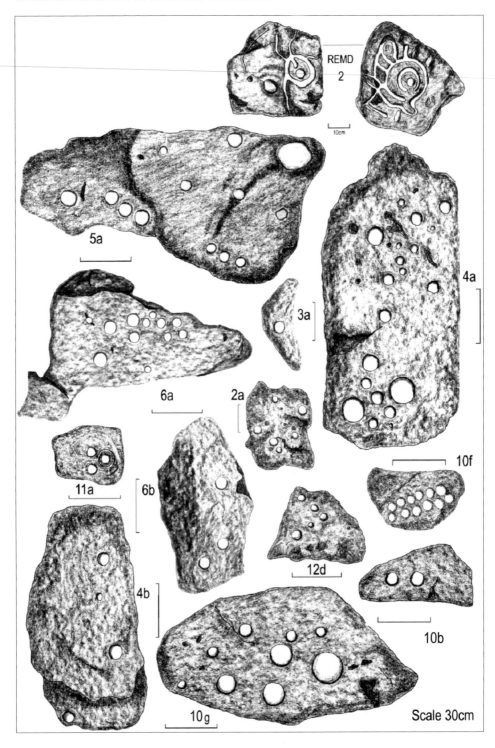

89 Near Moor motifs

stone found by C. Cook appears to be contemporary and close examination of the stone REM 02 within the Dorman Museum found that this is marked on both sides, indicating that this may well have been deposited intentionally and not from random clearance. Recent work in this same area by Brian Smith has uncovered further cup marked stones including a 'domino' style stone (*89, 10f*).

An isolated site was located on Pamperdale Moor. This has three marked rocks, one bearing four cups, and the others exhibit a single cup mark. The area has been extensively quarried for the rough ganister stone which is generally not selected for rock carving. The prehistoric rock markings have been pecked on the softer sandstones which are yellow to orange in colour. Quarrying has taken place right across Near Moor and this disturbance has possibly led to the removal of many marked stones and other prehistoric features. In addition to the two examples in the Dorman Museum over 30 marked stones have now been recorded on this moor.

Scarth Wood Moor

During the 1980s students from Leeds University carried out a detailed survey (Batey 1995, 171). The survey recorded over a dozen burial mounds and an oval enclosure, possibly associated with the Seven Sisters Standing Stones that form part of a substantial stretch of orthostatic walling. It has been suggested that these features may relate to the cross-ridge boundary monuments noted elsewhere on the North York Moors (e.g. Westerdale Moor) and a study of these sites suggests that they demarcate Early Bronze Age ritual areas (Vyner

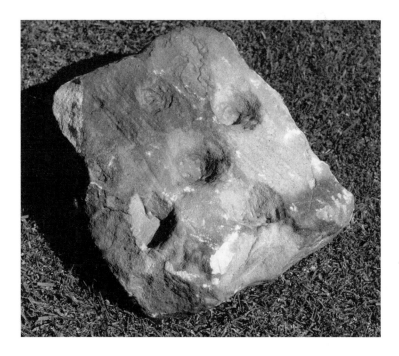

90 Scarth Wood Moor cup stone. *Photograph: Carol Cook*

1994, 27). In 1987, Mrs Carol Cook noticed a small cup marked stone (*90*) in a section of drystone walling that was being rebuilt at the north end of the Scarth Wood Moor. The stone was rescued and moved to the nearby village of Swainby, but unfortunately it was later stolen from its garden location (C. Cook, pers. comm.). The Scarth Wood Moor survey indicated that a group of burial mounds are clustered at the northern end of the moor and this cup marked stone might have originated in a barrow that had been quarried for wall building material. It would appear that both Near and Scarth Wood Moors have marked rocks, burial mounds, oval enclosures and orthostatic walling. Following on from Blaise Vyner's observations, their location on either side of the Scarth Nick Pass effectively created an ancient trackway through a 'territory of ritual' (Vyner 1994, 27).

THE WAIN STONES NZ 5587 0357

At 380m OD the sandstone formation known as the Wain Stones (NZ 5587 0357) dominates the head of Bilsdale and sits at the western end of Hasty Bank on the northern fringes of the North York Moors National Park. The North York Moors remained relatively ice-free during the last glaciation but a breach and overflow channel was created by a wall of ice that pushed through the escarpment, forming the area now known as the Garfit Gap which sits between Wain Stones and Cold Moor. The geology of the area is a result of earth movement in the latter part of the Jurassic period when the land tilted, exposing older rocks such as ironstone and shales containing rich seams of alum and jet – valuable commodities that were plundered from the seventeenth century, particularly between Hasty Bank and Cold Moor. The landscape there provides a natural high-level routeway, offering areas of natural shelter and fresh water from the streams and springs; these would attract game and wildlife. It also provides land on which to graze stock – an ideal place for a temporary campsite in the prehistoric.

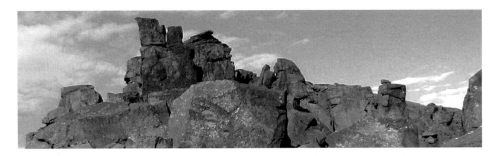

91 The Wain Stones

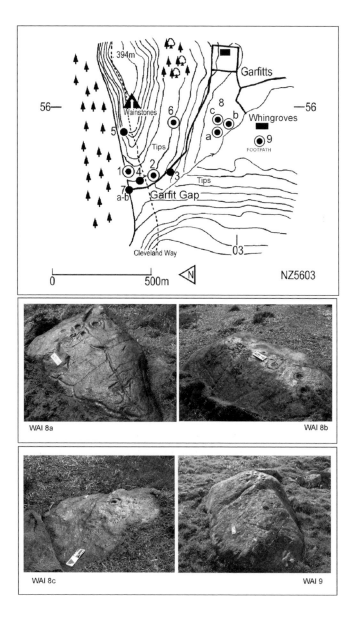

92a The Wain Stones map and, below, recent discoveries

WAI 8a

WAI 8b

WAI 8c

WAI 9

WAI 8a – Wainstones (NZ 55769 03138)

A large triangular-shaped rock (303 x 163 x 50cm) lies on the east bank overlooking Garfit's ravine, above the confluence of a watercourse that originates from a spring on the bankside. Two further rock art sites lie on the south slope of Hasty Bank, again at the confluence of a watercourse that originates at the same point. The stone has six large cups, four with single penannular (unenclosed) rings and an arrangement of linear grooves that form an intricate pattern. A single small cup has been carved close to a groove on the stone's northern crest and there is a linear arrangement of grooves forming an enclosure pattern on the

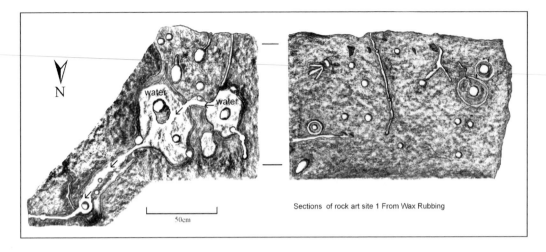

Sections of rock art site 1 From Wax Rubbing

50cm

N

water

water

92b The Wain Stones, Site 1

top of its sloping surface. One groove has been carved across and over the top of its north vertical face and winds along the remainder of the rock surface prior to reaching a natural hollow on the south-facing slope. One cup carved close to the bottom edge of the stone is encapsulated within a penannular ring and a number of pecked grooves link the top of the stone. Discovered by Colin Keighley (2009).

WAI 8b – Wainstones (NZ 55803 03119)

A rectangular-shaped boulder (280 x 158 x 70cm) located on the east side of the spring channel described in site WAI 8a. At its top are four cups, three of which are surrounded by very eroded rings. A number of pecked grooves lead to cup and ring motifs down its sloping surface and remnants of ironstone can be seen in the centre of the stone. A number of grooves 'flow' down the surface, others around the edges, which create an interesting effect.

WAI 8c – Wainstones (NZ 55806 03149)

A flat slab (140 x 117 x 20cm) which is mostly turf-covered. Only the tip is exposed; this exhibits a 5 x 6cm oval-shaped cup surrounded by a 15cm ring. It is located in a cluster of boulders some 30m to the north of a previously recorded site.

WAI 9 – Whingroves (NZ 55740 02674)

The area contains numerous large round and tabular boulders on the lower slopes of Cold Moor. A rectangular boulder (450 x 240 x 80cm) lies close to a public footpath alongside the western perimeter wall of Whingroves Farm. It has 26 cup marks, two of which are surrounded by single rings and 11 oval shapes on its top surface. A penannular groove terminating in a cup encompasses one of the cup and ring motifs. Rocks 8b, 8c and 9 discovered by Paul and Barbara Brown in 2009.

Rock 1a

This large tabular boulder (5.6 x 3.9 x 1.2m) lies close to the Cleveland Way, incorporated within the field edge boundary wall. Some sections of this wall have collapsed and have not been rebuilt. However, a stock containment fence has been erected along its length passing over the boulder's top surface. Much of the exposed surface has been marked by a number of modern day graffiti artists and it also exhibits an Ordnance Survey benchmark.

The initial survey in 2001 recorded the prehistoric motifs on the exposed western area, but the turf and loose stone that covered its eastern surface was not uncovered. In 2004 the removal of the remaining turf and stone debris was undertaken and this exposed further motifs. The first recording work on the western section yielded a number of random cups and two cup-and-ring motifs that were very eroded and visible only in acute angled lighting conditions. Also in the north-west corner are a number of cups and a small, circular basin with a countersunk cup and channels linked to the edge of the boulder.

The newly exposed eastern sector has two irregularly shaped shallow basins all with countersunk cups within their centres. Some cups are cut into the edges and two cups, lead by a linking channel into a countersunk cup, cut into the base of the rock basin. The larger basin has a cup within its edge and a pecked groove leads into a large natural channel marked with three small cups, links to a further basin and cups to finally 'disappear' over the edge of the rock. The pecking on one groove is rough and is uneroded – it could be that this has been protected and preserved by the thick vegetation cover, or it may well be a more recent addition. The whole sequence and appearance of cups, grooves and basins resembles a modern-day garden water feature! Perhaps its creation in the prehistoric was inspired by rainwater that gathered on the surface. The discovery of prehistoric motifs pecked on the stone's surface prompted searches within the area for further examples

Site 2a

A wedge-shaped slab (5.0 x 3.6 x 0.84m) has on its top eastern side two cups and rings and a cup with penannular motifs. On the north, sloping side are six cups in a close arrangement. The surface of this rock also exhibits many iron nodules, some have eroded leaving cup-type depressions and water has eroded the softer layers around the harder nodules forming faint grooves. If these natural hollows were present in the prehistoric they were perhaps incorporated in the overall decoration of the rock.

Site 3a

This site was described in the *Yorkshire Archaeological Journal* in 2003 by B. Smith. It lies on a sloping bankside above the Garfit Beck and the entire exposed surface is covered in iron stone nodules, similar to Site 2A. It is possible that the cups formed from the iron stone nodules may have been included in recording the motifs.

Site 4a

This large square block of stone 20m south-west of Site 1a exhibits similar features, with two irregularly-shaped basins with countersunk cups linked to a linear groove cut on its southern sloping edge.

Site 5a

This large flat slab lies at an angle of 45 degrees against a lower boulder. On the western edge of the slab a serpentine groove has been pecked and terminates in a small, shallow cup. The area is directly below the Wain Stones formations. Many of the fallen blocks form natural rock shelters and it is possible that the site may have been used as a temporary camp within prehistoric and later periods.

Site 6a

First noted in 2001, the site consists of a large, sloping wedge-shaped block with a shallow step to the western edge and, originally, a single exposed cup was recorded. Further research in 2004 revealed further motifs that consist of triple and single ringed cups incorporated within an arrangement of linear lines. The surface has many iron nodules forming 'rings' and depressions; these natural features may have been incorporated within the overall design during the prehistoric. Much of the area has been disturbed by mining and large spoil heaps surround the site altering water tables and courses. This site appears to be on the edge of an old water course and although there are many suitable surfaces for marking within the vicinity, it is possible that the position of the rock was chosen and it could have served as a way-marker on a prehistoric routeway to or from the Garfit Gap from the valley below.

Site 7a

This portable sandstone block has been used in capping the boundary wall; the motifs include five cups and its sloping sides have been plough-scarred. The boulder has probably been removed to a clearance heap from the adjacent fields following ploughing and reused in the construction of the enclosing walls. Site 1 has a date of 1772 and initials FF and JC carved on the northern side and this may be the wall builder's mark. It is of interest to note that this cup marked stone is typical of those deposited within cairns; however, a search of the SMR revealed no references to cairns being located at Garfit Gap, nor have any been included on old Ordnance Survey maps. Many of the colls within the northern fringe that link the adjoining moors do contain the remains of cairns; it is not so impossible to imagine that, given the amount of spoil heaps in the area, a cairn or cairns may well have been destroyed in the miners' search for alum and jet. Perhaps this boulder is all that remains.

Site 7b

This boasts a flat slab of sandstone (40 x 31 x 9cm), which has two deep cups located at the same position as 7a on top of the wall intersection. It may be that

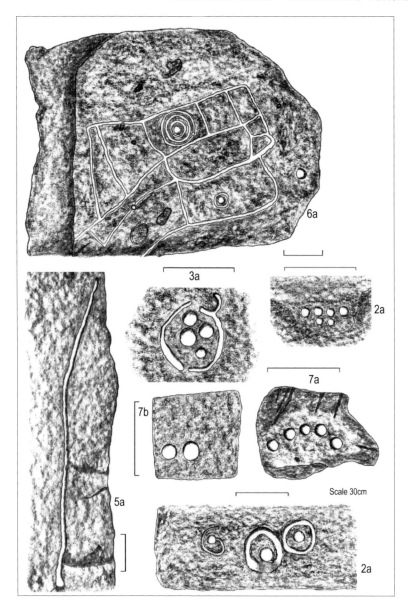

93 The Wain Stones sites, motifs

these two rocks are contemporary with and originated from the same cairn or may have been quarried from a large boulder within the vicinity.

Extensive searches have not revealed any carvings on the craggy mass of the Wain Stones itself. However, it is interesting to note that a large outcrop on the west side of the Wain Stones has a marked resemblance to a human head (over 6m in height) complete with facial features. This literal rock 'face' is known as the 'Sphinx Stone' among the climbing fraternity due to a passing resemblance to

the head of the Egyptian monument. It is, however, considered more reminiscent of the stone heads of Easter Island. The head faces due south, gazing out over Bilsdale and when viewed from certain angles the effect is quite striking.

Urra Moor

Urra Moor is located 2 miles to the south-east of the Wain Stones and situated on the high ground immediately to the east of Bilsdale and the Chop Gate routeway. An extensive series of prehistoric earthworks flank the western edge of Urra Moor, running along the top of the escarpment overlooking the head of Bilsdale. These linear earthworks extend over 2 miles, leading south towards Nab End Moor with its barrows, field system and the Bridestones Cairn Circle. Further earthworks exist towards the centre of Urra Moor and, during his survey of this area, Stanhope White reported finding a cup-and-ring marked slab incorporated into one of these stony banks (White 1987, 17). An error in the reported grid reference for this site led to several fruitless visits to the area, but the marked stone was eventually relocated by Chris Evans in June 2000. The large slab stands on an east–west section of an earthwork that has been constructed on the moor (94). The south-facing side of the stone has several very eroded markings, consisting of a small cup-and-ring mark and three more cup

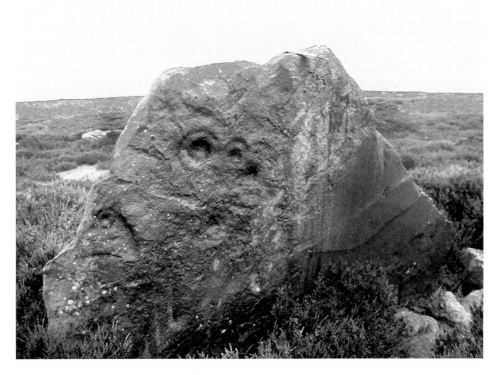

94 Urra Moor, standing stone in moorland dyke

marks, two of which have faint traces of an 'eyebrow' style groove above the cups, possibly the remains of surrounding ring marks. There are a number of uneroded linear marks on the slab that might be recent damage, while nearby slabs also have eroded cup marks and faint traces of rings that are only visible in good light. There is a possibility that these markings are a form of 'selective' erosion of the geological features within the local stone. Yet the proximity of other prehistoric sites and the similarity to the very eroded carvings at the nearby Wain Stones may add weight to suggestion that the markings are genuine.

Rowland Close (1908-1978)

The village of Kildale is located alongside the river Leven at the northern end of the Cleveland Hills. For many years this village was home to Rowland Close, a local estate worker and 'grass roots' archaeologist who had a keen interest in the history and archaeology of the area. His intimate knowledge of the moors led to numerous archaeological discoveries and a series of excavations, including the extensive Iron Age site on Percy Rigg, Kildale Moor. The meeting between Mr Close and that other legendary moors archaeologist, Raymond Hayes, led to them working together on several excavations, including the Ryedale Windypit caves and the Burton Howes. In later life, Mr Close set up a small museum in Kildale to display his collection of artefacts covering all periods from the Neolithic to medieval (Hayes 1980, 34).

Holiday Hill, Great Hograh Moor cup-and-ring stone NZ 632068

Place names often derive from local traditions and it has been suggested that Holiday Hill takes its name from the time Baysdale Abbey was built when people gathered on the hill on particular days in the religious calendar and was formerly referred to as Holy-day Hill. Located between Baysdale and Westerdale at the northern edge of North York Moors, Holiday Hill on Great Hograh Moor is a domed rise of land 330m OD. It is encircled by springs and the Great Hograh Beck lies to the east. The moor is a forest fringed heather-covered moorland that is now used for the rearing of grouse and sheep. On the plateau of the hill, to the north, is an area of flat slabs and two stone piles that are considered to be cairns. However, most of the plateau is under dense heather and further searches for other cairns and other features have been unsuccessful. The area surrounding Holiday Hill is rock strewn and much stone has been quarried, presumably to build enclosure walls to the north. Quality stone from the lower level of the moor that has been used to construct the Baysdale Abbey and homesteads in the valley.

On a downward slope of the hill there are a number of low field walls that lead to a large, partly quarried boulder at NZ 632068. This is covered in graffiti and at the base of this boulder on its north side there are five round depressions that the authors consider to be the result of work by quarrymen. However, to the west of this quarry-marked boulder, at NZ 65062 06697, a large, rounded

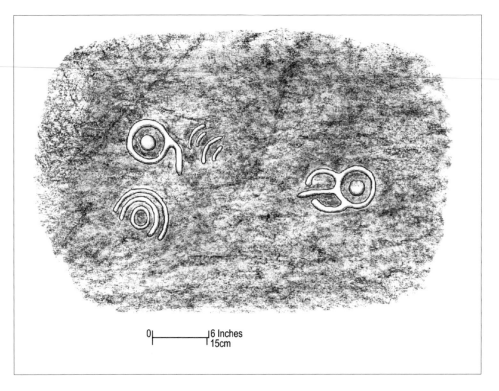

0 |——————| 6 Inches
|——| 15cm

95 The Holiday Hill Stone based on a drawing by Rowland Close

boulder exhibits a single cup mark on its surface. In the early 1960s Rowland Close discovered a panel of rock art and flints while fieldwalking on Holiday Hill. The finds were published in the *Yorkshire Archaeological Journal* (1964, 163) and described as a 'cup marked stone – a flat stone in the moor marked with two deep cups and incised lines forming an intricate pattern'. His flint implements found at NZ 624065–NZ 632066–NZ 629074 were described as 'Leaf shaped Neolithic type point, small leaf shaped with five barbed and tanged arrowheads and a large discoidale knife scraper'. In a further entry to the register (1970, 191) it is noted that the markings are 'now obscured' and that drawings of the rock art had been placed with the Yorkshire Archaeological Society Library.

Despite the use of GPS (satellite navigational equipment) the authors were unable to locate the marked panel at NZ 632068. It was hoped that some information could be gleaned from the drawings and the photographic record that Mr Close indicated had been deposited with the YA society archives. However, an intensive search of the records failed to reveal the material in question. Some considerable time later Paul Brown visited Tees Archaeology in Hartlepool to research the notes of the excavations of Hornsby and Laverick and, much to his surprise, hidden among the Hornsby documents was the drawing of the motifs on Holiday Hill by Rowland Close dated March 1961 (95). The figure shows two

cups, 2.5cm in diameter, enclosed by 10cm rings, with short semi-circular and linear grooves. A smaller ring (5cm) is enclosed by two semi-circles and another pattern consists of four curving lines similar to the carvings found on the Folkton drums (*44, 9*) and described as 'eyebrow motifs'. There is a scale of 0-6in on the sketch plan but no outline to indicate the size or shape of the slab and it may be that most of the panel lay buried under vegetation with only the section with the motifs visible when Mr Close visited in the 1960s. It may be that there will be more motifs present on the buried section.

In the early 1990s, when heather cover on this hill was less pronounced, a number of low mounds were noted on the hilltop close to the reported site of the cup-and-ring stone. It seems probable that, as previously discussed in our references to Allan Tofts, Near Moor and Fylingdales Moors, that the close proximity of marked stone to cairns also exists in this area of the moors. The authors believe that perhaps there was an error when compiling the report for the YAJ Register and map references may have been transposed.

Another point of interest was noted in our visit to Holiday Hill: the open moorland landscape of Warren Moor is visible and this moor fronts Roseberry Topping, a prominent landmark today, although its shape has been altered in the recent industrial past. While searching for the marked stones' location on the east slope of Holiday Hill, the authors noted that when descending the hill the peak of Roseberry Topping suddenly loomed into view. It is a significant sight across the open landscape of Warren Moor and it seems quite possible that the Topping could have had territorial or ritual significance to the Neolithic or Bronze Age cultures.

Little Hograh Moor – Westerdale

The Skinner Howe footpath links Holiday Hill to Little Hograh Moor (1 mile to the east) where Stanhope White noted a cup marked stone during his survey work in this area. This small boulder has two eroded cup marks either side of a vertical crack on the sloping face of the stone (*96*). The stone also appears to be located alongside a disturbed cairn. An interesting point here: it was noted that the tip of Roseberry Topping (a distinctive conical hill) can be seen on the skyline to the north-west from both stone and cairn. A search of the surrounding area also located another stone marked with a pattern of interconnecting lines on its flat surface, similar to those noted at Allan Tofts and the Bridestones (see Chapter 3). On first inspection the apparently random arrangement of the markings suggested a natural formation (trace fossil), but closer examination reveals a regularity in form and execution which might indicate an alternative origin, possibly related to the linear markings at other prehistoric sites in the region. It could be considered that stones marked in this way warrant further research.

Westerdale Moor

The large expanse of moorland that covers Holiday Hill and Hograh Moor, extends further eastwards onto Westerdale Moor. During the 1920s Frank Elgee

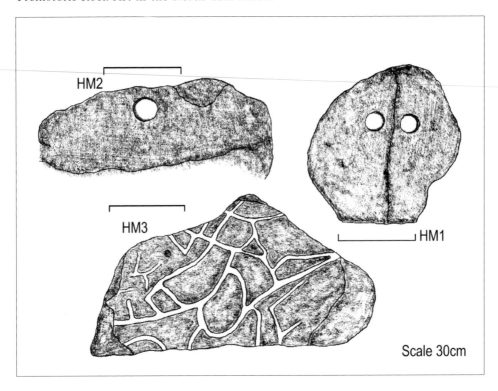

96 Little Hograh Moor motifs

noted a cup marked stone in this area (Elgee 1930, 142). A footnote in Elgee's book briefly mentions finding a 'cupstone in a modern field wall' near the Crown End prehistoric settlement, but, unfortunately, no further details have been traced regarding this stone. A search of the area brought to light a single cup mark on a flat rock at the base of a wall on the south side of the moor, this marked rock being located alongside the footpath heading up onto the moor – this may have been the stone noted by Elgee. The prehistoric features on the moor top include a cross-ridge boundary comprising a ditch and bank earthwork with standing stones, which cuts off an area eastwards towards the hill end. Approximately 100 small cairns are scattered across this demarcated area, and a large stone banked enclosure is located on the hill end, overlooking a stream confluence of the river Esk. Elgee suggested the features on this moor dated to the Bronze Age, comparing them to a similar site on Danby Rigg further east, while later investigations also showed evidence for Iron Age activity on the site. Several stones in the area around the enclosure appear to have single cup marks, which may be prehistoric but could also be a result of natural weathering. The Whitby Museum Archive includes a photograph listed as 'Cup and ring, Crown End'. The picture shows an upright boulder with an irregularly-shaped ring mark on its vertical end face. A search of the area located this rock at NZ 6662 0736 in a stony area among the dispersed

cairnfield. Examination of the ring mark led to the conclusion that this was a natural feature in the rock, with the whole end face of the stone, including the 'ring', being covered by a thin mineral 'crust'.

Warren Moor – Kildale

Rowland Close reported another marked stone in the Kildale area, this time on Warren Moor, located on the hills immediately to the south of the village (Close 1964, 171). A stretch of drystone walling runs for about 1 mile along the western edge of the moor, this walling apparently being located on top of a banked earthwork known as the Park Pale/Park Dyke. This earthwork formed part of the

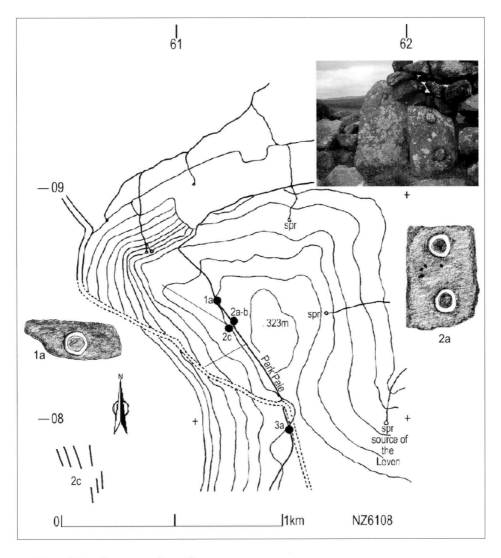

97 Warren Moor sites map and motifs

boundary of a medieval hunting park, but it has been suggested that part of the Park Pale may incorporate an earlier (possibly Bronze Age) bank and ditch earthwork, topped with sections of slab walling that were later incorporated into the drystone wall (Spratt 1993, 175). Rowland Close noted that one of these large stone slabs had two ring marks carved on its vertical east face (97, 2a). In 1996 a similar ring mark was noted by one of the authors on a small block of stone built into another section of the wall to the north. Further examples of linear earthworks, plus field systems and cairns, exist in this area so there is a possibility that parts of the Park Pale earthwork are prehistoric in origin, although there is uncertainty regarding the age of the ring markings. Examination of the carvings reveals the lower ring mark to be in an eroded condition, while in contrast, sharp pointed tooling can be seen in the upper ring. In addition, there are other stones nearby that are marked with letter-like symbols (T, H, R, W) so it is possible that all the markings relate to the boundary around the medieval park area as similar letter-like markings have been found on other stones in the Baysdale area (White 1989, 17).

Great Ayton Moor

Great Ayton Moor and the impressive peak of Roseberry Topping are located at the north-west corner of the North York Moors. During the 1950s, Raymond Hayes excavated the Neolithic chambered cairn and adjacent ring cairns on the western edge of the Ayton Moor, while in the 1970s a small enclosure 500m to the south-east was also excavated (Tinkler and Spratt 1978) (99). The excavation of this enclosure uncovered the remains of an Iron Age hut circle and it was

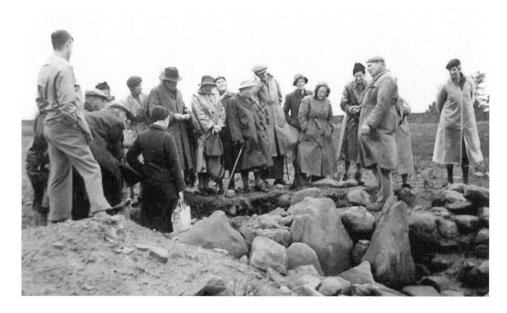

98 Great Ayton Moor Long Barrow, visit by the Whitby Naturalists Club

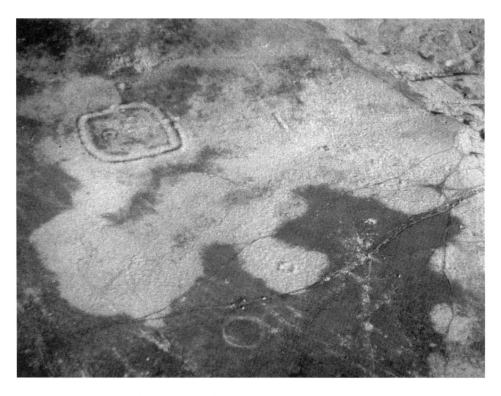

99 Great Ayton Moor enclosure. *Photograph: Blaise Vyner*

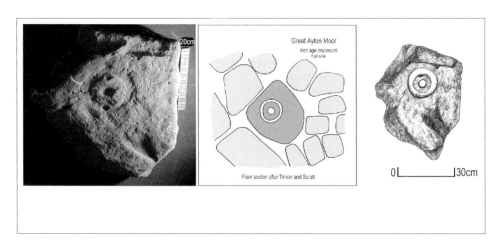

100 Great Ayton Moor hut site motifs, unprovenanced. *Dorman Museum Collection*

noted that a stone in the paved floor of the hut had a single cup-and-ring mark on its upper surface. The surface of the stone was very worn, although pick marks were noted in the central cup mark. The excavators proposed that the stone might have been removed from one of the nearby round barrows, and suggested that its reuse as a paving slab might indicate that it had lost its symbolic value. This may indeed have been the case, yet it is interesting to note that the marked stone was located between the hearth and the doorway on the east side of the hut – both areas known to have symbolic associations. Another flat slab from the site was reported to have a series of linear grooves (some pecked out) criss-crossing one face of the stone. The current location of these stones is not known but an unprovenanced stone in the Dorman Museum collection matches the description of the cup-and-ring marked stone from this site (see *100*).

5

The Eston Hills, northern sites and the Cleveland coast

THE ESTON HILLS

The outlying ridge of the Eston Hills is separated from the main bulk of the North York Moors by a gap of 2 miles, with the town of Guisborough located on the lower ground between the two. The large urban and industrial areas around Middlesbrough butt up against the north side of the Eston Hills, where the steep slopes create a scarp edge with extensive views to the west and north, overlooking the river Tees, its estuary and the coast beyond. The presence of numerous burial mounds and cairns, a hill fort and other enclosures, testify to the prehistoric activity on all parts of the Eston Hills. However, the proximity of nearby towns also led to many of the sites being explored by nineteenth-century antiquarians and later barrow diggers. Even at this early date, it was reported that some barrows had already been dug into, and as was common at this time, few records were made of these early investigations (Ord 1846, 108).

Palisaded Enclosure and Hill Fort – Eston Nab
Eston Nab (AS. Cneap: hilltop) is located at the north-west corner of the Eston Hills range, and at an elevation of 242m OD, forms the highest point on the hills. The Nab's location on a slightly protruding section of the scarp edge, with steep hill slopes dropping away along its north side, creates a site with extensive views over the lowlands to the north. This area of high ground became a focus for prehistoric activity on the hills, with Bronze Age burial mounds located on the Nab and a palisaded enclosure (approximately 75m in diameter) built around a low knoll occupying the centre of the site (this knoll marking the highest point on the Eston Hills). In the later Bronze Age, the palisade was dismantled and a substantial boulder wall was built in an arc across the Nab, later supplemented by a bank and ditch earthwork creating a hill fort type enclosure.

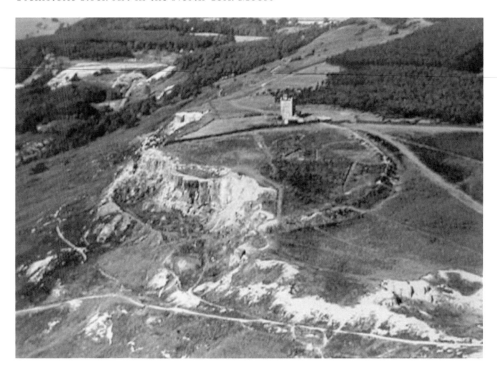

101 Eston Nab. *Photograph: RAF Thornaby 1933. Dorman Museum Collection*

In the late 1920s Frank Elgee carried out a series of excavations on Eston Nab, recording details of the palisade trenches, the surrounding ramparts and the outer ditch (Elgee 1930,152). He also noted several cremation burials associated with sherds of a food vessel in a barrow on the northern edge of the site, and uncovered a cup marked stone in the southern section of the earthwork ditch. This marked stone is now part of the Dorman Museum collection (*104*, 2m, *105*). During the mid-1960s, Alan Aberg also excavated several pits on the Nab as part of a Leeds University project which set out to clarify some of Elgee's earlier findings. Aberg found three saddle querns and several cup marked stones in the boulder wall around the site, but details regarding these marked rocks are not available and the excavations results have not been published (Vyner 1989, 63).

The most recent and detailed excavation on this site was undertaken by a team led by Blaise Vyner during 1984-87 (Vyner 1989). This work included an 8m-wide trench across the earthen rampart and boulder walling at the western end of the site, and this relatively small excavation uncovered eight marked stones in the short section of wall and ditch exposed. These stones were mainly of a small size with a few cup marks (one had a single cup-and-ring mark), the exception being a large boulder with numerous cup marks on its upper surface and one side, this stone being found on the inner edge of the wall, facing into the enclosure (*104*, 2a). The excavators suspected that the cup marked stones found in the outer ditch had originally formed part of the rampart walling, being re-deposited after its eventual collapse.

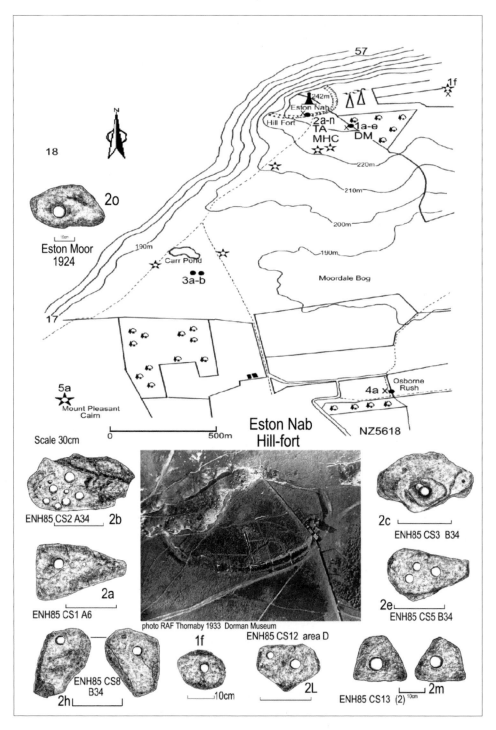

102 Eston Moor map and motifs

149

Another cup marked stone was found among the stones and rubble used to back-fill the southern section of the palisade trench, while a further cup marked stone was found in a small pit on the south side of the palisade trench. The large cup marked boulder now forms part of a display at the Margrove Heritage Centre while other stones from the excavation are in the Dorman Museum. Notwithstanding the excavations carried out on Eston Nab, it has not been possible to establish a clear picture of the activity on the site or the purpose of the prehistoric palisades, later walling and earthworks. Whether the features were wholly defensive or served some additional purpose is not known. Relatively little evidence for domestic activity has been found on the site, with only a small amount of pottery confined to the palisade area, where Elgee also noted many hammer stones and numerous burnt and unburnt flints, along with traces of cremated bone. Given the nature of the carved stones found on the site it seems possible that they originated in one or more Early Bronze Age barrows located on the Nab, so perhaps, in some way, the palisade and boulder wall enclosures continued this focus by incorporating elements from the earlier structures.

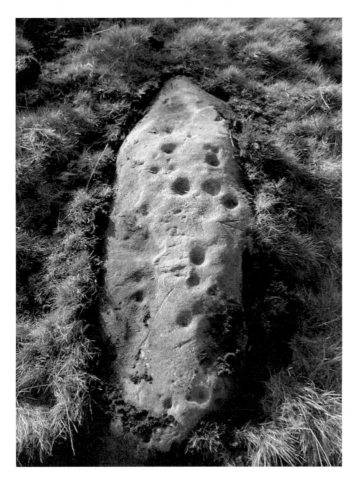

103 Eston Moor, Site 3b

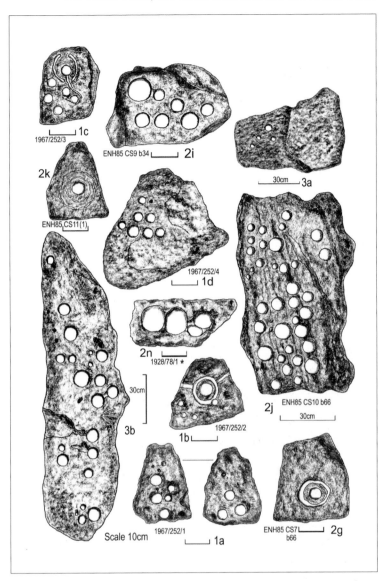

104 Eston Moor rock art panels

Marked stones from walling – Eston Moor

In the early 1970s, Alan Aberg and Don Spratt discovered five marked stones in a drystone wall located 200m to the south-east of the Eston Nab enclosure (Aberg & Spratt 1974). One stone had a single cup-and-ring mark on one face, whilst the other stones were cup marked (up to a maximum of 10 cup marks), one example having cup marks on opposing faces. The size range and markings on these stones are similar to those found in the Nab enclosure, raising the possibility that these stones may also have been incorporated into the boulder walling around that site, before being quarried for wall building material. These marked stones are now in storage at the Dorman Museum.

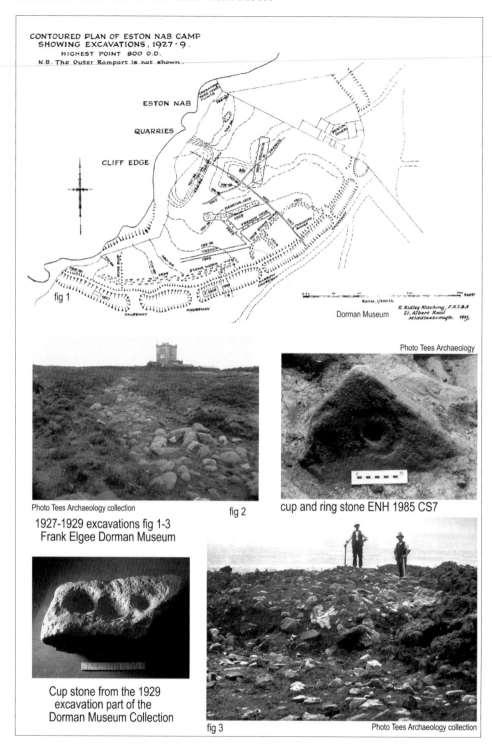

CONTOURED PLAN OF ESTON NAB CAMP
SHOWING EXCAVATIONS, 1927·9.
HIGHEST POINT 800 O.D.
N.B. The Outer Rampart is not shown.

ESTON NAB

QUARRIES

CLIFF EDGE

fig 1

Scale. 1/600th.

Dorman Museum

R. Ridley Kitching, F.R.I.B.A
21, Albert Road
Middlesbrough, 1933.

Photo Tees Archaeology

Photo Tees Archaeology collection

fig 2

cup and ring stone ENH 1985 CS7

1927-1929 excavations fig 1-3
Frank Elgee Dorman Museum

Cup stone from the 1929
excavation part of the
Dorman Museum Collection

fig 3

Photo Tees Archaeology collection

105 Excavations at Eston Nab Hill

Ord's Barrow II – Eston Moor (NZ 5691 1802)

Some of the earliest references to barrows on the Eston Hills were recorded by J.W. Ord in his book *The History and Antiquities of Cleveland* (Ord 1846). In this book he lists eight burial mounds and describes, in some detail, the excavations he carried out in this area. Two of the barrows explored by Ord can still be seen on the open moorland 200m to the south of the Eston Nab enclosure. In his account of the eastern barrow, Ord relates an incident where one of his workmen, having laboured all day without result, exclaimed in frustration 'Dom It, here's a bit o' carved stean!' and was about to strike it down with his spade when the antiquary jumped into the trench to rescue the carved piece (Ord 1846, 72). On closer inspection, the slab was found to be covering a cremation burial in a large collared urn, the underside of the slab being decorated with an arrangement of linear intersecting grooves. Ord's book includes an engraving of the marked stone and if this is drawn to the same scale as the accompanying large urn, then the stones dimensions were approximately 80 x 50cm. The marked stone was given to John Jackson of Lackenby (a local land agent) who was present at the barrow opening. However, the stone was subsequently lost and so at a later date a replica was created for the Dorman Museum using Ord's engraving of the original.

In a review of Bronze Age archaeology on the Eston Hills, Blaise Vyner catalogued the finds from this barrow site and included a note of caution regarding Ord's illustrations. Vyner noted that Ord's sketch of the urn bears only a passing resemblance to the original, adding that this might also be the case for the marked stone (Vyner 1991, 39). In this respect, it is interesting to note a marked stone held in store by Tees Archaeology, this stone also having an arrangement of intersecting linear channels on its flat surface. No details are attached to this stone and its origins are something of a mystery. However, its dimensions are comparable to those suggested above for Ord's marked slab. In light of Blaise Vyner's comments regarding the accuracy of Ord's engravings, it is just possible (using the eye of faith!) to see the elements of the decoration on the 'mystery' stone, within Ord's Sketch. Ord also illustrated a second, smaller fragment of carved stone, marked with a T-shaped arrangement of grooves. This stone, he states, was found at the foot of an internment in a barrow in the Court Green area towards the eastern side of the Eston Hills (Ord 1846, 105). The present location of this piece is unknown.

Cup marked Boulders – Eston Moor (NZ 5630 1727)

As noted above, several barrows can still be seen on the open moorland to the south of Eston Nab, and the Cleveland Barrow Survey (Crawford 1980) noted one site in this area as a possible example of a pond barrow/enclosed cremation cemetery at NZ 5619 1732 (Crawford 1980, 31). This burial structure comprises a circular, stone and earth bank (10m in diameter) enclosing an open and level area, the earthwork being located on a slight

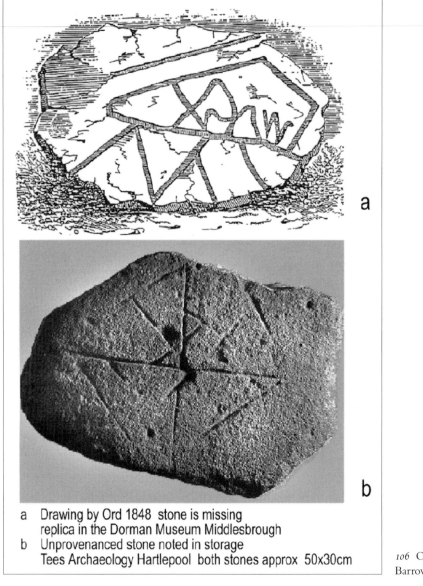

a Drawing by Ord 1848 stone is missing
 replica in the Dorman Museum Middlesbrough
b Unprovenanced stone noted in storage
 Tees Archaeology Hartlepool both stones approx 50x30cm

106 Ord's
Barrow Stones

rise in the moor. Approximately 100m to the south-east there are two cup marked stones located on the edge of an adjacent rise in the moor. One of the marked stones (*104,* 3a) is a small, wedge-shaped boulder with four cup marks on its sloping surface; the second stone (*104,* 3b), located 10m to the east, is a low, earthfast rock with 17 cup marks and some more recent markings including a bench mark and Roman numerals. There may be parallels between this site and the enclosure on Moorsholm Rigg, which also has a cup marked boulder nearby.

A third cup marked boulder has also been reported in this area, this stone being noted by David Heslop in the late 1970s, during research for his BA thesis (Heslop 1978). The stone is located 150m to the north-east of the two previous marked rocks and 50m to the west of an isolated barrow. This marked stone has not been located during recent fieldwork.

Wilton Moor

Wilton Moor covers the central section of the Eston Hills and in the early 1900s Frank Elgee noted over 20 barrows and cairns on the moor (Elgee 1930, 154). The enclosure of this area dates back to the early nineteenth century, and the land is now turned over to stands of forestry set amongst arable and pasture fields. This activity has damaged or destroyed several of the barrows on the moor and is likely to have removed other unrecorded sites.

Wilton Moor Cairn (NZ 5750 1838)

The Cleveland Barrow Survey carried out during the late 1970s was able to identify nine sites on Wilton Moor, the majority of which were either plough-damaged or showed signs of unrecorded excavations. One large cairn located at NZ 5750 1838 was noted to have been so reduced in height, that only the base of the mound survived. This denudation, however, revealed a small cup marked stone among the remaining cairn stones (Crawford 1980, 47). This marked stone has not been traced.

Wilton Moor Barrow (NZ 5743 1840)

The Cleveland Barrow Survey also recorded the remains of another low mound on Wilton Moor, noting that this barrow had been excavated a few years earlier in response to continued plough damage (Crawford 1980, 51). Don Spratt and other members of the Teesside Archaeological Society carried out the excavation during September 1970, at which time the barrow was reported to be part of a group of seven burial mounds in the area (Goddard, Brown & Spratt 1978, 15). The mound (6m in diameter) was found to cover an empty rock-cut grave pit, suspected to have held an inhumation, although no grave goods were found with the burial. The only finds from the site were a cupstone (102, 1f), part of saddle quern, and a flint scraper, all found in the upper levels of the mound material in the north-east sector of the barrow. The cupstone is now part of the Dorman Museum collection.

Cupstone – Barnaby Side Osbourne Rush (NZ 5710 1660)

A photograph from the Tees Archaeology archives shows a picture of the Revd Roy Jolly holding a small cupstone, which he found in 1963. The stone appears to have a single, deep cup mark on one surface and was found in a collapsed section of a field wall on the southern slopes of the Eston Hills. The current location of this stone is unknown.

Mount Pleasant Barrow – Normanby Moor (NZ 5582 1654)

The remains of this large burial mound (approximately 25m in diameter) are located at the south-west corner of the Eston Hills, the site having open views to the south, where the eye is naturally drawn to the prominent peak of Roseberry Topping. This barrow was partly excavated by Ernie Sockett over the course of several years starting in 1949. His work on this site uncovered an arrangement of low, circular walling around the centre of the mound, along with evidence for a second outer concentric wall. Within the central area, the excavator found the

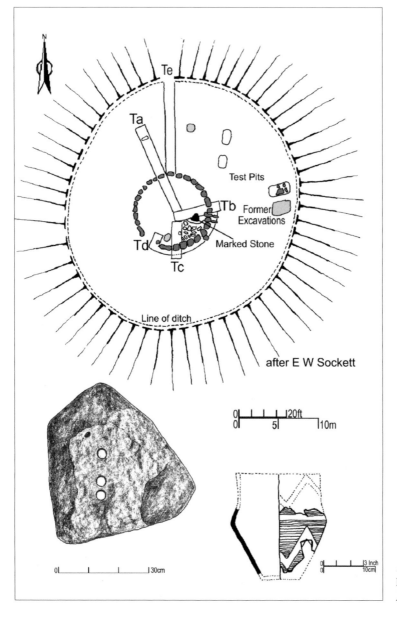

107 Mount Pleasant Cairn. *After E.W. Socket*

remains of a late southern British style Beaker buried beneath a large cup marked stone. Using the generic terminology of the day, this was originally reported as a cup-and-ring marked stone and as no description of stone appeared in the published report of the excavation (Sockett 1971) this created some confusion. However, later appraisals of the site noted the stone as being cup marked (Vyner 1991, 36; Crawford 1980, 42). Blaise Vyner, in his review of the Bronze Age archaeology on the Eston Hills (Vyner 1991), notes that he was unable to trace the whereabouts of this marked stone, so it may have been left onsite. Today, the remains of the barrow mound stand at the edge of cultivated land, with the excavation trenches still visible, and it is possible to identify where the Beaker and cup marked stone were found within the excavation. Several large stones lie in and around the trenches and among a group of stones left in the central trench there is one marked with three cup-like hollows on its surface. Close inspection of these hollows appears to indicate that they could be the result of natural erosion, although the linear arrangement might suggest otherwise. This marked stone may be the one uncovered by the excavator who judged the cup marks to be manmade, and if this is the case then it is still significant to find such a naturally marked stone placed over a buried Beaker.

NORTHERN SITES

The string of rock art sites located around the periphery of the North York Moors continues along the northern edge of the uplands, from the Cleveland Hills in the west, heading eastwards towards the lower ground nearer the coast. The carved stones in this area are generally connected with burial mounds, being located either in the vicinity of these structures or actually incorporated within them. The sites on Moorsholm Rigg and Spa Wood show that markings on exposed rocks do exist in this area and future research may reveal further examples.

Errington Wood Barrow – Upleatham (NZ 6212 1999)

The Upleatham Hills are located 5 miles to the east of the Eston Hills and form another outlying area of high ground separated from the North York Moors escarpment. Like the Eston Hills, this outlier provides the location for a number of hilltop barrows with extensive views overlooking the Tees lowlands, estuary and the coast. One of the burial mounds stands in Errington Wood at the north-west corner of the hills, and in 1973, a cup marked stone was noted on the south-east side of the barrow (Goddard et al. 1974, 143). The partly buried stone appears to form part of a kerb around the barrow and has 19 cup marks on its upper surface (*109*, 02a). In the early 1990s Peter Rowe (Tees Archaeology) noted several faint grooves and channels on another stone laid on the eastern side of this mound (Rowe 1994) and several years later one of the authors reported

108 Errington Wood Barrow

a series of cup marks on the underside of the same stone (*109*, 01a). This large sandstone slab has a cluster of six well-defined cup marks linked together by short grooves, in addition to which there are pick markings visible on the slab. It seems probable that this cup marked slab is actually a cist cover, removed during an unrecorded excavation of the barrow (also evidenced by the large pit in the top of the mound), and if this is the case, then the tools used to the remove the cover may explain the grooves and scrapes on the upper surface of the slab. As at Airy Hill (see below), this mound was also used as an OS trig point and it is possible that the original surveyors opened the barrow in the nineteenth century. Alternatively, Peter Rowe (ibid.) has suggested that the Revd George Young may have opened the barrow some time prior to 1817. Young states that he opened a burial mound at Upleatham, but did not provide details of its exact location, adding only that he found a cremation in a collared urn and an incense cup (Young 1817, 660).

Airy Hill Barrow – Skelton (NZ 6443 1675)

Airy Hill is located 2 miles to the south of the Upleatham Hills and provides another location for a hilltop burial mound. The barrow was inspected in 1975

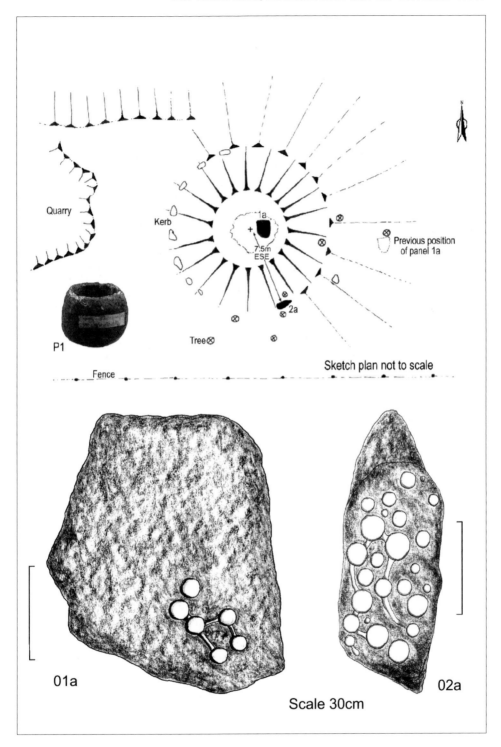

109 Errington Wood Barrow, site plan and motifs

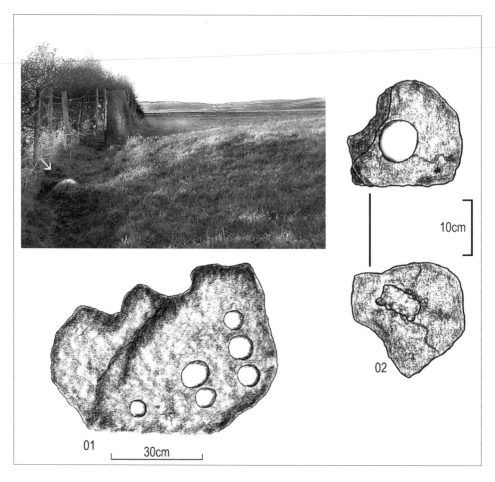

110 Airy Hill Barrow and motifs

as part of the Cleveland Barrow Survey (Crawford 1980, 64) and at that time, a cup marked stone was noted on the mound. The stone (possibly part of a kerb) is located on the southern edge of the barrow and has an arrangement of six weathered cup marks on the outer face of the stone (*110*, 01). An OS trig point stands on the upper part of the mound and was established some time prior 1864, when the vicar of Danby dug the barrow. On this occasion, the Revd J.C. Atkinson reported no finds within the mound and intimated that the barrow had already been opened by Ordnance Surveyors (Atkinson 1864, 20).

The Cleveland Barrow Survey also reported a second barrow, approximately 200m further to the west, but this mound had been almost ploughed away. It is possible that these two mounds are all that remain of another hilltop barrow group, and if agricultural activity has destroyed other barrows on Airy Hill this may explain the origins of a cup marked stone found by one of the authors in a drystone wall 200m to the south of this site (*110*, 02).

Kemplah Top Cairn — Guisborough (NZ 6075 1413)

The remains of a kerbed cairn are located in Kemplah Wood on the northern edge of the Cleveland Hills just to the south of Guisborough, the cairn's hilltop location providing wide views over the Tees lowlands to the north. The site was excavated by William Hornsby in 1921 and his unpublished report states that he found a cist (1.3m in length) within the mound. Unfortunately, the cairn had already been disturbed and the cist capstone was found on the south-east side of the mound. The capstone was found to have three cup marks on it, whilst a slab within the cist also had a single cup mark. The remains of a Handled Beaker were also found near the cist (see the Mount Pleasant barrow for another Beaker site). Today the barrow stands just within an area of forestry, and although excavated and tree planted, the mound appears relatively intact, suggesting that it was reinstated after the excavation. The large cist capstone is no longer visible on the side of the barrow, so this may have been replaced within the mound.

Marked stone from Spa Wood — Guisborough (NZ 6380 1552)

A large cup-and-ring marked stone forms part of an interesting display at the Margrove Heritage Centre, near Guisborough. The carved stone was originally noted among a pile of field clearance stones in Spa Wood, which is located in a

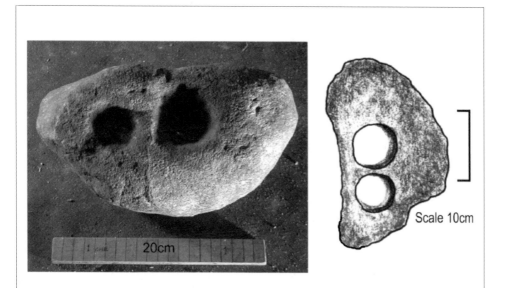

20cm

Scale 10cm

Guisborough c1951 Dorman Museum unprovenanced

111 Guisborough Moor cup marked stone

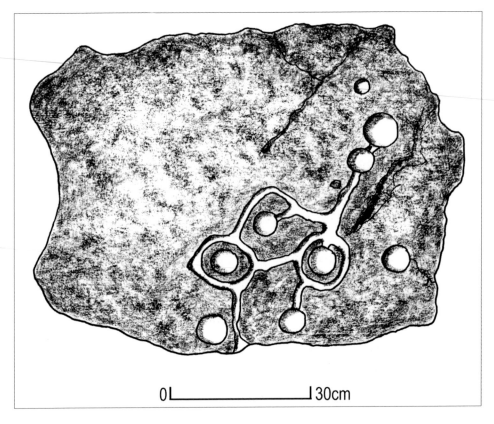

0 ⊢———————————⊣ 30cm

112 Spa Wood cup and ring stone

gap between the Cleveland Hills and the outlying Airy Hill site, located 1 mile to the north-east (see above). The footpath through Spa Wood is now part of the Cleveland Way, which also passes the Airy Hill site and may follow an older route from the coast and heading towards the higher moorland areas.

Dimmingdale Farm Barrow – Moorsholm (NZ 6910 1199)

The large conical mound of Freebrough Hill forms a striking topographical landmark in this area (*113*). Although the hill is a naturally formed outlier, separated from the main moors escarpment, the regular conical shape of the hill has drawn comparisons with the large mound of Silbury Hill in Wiltshire. Several burial mounds exist in the vicinity of Freebrough Hill and, in 1975, a cup marked boulder was noted alongside a barrow located 500m to the south of the hill (Hayes 1976, 2). This large stone, along with others nearby, may have been clearance from the adjacent field, which had only recently been ploughed for the first time. Another account states that the southern edge of the mound was removed during ploughing operations, which uncovered part of the barrow kerb including the cup marked stone (Crawford 1980, 44). Crawford also suggested

113 Dimmingdale Freebrough Hill from the cairn

this barrow as a candidate for a mound explored by Robert and William Porritt of Moorsholm, around the year 1770 and then later excavated by Canon Atkinson in 1863, when he noted an internal circle of stones (Crawford 1980, 45). Subsequent to the 1975 report, this cup marked boulder disappeared from the site and several attempts to trace its whereabouts failed. In April 2003 one of the authors made a renewed effort to track down the marked stone and after an extensive search of the area, found the boulder on the hill slopes alongside Haw Beck, 400m to the south-east of the barrow site (*114, 02*)

Cup marked boulder – Moorsholm Rigg (NZ 6862 1192)

The heather-covered high ground of Moorsholm Rigg is located half a mile to the south-west of Freebrough Hill. Several barrows exist on the east side of the Rigg, whilst on the north side, a cluster of small cairns are located above the strong flowing Moorsholm Spring. An oval enclosure has been identified in the area between the barrows and the cairns and it has been suggested that this feature may be an enclosed cremation cemetery, a type of monument possibly dating to the Late Neolithic period (Crawford 1980, 43). In this context, it is

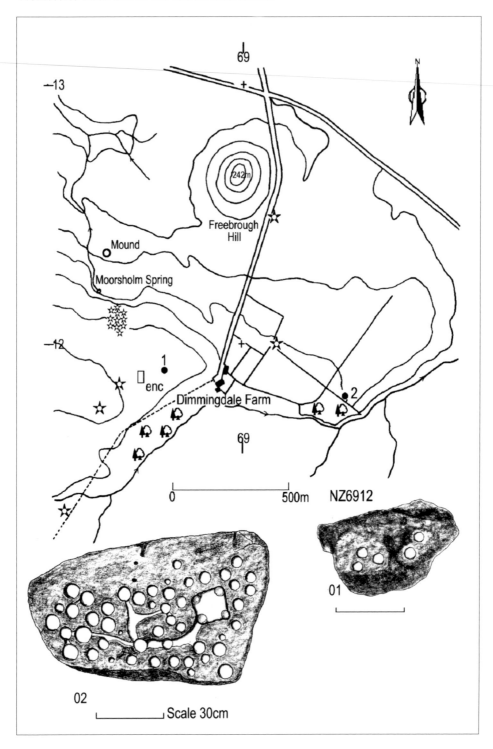

114 Dimmingdale map and motifs

interesting to note that a cup marked boulder (*114, 01*) is located 75m to the north-east of this enclosure, which has parallels with a similar site on the Eston Hills (see above).

Barrow – Newton Mulgrave Moor (NZ 7712 1380)

Newton Mulgrave Moor is located 5 miles to the east of Freebrough Hill, and at 220m OD this area of rough heathland sits midway between the coast and the higher moorland areas to the south. A group of 10 burial mounds (including a long barrow) plus a field system and several standing stones are scattered across the relatively flat ground on the higher part of the moor, and such a barrow group provided an attractive target for the nineteenth-century barrow diggers. In this particular area, it was the Whitby antiquarian, Samuel Anderson, who employed workmen to dig into several barrows on the moor during the years 1852-53. It is known that one of the men employed was James Ruddock of Pickering, an experienced barrow digger who had previously excavated numerous barrows for the Derbyshire antiquarian, Thomas Bateman (Manby 1995, 96).

Anderson's manuscript describes one large mound, which covered a number of concentric circular walls within the barrow. Inside the central ring he found 'a variety of curious figured stones', while another 'curiously marked stone' covered a deposit of cremated bones on the north side of the mound. Two further burials were found in the barrow along with two food vessel urns. The site of this barrow has been tentatively identified at NZ 7712 1380 (Smith 1994, 80). However, the present location of the carved stones is not known and it is assumed they remain within the barrow.

Anderson's 'curious figured stones' were, in all likelihood, decorated with cup-and-ring marks, and his noting of the stones illustrates the growing awareness of prehistoric rock carvings in the early 1850s. It also seems likely that it was the presence of James Ruddock on the site, which led to Anderson's attention being drawn to the stones. In the years prior to his work for Anderson, Ruddock had already collected similar carved stones during his barrow digging activities for Thomas Bateman, which took place on the moors further to the south (Bateman 1861).

Terry Manby's study of the Anderson pottery collection provides details of approximately 50 vessels (Manby 1995, 93). There are four Beakers and four food vessels listed among the collection, and these finds either came from barrows that also contained carved stones, or barrows located in areas with exposed rock art, i.e. Newton Moor, Swarth Howe and Fylingdales. Interestingly, one of the Fylingdales Beakers is decorated with a chequer-board pattern of incised lines, reminiscent of the grid-like patterns noted on some carved stones, while the Newton Mulgrave food vessels appear to have been relatively rare examples and only comparable to vessels found outside the East Yorkshire region.

The carved stones found within the Newton Mulgrave barrow effectively completes the 'chain' of rock art sites located around the periphery of the North York

Moors. The sites at Aislaby and Swarth Howe are located 5 miles to the south and provided the starting point for the description of sites around the moors uplands.

CLEVELAND COAST

The last chapter gave details of the rock art located along northern edge of the moors, finishing at the barrow site on Newton Mulgrave Moor, and completing a full circuit around the periphery of the North York Moors uplands. In addition to the moorland rock art in this region, an important group of rock art sites are located along the Cleveland Coast between the mouth of the river Esk at Whitby and continuing on to the Tees estuary. The coastal area between these two rivers is characterised by small bays and rocky sea cliffs, which rise to over 200m at Boulby, forming the highest cliffs on the east coast of England. Several barrow groups are located along the hills and ridges on this stretch of coast, where past excavations have uncovered cup-and-ring marked stones in a number of these burial mounds.

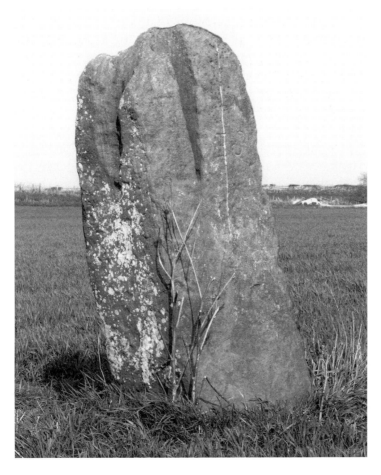

115 Wade's Stone

Whinny Hill, Goldsborough (NZ 8329 1450)

Canon Greenwell explored two burial mounds that were located on Whinny Hill, close to the village of Goldsborough, north-west of Whitby. These excavations took place shortly before the publication in 1877 of his monumental tome, *British Barrows*, and as a result the details were not included in this work it was referred to several years later in the *Archaeologia Journal* (Greenwell 1890, 43). One barrow that had originally been in excess of 19m in diameter had been reduced to less than half 0.5m in height through prolonged agricultural activity. Greenwell noted evidence of disturbance on the site, and this was confirmed when the central cist was found to have been partly destroyed during a previous dig. The cist, however, still contained an intact food vessel urn, calcined flint, some jet pieces and a water-rolled pebble. This barrow also covered a second stone-lined grave and this too had been disturbed; it contained only a small quantity of burnt flint and charcoal. In the main body of the mound Greenwell also found a small stone (240 x 230 x 145mm) marked with three cup marks (*116*) (a single cup on each face and on one side).

Whinny Hill is also the location of a standing stone known locally as Wade's Stone (see also Barnby Howes below); this stone is situated approximately 150m to south of the barrows dug by Greenwell. Several records mention another stone that stood 30m from the Wade's Stone, and local tradition has it that these two stones marked the grave of a legendary giant called Wade. Allegedly, one stone was situated at the head of the grave and another at the foot, to give some indication of his stature! Only one Wade's Stone survives today but it is possible that these stones may have been the remains of a prehistoric monument (possibly a stone row?) connected with the burial mounds or some other ritual activity on the hill.

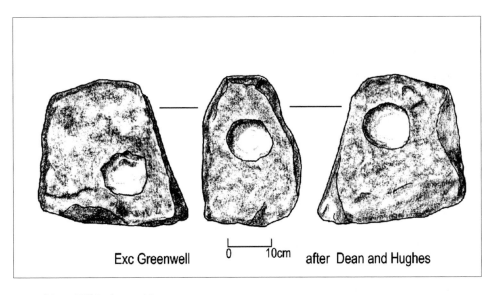

Exc Greenwell 0 10cm after Dean and Hughes

116 Whinny Hill Lythe motifs

Barnby Howes, Barnby (NZ 8302 1381)

Two barrows had existed here prior to removal, one adjacent to the other and located on Barnby Howe Farm 600m to the south of Whinny Hill. These barrows were excavated in 1951 because they had deteriorated through continuous plough damage and the sites were later cleared. Both barrows were found to have stone outer kerbs and the westernmost barrow had a turf mound that covered a robbed-out cremation burial. The kerb of this barrow had an opening towards the south-east, and a cup marked stone was noted in the southern sector of the kerb. Beaker pottery, unfortunately plough-damaged, had been found in the eastern barrow. The west barrow, and any possible associated pottery it may have contained, was completely destroyed and spread through the plough soil. No details of the cup marked stone appeared in the excavation report published in the *Yorkshire Archaeological Journal* (Ashbee and ApSimon 1956). However, a photograph in the Whitby Museum shows a small block of stone (approx. 0.18 x 0.18m) with a single cup-like depression on its upper surface. This small stone was the only marked rock found and its location within the southern point of the barrow may be significant, adding to the amount of marked stones that have been located or associated within the southern sectors of barrows around the North York Moors. Another Wade's Stone stands 800m to the south of the

117 Barnby Howes excavation 1951. Photograph: W.H. Lamplough. Whitby Museum archive

Barnby Howes, on a small mound (a possible burial cairn?) on Wade's Hill. This stone caught the attention of John Leland, the famous librarian who was charged by Henry VIII to record antiquities in Britain, and during his eight-year archaeological tour in the sixteenth Century he noted the location of this stone and described a second stone that stood alongside it. The setting of two stones on Barnby Howes has parallels with the stones at Whinny Hill.

Excavations by Hornsby, Laverick and Stanton

In the early 1900s William Hornsby, John Laverick and Richard Stanton excavated at least 20 barrows along the Cleveland coast and a small number of sites along the northern edge of the North York Moors. These men were local to the area (Hornsby lived at Saltburn) and their initial interest lay in locating and investigating the series of Roman signal stations thought to have existed along this stretch of coast. Having examined a site at Huntcliff, near Saltburn, they moved along the coast and searched the area around Boulby suspecting this to be the next location in the chain of stations, but to their disappointment they found nothing and concluded that the quarrying along the cliffs had destroyed any remains. Their lack of success in locating Roman archaeology, however, led them to investigate the prehistoric barrows in the neighbourhood and accounts of their activities later appeared in the journals of the Yorkshire Archaeological Society. Most of the excavations at Boulby, Hinderwell and Brotton took place a few years before the First World War and in some respects the accounts of their investigations are reminiscent of some grand antiquarian digging foray, for example '... On leaving Boulby, the writers still journeying south came to Hinderwell and in this township they were at once drawn to a large mound part natural, part artificial, known as the Hinderwell Beacon'. (Hornsby & Laverick 1920, 445). While this description may give the impression that they were prepared to investigate any barrow that caught their eye it is more likely that extant or upstanding mounds were investigated as part of their quest to determine whether they were indeed remains of the Roman signal stations. It is to their credit that they recorded details of their excavations and deposited the finds in the Dorman Museum, Middlesbrough. These records continue to provide a useful source of information since only a relatively small number of barrows in the region have been excavated using modern techniques.

Butter Howe, Barnby (NZ 8273 1513)

Hornsby and Laverick excavated a barrow 'one mile north-west of Goldsborough', while they were in the process of searching for the Roman signal station in that area. This barrow is likely to have been Butter Howe, which is approximately that distance from the village. The excavation uncovered a paved area of broken sandstone slabs on the underside of which were 'many ripple markings'. Whether these marks were geological in origin or manmade was not recorded, but the fact they were recorded may be of significance. No record of these 'ripple-marked'

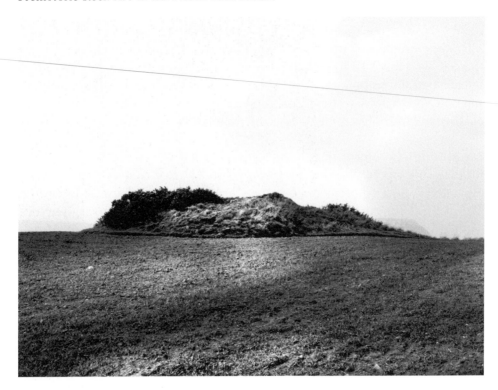

118 Hinderwell Beacon

stones has been traced in any of the local museums so it seems likely that they have been reburied on site. A number of stones with linear and curvilinear markings have since been discovered and reported in the area and in this context the ripple markings on the Butter Howe stones are worth noting. A 'British' grave pit was located at a lower level in the mound and a cremation deposit was found close to the mound surface where, nearby, lay several sherds of 'Anglian' pottery. The remains of an oak post was uncovered alongside the paved area and its presence prompted the excavators to suggest that the mound of the barrow may have been reused in later centuries as a gallows site. (Hornsby & Laverick 1918, 50).

Hinderwell Beacon, Hinderwell (NZ 7933 1780).

A unique large and prominent burial mound is located on Beacon Hill to the north of Hinderwell village (*118*). It is unique because of the 300 marked stones that were uncovered within the burial site. The barrow now stands only a few hundred metres from the modern cliff edge and, as its name suggests, the mound was reused as a beacon site. Hornsby and Laverick's excavation took place over several years, possibly due to its size and the prolific amount of stone content. The mound covered an internal circular wall some 9m in diameter and enclosed seven cremation burials associated with food vessels. (Hornsby & Laverick 1920,

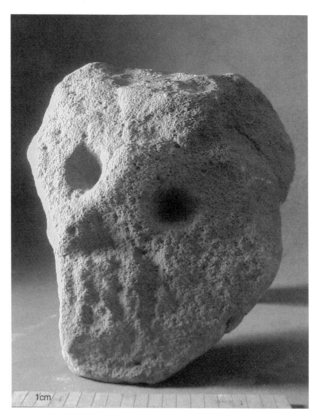

119 Hinderwell Beacon
1914/7.3 cups and comb motif

446). Of the 300 marked stones, approximately half that amount were cup marked, others were marked with incised lines and several had grinding and polishing marks. One particular stone was described and reported to be a 'sinker' stone because its appearance was identical to stones used by local fishermen; a similar stone was found at Rudda Howe, south of Fylingdales Moor. Another curiously marked stone was referred to as the 'Ship Stone' because of its resemblance to the boat figures found in Scandinavian rock art. The surface of the stone exhibits an incised horizontal line crossed by shorter vertical lines. A number of the marked stones have been deposited in the Dorman Museum, Middlesbrough.

North-east of Hinderwell Beacon (NZ 795 179)
Hornsby and Laverick also noted a ploughed barrow 'slightly north-east of the beacon' and the excavation of this mound uncovered an empty grave pit, fragments of a food vessel and a cupstone (Hornsby & Laverick, 1920, 445).

Boulby, Easington
Hornsby and Laverick excavated a cluster of barrows located to the east of Boulby during 1913-14, just prior to their excavations at Hinderwell. These barrows are situated in fields along the cliff tops, with one mound less than 100m from the

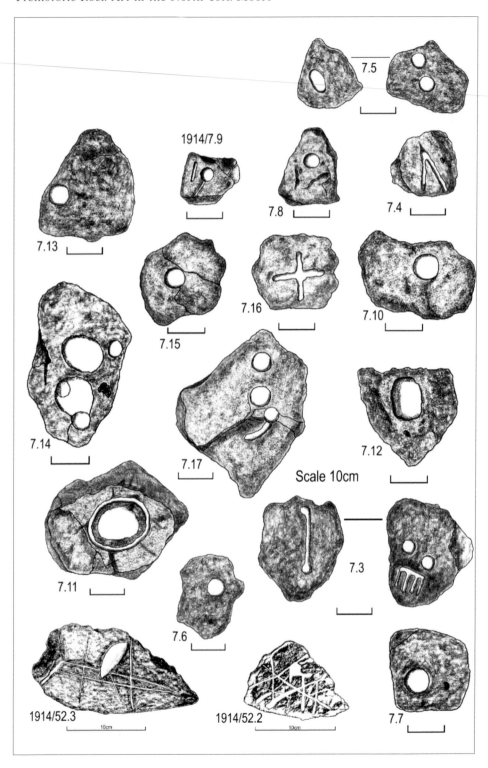

7.5

1914/7.9

7.8

7.4

7.13

7.16

7.10

7.15

7.14

7.17

Scale 10cm

7.12

7.11

7.3

7.6

1914/52.3 10cm

1914/52.2 10cm

7.7

120 Hinderwell Beacon motifs

modern cliff edge; eight barrows in all were spread out in a crooked line over an area 1km in length, and it was suggested (Elgee 1934,124) that this barrow group had been positioned to resemble the constellation of Ursa Major or the Plough. Interestingly Robert Knox also noted a similar 'Plough' arrangement formed by a group of 'conspicuous howes' to the south-west of Ugthorpe village (Knox 1851). At the time of Hornsby and Laverick's investigations some of the Boulby barrows were recorded as being well defined, while others were much reduced by agricultural activity. During the excavations several of the mounds were found to contain marked stones; however, it appears that these stones have been removed and regrettably the present location is unknown. The list below details only those barrows in which cup marked stones were noted.

Boulby Barrow 1 (NZ 7496 1943)

A trench excavated over the centre of the cairn uncovered a cremation deposit above a layer of charcoal and cremated bone, mixed with fragments of a collared urn. At a lower level the excavation uncovered a line of four stones set on edge that appears to have been the remains of a disturbed cist, alongside which was an internment that was accompanied by several cupstones and pieces of flint.

121 Boulby Barns Barrow, Sites 3 and 4

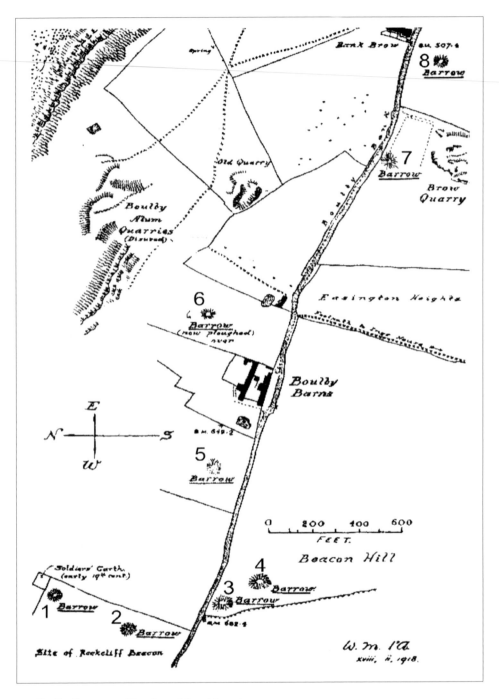

122 Boulby Barns map. *Hornsby and Laverick 1918*

Boulby Barrow 3 (NZ 7494 1918)

This mound (9m in diameter) covered a central grave pit cut into the underlying sandstone. The grave contained a cremation that was covered by a flat stone (0.3 x 0.6m) with 'peculiar markings' on its underside. The excavators had previously referred to a 'cupped and grooved stone' as 'peculiarly marked' so this may account for the markings on this stone cover. Above this flat stone were two similar sized slabs partly overlapping and roughly trimmed.

Boulby Barrow 4 (NZ 7496 1913)

Some 13m in diameter, the barrow covered two concentric circles of stones. The outer wall/kerb contained a large stone with polishing or grinding marks, a similar stone was also found at Hutton Buscel (80). A rock-cut grave was also noted inside the south-east section of the outer circle. Within the inner circle of stones two sandstone slabs at the centre of the mound covered a pit containing a cremation in a collared urn.

Boulby Barrow 5 (NZ 7515 1919)

A possible outer ditch surrounded this barrow and the only discovery made within the mound was a central cobbled area that formed a rectangle 1.8 x 1.0m. This layer was mainly composed of rounded water-worn stones and one stone was reported as having 'pittings upon one side and deep groove at the end'. Similar to the Butter Howe site there was no evidence of burials within the barrow.

Boulby Barrow 6 (NZ 7539 1920)

This mound (11m in diameter) was found to cover an empty central cist that appears to have been previously disturbed, as the cist cover and a side slab were missing. A cremation deposit was located to the south of the cist but at a higher level within the barrow. Artefacts found in association with the burial include a shale pendant, numerous flints and a decorated stone, bearing cup marks on one face and a series of 12 parallel grooves on its adjacent side (123). This stone is thought to be in the Dorman Museum, Middlesbrough.

Boulby Barrow 7 (NZ 7564 1895)

The barrow (12m in diameter) was composed of soil-covered sandstones and under these was a layer of green stones; an outer kerb of sandstone blocks had been placed around the base of the mound. At the mound centre a cremation was discovered within an inverted collared urn that was also surrounded by a circle of small green stones. A second cremation associated with a food vessel was located 2.7m to the south-west of the collared urn. Two cup marked stones were also found in the mound material along with a quantity of flints.

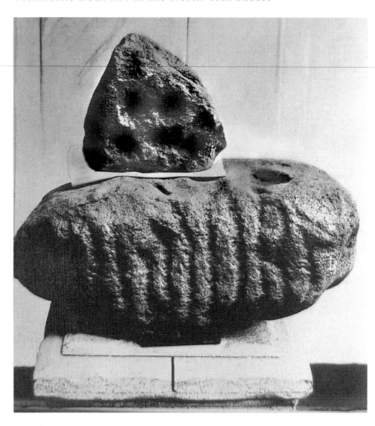

123 *Left* Boulby Barns rock art. *Photograph: Hornsby and Laverick 1918*

124 *Below* Boulby Barns marked stone 1914/7.1

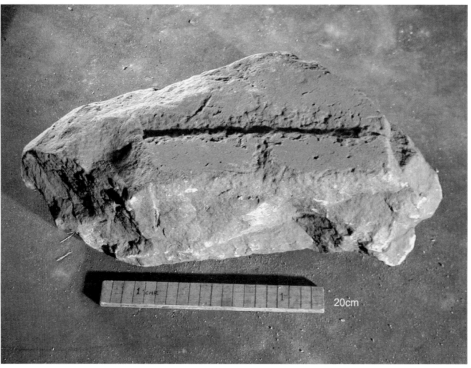

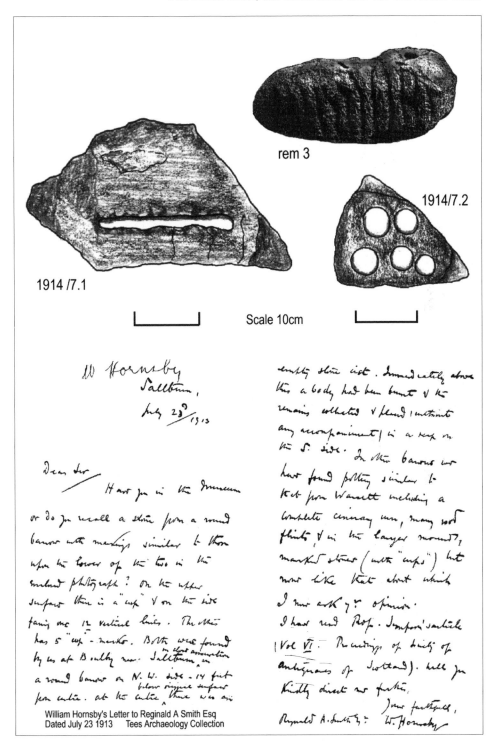

rem 3

1914/7.2

1914 /7.1

Scale 10cm

William Hornsby's Letter to Reginald A Smith Esq
Dated July 23 1913 Tees Archaeology Collection

125 Boulby Barns, marked stones and letter by William Hornsby

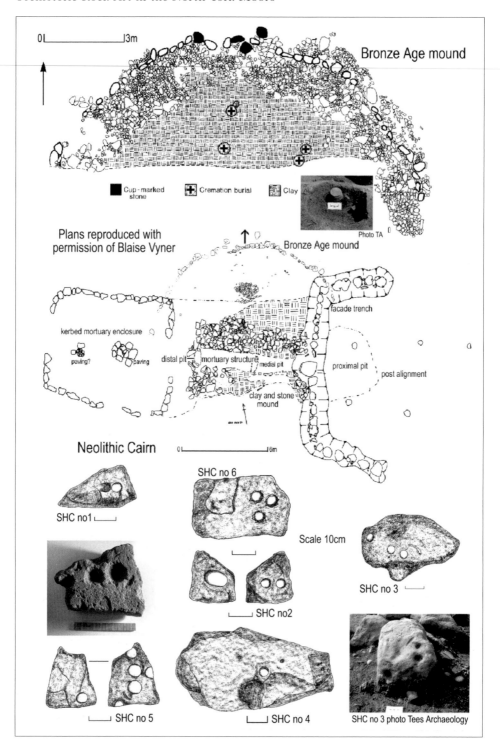

126 Street House Cairn and motifs excavation plans. *Blaise Vyner*

Street House Cairn, Loftus (NZ 7365 1962)

The site of this barrow is located 1.3km along the cliff top to the west of the Boulby barrow group dug by Hornsby and Laverick. A team led by B. Vyner excavated this site from 1979-81 and uncovered the remains of a kerbed round barrow. This formed part of a fascinating sequence of monuments that included a Neolithic long cairn, a kerbed enclosure with an adjacent mortuary structure and adjoining curved timber facade. The barrow overlay the east end of the low Neolithic long cairn, which in turn overlay the burnt and dismantled remains of the mortuary structure and timber facade. Ploughing had damaged much of the southern half of the barrow (*c.*15m in diameter), but in the northern section a kerb of larger stones remained in place around a 2m-wide ring of smaller water-rolled stones. The larger stones were thought to have originally formed part of an underlying Neolithic cairn, and several of these stones were cup marked. The marked stones were found at the northern point in the barrow kerb; three of the kerbstones were cup marked while a fourth had an oval pit with a runnel leading to the edge of the stone. The barrow phase of this sequence of monuments was dated to around 1900 BC, while the underlying long cairn dated to 3200 BC. Four collared urns and an accessory cup were found within the burial mound together with a spindle whorl fragment, worked flints and jet buttons. (Vyner, 1984).

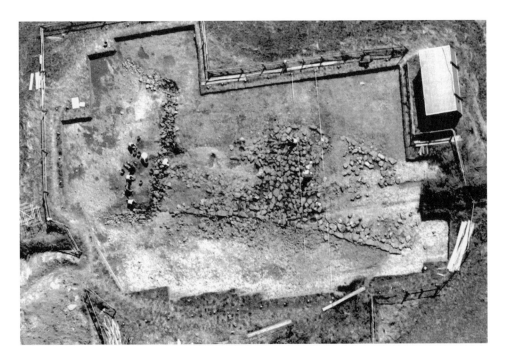

127 Street House Cairn excavation, aerial view

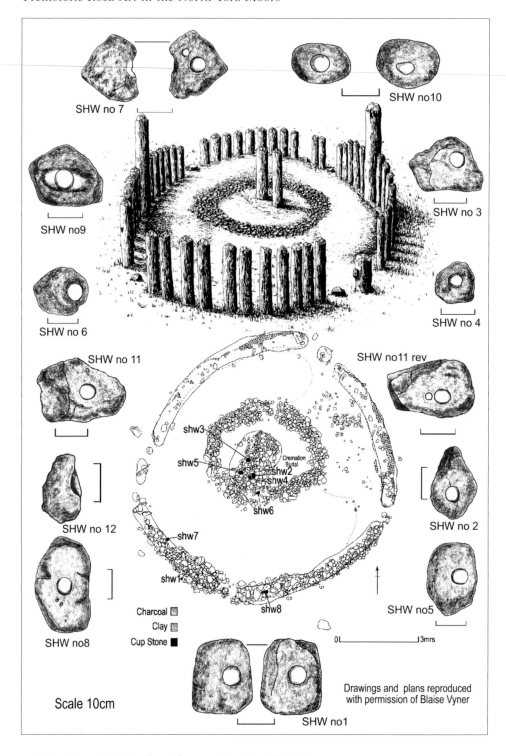

128 Street House Wossit and motifs, excavation plans. *Blaise Vyner*

Street House 'Wossit' (NZ 7390 1892)

Following the excavation of the cairn and mortuary structure at Street House Farm, a second site was identified 850m to the south. Initially this feature had the appearance of a ploughed-down barrow, but subsequent excavation revealed the remains of a structure of such curious appearance and so unique that it prompted the excavators to instantly name it 'Wossit'. It comprised a small enclosure, approximately 9m in diameter, that had been created using closely spaced timber uprights in four curved trenches. These trenches surrounded a central pit that held two upright posts and radiocarbon dates for the charcoal from the timbers suggest a date of around 2200 BC for the construction and initial use of the site. At some point the timbers were removed and the trenches back-filled and at a later date the back-filled trenches and central pit were enhanced by the addition of a stone-capping layer, in which were 12 marked stones each bearing one or two cup marks. These marked stones had been placed over the central pit and over the southern sectors of the palisade trenches; two cremation burials were associated with this later phase of the site, one placed in a collared urn among the stones over the central pit. Sherds of Grooved Ware and Beaker pottery together with a perforated jet button and flint tools were found and two saddle querns had been placed or deposited in the southern palisade trench together with an axe 'sharpening' stone or whetstone and two perforated fishing net 'sinker' stones in the capping layer. This unique feature is so rare within the archaeological record that it was subsequently interpreted as a palisaded ritual enclosure (Vyner 1988) (colour plate 19).

Brotton barrows

In 1914 Hornsby and Stanton excavated a cluster of seven mounds on Warsett Hill, located to the north of Brotton village some 4km further west along the coast from the Street House sites. The hill formed part of the coastal chain of beacons, similar to Hinderwell. At the time of digging, the excavators were unaware that Canon Atkinson had previously explored the mounds on Warsett Hill and had found no evidence of burial. Hornsby and Stanton had similar results in six of the mounds, finding only flints; however, they had a measure of success with the largest barrow – it covered a circle of stone-walling at the centre of which lay a cremation and two associated food vessels.

Howe Hill (NZ 69501887)

In the year prior to their visit to Warsett Hill, Hornsby and Stanton had excavated the remains of a large mound known as Howe Hill, located to the south of Brotton (Hornsby and Stanton 1917). Although the latterday Brotton to Kilton roads cut through the east side of the barrow, the excavators found that the outer mound, some 16m in diameter, covered a large cairn measuring 9m in diameter and made up of cobbled stones. These stones covered two grave pits that had been dug into the original land surface and filled with stones. In the fill of the central grave eight

129 Howe Hill Brotton

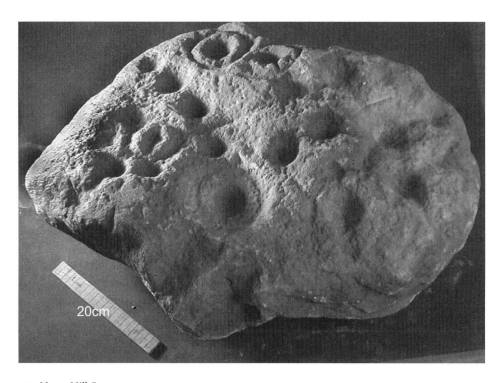

130 Howe Hill Stone

131 Howe Hill Stones. *Hornsby And Laverick 1917*

cup marked stones had been deposited in face-downward position – most exhibited one single cup mark. The second grave pit, 5m to the south-west, contained traces of an oak tree-trunk coffin. Cremation deposits were located at the top and bottom sections of the coffin. The grave pit was filled with stones; 16 were cup marked and one had a wedge-shaped mark. Mid-way between the two graves the excavators found a large cup-and-ring stone (*130*) laid on the original land surface; this stone had also been deposited with the markings face-downward. This stone is now in Middlesbrough's Dorman Museum collection, but the smaller cup marked stones have not been traced and were possibly replaced in the mound.

Kilton Thorpe 'Lattice' Stone NZ 691 176

An Iron Age site was excavated in the hamlet of Kilton Thorpe, 1km to the south of Howe Hill (Vyner 2001, pers. comm.). A stone was uncovered which was marked with a series of shallow pecked lines in a criss-cross or lattice pattern. This stone (*133* and discussed in Chapter 6) was found with its carved surface face-downwards and buried in a pit associated with one of the structures on the site. The excavators suggest that the stone probably predated the Iron Age activity on the site and is almost certainly contemporaneous with the Early Bronze Age tradition of rock carving. It is interesting to note its reuse in an Iron Age context and it was suggested that the stone may have been attributed a 'ritual' significance, hence its burial on the site. The 'lattice' stone adds to the growing

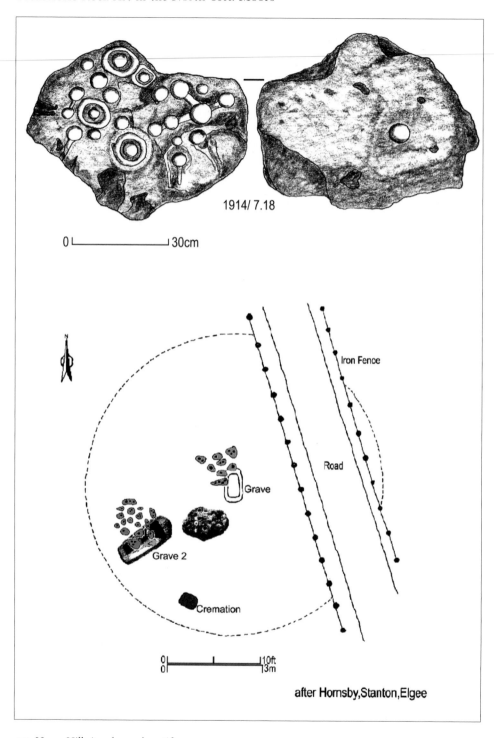

1914/ 7.18

0 └——————┘ 30cm

N

Iron Fence

Road

Grave

Grave 2

Cremation

0 └——————┴——————┘ 10ft
0 └——————┴——————┘ 3m

after Hornsby,Stanton,Elgee

132 Howe Hill site plan and motifs

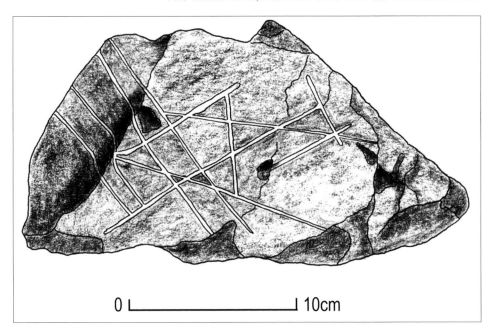

0 |_____| 10cm

133 Kilton Thorpe 'Lattice Stone'

tally of stones with linear decoration to be found in north-east Yorkshire, and its reuse on an Iron Age site has parallels with the previously mentioned site on Great Ayton Moor. The stone is now in the Kirk Levington Museum.

Foxrush Farm NZ 586 230, 1.5km south-west of Redcar

The discovery of a cup marked rock at Foxrush Farm (Sept 2003) on the lower ground 4km to the north west of the Upleatham Hills extends the chain of sites to within 3km of the river Tees. The cup marked stone was uncovered during the excavation of an Iron Age site on the farm, and was located in an area possibly connected with metalworking. Two large pits were uncovered in this area and one of these contained a small slab with cup like marks; this stone was sandwiched between two other stone slabs. It was suggested by the excavators that the pits may have been part of the foundations for a building and that the stone was most likely brought from the moors for reuse on the site. The cup marked stone had been covered by a capping stone and it has been suggested that this may have some ritual significance. Some time later closer examination of the slab in the vault at Tees Archaeology, Hartlepool, showed the slab to be water-worn, the slab probably originated from the beach. (In the past the sea penetrated further into the Tees Valley.) The 30 or more cup-type depressions extend to all faces of the slab, with some less than 1cm diameter. These cups are very smooth (showing no visible peck marks) and some undercut, therefore it is probable that these are the remains of trace fossil or dissolved minerals and not cup marks.

ENDNOTE

The placing of barrows and cairns within the Late Neolithic and Early Bronze Age landscape was not random; sites appear to have been carefully selected and deliberately placed at ridges or high points establishing their prominence within the landscape. The North Yorkshire coastal ridges and hilltops in the Late Neolithic and the Early Bronze Age clearly attracted extensive funerary and ritual activity from the evidence presented by The Brotton barrows, the Street House sites, the Boulby barrow group, Hinderwell and Goldsborough. The placing of funerary monuments on sites overlooking the coastline may have a greater significance in this area. The unique angle of the coastline in the area around Whitby bears witness to a rare and natural visual phenomenon. Here the midsummer sun can be seen to rise and set over the North Sea, a very unusual sight indeed when viewed from the east coast of northern Britain, particularly when viewed along the line of horizon within a seascape. An event that would not have been overlooked in the prehistoric. While the North Yorkshire coastline has eroded over millennia it retains its natural beauty and its coast and moors have earned status as a National Park that attracts thousands of visitors to the area.

6

Maiden's Grave Farm

Rock art in general is found carved on sandstone, but isolated examples have been discovered on limestone, coral rag, and calcareous grit, protected from weathering within barrows. Many of these carved stones were found during excavation of the Hutton Buscel sites. Archaeologists have also considered that because the Yorkshire Wolds area is predominantly chalk, it could be assumed that rock art would not survive the effects of weather on such friable material. Some carvings within the area have survived in barrows protected by the overlying mound material. Fine examples of carvings were found at the Folkton Barrow site, Kirklands, where three chalk drums were discovered during excavation. It was for this reason that we contacted the Sites and Monuments Record at Humberside Archaeology. We were astounded to find that the record shows that a small sandstone cobble had, in fact, been discovered close to an ancient monument, the henge at Maiden's Grave Farm; unfortunately, this oval henge, measuring 85 x 74m in diameter, has now been virtually ploughed out.

The sandstone cobble with six cup marks was noted in an area of stone scatter and field clearance by the Field Monument Warden, Miss M.E. Bastow, and the following is an extract of her report to the SMR dated 17/12/1990.

Whilst visiting the Rudston area this week I went to inspect the prehistoric site south of Maiden's Grave Farm. I parked my car on the grass verge beside the road that forks at right-angles to the Rudston-Burton Fleming road and continues to Argam cross roads. I entered the field just past the little bridge over the Gypsey Race. Whilst walking across it, I noticed a spread of sandstone boulders stretching about 150 yards. These struck me as being unusual as they are not like the stones associated with river gravels in the valley and while they might be the result of glacial drift, somehow I doubt it. From experience, spreads of sandstone boulders or blocks on a chalk area are often associated with settlement sites.

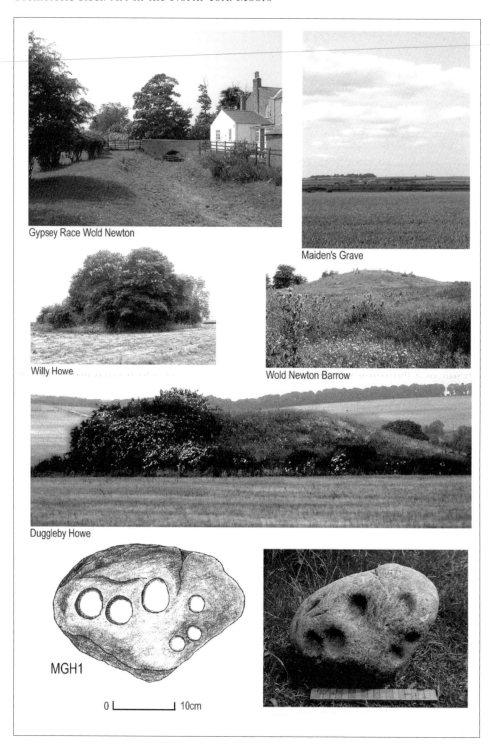

Gypsey Race Wold Newton

Maiden's Grave

Willy Howe

Wold Newton Barrow

Duggleby Howe

MGH1

0 10cm

134 Field Monuments and a cup marked stone from Maiden's Grave Farm, Burton Fleming

However there is usually other evidence such as broken brick/tile, fragments of pottery etc. In this case I did not find any such supporting evidence. By sheer luck I came across the sandstone boulder with cup marks on it. I have seen scores of these cup marked rocks in West Yorkshire (e.g. on Ilkley Moor) so I do know what they look like, I also know that there is vast variation in size and that many are portable.

This cup marked stone or cobble now forms part of a private collection and we were given the privilege to inspect and photograph it. The stone could be described as portable and was found in an area rich in prehistoric remains, close to the Gypsey Race, a water course that sinks and emerges on its way to the sea. It is possible that this phenomenon may have been noticed in the prehistoric where springs and wells appear to have had significance. This ritual decoration appears to have been continued into historical times where wells were given 'Christian' symbols and given the status of a Holy Well. It has also been well documented that wells were used throughout all periods as places of meditation and to receive votive offerings or even become wishing wells.

Rudston village lies in the centre of the prehistoric complex within the Yorkshire Wolds. A great monolith looms over the graveyard in the grounds of All Saints church. It is reputed that the top 1.7m of this great stone fell away as a result of a lightning storm in the nineteenth century and it currently stands at 8m in height and 5m in circumference at ground level. A lead cap has been fitted to the top section presumably for protection from further lightning strikes. In the late eighteenth century William Strickland carried out a limited excavation at the site of the monolith and concluded that the buried section was 'as much in depth as above'.

The stone slab of Jurassic grit is not indigenous to the area and it has been suggested that this was brought in from the nearest outcrop; this is located along the coast around Cayton Bay some 10 miles distant, a major achievement of human effort.

Four separate cursus monuments have been constructed and these converge on the site of Rudston. Some of these were discovered by aerial photography, and are only visible as cropmarks. They consist of parallel banks and ditches that form a track or routeway and cursus monuments were so named by William Stukeley in the eighteenth century when he noted similar examples around Stone Henge. He considered them to be a form of racecourse possibly used in challenging and competitive athletic games in the prehistoric and he gave them the latin name of cursus meaning a racecourse.

The southern cursus terminates on Rudston Hill and excavation around the site revealed many Neolithic pits; a number of barrows are also sited within the vicinity. Five kilometres to the north of the Rudston monolith the northern cursus, again visible only as cropmarks, can clearly be followed on the aerial photograph, to a point 1.5km east of Burton Fleming passing close to the henge at Maiden's Grave Farm. To the west of the village lies the great Neolithic round

barrow of Willy Howe (TA 0615 7635). It is oval and measures 43m in diameter at its widest point and 8m high; the Howe is surrounded by a ring ditch, 14m across.

The Wold Newton Barrow (TA 0480 7260) sited just south of the village is close to the course of the Gypsey Race and today this section remains dry. The waters have, at present, gone to ground. More recent research within the area revealed another cursus aligned north-west between Willy Howe and Burton Fleming. The second largest Neolithic barrow within the area, Duggleby Howe measures 38m in diameter and 6m high. This is 22km west of the complex, just outside the village of Duggleby at SE 8802 6690, and the mound is enclosed by a circular ditched enclosure 370m in diameter, unfortunately only visible today as a cropmark.

Though the area is rich in prehistoric remains the cup marked cobble remains at present the only example of cup-and-ring tradition within the Yorkshire Wolds. It is possible that the cobble, being portable, had been brought into the area and may have been deposited within arrow material or within the water course of the Gypsey Race as a ritual offering. Close examination of the cups indicate that they are water-eroded and very little remains of the pecking that is usually clearly evident on cup marked stones within newly-exposed cairn material. The course of the Gypsey Race has altered over the millennia and it is possible that it cut through a barrow and its material was swept down its water course. Miss Bastow makes clear reference that the sandstone cobbles lay in a linear scatter for some 138m (150 yards) within the field.

LINEAR INSCRIBED STONES

During our research of the carved rocks in the North York Moors we observed other distinctive features on the outcrop boulders and stones at Allan Tofts, Fylingdales, Thimbleby and Warren Moors. While not in the cup-and-ring tradition, these incised lines were evident on rocks that been cup marked. Initially our interest was stimulated from the discovery of the comb-marked motifs on Fylingdales Moor but we began to note that more of these unusual linear marks occurred at other sites. We discovered more when we examined stones from barrows and cairns which had been held in collections. Naturally we were interested to learn whether these incised motifs were contemporary with the cup-and-ring marks being created during the Late Neolithic. Curiosity having been roused we decided to investigate further. The first historic account of incised line markings in Britain was published in 1864 by a cleric who had been researching ancient stone crosses in Wales. It was originally thought that the feature was restricted to the Welsh region of Britain but it appears to have a much wider distribution. At the outset we discovered that they featured in the famous Orkney Chambered Tombs and in the Irish Passage Graves in the

Boyne Valley and on chalk plaques and amulets in Amesbury and Windmill Hill in Wiltshire. Further investigation indicated that they had been recorded in the Channel Islands and Brittany, western central France and north- and south-west Iberia, in Spain. The latest discovery was found in a Bronze Age cairn at Balblair in Inverness, Scotland.

The illustrations in *135*, 1a-n, indicate the nature of incised stones located on the North York Moors. Figure *135*, 2a-k, provides parallels with incised lines from other areas of Britain, Ireland and some other parts of the world. Some of the stones in *135*, 1, were excavated from Early Bronze Age (EBA) burial sites such as Hinderwell (1b and 1c) which have lattice-type markings. Stone 1d, the Kilton stone, also exhibits lattice markings and was located in the posthole of an Iron Age site. Stone 1e from Hinderwell exhibits comb-style markings as does 1k from the Hutton Buscel Barrow 2; this stone was placed in the kerb of the barrow and is also thought to have been a polishing stone. Stones 1f, g and h were discovered on large boulders on open moorland at Fylingdales and 1f and 1h were also cup marked. It is of interest to us that the comb-style marking appears to feature in open moorland (1g), and at two EBA barrow sites (1k and 1e). Unfortunately we do not know whether the incised lines or comb motifs were created within the same period as the cup-and-ring marks that appear at these sites or if one motif precedes the other. While all four are comb-style, it appears from the sketch that the comb at Hutton Buscel 2 (1k) has been incised in similar style to the stones at Fylingdales (1g). On Fylingdales (1g) it was clear that one of the combs had been superimposed by another motif indicating that the comb had been inscribed prior to the imposition of a secondary marking. Stuart Feather also made reference to this in his report in the *Yorkshire Archaeological Journal* (1966, 557; 1967, 3). The markings at Allan Tofts (1m) appear to be unique and are of an entirely different character to the other incised stones in Panel 1; however, it does appear to have some similarity with the incised lines discovered at the Broom Rigg complex in Cumbria (2b) (K.S. Hodgson CWAAS 2 1952, 1-8).

The incorporation of incised rock in the barrows and cairns of the area is of particular interest. The site at Hinderwell contained three stones with these marks (1b, c, e) and the site, discussed in an earlier chapter, had a total of 150 marked stones within the infill of the cairn, the majority being cup marked. The inclusion of stones with incised marks in the EBA burial sites of Hinderwell and Hutton Buscel 2 suggests that these stones were also of significance in the burial process. The Hawsker stone (1n) has an interesting history. The stone came to our attention while researching the Whitby Museum photographic collection. We do not know why or how the photograph came to be in the collection. However, a check through the museum records indicated that the stone was not part of their considerable display collection. The lines on the stone appear to be of a different nature than those incised in other parts of the Moors area and in the EBA burial sites, and in a bid to obtain further information it was decided to make further enquiries. Unfortunately despite much research, including a

visit to the village and a check on the local churchyard (where such stones are sometimes deposited), the stone was not located.

The unprovenanced stone 1a was located in storage at Tees Archaeology and one of the authors believes that the boulder may be from Ord's tumulus in the Eston Hills, but this has not been confirmed. The design here is different in style and decoration from the others featured and appears to be, in our western way of thinking, 'geometric' in nature and style. The incised cut lines at Hanging Stones, Thimbleby Moor (1i) show four parallel lines that had been cut into this impressive piece of outcrop rock. Warren Moor (1j) shows a similar feature to the Hanging Stones site and this occurs on an earthfast boulder built into Park Pale dyke wall and consists of seven incised marks, in two groups of four and three. These incisions at Hanging Stones and Warren Moor bear some resemblance to others that were found in the Welsh Mountains and noted by the cleric, the Revd Elias Owen.

The stone from Little Hograh Moor (1l) is included here to provide a discussion point. Several stones on the moors exhibit these 'patterns' and it is considered that it is the result of Ichno-type trace fossil and an early form of worm that thrived in the sand beneath the warm early prehistoric seas. Its tubular burrows left tracks as it moved its way around in sand that eventually became a sandstone boulder. At a later stage in prehistory the boulder that contained the trace fossil had, at some point, been split, possibly by ice, to reveal the markings made by the creature. There are several instances of these stones in other areas of Britain.

In 1864 the Revd Elias Owen published an account of 'Old Stone Crosses in the Vale of Clwyd'. While the focus of his research was early Welsh crosses he makes reference to other archaeological features that he noted during his research. He noted cup marks on the pedestal that was used to hold the shaft of the Corwen Cross and throughout the course of his work he noted grooves on the bases or pedestals of crosses. Grooved stones had been found in the mountains 'in secluded and unfrequented places' and tradition had it that such a stone was used on a mountain behind the village of Llanllechid, Caernarvonshire. The mountain is still known as Carreg Saethau (Arrow Stones). The surface of the stone had allegedly been used to sharpen arrows; in effect they were arrow whetstones and similar marks on stones continue to be found in the hills around Caernarvonshire and Denbighshire. The Revd Owen concludes his article by stating that there were so many incised markings around local churchyards and freestanding altar tombs that they were a common occurrence (Owen 1864, 315–320).

'Arrow' stones have since been recorded in RCAHMWM throughout various locations in Wales. H.S. Chapman proposes that the arrow stones are not in actual fact whetstones. In plotting locations of open-air examples he identified that the arrow stones had a restricted geographical spread. He suggests that there were many smaller and more suitable rocks for the task and that the stones were in fact 'neglected examples of rock art'. In his article he quotes others that have been

located in Donegal, Loughcrew, Newgrange, Skara Brae, Orkney, Portugal and Brittany ('Arrow Stones and Related Phenomena' *3rd Stone* Oct-Dec 1998).

Richard Bradley et al. describe the incised and pecked motifs in the Orkney Chambered Tombs. Bradley questions the prescriptive term of art that had been applied to the incised motifs in the Orkney Tombs, he argues that 'we are restricted to a modern western concept of art that is different from the "visual imagery" of prehistoric art'. The abstract lines in the Orkney Tombs are angular rather than curvilinear and are mostly of parallel lines, zigzags, chevrons, triangles and Vs. The article cites that parallels have been made with the motifs found in Megalithic Art of the Irish Passage Grave Tombs. It was suggested that while the motifs evident in the Irish Passage Grave Tombs symbolise the commemoration of the dead, the motifs in Orkney had a continuous involvement with the living and appeared in the houses of the period. Their research indicates that tombs in Orkney have comparison to the houses of the living in that they are built in a similar way. In some instances tombs had been constructed using the layout and plans of houses from an earlier period. Incised lines were found on the walls of houses at Maes Howe and at Skara Brae and on small items of domestic pottery. Bradley suggests that the decoration used in the Orkney passage tombs made a direct reference to domestic life and its presence forged another link between the living and the dead (2f).

The pecked motifs in Orkney have been known and recorded since 1850, with the incised marks a more recent discovery. Being roughly sketched they were difficult to see and did not have regular depth, they were more or less scratched onto the entrances of tombs or walls of houses with a flint or quartz point. The tombs also contain runic inscriptions and one incised motif at Maes Howe had been overlain with a later runic inscription (2k) (R. Bradley et al. 'Decorating the Houses of the Dead: Incised and Peck Motifs in Orkney Chambered Tombs', *Cambridge Archaeological Journal* Volume 11, No.1, 2001).

Philip Harding describes in detail two small engraved plaques that were discovered during a rescue excavation at King Barrow Ridge in Amesbury in 1968; they were found in a Neolithic pit close to Stone Henge. Harding made a detailed microscopic examination of the incised decoration on each of the plaques and, although the artefacts were eroded, he described the design on each. Both plaques exhibited incised line markings, the back of the larger of the two plaques appeared to be better prepared than that of the smaller. This had two 'crude' lozenges and several lines that repeatedly fanned out so that one of the lozenges is filled with cross-hatched lines as detailed in 2c. Its front panel appeared to be in the style of an opposing 'Greek Key' or stepped pattern it also had a number of cuts or 'slashes' across its decoration. The smaller of the two plaques had a border decorated by a continuous zigzag line with alternate chevron infills. Its central panel is composed of intersecting, parallel diagonal lines that form two rows of lozenges offset toward the base of the panel (Harding 1988, 54).

While the back of the smaller plaque also exhibits incised lines, or 'slashes' as Harding described them, the detail on the front of the smaller plaque is of particular interest to us. It is decorated with continuous zigzag lines with alternate chevron infills. The design appears to have parallels with the design on the linear marked stone on Fylingdales Moor described in detail in Chapter 2.

Tiny chalk amulets were also found at Windmill Hill close to the Amesbury find and these exhibited incised lines (2e). These line drawings were produced and published by Stuart Piggott (1954, 87).

Incised lines and cup-and-ring motifs feature at the famous Late Neolithic open-air rock art site at Magheranaul in Donegal, Ireland (2d). A number of rocks exhibit incised lines and on a large slab of outcrop rock that is decorated with rock art, a small circular motif has lines incised in its centre (Van Hoek 1987).

In our research of other areas we have noted incised lines on the rock art in the Kilmartin area of Argyll. Incised lines feature on the well-publicised rock art sites at Cairnbaan (2i). At the famous chambered cairn at Ri-Cruin, Kilmartin, a vertical slab was excavated by Mapleton in 1870. Here the inscriptions have a vertical groove and 10 incisions at right angles that form a style of comb motif (2g). Incised carvings have recently been discovered during the excavations of a Bronze Age cairn at Balblair near Inverness (2005). The incised stone is thought to have been freestanding prior to its incorporation in the cairn. A chambered cairn lies close to the site (Headland Archaeology Project, Balblair 2005).

The authors were curious to learn more about the origins of the incised motifs in general and decided to undertake further research. Incised lines appear to have an earlier prehistory than the Late Neolithic cup-and-ring. One of the earliest known artefacts that exhibited incised lines appeared on an ivory plaque fashioned from a Mammoth tusk from Mezhirich, Ukraine, that dates to 14,000 years ago (2h) (Bahn 1997, 203). The first cave engravings to be discovered were found at The Early Man shelter in Queensland, Australia. Engravings of intertwined lines disappeared into the archaeological layer of the shelter; the layer was dated to 13,200 years ago and the engravings are considered to be of similar age (Bahn 1997, 33). Lines found in a rock shelter at Inca Cueva, Jujuy Provence, Argentina, had been painted on a preparation of gypsum. An x-ray diffraction analysis was made and it was found that the radiocarbon date of the occupation level was found to be 10,620 years ago and Bahn suggests the paintings predate that time (Bahn, 1997, 28). Bahn also describes the painted lines at Cueva De La Pileta, Malaga (2a), that have their origins in the Magdalenian (Bahn 1997, 154).

The markings originating from the trace fossil stone at Little Hograh Moor on the North York Moors (1l), cannot be considered in context with the incised lines that have been created by man. Records indicate that incised lines occur in three distinct types: comb-style, parallel lines and incised lines integrated with the cup-and-ring motif. Are the incised lines contemporaneous with the cup-and-ring markings or did one precede the other? They both occur in open-air sites and in funerary monuments. Random scratches that form incised lines or lattice-type

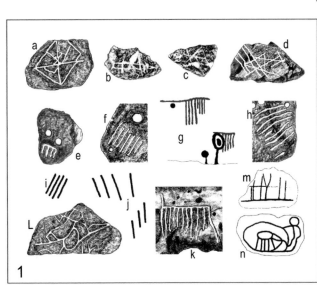

1
a Unprovenanced
 Tees Archaeology

b Hinderwell Beacon

c Hinderwell Beacon

d Kilton

e Hinderwell Beacon

f Fylingdales Moor site 9c

g Fylingdales Moor site 3h

h Fylingdales Moor site 9b

I Hanging stones
 Thimbleby Moor

j Warren Moor site 2c

k Hutton Buscel Barrow 2

L Little Hograh Moor site 3

m Allan Tofts site 12

n The Hawsker Stone

Parallels from other areas

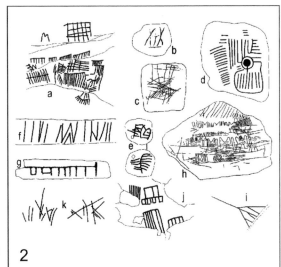

2
a Cueva De La Pileta Spain

b Broomrigg Cumbria UK
 after K Hodson 1952
c The Chalk Pit Amesbury UK
 after P Harding 1988
d Magheranaul co Donegal IRE
 after M Van Hoek 1987
e Windmill Hill Wiltshire UK
 after S Piggott 1954
f Skara Brae Orkney

g Ri Cruin Kilmartin Argyll SCOT
 after RCAHMS Argyll vol 6
h Mezhirich Ukraine after Gladkih

l Cairnbaan Kilmartin Argyll

j Inca Cueva 4, Argentina
 ref Paul Bahn 1997
k Maeshowe Orkney after Bradley 2001

135 Linear inscribed stones from the North York Moors

patterns appear to have significance both to the living and the dead. In discussing the motifs we must consider that the earliest link relates to a period when they appeared as parietal art, paintings on the walls in caves. Is there a relationship or association between painted and incised lines? Did the incised lines evolve from the painted ones? If so it would appear that they originate from a much earlier period in the prehistoric than the cup-and-ring and this implies a remarkable time span. One of the authors has visited Cueva de la Pileta in southern Spain and viewed the markings shown in figure 135, 2a. This is a fascinating site involving a long journey into the mountains, a steep climb to the entrance of the cave and a walk into its deeper recesses before the art and markings can be viewed. The art here includes accurately detailed drawings of animals that possibly relate to a much earlier period of time than the lines on the cave walls that have been emphasised with charcoal sticks and form combs, lines and lattice designs – these markings have been C14 dated to the Neolithic.

The recent discovery at Balblair adds yet another dimension to the number of incised rocks that we have discussed. It would appear that we are now faced with a phenomenon that is every bit as enigmatic as the cup-and-ring motif. They appear to share a similar context in their inclusion at open-air sites and in funerary monuments; indeed, they appear on stones and outcrop rocks that exhibit rock art. It appears to provoke the same question that is asked when viewing a rock art panel: what does it mean? It is possible that some of these markings are an early form of writing or recording in the style of ogam or runic script; the incised lines at Ri Cruin, Kilmartin, are considered to be an early form of script. It possibly represents barter marks used in the trade for goods or animals. The lattice marking on some examples may be the result of early farming practices, plough scars or marks left by the sharpening of tools. The small, flat incised stones found at Hinderwell Beacon Barrow could be considered to be honing stones to sharpen flint. The excavators are said to have discovered around 300 marked stones of which 150 were cup-and-ring. As well as cup-and-ring stones the infill of the site included stones that would have had everyday use in the prehistoric; perhaps these were offerings of items that had been used by the deceased or maybe they were ritual deposits for use in the afterlife. These items included whetstones, querns and grain rubbers, pot boilers and net sinkers. Net sinkers were also found in the burial sites at Rudda Howe and Seamer sites in the North York Moors. The tradition of these incised marks in a burial context is also reflected at Hutton Buscel Barrow 2; Maes Howe and other tombs in Orkney; Irish Passage Grave tombs and in the Bronze Age cairn at Balblair, Inverness.

7

A search for meaning

What do these markings mean? What were they used for? These must be the two questions most frequently asked when people see cup-and-ring marked stones for the first time. Unfortunately, in most cases the enquirer will be hard pressed to find any relevant information concerning this aspect of Britain's prehistoric rock carvings. In the following chapter the authors attempt to shed some light on this intriguing element of the rock art tradition, highlighting possible interpretations based on informed research and personal observations on the subject. Hopefully this will stimulate further discussion and lead to a wider debate regarding the purpose of the carvings.

BRITISH ROCK ART IN FOLKLORE AND CULTURE

Over 150 years have passed since Britain's cup-and-ring rock carvings were tentatively identified as prehistoric in origin. The interest generated at that time led to much speculation and debate among the antiquaries of the day, as to the purpose and meaning of the motifs. George Tate, Sir James Simpson and Canon Greenwell, among others, all expressed opinions on the subject, but due to the lack of conclusive evidence it could only be proposed that the markings were of some religious significance to the 'ancient Britons'. The absence of an interpretative element in this formative period of the study appears to have shifted the focus of subsequent work towards methodical recording, while the interpretation of the actual carvings and their sites received little attention. Recent work in Ireland (O'Conner 2003) and Northumberland (Waddington 2005) has begun to address this imbalance, with excavations uncovering dating evidence and traces of activity at rock art sites. However, progress on the interpretation of the actual carvings remains elusive.

One approach to this problem would be to take a wider perspective and view Britain's rock carvings in their European context and as part of a widespread cultural practice, which still continues in some parts of the world even today. From this perspective, it is possible to take into account the wealth of archaeological and

ethnographic information, which has been gathered through the field of global rock art studies. Such an approach makes it possible to formulate interpretive frameworks that could assist in the explanation of Britain's prehistoric rock art sites.

A useful starting point for gaining some understanding of Britain's cup-and-ring tradition is its association with funerary monuments where, as noted in previous chapters, carved stones have been found in close proximity to or actually incorporated within these structures. Local sites such as the Raven Hill Barrow had carvings close to the internment, with concentric rings being carved on a cist slab. At other sites, such as Hutton Buscel, the carvings were found on kerbstones around the mound structure, while cup marked stones were also incorporated into the Neolithic/Bronze Age cairn at Street House. These, and other examples indicate that the markings were held to have some significance or connection with the dead: featuring in the associated burial rites and perhaps in subsequent activity on the sites. At this point, we encounter the world of prehistoric ritual and religion, a world of ceremonial monuments, ritual landscapes, venerated ancestors, votive offering and deposition. Bearing these concepts in mind, it is interesting to note that a number of related themes can be discerned in the instances where ethnographic research has recorded folk beliefs and practices connected with prehistoric rock carvings. By definition these recorded examples date to the historic period and cannot automatically be assumed to link directly back to prehistoric times. However, their wide distribution and the similarities between the accounts, plus the basic nature of the concerns addressed by the practices, hint at some core belief from which these later activities derive. The fact that genuine beliefs and customs have been recorded in connection with the rock carvings clearly invites a closer scrutiny of these practices.

Across many parts of Europe, including the British Isles, Scandinavia, Estonia, Germany, Switzerland and Italy, cup markings have been recorded in Neolithic, Bronze Age and Iron Age contexts. In addition to this, there are a significant number of accounts of their continued use in these areas during the historical period up until a relatively recent date. For example, in Sweden and Finland there are accounts of cup marked 'Offerstenar' (offering stones) where, as the name suggests, a variety of offerings were made to ancestral spirits and Landvaittr (land spirits) in order to secure good harvests, healthy livestock, cures for illness and infertility etc. (Rau 1882, 86). These offerings took several forms including harvested grain, pieces of prime meat from slaughtered or hunted animals, or a token amount of a cow's first calf milk (the same custom apparently extending to mothers with new babies). Ronald Morris noted similar practices in his survey of Scottish cup-and-ring marked stones (Morris 1969, 53). For example, on the small island of Seil to the south of Oban, Morris recorded details of a cup marked slab located on a hill at Clachan Seil (Gaelic clachan: stone). He noted that: 'The widow of the late farmer there states that in her youth, one day each spring this basin had by custom to be filled with milk. If it was not so filled, the "wee folk" (fairies) would see that the cows gave no milk that summer'.

This springtime ritual had continued until the early 1900s, and Morris heard other accounts of similar practices taking place on remote farms on the isles of Skye and Islay, and at a cup marked stone located near a waterfall at Cove in Knapdale. Perhaps more surprisingly, another example of this activity appears to have been recorded as still taking place on a Pennine hill farm near Haworth, in West Yorkshire, during the mid 1980s (Dodd 1986, 19). On this old farmstead, it was noted that the farmer regularly poured milk onto a number of cup marked 'Dobbie stones', the old tradition in this area being that the milk was left out for the Dobbie spirits who were believed to watch over the farm at night. Elsewhere, there are named stones such as the cup-and-ring marked 'Fertility Stone' on a hill farm near Pateley Bridge in the Yorkshire Dales, which hint at the possibility of similar beliefs in this area. This theme appears to continue in connection with a number of cup marked rocks bearing names such as the 'Witch's Stone', with examples being recorded at locations across Europe.

A large boulder known as the Witch's Stone originally stood on Tormain Hill near the village of Ratho, to the west of Edinburgh. The stone had a line of 23 cup marks along its sloping upper surface, which had been worn smooth through the action of people sliding down the rock (Romilly-Allen 1882, 80). The Witch's Stone was destroyed around 1900 and although no tradition survives regarding the purpose of this particular sliding custom, at Hollyrood Park in Edinburgh, women would also slide along a large recumbent stone in the belief that it would help them conceive a child (Bord 1976, 48). A continental example

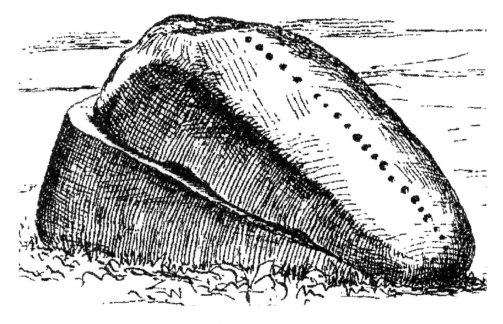

136 The Witch's Stone, Ratho. *J. Romilly Allen*

mirrors the activities at Tormain Hill and Hollyrood, this time at a site in the Bessa Park nature reserve in northern Italy, where around 50 cup marked rocks have been recorded. One large cup marked boulder is known as 'The Roch d'la Sguia' (Rock of the Slide), an alternative name being the 'Fecundity Rock'. Both these names relate to the tradition that women slid down the boulder in the belief that it would help them to conceive a child. Another Scottish example of a 'sliding stone' is located to the south of Murthly Farm at Aberfeldy, near Pitlochry. Here, a large cup marked boulder also had its sloping surface highly polished through the act of people sliding across it, apparently for 'amusement' (Romily-Allen 1882,98). Again, there are no details as to why this particular marked stone, set amongst a group of boulders in a rather remote location, had been selected for such an amusement. In this respect, it may be worth noting that children were allowed to play on the Sliding/Fecundity Rock at Bessa, perhaps in the belief that it would have some beneficial effect. These accounts of 'sliding stones' raise several questions, for instance how much activity (and over what time period) would be required to highly polish the surface of these stones? Given that they are not steeply sloping they would more realistically entail people shuffling themselves across the surface rather than any actual sliding.

Looking a little further afield, a similar theme can be discerned in the beliefs and practices recorded on the island of Hawaii, where several thousand cup markings are to be found on Pu'u Loa: the 'Hill of Long Life' (Lee & Stasack 1999). While researchers were in this area recording the rock art, it was noted that new cup marks were still being created as part of a ritual following the birth of a child. At this time, the child's family make a pilgrimage to Pu'u Loa where the mother then creates a new cup mark, in some cases adding it alongside existing cup marks arranged in family groups. After the cup mark is made, a piece of the baby's umbilical cord is placed within the hollow cut into the rock. For the Hawaiian people Pu'u Loa is a sacred hill, full of mana (spiritual power) and through this ritual it is hoped that the new born baby will be linked to the hill's potency and blessed with a healthy and long life. Returning to Scotland, a similar type of belief could also lie behind the story connected with a large cup marked rock on the Balvarran Estate near Pitlochry. This stone was central to a tradition that all the heirs to the estate were christened at the stone using water contained in the cup marks, and a new cup mark created on each occasion. However, when this tradition ceased there were no further male heirs born and so the family line died out (Dixon 1920, 95).

Another example of a cup marked offering stone (perhaps relating to a harvest grains offering), may have been recorded in the report of a cup marked slab on Craskie Farm in Glen Cannich, south-west of Inverness (Jolly 1882, 360). A stone circle once stood near this remote farmhouse, with the stones encircling a central mound, perhaps similar to the chambered cairn and circle at Corrimony, a few miles to the east. A large cup marked slab was located alongside one of the standing stones and the report noted that the slab had been used as a threshing

floor where, for generations, a wooden flail had pounded the harvested husks against the stone in order to release the grains. Although this seems a reasonable supposition, in reality the cup marked surface of this slab would have rendered it an impractical choice for the threshing process, whilst its location alongside a stone circle (and burial mound?) suggests some more esoteric activity may have been taking place. The noisy beating of this stone, releasing the seed grains into the cup marks, perhaps had symbolic or ritual connotations, which could also have relevance to the numerous 'knocking stones' recorded in Scotland. In some cases these rock-cut basins are found associated with cup markings on isolated slabs and boulders, and connected in folklore with cures for infertility, healing ailments and invoking favourable weather. There are also antiquarian references to the knocking stones being used in the preparation of pot barley, the grains being pounded in the basins to remove the husks. However, it has been suggested that this same procedure may have formed part of the offering ritual, as performed by the clan chiefs on the Isle of Colonsay, in order to secure favourable weather for sea journeys and for fishing etc. (Mackenzie 1900, 325).

The above accounts (often fortuitously recorded) provide examples where cup marked stones were the focus of rituals and ceremonies performed to promote the fecundity of the land, animals and people. Such beliefs and practices have been recorded in cultures around the world and reflect an ancient worldview where the whole of nature is perceived as being inhabited by spirits and supernatural forces, which can have a beneficial or harmful influence on the lives of people. In many respects these beliefs seem alien to the modern western mind, perhaps the result of an education in an industrialised society; however, in many societies around the world these type of beliefs and practices still exist, with people continuing to visit culturally sacred sites in order to have contact with the numinous powers residing there. Ethnographic and folklore studies indicate that certain common features within the natural environment are often regarded as focal points for these otherworld forces, among which, stones, boulders, and rock outcrops feature strongly, as do water sources such as wells and springs, waterfalls, lakes and rivers. Where these continuing traditions involve rock art, the carvings or paintings are often said to mark places where these spirits are present or have been accessible in the past. In some cases shaman or ritual practitioners describe cracks and crevices in rock surfaces 'opening' to allow them to enter the 'sacred realm' in order to communicate with the spirits residing there (Whitley 2000). Again, this concept of spirits dwelling within stones, boulders and rock outcrops is widespread, being found in cultures and folklore around the world.

In the traditions of the Saami People, who inhabit the Baltic regions of northern Europe, there are references to stone Sieidi, translated as 'worship stones'. The Saami believe that the spirits of their ancestors passed into the Sieidi, providing a link or gateway to the underworld. These Sieidi range in size from small portable stones up to larger earthfast boulders and rock outcrops, which are located at important sites connected with the seasonal life of the Saami folk.

Cracks, crevices and caves within these rocks are noted as significant features of the Sieidi, while others have a natural mark or feature resembling part of an animal or a person, one example having the profile of a human head. The Saami visit the Sieidi to make offerings to their ancestors and to the spirits of animals, both domestic and hunted. Offerings such as the best parts of hunted wild deer, reindeer meat and antlers, or fish fat etc. are all given with the aim of securing future prosperity. At some Sieidi sites, the ceremonies were more elaborate with the offerings being placed in hollows beneath small cairns.

In the late 1800s, the Revd J.B. Mackenzie noted the existence of stones and boulders referred to in Gaelic as Clachan Aoraidh (worship stones), which were located in the Kenmore district in the central highlands of Scotland (Mackenzie 1900, 30). These old worship stones, some of which were cup marked, were to be found adjacent to many old homesteads in the area and Mackenzie found that the local people regarded any stone marked with holes or hollows as having a sacred character, even if the markings were natural in origin. In some cases, the worship stones were a hindrance, being inconveniently sited near the houses, but the residents were reluctant to interfere with them, as one old man told Mackenzie: ' … it would not do to destroy these old worship stones … for it would never do to incur the anger of the spiritual beings by breaking them up.'

These 'spiritual beings', the Daoine Sithe of Gaelic folk belief (Evans Wentz 1911, 91), were believed to inhabit certain localities within the landscape of the highlands, and a strong belief in their existence lasted well into the nineteenth century, when many of the numerous stories and legends connected with them were first written down. Folklore scholars have studied the widespread beliefs pertaining to the Daoine Sithe (pronounced Deena Shee, meaning the people of the hills/mounds), along with their counterparts in other parts of the British Isles and further a field. These studies suggest that the Daoine Sithe were originally believed to be the spirits of the dead awaiting rebirth into this world, and residing in hills, mounds, stones and rock outcrops etc. until their time came.

The Clachan Aoraidh 'spiritual beings' shed some light on the 'wee folk' referred to in connection with the milk offerings at Clachan Seil, where the spirits were believed to have influence over the farm's livestock. Another example of the link between the Daoine Sithe spirits and marked stones can be found in the record of a large cup marked slab on the isolated farm at Corrary in Glen Beg, near the Isle of Skye. This marked stone was found near the Balvraid Chambered Cairn, and was known to the local people who referred to the cup marks as the Luirgan sithe 'fairies' footmarks' (Jolly 1882, 120). A further example of these fairies' footmarks has been recorded in connection with a cup-and-ring marked stone alongside Lochan Hakel near the village of Tongue, in the north of Scotland (Horsburgh 1870, 277). Similar examples are also to be found in Italy, with the cup marked 'Roca 'dle Faie (Rock of the Fairies) near Sant Antonino Di Susa in northern Italy (GRCM Archivio). This large boulder is located on a steep hillside, and the stone's upper surface has over 130 cup marks located alongside

numerous natural cracks and crevices. The 'Sasso Delle Fate' (Rock of the Fairies), is also located on a wooded hillside, at the head of a narrow valley near the town of Monte San Savino in Tuscany. Several springs rise in the vicinity of this rock, which is a large outcrop eroded and shaped by nature so as to resemble a human face. Several carvings have been recorded on the stone, including a small anthropomorphic figure, along with clusters of cup marks and other markings associated with crevices and hollows in the rock (Burroni 1997).

Finally, to further emphasise the widespread nature of these types of beliefs and the practices associated with them, it is worth noting the fascinating accounts of the use of cup marks and cup-and-ring-like motifs recorded amongst the indigenous peoples of Australia. Within the ancient and still living traditions of these people it is believed that powerful ancestral spirit beings created the world and then entered the earth, merging with the landscape, where their spirit force still pervades certain locations regarded as sacred dreaming sites. At these sites, boulders, rock outcrops, caves, hills, rivers and waterholes etc. are believed to hold the spirit essence and potency of these ancestral beings, who are intimately connected with specific animals, plants and other important elements in the lives of the people. The fundamental nature of these sacred places is also demonstrated by the belief that they provide a dwelling place for the spirits of unborn children

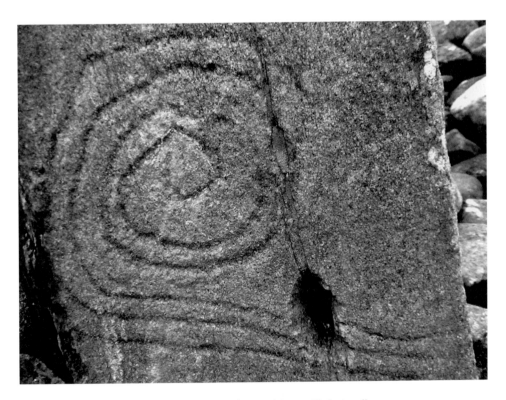

137 Example of motifs around hollow at Temple Wood Stone Circle Argyll

and the place to which the souls of the dead return (Caruana 1993, 59). These indigenous traditions include elaborate ceremonies, which are carried out in order to promote the well-being and fecundity of the clan groups, along with the flora and fauna in the locality. In some cases, these rituals involve the creation of cup marks in order to release the fertilising spirit stored within the dreaming site and disperse it into the surrounding landscape (Flood 1997, 146). In other rituals, lines are scored into stone surfaces in order to cut the 'body' of the ancestral being in the belief that this symbolic 'bleeding' will bring rain. On a larger scale, some ceremonies involve the creation of ground paintings, where patterns and symbols are laid out on the ground. These symbols include geometric motifs similar to the cup-and-ring concentric circles, which are said to symbolise the potency or spiritual power present at that location. During the ceremonies, these motifs are believed to provide a 'gateway' for the ancestral power residing deep within the earth, allowing it to be drawn up and then returned back into the land. These motifs are laid out on the ground with the intention that they will be seen from the 'other side' i.e. from within the earth or the rock surface.

SUMMARY

The making of cup marks on stone surfaces is a cultural practice found around the world, cup marks and the cup-and-ring motif being part of an intercontinental genre of rock markings (Flood 1997, 178). The accounts and references noted above serve to illustrate the connection between cup markings and aspects of the once widespread belief that certain stones, boulders and rock outcrops were believed to provide a contact or dwelling place for spirits. In many cases, these spirits (often ancestral in nature) were regarded as having a powerful influence over the surrounding landscape and people. At one level the 'spirit rocks' could be small, undistinguished stones (perhaps from a location held sacred), while on a larger scale they were boulders, outcrops, and rock formations, which, being connected to the underlying bedrock, were perhaps seen as extending the domain of the spirits out into the wider landscape. Cracks, crevices, and hollows in the 'spirit rocks' appear to have been regarded as a natural access or 'gateway' for the spirits within the rocks and as a focal point for communication with them.

The Scandinavian Offerstenar, along with the Clachan Aoraidh and the milk offerings to the 'wee folk' on the Isles of Seil and Skye, provide examples where these 'spirit stones' were cup marked. On a purely practical level the cup marks could be seen as providing a receptacle for offerings and a visible indication of a ritual site; however, it seems likely that this function, although perhaps related, was not the primary purpose of the markings. Taking account of the wider ethnographic parallels it seems more probable that cup marks were originally chipped into stone surfaces during specific rites or ceremonies, which required

the creation of a physical/symbolic opening between the world of the living and the perceived realm of the spirit or supernatural otherworld, accessible through the rock. In this situation, the often-apparent relationship between cup marks and natural cracks and crevices suggests that the cup markings were seen as an extension of these naturally created 'gateways'. While the noisy process of chipping out a cup mark in proximity to existing openings in the rock surface was perhaps seen as an act of reawakening or revitalising the connection.

With the above beliefs and practices in mind we can perhaps look again at Britain's ancient burial mounds, noting the carved stones located around the remains of those interred within the site, and put forward the suggestion that we could be looking at a version of the same ancient and widespread beliefs? The marked stones being so placed in order to provide a link to the spirit world for the deceased and in some instances a place of otherworld contact for the living.

On a local level, this might also shed some light on the incidence of small cairns found alongside marked stones and outcrops, as noted on Fylingdales Moor, Allan Tofts and Near Moor. The ambiguous nature of this type of 'clearance' cairn is still the subject of debate (Johnson 2002), while excavations have shown that in some cases these cairns can have structural elements similar to larger burial mounds. In other cases the cairns have been found to contain burials, or to have scooped hollows in the surface beneath the cairn, perhaps echoing the ritual cairns constructed by the Saami to cover pits containing perishable offerings. If these small mounds are indeed a type of ritual cairn, intentionally located alongside marked stones, then it suggests some link with the function of the stone. This kind of association possibly being a precursor to actually placing the carved stones within the mound structures, as happened in the Bronze Age period.

This interpretation would tend to support the suggestion that the carved stones found within Bronze Age round barrows indicate a change in the use and the focus of the markings, turning them inward to directly face the dead (Bradley 1997, 149). However, the cup marked stone placed on the floor of the Neolithic mortuary structure within the long barrow at Dalladies suggests that this association already existed at an earlier period (Piggott 1972). Instead, it could be argued that incorporating carved stones within burial mounds served as a link between the larger barrows and the traditions associated with the smaller cairns and exposed rock carvings, especially when it has been suggested that some of the burial mound rock art may have been removed from such sites (Beckensall 1999, 9). These points also touch upon the significance of those buried within these mounds, in relation to the majority of the prehistoric population whose funerary rites are, for the most part, archaeologically invisible, their remains having merged with the landscape either through shallow burials, cremations or scattered on land or water.

The main concentrations of rock art in Britain are generally found in areas of higher ground, on hills, ridges and moorland, often in association with other

features such as cairns, burial mounds and earthworks. This distribution suggests that the local topography formed an integral part of the rock art tradition, with exposed stone surfaces at these sites being selected for decoration. The funerary element of this tradition might also indicate that some of the prehistoric dead were taken to the same areas for burial, possibly involving rites connected with the rock carvings. If this is the case then the carved stones incorporated into later round barrows (essentially small artificial hills) perhaps emphasise a continuity with this tradition of 'burial in the hills', these mounds containing the remains of 'select' members of the population who were interred within a symbolic hill on higher ground.

In the later traditions of Ireland, those interred within the prehistoric burial mounds became known as the Daoine Sidhe: 'the People of the hollow Hills', whilst a still later account provides a rare example of this tradition in relation to a Norse settler called Thorolf Mostrarskegg (Ellis Davidson 1964, 158). Thorolf settled in Iceland in the ninth century and, after his death, his body was interred within a burial mound. However, it was said that his spirit did not remain long in the barrow, but instead entered the prominent hill called Helgafell (Holy Hill) near his home, where his family and descendents would eventually join him, believing firmly that they would 'die into the hills' (GC).

8

Recording techniques

Recording rock art is by no means straightforward. Rock does not present flat even surfaces that are easy to record or photograph. Most are uneven and, not surprisingly after thousands of years, carvings are often hidden from view, lying in deep grasses, heather or bracken and covered in lichen, ferns, mosses and, depending on the location, animal dung. Having been in an open landscape enduring thousands of years of environmental and climatic change and much animal movement, stone surfaces tend to be friable and vulnerable. Rocks are generally covered in debris and it is inevitable that preparation of the surface and surrounding area is necessary for recording purposes. With an increase in the number of panels being discovered in recent years and the number of books being published, interest in the subject has grown. Websites have been created where people can contribute and exchange detailed and up to date information. Universities offer degree courses in the subject and institutions such as English Heritage, charged with protection of antiquities, have access to grants and funding not available to the independent researcher. These institutions are now keen to take control of the recording process that inevitably includes great expenditure, not only in the latest technology but also payment to those with the skill to operate it. The principal and commendable aim is to effect non-contact recording in order to preserve the carvings and rocks. However, this is often virtually impossible to achieve since preparation and clearance of the area is still clearly required even when using highly sensitive technology. Any recording technique that prevents further unnecessary damage to an already fragile surface is an ideal to strive for and is essential for future conservation of rock art panels. Use of technology will, it is believed, eliminate subjectivity in the recording process, a problem frequently encountered by individual recording in the past.

Famous antiquarians who recorded carvings during the nineteenth century naturally did not have access to modern technologies or digital cameras. Equipment was rudimentary by today's standards but, nevertheless, some very fine work was presented in the form of detailed drawings of Northumberland's rock art made by George Tate and Collingwood Bruce, as well as art commissioned by Sir James Simpson. These form the basis of an influential library on the subject

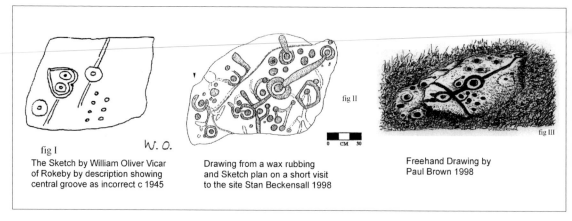

fig I

W. O.

The Sketch by William Oliver Vicar
of Rokeby by description showing
central groove as incorrect c 1945

Drawing from a wax rubbing
and Sketch plan on a short visit
to the site Stan Beckensall 1998

fig II

Freehand Drawing by
Paul Brown 1998

fig III

0 CM 30

138a Early recordings

currently held in Alnwick Castle. With the passing of the antiquarians recording
has, until now, been the province of independent archaeologists who, prior to
the development of digital cameras, photogrammetry and laser technology, used
traditional photography and marked outlines of carvings with chalk or used wax
rubbing. Simple and cheap wax rubbing involves placing a sheet of paper, such
as unprinted news-sheet, onto the rock surface and taking an imprint of carvings
using a wax crayon. Notations of height, width, depth and orientation are noted
and a scale drawing reproduced for publication. As always, caution should be
exercised to avoid subjectivity in the interpretation of results.

During the last decade technology has advanced to the degree where
successful recording by electronic means and using processing software provides
an accurate and detailed outcome. Cost and use of laser scanners is prohibitive to
most but are widely favoured by universities and organisations that have adopted
the technology for application on a variety of projects. It makes no difference
whether rock art is to be recorded by the amateur or by the professional, using
laser scanner, digital camera or wax rubbing, no record can be made without
preparing and clearing the debris that generally obscures both rock and carving.

Technology and software will continue to develop and current methods will
be rendered obsolete, yet rock art remains under threat from contact in the
process of preparation and clearance.

The above drawings of the 'Howgill Stone' in Baldersdale, Co. Durham, are
indicative of differences in recording techniques. It should be borne in mind that
all manner of circumstances influence and affect the result (*138a*).

The stone was uncovered by Miles Alderson of Howgill Grange while
ploughing in 1942. Information was later exchanged with the incumbent Rector
of Rokeby, a keen amateur archaeologist, who drew a rough sketch from Mr
Alderson's description. A note was passed to the archaeology section at Bowes
Museum in Barnard Castle for inclusion on the Sites and Monument Record

(*138a* fig I). The whereabouts and location of the stone was somehow 'lost' in 1942. However, in 1997 it was relocated by the author and recorded in the Teesdale Record Society Journal (1999 Vol. 7 p23-26). Stan Beckensall briefly visited the area in 1998 and recorded the stone by wax rubbing during atrocious wet weather conditions (*138a* fig II). In his recording the author used paper and wax and then created a visual interpretation of the carvings that was scaled down for publication (*138a* fig III). This method was used by the author for some of the carvings in this publication and for many in the first edition of this book (2005). For those interested the following brief description of the method may be useful.

In presenting a final three-dimensional image of the natural proportions of a rock it is vital to define the uncarved surface area. All rock surfaces exhibit wear and tear through time and the forces of nature. The grain and texture of rock and natural features such as small fissures or cracks can be picked up by gently rubbing a wax crayon across and over the paper surface. This action can highlight indistinct or faint motifs that are not always clearly visible to the naked eye. At any time during the recording process it is generally easy to make a visual check of the placement and accuracy of the carvings by lifting an individual corner of the paper – corrections can then be made. Orientation is established using a field compass, and this is drawn on to the completed rubbing prior to the paper being removed from its position.

A photograph is taken using a scale measure near the rock and the surface photographed from four different angles, including stereo pairs. Location shots of the rock's position in the landscape are also useful, as well as a perspective or 'view' from the rock.

Field notebooks are invaluable for noting relevant and general information around the site. A small sketch/plan of the rock or site is useful, together with information on its current condition or status: evidence of damage, natural or man-made (eg quarrying or graffiti). Basic details such as length, breadth and height, proximity to other rock art sites and/or related phenomena, cairns, monuments, springs, viewpoints etc. are also useful. The latter stages of the recording process can be done back at base where a 1m square sheet of clear plastic marked in 10cm square-grids is placed on the wax rubbing.

Using a clipboard, a sheet of graph paper and a soft graphite pencil, a scale drawing is produced. Finally the rock profile, motifs or carvings, countersunk cups (a feature much favoured at the Wain Stones site (pge 134, 2005 edition)) and any natural features can be noted on the drawing. This produces an accurate and detailed image ready for conversion to a three-dimensional drawing of publication standard (*138b* VI).

A sheet of A4 cartridge paper is stapled to graph paper with the drawn image and placed over a light box where the image is transferred on to cartridge paper. The image can be enhanced artistically if required by incorporating greyscale shadows, texture and other features with a graphite crayon and soft pencil. The author's method of illustration is to show a negative image with the 'artificial'

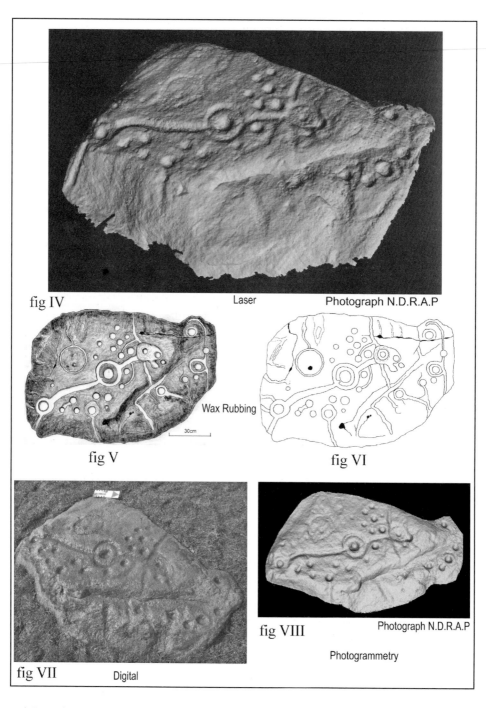

fig IV Laser Photograph N.D.R.A.P

Wax Rubbing

30cm

fig V fig VI

fig VII Digital

fig VIII Photograph N.D.R.A.P

Photogrammetry

138b Recording techniques

or man–made marks shown in white and the natural surface and texture of the rock as grey/black or shaded. A scale is incorporated below the drawing in 10cm, 30cm or up to 1m for sizeable rocks. The completed image is then scanned onto a computer to be stored on file for future publication. A sketch of rock art on a flat two-dimensional drawing or a selected panel from a larger surface, while offering an interpretation of the motifs, does not present a visual image of the rock itself. While it's helpful to have a degree of artistic ability in order to create a drawing that presents a clear, recognisable image in 3D format, using the technique described above it is possible to produce a clear impression that represents both rock and rock art. The technique requires only a little patience and practice, and offers a complete visual image that will aid future identification of a carved rock in its landscape setting (*138b* fig V).

It is also possible to record carvings on surfaces that may be considered too fragile for wax rubbing, with the use of a 1m square portable drawing frame in 10cm sections. This can be supported above the surface avoiding contact with the damaged area. A profile of both rock and motifs can be drawn directly onto graph paper. Finally the full photographic recording process is implemented under low-angled lighting conditions with stereo pairs followed by section close-ups.

The availability of handheld GPS systems has assisted in providing greater accuracy with map references. The introduction of WAAS (Wide Area Augmentation System) correction now guarantees an accuracy of less than 3m – a distinct advantage when pinpointing sites that may be hidden in a sea of heather or obscured by dense vegetation. A basic back–up system is also useful, with notes of accurate map references and quality digital photographs. Digital cameras with stitching facilities are accessible and affordable, and the author now uses this process to aid future research.

THE FUTURE OF RECORDING

The work of the independent has been pivotal in raising the profile of rock art, not least with professional institutions. Universities offer graduate studies in the subject and interest has spread with organisations such as English Heritage providing funding for future research and protection of sensitive sites. A pilot project was established with a purview to create a national index and to standardise methods of recording. All are keen to advocate the use of specialist technical equipment such as laser scanning and photogrammetry for future recording and monitoring of potential deterioration.

The application of technological equipment, however, remains dependent on knowledge of the location of sites. Laser scanning equipment and software is currently expensive and requires complex processing programmes that were principally designed to present a three dimensional image of, among other

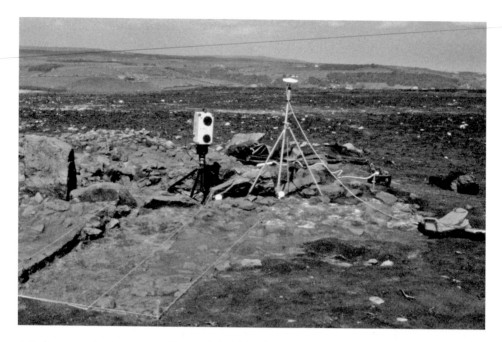

138c Laser scanning in progress. *Photograph by Blaise Vyner*

things, buildings in the study of architecture. The Konica-Minolta VIVID 3D gives accuracy down to 0.005", however it is bulky and requires team effort to get it on site. Its use is generally restricted to sites that are readily accessible. During the last few years technical advances have seen units become lighter and more user-friendly, though complex software is still required to process to good levels of accuracy. Unfortunately the majority of rock art sites lie in difficult terrain and transporting unwieldy and sensitive equipment places it at great risk of damage. Laser scanning does offer an invaluable service for future protection of sensitive sites. It can produce software models that can be used to predict and measure potential surface erosion and deterioration in the rock surface.

Photogrammetry using a standard camera that has been calibrated is based on stereo-photography taken at different angles, forming a displacement of the image. Scales are placed within the image view prior to photographing. It has limitations of proximity to the rock surface of 1m equidistant and is restricted to small rocks.

Larger rocks may require software recalibration to photograph. Targets have to be attached to rock surfaces to enable calibration of the required data for contour maps, in order to create a 3D surface model providing accuracy of *c.*1-3mm. This method was used for a pilot project by English Heritage using standard cameras and 'Topcon' software. Product licenses and software currently remains expensive but new lower-priced software has been developed that may offer a promising alternative. The method used is based on research work

previously undertaken in recording Australian rock art. English Heritage's project advocates its suitability along with laser scanning as a viable non-contact method of recording – perhaps true in one sense, but in practice disturbance is inevitable in preparing a site prior to recording.

International symposiums have discussed the threat that acid rain now poses with regard to erosion of rock surfaces. However, until some form of protection is devised, there is little doubt that this will continue to have a detrimental effect. The use of acid-free paper in the recording of rock art has also been widely debated. While its use could be advantageous in those parts of the world where there is a higher precedence of alkaline element to be found in the component structure of rocks, there is absolutely no evidence to suggest that the medium employed by a minority of independent researchers in recording rock art in Britain will result in or constitute a long-term detrimental threat. Certain institutions may labour under the misapprehension that new technology is superior to all others in effecting a non-contact system, yet there possibly never will be a system which does not require preparation prior to recording. Neither will the application of sophisticated technical equipment eradicate the need for objectivity in the final analysis and interpretation of data. Users face the same dilemma that haunts the less vigilant independent researcher – that of possible subjective interpretation of what can be seen.

The process has proved useful in other applications and in the process of manufacturing replicas for display in order to protect rock art that has been buried, "gone to ground" or that is in danger of becoming badly eroded. Yet is there a need for sophisticated technology to produce a detailed report describing a rock has lost 3mm of surface over a period of three years? Are there sufficient funds to finance and sustain long-term conservation projects? The Royal Commission on the Ancient Historical Monuments of Scotland (RCAHMS) has over the years declared all sites legally protected, and a number of major sites have been cleared of vegetation, fenced and surrounded by viewing platforms. Yet many more panels (some very fine indeed) are left in open landscape still 'legally' protected but open to elements, walked over by animals and damaged by vehicles. Perhaps the institution of a policy may prove much more effective in physically protecting sites in England where the majority of panels are at risk. Though still not without cost to the public individual landowners could take on the responsibility of assisting in the protection of vulnerable sites.

For the non-funded independent researcher in the search for new sites, use of digital photography, GPS technology and digital mapping has improved the recording process. Detailed field notes and accurate three-dimensional drawings derived from a simple wax rubbing also offer an altogether more flexible and affordable package.

RECORDING ROCK ART USING A DIGITAL CAMERA AND INEXPENSIVE STITCHING SOFTWARE

Both digital photography and photo-processing software packages are now accessible to most people. Software such as Adobe Photoshop, ArcSoft PhotoImpression and Serif PhotoPlus all contain numerous useful tools including a 'panorama' function. 'Panorama' functions scan and match digital codes within a photograph, automatically 'stitching' an image into a panoramic photograph. Provided there is concurring overlap of the subject it can cover an area up to 360 degrees. This function is also built into the majority of the latest cameras.

These tools gave the author the idea to photograph directly above specific sections of rock art panel. Stitching images together thus formed a good template that not only allows the panel to be traced but also offers close and detailed examination of carvings on either computer monitor or projector screen. The main concern was whether the software could stitch vertical, horizontal and angled horizons without distortion. To assess the feasibility of the system a number of trials were undertaken on previously recorded rock art panels in North Yorkshire, all of which yielded positive results.

In a bid to effect a cheap non-contact method of recording it was decided to put the method to the test on a visit to the elaborately decorated panel at Ormaig in Argyll. Sitka Spruce had been planted many years ago and the site, recently excavated and surveyed by archaeologists, was covered in pine needles that exude acidic elements. Using a soft natural fibre hand brush the residual needles were brushed to expose the carvings. In photography rainwater generally highlights depth and texture in carvings. A 10cm scale that also indicates north was placed against the rock to show size and orientation. Dull but bright days offer the best uniform exposure – shadow-free with no reflection on the rock surface. Naturally not all rock surfaces are conveniently flat, for example the rock art at Ormaig is on a slope and had to be photographed section by section horizontally, moving the camera parallel with the surface and allowing a slight overlap so that the picture is repeated on the next shot. The camera can be mounted on an extendable monopod pole at maximum length and held horizontally over the section to be photographed. Each picture was checked prior to shooting the next frame.

The camera is held parallel and equidistant to the rock surface to follow contours of the surface, and the completed sequence of photographs can be downloaded via a card reader to laptop or PC. The camera used was a Fuji FinePic S5500 triggered by the inbuilt 10 sec timer, though many cameras now have infra-red remote triggering for continuous shooting. The stitched photograph of Ormaig Fig (*138d*) was created using Serif Panorama Plus 3, a separate stitching software programme available from the Serif website. This programme has proved simple to use with photos imported from a selected folder and stitched in batches of six

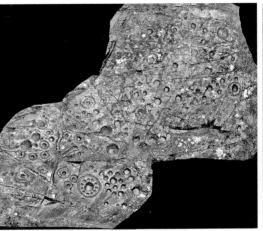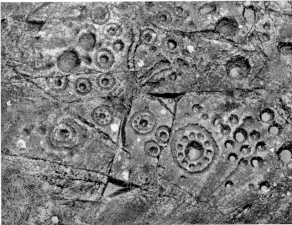

138d Ormaig, Kilmartin, Argyll.
Left: full panel. Right: detail

until the full area of selection is covered. Some quality may be lost during the stitching process, for example the Fuji Finepic has a 4 Megapixel CCD sensor and the processed composite image resolution is greater than 150dpi (dots per inch). Projection on a 2 x 2m screen provides an acceptable image that does not pixcellate. Re-sizing using Photoshop can achieve in excess of 300dpi that is close to publication standard. A recent upgrade to Olympus SP-590 with on-board panoramic software and 12MP resolution provides greater clarity and resolution in image quality.

P. & B. Brown

Appendix

Recent discoveries

THE ESTON HILLS MOORDALE BOG (NZ 56914 17364)

It's been some time since a new site has come to light in the Eston hills. However, the keen eye of Warden David Spencer recently noted the tip of a newly exposed panel (*139a* MOR 1). It currently lies just below ground surface obscured by turf and heather, and close to a marshy area known as Moordale Bog *c.*500m east of other known rock art sites at Carr Pond (sites 3a & 3b in the Gazetteer and map). Today the area has a natural vegetation cover of birch and gorse, but there are open areas of heather and bracken that contain numerous man-made tracks, many of them modern. The location of the panel and its proximity to Moordale Bog would suggest an appropriate site for a temporary camp during the prehistoric. The bog probably is possibly all that remains of a small lake that once existed in an earlier period but over millennia has become silted; a number of natural springs still flow into the area. The sandstone panel (136 x 76 x 2cm) is decorated with *c.*30 cups, three of which exhibit penannular (unenclosed) rings. A deep groove links both cups and penannulars along the length of the rock. There is some damage to the south-east section and a fracture has detached a penannular-enhanced motif from the main decorated area of the rock. Exactly when this damage occurred is uncertain since the area has seen much military and agricultural activity within the past, though there is no evidence of plough-scarring.

The rock has several parallels with a stone discovered at Howgill Grange, Baldersdale, County Durham (NY 95541 20142) (Brown, P. 1999; Brown & Brown 2008). The Howgill stone was located in a group of three on a terrace above a spring rising, and marks a fresh water source that would enable temporary use of the land as a camp site. Interestingly, both Howgill and Eston Moor stones have similarities in their markings: each have a long groove that links cup-and-ring motifs. The Howgill stone is a large rectangular slab (154 x 96 x 19cm) that has 30 cups, three surrounded by single rings, a linking groove along its length as well as an eroded ring motif enclosing a small depression and a pecked area with countersunk cup (Brown and Brown 2008).

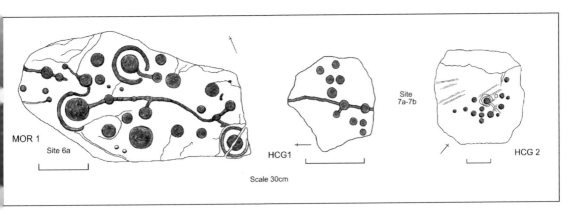

139a Eston sites

HIGH COURT GREEN CUP STONES

Two cup-marked stones discovered during the removal of stone for footpath repairs; they currently lie in a rubble pile of a collapsed field-edge wall. It's not possible to confirm whether these were originally carved as open-air rock art or were intended for inclusion in a burial or monumental context, as they have been removed from their original position. In general rock that was marked in the open appears on rounded or flat earthfast boulders.

Rock 7a (NZ 58643 17795) HCG 1
This boulder may have originally come from a cairn or barrow in the area but now lies in a collapsed field wall. A wedge-shaped sandstone boulder (55 x 47 x 75cm), it exhibits 11 cups and an enhanced natural groove that bisects its surface. No plough scars were present and though some of the cups show signs of erosion, others are under-cut indicating that they may be 'natural' in origin, and possibly caused by mineral erosion. Wedge-shaped boulders have in the past been used in the construction of kerb material of cairns. This stone has comparison with the wedge-shaped boulder from Carr Pond Stone (3a) in the Gazetteer.

Rock 7b (NZ 58667 17722) HCG 2
This flat sandstone stone slab (124 x 113 x 26cm) has 14 cups and numerous plough scars that scour its surface in many directions. One large cup in the centre has been damaged and a section detached forming a countersunk cup. The stone appears not to have been integral to the construction of the wall but was possibly exposed during recent ploughing in a nearby field; it had been placed on top of the rubble wall. It is similar in size and shape to that used in the prehistoric as a cist cover.

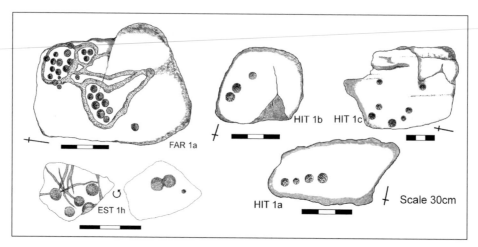

139b New sites

These stones are situated along a level terrace at 170m OD above Moordale Beck, an area that has been farmed extensively over the centuries. There is evidence to suggest that the terrace may have previously contained a number of Bronze Age cairns and areas of settlement that were subsequently destroyed by later period agriculture. The cup-marked stones are 600m north-north-east of the remnants of a large barrow (Court Green Howe, 190m OD), one of a complex previously identified at Court Green. In researching the rock art collection in the Dorman Museum it was noted that the collection contained a single cup-marked stone that had 'Eston Moor 1924' painted on its reverse, though there was no accession number. The stone may relate to the excavation at Court Green Howe by local archaeologist William Hornsby *c*.1923. This is possibly substantiated by the fact that no other evidence or references have been recorded around this date. This single cup-marked stone is listed as EST 2 (20) in the Gazetteer.

WILTON MOOR MARKED STONE (NZ 57957 18300)

This small cup-marked boulder was discovered by Paul Brown in a stone clearance pile in March 2009, beside a single-track roadway linking the communication complex on Eston Nab and the A174 at Wilton. The stone measures 36 x 26 x 16cm, is marked on two faces and shows plough scars. The following describes the two marked surfaces:

Side 1: Two linked cups of 6cm diameter. Shows signs of iron pan indicating that this side has remained undisturbed for a considerable length of time.
Side 2: Four cups (6.5cm, 6cm and two at 5cm). A number of plough scars are evident that have damaged the edge of one cup. The stone is typical of

those that were deposited as in Early Bronze Age barrows. Hinderwell Beacon excavated in 1918 by Hornsby & Laverick contained around 150 examples. Similar displaced portable stones were found on a wall close to Eston Nab Hillfort; several were marked on both sides and may have originated from a destroyed barrow (Aberg & Spratt 1974).

DANBY RIGG, DANBY CP, NORTH YORK MOORS

The landscape of Danby Rigg contains many prehistoric enclosures, stone circles, cairns, settlements and field systems. There are a number of such structures spanning a number of periods throughout the prehistoric at Double Cross Dykes. The moor itself is littered with stone ideal for carving, but as yet no evidence of open-air rock art has been discovered, though carved rocks have been located on the lower slopes in the adjoining dales. During excavation of a Bronze Age barrow at NZ 70952 06062 a cup-marked stone was discovered, regrettably its whereabouts are now unknown.

Little Fryupdale, Danby CP, North York Moors, Site 6, LF 1a (NZ 72429 06277)

This small cup-and-ring-marked stone is the first to have been found in the area. It lies close to a wall east of a public footpath (550m north-east of Foresters Lodge). The stone (196 x 112 x 58cm) has a flat-topped surface exhibiting a single cup-and-ring and two isolated cup marks.

It is possible that there are other examples that are yet to be found. This is one of many slabs in a boulder field where extensive quarrying has taken place. From the remains of a number of rough-outs it appears that these slabs have intended use in the production of gate posts. Discovered Paul & Barbara Brown (2006).

Great Fryupdale, Danby CP, North York Moors, Site 7, GF 1A (NZ 72588 04883)

This fragment (59 x 39 x 15cm), split from a larger stone, has two cups (7.5cm and 3cm) and a number of natural indentations. The stone is located *c.*200m north-east from the junction of Street Lane / Nuns Green Lane and currently lies close to a clump of blackthorn bushes on the wall to the right of the road from the nearby junction. The stone has been quarried on three sides and used as a capping stone for the field edge wall. Similar to Little Fryupdale, this is the first discovery of prehistoric rock art in the area and it's possible that the missing section may have been incorporated in another structure in the area. Discovered by Barbara Brown (2007).

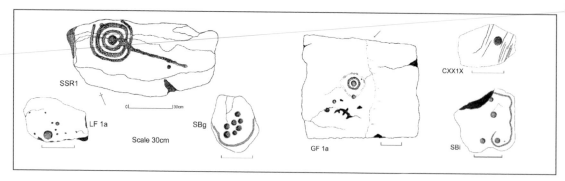

139c New sites, general

Brow Moor, Fylingdales CP, North York Moors, Site 8

Cup-marked stones 1–3 were discovered in 2005 during field walking. A number of rock art sites were discovered prior to re-seeding the moorland following the devastating fire in 2003. Drawings of these stones appear in *139c*.

SBg (NZ 95997 01771): Small rounded boulder (55 x 40 x 10cm). Six cups and a natural groove to the base of the rock.
SBh (NZ 95986 01792): Small boulder (65 x 54 x 8cm). Five cups, one with a double ring.
SBi (NZ 96015 01720): Flat slab (63 x 60 x 10cm) has five cups and a pecked groove.
SBj (NZ 96025 01742): Rectangular slab (50 x 32 x 5cm). One eroded cup-and-ring motif. Site discovered by Barbara Brown, 2003.

Standingstones Rigg, Cloughton CP, North York Moors, Site 9, SSR1 (SE 98064 97000)

This site was initially reported by forestry workers within Harwood Dale Forest, 50m west of the cairn circle excavated in the nineteenth century by Tissiman. (A number of fine examples of rock art were recovered during this excavation and are now in the collection of the Rotunda Museum at Scarborough.)

The site can be accessed by a forest track close to a forest ride at the junction of the Scarborough to Whitby road at NZ 9815 9745. The surface of this rectangular stone (99 x 60 x 18cm) is rough and irregular. It has one cup with three rings; one of its rings exhibits an attached micro cup and a groove links its central cup.

Standingstones Rigg, Cloughton CP, North York Moors, Site 9, SSR 2 (SE 98119 96947)

A small rounded boulder (54 x 40 x 13cm) with one 6cm cup. Discovered by Paul Brown.

BYLAND MOOR, BYLAND AND WASS CP, NORTH YORK MOORS

Barrow CXXIX, Site 10 (SE 5432 8064)

Three round barrows excavated in the nineteenth century by Greenwell and described as CXXIX, CXXXI and CXXX. All were grouped in a linear arrangement and reported as containing marked stones and it's possible that the example described below originated from one of the barrows.

Greenwell recorded other marked stones and these were placed in the British Museum in London. Raymond Hayes *c.*1980 noted a flat slab (56 x 39 x 20cm) in a stone pile in the central depression of Barrow CXXIX. This stone is marked with a 6cm cup and has a number of plough scars. Its present placement is probably the result of later period field clearance. This stone was recorded in *Excavated Bronze Age Burial Mounds* by M.J.B. Smith (1994).

HITHER MOOR (HIT 1A–C)

Three new sites were located close to a Bronze Age cairn in the bracken- and grass-covered moor south of Scarth Wood (opposite Cod Beck Reservoir on the Osmotherley to Swainby road) by Paul and Barbara Brown between 2006 and 2011. With only simple cup marks this is the first rock art to have been discovered in the area. At Near Moor only 1.5km to the north-east 33 sites have been identified. During research it was noted that a small cup-marked fragment that had previously been recorded in the 2005 edition is now missing from its position in a wall at Scarth Wood Moor 1.2 km to the north.

HIT 1A

A square-shaped boulder close to the roadside with three cups showing signs of erosion. The boulder is located 10m north-east of a prominent tumulus.

HIT 1B

This rectangular-shaped boulder lies under bracken; its surface has four eroded cups. It, too, is close to the roadside 30m north-east of the above mentioned tumulus.

HIT 1C

Close to a spring source and natural drainage channel is this large wedged-shaped boulder. Its sloping side is decorated with seven cups, the largest of which is 8cm (diameter) x 3cm (depth) and shows well-defined peck marks. A number of the other cup marks on the stone show signs of erosion. It is approximately 30m to the north of a boundary stone set in a prominent mound near to the road.

GREAT AYTON MOOR

A small portable cup-marked stone discovered during a walk-over survey by archaeologists Blaise Vyner and Steve Sherlock in 2008 (AYT 2). The boulder is 33 x 27 x 10cm and marked with a single cup 7cm (diameter). It lay in the eastern outer-edge of a ring cairn. Though the area is rich in prehistoric remains this is only the second marked stone to have been discovered on the moor. The first was in the paved floor of a hut circle within an Iron Age enclosure found during excavation in 1978 by Tinkler and Spratt.

FAR MOOR

During research of Mesolithic flint sites in April 2010 John and Siriol Hinchcliffe discovered this remarkable cup-marked rock (FAR 1a). It lies on a prominent terrace that provides stunning views and overlooks Scugdale. This is the first rock art site in the area – the nearest is 2.5km west at Near Moor. During the process of recording this rock a further two cup-marked stones were found (FAR 1b-c). The landscape contains a number of low field walls, small clearance cairns and many loose rocks and boulders. A large barrow is also visible in a recent burn area. It is possible that with further fieldwork more sites may be found.

RAVEN HALL HOTEL, RAVENSCAR

A small cup-marked rock was discovered in what now forms part of the lower garden rockery close to a grotto in the wall (RAV 1b). The boulder measures 33 x 25cm and is marked with two deep 7cm cups. This is possibly Stone D from Raven Hill Barrow 1, one of eight marked stones mentioned by Greenwell at the former Peak House (now Raven Hall Hotel) and possibly collected by one of the original excavators in 1851 – Mr Marshall (the other being John Tissiman) as referenced by Knox (1855).

A number of other stones from this barrow are currently held at the Rotunda Museum in Scarborough but it is not impossible that others may adorn the hotel's rockeries. A stone with a keyhole-shaped motif was also discovered that had been built into the wall of the garden grotto, recorded and published by Brown and Chappell in 2005.

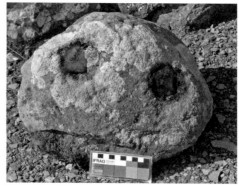

140 Stone RAV 1b

NEW SITES GAZETTEER, UPDATED 2012

Site	Location	OS Grid Ref	Description	References	Notes
WAI 8a	Garfit Gap, Bilsdale, Midcable	NZ 55769 03138	8a Large triangular shaped rock 303 x 163 x 50cm Six cups four with single penannular rings and arrangement of linear grooves forming a intricate pattern.	NPA pers comm. April 2009.	Large boulder marked on three sides, overlooks Garfits beck north of spring rising. Discovered by Colin Keighley, April 2009.
WAI 8b	Garfit Gap, Bilsdale, Midcable	NZ 55803 03119	8b Rectangular slab 280 x 158 x 70cm. Five cups, three with single rings. Some faint and eroded. Arrangement of linear grooves forming a pattern. Iron stone nodules protrude from the top central area of the boulder.	P. & B. Brown 2009. Private survey notes 2009.	Discovered by Paul and Barbara Brown 2009. Overlooks Garfits beck south of the spring rising.
WAI 8c	Garfit Gap, Bilsdale, Midcable	NZ 55806 03149	8c Flat slab 140 x 117 x 20cm. 5cm cup with 15cm ring.	P&B Brown 2009. Private survey notes 2009.	Discovered by Paul and Barbara Brown 2009. Overlooks Garfits beck east of the spring rising.
WAI 9	Garfit Gap, Whingroves, Bilsdale, Midcable	NZ 55740 02674	A rectangular boulder, 450 x 240 x 80cm, located beside the western perimeter wall of Whingroves Farm. Lies close to a public footpath. Its top surface exhibits not only 26 cup marks, two of which are surrounded by single rings, but also 11 oval shapes.	P. & B. Brown 2009. Private survey notes, 2009.	Discovered Paul and Barbara Brown, 2009.
RAV 1b	Raven Hall Hotel, Ravenscar	NZ 980 019	Rounded sandstone boulder 35 x 30cm, with two 7cm cupmarks. Discovered in lower hotel garden c.8m to right of grotto site (RAV 1a).	Authors' research notes.	Stone located at path edge close to entrance steps. Possibly missing stone (D) from Barrow 1. Paul and Barbara Brown, 2006.
HIT 1a	Hither Moor, Cod Beck Reservoir	SE 46690 99225	Rectangular boulder, 130 x 54 x 20cm. Four eroded cups, 6-3.5cm.	Authors' research notes, 2006.	Discovered under bracken close to a tumulus. Paul and Barbara Brown, 2006.
HIT 1b	Hither Moor, Cod Beck Reservoir	SE 46678 99177	Square boulder 69 x 60 x 25cm. Three shallow cups, 6-6-4-3.5cm. All eroded.	Authors' research notes, 2006.	Discovered under bracken close to a tumulus. Paul and Barbara Brown, 2006.

Site	Location	OS Grid Ref	Description	References	Notes
HIT 1c	Hither Moor, Cod Beck Reservoir	SE 46619 99346	Large rectangular boulder, 175 x 115 x 50cm. 7 cups, largest 8cm, smallest 5cm.	Authors' research notes, 2011.	Discovered under bracken close to a tumulus. Paul and Barbara Brown, 2011.
FAR 1	Far Moor, Whorlton	SE 50203 99580	Wedge-shaped stone, 97 x 74 x 60cm, marked with 27 cups and grooves. Eight cups form a domino pattern with groove enclosure; 3 cups in rosette form with groove enclosure; 7 cup rosette in enclosing groove together with attached cups and terminating in a natural boss.	Pers comm. John Hinchcliffe.	Discovered John and Siriol Hinchcliffe, 2010.
FAR 2	Far Moor, Whorlton	SE 50057 99530	Flat slab in boulder field, 82 x 64 x 19cm. Two cups and 2 shallow depressions. Cups shallow and eroded.	Authors' research notes.	Discovered Paul and Barbara Brown, 2010.
FAR 3	Far Moor, Whorlton	SE 50114 99514	Flat slab at edge of boulder field, 100 x 50 x 10cm. Single 7cm cup.	Authors' research notes.	Discovered Paul and Barbara Brown, 2010.
EST 1h	Wilton Moor, Eston Hills	NZ 57957 18300 (Stone removed to wall at NZ 57934 18285)	Stone pile beside track 250m north-east of Wilton Barrows. Small boulder 36 x 26 x 16cm. Four cups: 6, 6, 5, 5cm. Two 6cm cups linked on reverse side. Stone probably originated from Wilton barrow complex.	Authors' research notes, 2009.	Discovered Paul and Barbara Brown, 2009.
AYT 2	Great Ayton Moor	NZ 59734 11292	Small cup stone in outer stone setting of Ring Cairn, 33 x 27 x 10cm. One 7cm cup.		Discovered Blaise Vyner and Steve Sherlock, 2008.
LFRY 1	'Heads', Little Fryup Dale	NZ 72429 06280	Rectangular boulder, 182 x 138 x 69cm. Motifs consist of 7cm cup surrounded by a 18cm ring. There are a further three cups, some shallow. The surface of the rock is eroded.	Private survey notes. P. and B. Brown.	Discovered Paul and Barbara Brown, 2006. Site located in a boulder field east of the footpath, below the western scarp of 'Heads'.
GF 1a	Great Fryupdale, Danby CP, North York Moors	NZ 72588 04883	Fragment, 59 x 39 x 15cm. Split from a larger stone. Exhibits two cups, 7.5cm and 3cm, and a number of natural indentations.	Private survey notes. P. and B. Brown.	Discovered Barbara Brown, 2007. The stone is located c.200m north-east of the junction of Street Lane.

UPDATED GAZETTEER OF PREHISTORIC ROCK ART
IN THE ESTON HILLS 2005–09

Site	Location	OS Grid Ref	Description
EST 1 (1a–e)	Drystone wall, Eston Moor, (Dorman Museum Store).	NZ 569 182	Ref YAJ 46, 141. 1974 YAJ 63, 1991, 25. Stone 1a. (30 x 22 x 9cm). Six cup-marks on one face, three on opposing face. Stone 1b. (28 x 23 x 11cm). Four cup marks, one with a single concentric ring. Stone 1c. (30 x 20 x 12cm). Six cup-marks (one having a single concentric ring). Stone 1d. (40 x 35 x 20cm) Seven cup-marks on one surface. Stone 1e. Reference to a fifth cup-marked stone in this group.
EST 1 (1f)	Cairn, Wilton Moor, (Dorman Museum Store).	NZ 5743 1840	Ref Goddard, Spratt & Brown, 1978. Stone 1f (15 x 15 x 7cm), one central cup-mark.
EST 1 (1g)	Cairn, Wilton Moor.	NZ 5750 1838	Crawford, c.1980. Reference to a cup-marked stone.
EST 1 (1h)	Wilton Moor.	NZ 57957 18300	Marked on two faces and plough-scarred, 36 x 26 x 16cm. Side 1: Two linked cups of 6cm diameter. Side 2: Four cups, 6.5cm, 6cm and two at 5cm.
EST 2 (2a–m)	Palisade Enclosure / Hillfort, Eston Nab., (Tees Archaeology Bunker)	NZ 567 183	Ref Vyner 1989, 83 Tees Archaeology Records. 2a. (50 x 30 x 25cm). One cup-mark. 2b. (65 x 35cm). Seven cup-marks. 2c. Single cup-mark. 2d. (35 x 29 x 17cm). One cup-mark. 2e. (38 x 28 x 10cm). Three cup-marks. 2f. Single cup-mark. 2g. (30 x 30 x 15cm). Single cup-mark enclosed by a concentric ring. 2h. (39 x 31 x 18cm). One cup-mark on each opposing side. 2i. (37 x 25 x 22cm). Eight cup-marks, seven on one face, and a single cup-mark on reverse. 2j. (110 x 55cm). Thirty-three (approx.) cup-marks on the upper surface of stone. 2k. (28 x 22 x 14cm) Single cup-mark enclosed by two concentric rings. 2l. Two cup-marks. 2m. Two cup-marks on opposing sides.
EST 2 (2n)	Palisade Enclosure / Hillfort, Eston Nab., (Dorman Museum Store).	NZ 567 183	2n. (36 x 28cm). Three large cup-marks on one surface. Located during Elgee's excavation of the enclosure ditch c.late 1920s.
EST 2 (2o)	Eston Moor area. (Dorman Museum Store)	Unknown	Stone 2o Single cup-mark. Marked stone has 'Eston Moor 1924' on reverse, may relate to William Hornsby's excavation at court Green Howe c.1923

Site	Location	OS Grid Ref	Description
EST 2 (misc)	Palisade Enclosure / Hillfort, Eston Nab.	NZ 567 183	Aberg c.1960 reference to a number of cup-marked stones in the enclosure's boulder-constructed wall.
EST 3 (3a)	Boulder, Eston Moor. On site.	NZ 5629 1727	Stone 3a (82 x 58cm). Four cup-marks on sloping surface.
EST 3 (3b)	Boulder, Eston Moor, On site.	NZ 5630 1727	Stone 3b (190 x 55cm). Seventeen cup-marks on the upper surface. Also exhibits bench mark and Roman numerals.
EST 3 (3c)	Stone, Eston Moor. Lost?	NZ 564 174	Ref David Heslop (1978). Cup-marked stone, located 150m north-east of site 3b and 50m west of barrow.
ORD 2	'Ord' Barrow 2. Eston Moor. Lost?	NZ 5691 1802	Ord 1864, 72. Reference to: Stone 1a. (c. 50 x 30cm) marked with a pattern of intersecting straight lines, creating a series of triangles. Stone b. Small stone with Y-shaped markings.
UNP 1	Stone Slab, Tees Archaeology Bunker. Unprovenanced.	N/A	Stone (43 x 29 x 9cm) marked with a pattern of intersecting straight lines, creating a series of triangles within a square outline. Possibly Ord's missing stone (ORD 1a?).
OSB 1 (4a)	Field Wall, Osbourne Rush, Barnaby Side. Lost?	NZ 5710 1660	Ref Rev. Roy Jolly c.1963, Tees Archaeology SMR. Stone (c. 25 x 15cm). Single cup-mark.
NOR 1 (5a)	Barrow, Mount Pleasant, Normanby Moor. On site.	NZ 5582 1654	Reference E. Socket, 1971, private unpublished papers. Cup-and-ring marked stone? Stone near cairn centre (60 x 50 x 20cm) with three cup-like depressions in line.
MOR 1 (6a)	Moordale Bog. On site.	NZ 569 173	Ref Warden David Spencer. Rectangular slab (136 x 76 x 2cm) decorated with c.30cups, three with penannulars. Also exhibits a groove along the length of the rock that links cups and penannulars.
HCG 1 (7a)	High Court Green. On site, private land.	NZ 58643 17795	Ref Peter Rowe, Tees Archaeology. Square block (5 x 47 x 75cm) with 11 cups.
HCG 2 (7b)	High Court Green. On site, private land.	NZ 58667 17722	Ref Peter Rowe, Tees Archaeology. Square slab (24 x 113 x 26cm). Fourteen cups; plough-scarred surface.

Gazetteer

The following gazetteer provides details of the North York Moors rock art in a tabulated format. The site information has been grouped into five main areas; north, south, east, west and the Cleveland coast, with the addition of separate tables covering the larger sites. The tables provide location details, a brief description, references and relevant notes for all the sites known to the authors, including a small number of minor sites not included in the main text of the book. The information contained in the gazetteer is a condensed version of a larger database (Microsoft Access) that is being created to hold details of the rock art located in the North York Moors region. A copy of this database will be placed with the SMR at the National Park offices in Helmsley. All 10 figure map references listed were taken on site using handheld GPS with maximum user satellites in view; the data is uncorrected and is accurate only to eight figure reference (10m). All other NGRs are from publications or from site monument records.

Updated information and details of ongoing research relating to the North York Moors Rock Art can also be found on the Yorkshire Rock Art website at www.cupstones.f9.co.uk

INFORMATION ON USE OF TABLES

The first column number denotes the amount of sites in an area. The letters in column 2 refer to specific sites; for example HIN1, which refers to Hinderwell 1, Barrow 1. Stones from the excavation are listed as 7.3, 7.13 etc. These are the reference numbers allocated by the Museum in which they are held. At some sites, in column 2 the reference 01, 02 etc. is used; however, on maps and figures these reference numbers are restricted to single figures. Sites on open moorland such as Allan Tofts have been given an abbreviated reference (e.g. ALL) and are numbered as clusters (e.g. 2a, 2b). In some cases place names have changed over the years: Ravenscar was previously referred to as 'Peak', Raven Hall Hotel was known as 'Peak House' and Allan Tofts was Allan Tops.

FYLINGDALES MOOR

No	Site	Location	OS Grid Ref	Description	References	Notes
1	a	Stoupe Brow Moor Map A	NZ 96220 02020	A low flat rock (130 x 90 x 10cm) with markings on its flat upper surface, consisting of 2 cup marks, with possible traces of a third eroded cup mark and pick marks.	Private survey notes 1992–2002 G. Chappell.	Noted by Ordnance Survey (1970s). Located again by G. Chappell (Nov 1994). Cairns nearby.
2	b	Stoupe Brow Moor Map A	NZ 96154 01874	A large flat slab (180 x 150 x 20cm) has on its upper surface, at least 20 cup marks and irregularly-shaped depressions. A groove bisects the west corner of the stone.	Private survey notes 2002–2004 Chappell & Brown.	Discovered under burnt vegetation Nov 03. G. Chappell, P. Brown.
3	c	Stoupe Brow Moor Map A	NZ 96010 01806	A wedge-shaped rock (160 x 110 x 50cm) has on its eastern sloping surface, 24 cup marks, one with a single ring. On the vertical west face are at least 2 cups and erosion hollows plus many vertical grooves, some of which may be artificial.	Private survey notes 2002–2004 Chappell & Brown.	Discovered under burnt vegetation Nov 03. G. Chappell, P. Brown.
4	d	Stoupe Brow Moor Map A	NZ 96282 01919	A small flat stone (45 x 38 x 5cm) has on its upper surface, 11 parallel grooves (very faint). Stone is located on the west side of a Barrow. PROTECTED MONUMENT	Private survey notes 2002–2004 Chappell & Brown.	Discovered March 2004. G. Chappell, P. Brown.
5	e	Stoupe Brow Moor Map A	NZ 90012 01776	Rounded boulder (87 x 49 x 14cm) – two cups one with groove	Private survey notes 1992–2002 Chappell	Discovered by P. Brown G. Chappell April 2004.
6	f	Stoupe Brow Moor Map A	NZ 9573702095	Triangular-shaped stone(41 x 36 x 14cm) two linked cups now placed face down on the north-east side of a large Barrow	Pers. comm. B. Smith.	Found Sep 2004 B. Smith.
7	1a	Brow Moor Map B	NZ 95763 01790	A large outcrop (3.5 x 1.2 x 0.5m) protruding from sloping bank side. The motifs consist of more than 28 cups, one surrounded by 3 rings, one with 2 rings and 6 with single rings. Grooves linking motifs form an intricate pattern.	Private survey notes 2002–2004 Chappell & Brown.	Discovered under burnt vegetation Dec 2003. P. Brown, G. Chappell.
8	1b	Brow Moor Map B	NZ 95737 01807	A flat oval-shaped boulder (0.9 x 0.8 x 0.2m) has on it upper surface, four cup marks, three surrounded by single rings.	Private survey notes 2002–2004 Chappell & Brown.	Discovered under burnt vegetation Dec 2003. G. Chappell, P. Brown.

No	Site	Location	OS Grid Ref	Description	References	Notes
9	1c	Brow Moor Map B	NZ 95719 01817	A flat triangular-shaped rock (1.0 x 0.8 x 0.2m) has on it upper surface, seven cups, four surrounded by single rings. An irregularly-shaped groove linked to one of the rings, surrounds the group of motifs. Ring of stones? at 95721 01816.	Private survey notes 2002-2004 Chappell & Brown.	Discovered under burnt vegetation Dec 2003. Barbara Brown.
10	1d	Brow Moor Map B	NZ 95690 01847	A large boulder (2.3 x 1.8 x 1.1m) has on its upper surface, a number of grooves and cup like depressions possibly natural. Recent exposure shows a number of artificial cups.	Private survey notes 1992-2002 G. Chappell .	Discovered June 1996. G. Chappell.
11	1e	Brow Moor Map B	NZ 95705 01812	A flat rock (1.0 x 0.7 x 0.2m) protruding from bank side. Has four cup marks, one surrounded by an eroded ring.	Private survey notes 2002-2004 Chappell & Brown.	Discovered under burnt vegetation Dec 2004. P. Brown, G. Chappell.
12	1f	Brow Moor Map B	NZ 95743 01797	A low flat rock (0.5 x 0.5 x 0.1m) with two cups on upper surface.	Private survey notes 2002-2004 Chappell & Brown.	Discovered under burnt vegetation Dec 2003. P. Brown, G. Chappell.
13	1g	Brow Moor Map B	NZ 95751 01775	Large flat slab on slope(1.6 x 1.4 x 0.10m) two cups linked by a circular channel.	Private survey notes 1992-2002 G. Chappell.	Discovered under burnt vegetation Feb 2004. P. Brown, G. Chappell.
14	1h	Brow Moor Map B	NZ 95747 01772	Large flat rock on slope(1.25 x 1.17 x 0.10m) four cup marks on the southern edge.	Private survey notes 1992-2002 G. Chappell.	Discovered under burnt vegetation Feb 2004. P. Brown, G. Chappell.
15	1i	Brow Moor Map B	NZ 95752 01780	A low flat rock (1.2 x 1.2 x 0.1m) has on its upper surface, two cup marks.	Private survey notes 2002-2004 G. Chappell P. Brown.	Discovered under burnt vegetation Feb 2004. P. Brown, G. Chappell.
16	1J	Brow Moor Map B	NZ 9571401738	A rounded boulder on the North side of a sheep fold (80 x 78 x 28cm) the motifs consist of eight cup marks.	Private survey notes 1992-2002 G. Chappell.	Found by Brian Smith March 2004 under burnt vegetation.
17	1k	Brow Moor Map B	NZ 95929 01536	Boulder with flat surface (79 x 74 x 20cm) five cups.	B Vyner and S Sherlock EH Survey Jan-March 2004.	Located close to trees, over looks Slape Stone beck from the North side.

No	Site	Location	OS Grid Ref	Description	References	Notes
18	1L	Brow Moor Map B	NZ 95995 01650	Large cobble in stream bed single cup mark (43 x 28 x 6cm).	Private survey notes 1992–2002 P. Brown G. Chappell.	Possible stone from destroyed Barrow north–south track crosses over at this point Located by Brown and Chappell March 2004.
19	1m	Brow Moor Map B	NZ 95882 01784	Flat Slab (78 x 63 x 5cm) a footprint style motif and a single cup mark, the footprint may be natural other rocks on the moor have similar pecked areas with good defined pick marks.	Private survey notes 2002–2004 G. Chappell P. Brown.	Located Dec 2004 Brown and Chappell under burnt vegetation.
20	1n	Brow Moor Map B	NZ 95708 01805	A large slab east of 1o (160 x 123 x 5cm) the motifs consist of a triple ringed cup with curving groove linked to two further cups and rings each decorated with two rings two additional cups have single rings.	Private survey notes 2002–2005 P. Brown G. Chappell.	Located May 2005 Brown and Chappell under burnt vegetation.
21	1o	Brow Moor Map B	NZ 95706 01806	Boulder with two faint rectangular motifs.	Private survey notes 2002–2004 G. Chappell P. Brown.	Located Dec 2004 Brown and Chappell under burnt vegetation.
22	1p	Brow Moor Map B	NZ 95939 01676	Small rounded boulder (50 x 40 x 10cm) the motifs are very faint and only seen in low angled light the decoration consists of two cups surrounded by double penannular rings the inner links the two motifs together.	Pers. comm. Alan Walker.	Discovered Alan Walker June 2005 (exposed) close to a moorland track.
23	1q	Brow Moor Map B	NZ 95760 01783	A low flat slab (1.7 x 1 x 0.2m) has on its upper surface a single cup mark.	Private survey notes 2002–2004 G. Chappell P. Brown.	Discovered under burnt vegetation Feb 2004. P. Brown, G. Chappell.
24	1r	Brow Moor Map B	NZ 95764 01781	A low, flat rock (0.7 x 0.3 x 0.05m) has on its upper surface, a single cup mark.	Private survey notes 2002–2004 G. Chappell P. Brown.	Discovered under burnt vegetation Feb 2004. P. Brown, G. Chappell.
25	2a	Brow Moor Map C	NZ 96211 01739	A roughly rectangular rock (1 x 0.7 x 0.2m) has on its upper surface, five shallow cup marks) 3m north-east of 2b.	Private survey notes 1992–2002 G. Chappell.	Located by G. Chappell (Nov 1994) 1st Ed. OS map marks a tumulus to the east of this stone Three more small cairns exist nearby.

No	Site	Location	OS Grid Ref	Description	References	Notes
26	2b	Brow Moor Map C	NZ 96207 01737	A low flat rock (1.0 x 0.5 x 0.15m) has on its upper surface, three cup marks, one being surrounded by three concentric pen annular rings with traces of a fourth incomplete outer ring.	*YAJ* 41 (1966), 557. Private survey notes 1992-2002.	Reported by S. Feather (1966). Located again by G. Chappell. (Nov 1994). 1st Ed. OS map marks a tumulus to the east of this stone. Three more small cairns exist nearby.
27	2c	Brow Moor Map C	NZ 96011 01701	A flat rock (0.6 x 0.6 x 0.2m), has on its upper surface, two cup marks. Located alongside a small cairn.	Private survey notes 2002-2004 G. Chappell P. Brown.	Discovered under burnt vegetation Nov 2003. P. Brown, G. Chappell.
28	2d	Brow Moor Map C	NZ 96109 01690	A large rock (2.1 x 1.3 x 0.4m) has on its sloping upper surface, three cup marks.	Private survey notes 2002-2004 G. Chappell P. Brown.	Discovered under burnt vegetation Dec 2003. P. Brown, G. Chappell.
29	2e	Brow Moor Map C	NZ 96140 01673	A large slab (1.8 x 1.2 x 0.3m) has on its upper surface, a single cup and ring mark and one cup mark. 2f adjacent	Private survey notes 2002-2004 G. Chappell P. Brown.	Discovered under burnt vegetation Nov 2003. P. Brown, G. Chappell.
30	2f	Brow Moor Map C	NZ 96141 01671	A roughly rectangular rock (1.3 x 1 x 0.25m) has two adjacent cup marks on its sloping upper surface.	*YAJ* 41 (1966), 557. Private survey notes 2002-2004 G. Chappell P. Brown.	Reported by S. Feather (1966). Located again Sept 2003 P. Brown, G. Chappell.
31	2g	Brow Moor Map C	NZ 96177 01652	A large flat rock (2.1 x 1.3 x 0.3m) has on its flat upper surface, two cup marks.	Private survey notes 2002-2004 P. Brown G. Chappell.	Discovered under burnt vegetation Feb 2004. P. Brown, G. Chappell.
32	2h	Brow Moor Map C	NZ 96178 01661	A low, flat rock (0.7 x 0.6 x ??m) has on it sloping upper surface, a single cup and ring mark along with a series of interconnecting linear grooves forming a grid like pattern.	Private survey notes 2002-2004 G. Chappell P. Brown.	Discovered under burnt vegetation Feb 2004. G. Chappell, P. Brown.
33	2i	Brow moor Map C	NZ 96215 01725	A low flat rock (1.7 x 0.8 x 0.2m) has on its upper surface, two cup marks.	Private survey notes 2002-2004 G. Chappell P. Brown.	Discovered under burnt vegetation Dec 2003. P. Brown, G. Chappell.

No	Site	Location	OS Grid Ref	Description	References	Notes
34	2J	Brow Moor Map C	NZ 96045 01643	A rounded boulder (0.4 x 0.25 x 0.1m) has on its sloping surface, seven cup marks, three of which are linked together by a groove. A small cairn is located nearby (2K at same location).	Private survey notes 2002–2004 G. Chappell P. Brown.	Discovered under burnt vegetation Nov 2003. G. Chappell, P. Brown.
35	2k	Brow Moor Map C	NZ 96045 01642	A rounded boulder (0.55 x 0.47 x 0.22m), has on its flat surface, 11 cup marks, one surrounded by a single ring and one with a groove to the edge of the stone. A small cairn is located nearby (2J at same location).	Private survey notes 2002–200 G. Chappell P. Brown.	Discovered under burnt vegetation Nov 2003 G. Chappell, P. Brown.
36	2L	Brow Moor Map C	NZ 96045 01646	rectangular slab (53 x 26 x 13cm) single cup mark.	Private survey notes 2002–2004 G. Chappell P. Brown.	Discovered under burnt vegetation April 2004 G. Chappell, P. Brown.
37	2m	Brow moor Map C	NZ 96009 01702	A small flat slab (0.46 x 0.43 x 0.16m) has on its upper surface, 10 cup marks. Forming part of the kerb of a robbed-out small cairn. (2-,n,o at same location).	Private survey notes 2002–2004 G. Chappell P. Brown.	Discovered under burnt vegetation Dec 2003. P. Brown, G. Chappell.
38	2n	Brow moor Map C	NZ 96009 01702	A small boulder (0.7 x 0.62 x 0.2m) has on its sloping surface, 17cup marks (some up to 9cm diameter). A groove bisects the carved surface. Forming part of the kerb of a small cairn (2-m,o at same location).	Private survey notes 2002–2004 G. Chappell P. Brown.	Discovered under burnt vegetation Dec 2003. P. Brown, G. Chappell.
39	02o	Brow moor Map C	NZ 96009 01702	Rock within the kerb of a robbed-out cairn (70 x 47 x 25cm) 10 cups one with a double penannular a groove from the central cup links to a single cup and ring and three cups (2m,n part forming part of the of the same kerb).	Private survey notes 2002–2004 G. Chappell P. Brown.	Discovered under burnt vegetation April 2004. P. Brown, G. Chappell.
40	02p	Brow moor Map C	NZ 96009 01702	Rock within the kerb of a robbed-out cairn three faint cups forming a group of four marked stones.	Private survey notes 2002–2004 G. Chappell P. Brown.	Discovered under burnt vegetation Dec 2003. P. Brown, G. Chappell.
41	2q	Brow Moor Map C	NZ 9604301593	Small boulder one cup mark 50m West of central Barrow.	Private survey notes 2002–2004 G. Chappell P. Brown.	Discovered face up April 2004 Brown and Chappell.

No	Site	Location	OS Grid Ref	Description	References	Notes
42	2r	Brow Moor Map C	NZ 96088 01612	A small flat slab (0.33 x 0.25 x 9m) has a single cup mark on one face. Stone is located 10m from the crest, on the south western slope of a large barrow.	Private survey notes 2002-2004 G. Chappell P. Brown.	Discovered under burnt vegetation Dec 2003. P. Brown, G. Chappell. Stone now placed with motif face down for protection.
43	2s	Brow Moor Map C	NZ 96095 01600	Rectangular-shaped rock sited 10 m south-east side of the central barrow between two small boulders (60 x 20 x 8cm) the motifs consist of one cup mark.	Private survey notes 2002-2004 G. Chappell P. Brown.	Discovered under burnt vegetation Jan 2003. P. Brown, G. Chappell.
44	2t	Stoupe Brow Moor Map C	NZ 96486 01594	A low flat rock (1.0 x 0.70 x 0.12m) has on its upper surface, three cup marks, one enclosed by a single ring, this being linked to a groove enclosing the remaining cups. Large barrow approx. 50 m to east.	Private survey notes 2002-2004 G. Chappell P. Brown.	Discovered under burnt vegetation Dec 2003. P. Brown, G. Chappell.
45	2u	Stoupe Brow Moor Map C	NZ 9652401583	oval slab (74 x 46 x 10cm) one deep cup and three small round depressions.	Private survey notes 2002-2004 G. Chappell P. Brown.	First noted by Barbara Brown Dec 2003.
46	2v	Brow Moor Map C	NZ 9651901587	Boulder (80 x 47 x 20cm) two shallow cups	Private survey notes 2002-2004 G. Chappell P. Brown.	First noted by Barbara Brown Dec 2003.
47	2w	Brow Moor Map C	NZ 9661901587	rounded boulder pos cups East of large barrow.	Private survey notes 2002-2004 G. Chappell P. Brown.	First noted by Barbara Brown Dec 2003.
48	2x	Brow Moor Map C	NZ 9647701720	flat slab footprint type motif (63 x 33 x 12cm).	Private survey notes 2002-2004 G. Chappell P Brown.	Discovered under burnt vegetation Nov 2004. P. Brown, G. Chappell.
49	2y	Brow Moor Map C	NZ 96047 01646	Flat slab (28 x 23 x 8cm) 3 large cups.	Private survey notes 2002-2004 G. Chappell P. Brown	Discovered under burnt vegetation Nov 2004. P. Brown, G. Chappell.
50	3a	Howdale Moor Map D	NZ 95847 01531	A loose stone block (0.7 x 0.5 x 0.2m) has on its flat upper surface, three cup marks. Stone is located on top of a large cairn.	Private survey notes 2002-2004 G. Chappell P. Brown.	Located by P. Brown, G. Chappell. July 2002.

No	Site	Location	OS Grid Ref	Description	References	Notes
51	3b	Howdale Moor Map D	NZ 95861 01523	A low flat slab (1.2 x 0.8 x 0.2m) has on its upper surface, 20 cup marks (two surrounded by single rings), plus two larger cup mark/basins and an arrangement of channels, plus areas of pick marking on the rock surface. Cairn at 95859 01531	*YAJ* 41 (1966), 557. Private survey notes 1992–2002 G. Chappell.	Reported by S. Feather (1966). Located again by G. Chappell (May 1994). Part of a cluster of carved rocks. 1st Ed. OS map shows 3 tumuli in this area.
52	3c	Brow Moor Map D	NZ 95866 01514	A low flat rock (1 x 0.6 x 0.1m) has on it upper surface, five small cup like depressions. Possibly natural?	Private survey notes 2002–2004 G. Chappell P. Brown.	Discovered by P. Brown, G. Chappell Aug 2003.
53	3d	Howdale Moo Map D	NZ 95860 01511	A wedge-shaped rock (0.75 x 0.6 x 0.65m) has on its sloping surfaces, two cup marks with possible traces of a channel and four other faint eroded cups. The northern face has an 'X' and 'WC' carved into it and the top of the rock has eroded depressions – possibly natural.	*YAJ* 41 (1966), 557. Private survey notes 1992–2002 G. Chappell.	Reported by S. Feather in 1966. Located again by G. Chappell Nov 1994. Part of a cluster of carved rocks. 1st Ed. OS map shows 3 tumuli in this area.
54	3e	Brow Moor Map D	NZ 95874 01510	A small triangular rock (0.3 x 0.2 x 0.05m) with a single cup mark on its upper surface.	*YAJ* 41 (1966), 557. Private survey notes 1992–2002 G. Chappell.	Reported by S. Feather in 1966. Located again by G. Chappell Nov 1994. Part of a cluster of carved rocks. 1st Ed. OS map shows 3 tumuli in this area.
55	3f	Brow Moor Map D	NZ 95879 01505	A low flat slab (1.2 x 0.55 x 0.1m) has on its upper surface, 15 cup marks with two irregularly-shaped depressions.	*YAJ* 41 (1966), 557. Private survey notes 1992–2002 G. Chappell.	Reported by S. Feather in 1966. Located again by G. Chappell Nov 1994. Part of a cluster of six carved rocks. 1st Ed. OS map shows 3 tumuli in this area.
56	3g	Brow Moor Map D	NZ 95919 01500	A small ridge-shaped rock (1.0 x 0.65 x 0.3m) has on its upper surface, two cup marks.	*YAJ* 41 (1966), 557. Private survey notes 1992–2002 G. Chappell.	Reported by S. Feather in 1966. Located again by G. Chappell Nov 1994. Part of a cluster of six carved rocks. 1st Ed. OS map shows 3 tumuli in this area.

No	Site	Location	OS Grid Ref	Description	References	Notes
57	3h	Brow Moor Map D	NZ 95927 01487	A large ridge-shaped rock (1.5 x 1.5 x 1.0m) has on its south-west side, five cup marks (four of which are surrounded by single rings, each with an arrangement of channels) plus two 'comb' type motifs, one of which is cut into by a 'later' cup and ring mark.	YAJ 41 (1966), 557. Private survey notes 1992-2002 G. Chappell.	Reported by S. Feather in 1966. Located again by G. Chappell Nov 1994. Part of a cluster of carved rocks. 1st Ed. OS map shows 3 tumuli in this area.
58	3i	Brow Moor Map D	NZ 95904 01495	A rounded rock (1.1 x 0.8 x 0.3m) has on its upper surface, a large cup like depression (natural?) and one small cup mark.	Private survey note 2002-2004 G. Chappell P. Brown.	Discovered under burnt vegetation Oct 2003. P. Brown, G. Chappell.
59	3j	Brow Moor Map D	NZ 95930 01486	Flat rock (50m x 46m x 0cm) three cups two appear to show erosion and could be natural?	Private survey notes 2002-2004 G. Chappell P. Brown.	Discovered by P. Brown, G. Chappell June 2005 close to 3g.
59	4a	Brow Moor Map D	NZ 96003 01557	A large flat slab (1.6 x 1.5 x 0.15m) has on its upper surface, over 50 cup marks, one cup mark with two concentric rings, three cups with single rings and two cups and rings linked together.	YAJ 41 (1966), 557. Private survey notes 2002-2004 G. Chappell P. Brown.	Reported by S. Feather (1966). Located again by G. Chappell, P. Brown Oct 2003.
60	4b	Brow Moor Map D	NZ 96005 01546	A flat triangular slab (1.7 x 1.5 x 0.15m) has on its upper surface, approx. 40 cup marks, two cups and rings, some cups are linked by a series of channels.	YAJ 41 (1966), 557. Private survey notes 2002-2004 G. Chappell P. Brown.	Reported by S. Feather (1966). Located again by G. Chappell, P. Brown Oct 2003.
61	4c	Brow Moor Map D	NZ 96003 01548	A flat triangular rock (1.7 x 0.9 x 0.1m) has on its upper surfaces, 2 cup and ring marks and a rectangular channel motif. Possible cup mark on adjacent slab?	YAJ 41 (1966), 557. Private survey notes 2002-2004 G. Chappell P. Brown.	Reported by S. Feather (1966). Located again by G. Chappell, P. Brown Oct 2003.
62	4d	Brow Moor Map D	NZ 96006 01557	A low flat rock (1.15 x 1 x 0.1m) has on its upper surface, a single cup mark. Stone is located alongside 4c.	Private survey notes 2002-2004 G. Chappell P. Brown	Located by G. Chappell, P. Brown Oct 2003
63	4e	Brow moor Map D	NZ 96006 01546	A flat stone (1.6 x 0.8 x 0.1m) has on its upper surface, six cup marks with pecked lines forming an enclosure. Possible rosette of cup marks?	Private survey notes 2002-2004 G. Chappell P. Brown.	Discovered under burnt vegetation Oct 2003. P. Brown, G. Chappell.

No	Site	Location	OS Grid Ref	Description	References	Notes
64	4f	Brow Moor Map D	NZ 96008 01547	A large outcrop rock (2.4 x 2 x 0.15m) has on its uneven upper surface, approx. 10 cup marks and a small rectangular channel motif.	*YAJ* 41 (1966), 557. Private survey notes 2002–2004 G. Chappell P. Brown.	Reported by S. Feather (1966). Located again by G. Chappell, P. Brown Oct 2003.
65	4g	Brow Moor Map D	NZ 96034 01546	A low flat rock (1.5 x 1.0 x 0.2m) has on its upper surface, six cup marks one surrounded by a possible eroded ring? Adjacent to 4h.	Private survey notes 2002–2004 G. Chappell P. Brown.	Discovered under burnt vegetation Oct 2003. G. Chappell, P. Brown.
66	4h	Brow Moor Map D	NZ 96034 01546	A low flat rock) has on its upper surface, four cup marks.	Private survey notes 2002–2004 G. Chappell P. Brown.	Discovered under burnt vegetation Oct 2003. G. Chappell, P. Brown.
67	4i	Brow Moor Map D	NZ 96120 01523	A rounded boulder (0.65 x 0.6 x 0.4m) has on its sloping side, 7 cup marks .and erosion hollows Located alongside 'stream' feeding Slape stone beck.	Private survey notes 2002–2004 G. Chappell P. Brown.	Discovered under burnt vegetation Oct 2003. P. Brown, G. Chappell.
68	4j	Brow Moor Map D	NZ 96120 01523	Flat slab in stream bed close to 4I motifs consist of three cups.	Private survey notes 2002–2004 G. Chappell P. Brown.	Discovered under burnt vegetation Oct 2003. P. Brown, G. Chappell.
69	4k	Brow Moor Map D	NZ 96230 01469	A low flat rock (1.4 x 1.0 x 0.1m) has on its upper surface, one cup mark surrounded by a pen annular ring, along with two faint channels (possibly natural rock strata lines?). Also possible traces of faint pick marked areas.	Private survey notes 1992–1994 G. Chappell.	Located by G. Chappell (Nov 1994).
70	4l	Brow Moor Map D	NZ 96226 01455	A low flat rock (1.4 x 0.7 x 0.1m) has on its upper surface, 12 cup marks, arranged in 3 rows of 4 cups.	Private survey notes 2002–2004 G. Chappell P. Brown.	Located by G. Chappell (May 2000).
71	4m	Brow Moor Map D	NZ 96115 01601	A small loose rock (0.6 x 0.25 x 0.1m) has on its upper surface. A single cup mark (pick marks visible?) Stone is located between two other stones alongside a small rectangular ditched feature.	Private survey notes 2002–2004 G. Chappell P. Brown.	Discovered under burnt vegetation Oct 2003. G. Chappell, P. Brown.
72	05a	Brow Moor Map E	NZ 96446 01316	A low flat rock (0.8 x 0.6 x 0.15m) has on its upper surface, two deep cup marks, with possible traces of three more eroded cup marks and an irregularly-shaped depression.	Private survey notes 1992–1996 G. Chappell.	Located by G. Chappell (June 1996).

No	Site	Location	OS Grid Ref	Description	References	Notes
73	05b	Brow Moor Map E	NZ 96464 01316	A low flat rock (1.0 x 0.9 x 0.1m) has on its upper surface, a cluster of 17 cup marks enclosed by a channel. Also two irregularly-shaped depressions.	Private survey notes 1992-2002 G. Chappell.	Located by G. Chappell (June 1996).
74	05c	Brow Moor Map E	NZ 9650701312	A low flat rock (0.9 x 0.6 x 0.1m) has on its upper surface, two cup marks (one surrounded by two concentric rings), possible traces of three more eroded cup marks and a small comb motif.	Private survey notes 1992-2002 G. Chappell.	Noted for the Ordnance survey (1970s). Located again by G. Chappell (October 1994).
75	05d	Brow Moor Map E	NZ 96420 01307	A low flat rock (1.6 x 0.9 x 0.2m) has on its upper surface, 15 cup marks, some being enclosed by an arrangement of channels. Possible traces of five more eroded cup marks.	Private survey notes 1992-2002 G. Chappell.	Located by G. Chappell (Nov 1996). Carved rock is near a small (15m dia.) banked enclosure (NZ 96424 01269).
76	05e	Brow Moor Map E	NZ 96478 01283	A flat boulder (1.2 x 1 x 0.3m) has on its upper surface, three cup marks. Remains of a cairn 3m away.	Private survey notes 2002-2004 G. Chappell P. Brown.	Discovered by Paul Brown Jun 2003.
77	05f	Brow Moor Map E	NZ 96525 01274	A low flat rock (1.5 x 0.9 x 0.1m approx.) has on its upper surface, a single cup and ring mark as part of a P-shaped arrangement of channels.	YAJ 33 (1936), 120. Whitby Naturalist reports Vol. 3 1938/39 p19 Photograph Whitby archive.	Reported by H.P. Kendall (1936). Noted for Ordnance Survey (1970s). Located again by G. Chappell & P. Brown (Dec 2002).
78	05g	Brow Moor Map E	NZ 96526 01270	A low rock (1.0 x 0.85 x 0.15m) has its sloping upper surface divided by a cross or X-shaped arrangement of channels, with a single cup mark in three of the divisions. Plus a small roughly circular channel.	Private survey notes 2002-2004 G. Chappell P. Brown.	Located by G. Chappell (May 2002).
79	05h	Brow Moor Map E	NZ 96500 01258	A low flat rock (1.4 x 1.1 x 0.1m) has on its upper surface, seven cup marks (one being surrounded by a 'recess' (or damaged?) concentric ring and an arrangement of channels.	Photograph in Whitby Museum archive. Private survey notes 1992-2002 G. Chappell.	Noted by Whitby Naturalist Club 1937. Noted for the Ordnance survey (1970s). Located again by G. Chappell (October 1994).

No	Site	Location	OS Grid Ref	Description	References	Notes
80	05i	Brow Moor Map E	NZ 96508 01221	A low flat rock (3.0 x 1.0 x 0.25m) has on its upper surface, two cup and ring marks (one with three concentric rings the other with two rings). A channel divides the rock midway along its length with the cup and ring marks at opposite ends. Possible traces of four more eroded cup marks.	Private survey notes 1992–2002 G. Chappell.	Noted for the Ordnance survey (1970s). Located again by G. Chappell (October 1994). Cairn field.
81	05J	Brow moor Map E	NZ 96253 01217	A small square boulder (0.5 x 0.5 x 0.25m) has on its flat upper surface, possible traces of very eroded linear grooves forming grid pattern with small cup like depressions Possibly geological?	Private survey notes 2002–2004 G. Chappell P. Brown.	Discovered under burnt vegetation Sept 2003 P. Brown, G. Chappell.
82	05k	Brow Moor Map E	NZ 96492 01215	A large boulder (2.7 x 2.1 x 0.4m) has on its sloping surface, a series of vertical pecked lines and pecked circles.	Private survey notes 2002–2004 G. Chappell P. Brown.	Discovered under burnt vegetation Sept 2003. G. Chappell, P. Brown.
83	05L	Brow moor Map E	NZ 96513 01230	A large flat slab (1.6 x 0.9 x 0.1m) has on its upper surface, a single cup with ring with adjoining square motif? Carving is on ganister type stone? Hence odd appearance?	Private survey notes 2002–2004 G. Chappell P. Brown Pers. comm. Alan Walker.	Discovered under vegetation August 2003.by Alan Walker The rock is of hard ganister the motif under certain lighting conditions appears to be unfinished and may be considered of recent origin
84	05m	Brow Moor Map E	NZ 96489 01236	A large flat slab (2.1 x 1.2 x 0.2m) has on its upper surface, 5 cup marks and interconnecting channel.	Private survey notes 2002–2004 G. Chappell P. Brown.	Discovered under burnt vegetation Sept 2003 P. Brown, G. Chappell.
85	05n	Brow Moor Map E	NZ 96485 01277	A flat slab (0.87 x 0.4 x 0.05m) has on its upper surface, one 5cm cup mark. Stone is close to 5e.	Private survey notes 2002–2004 G. Chappell P. Brown.	Discovered under burnt vegetation Jan 2004. P. Brown, G. Chappell.
86	05o	Brow Moor Map E	NZ 96440 01362	A rounded boulder (0.8 x 0.8 x 0.1m) has on its upper surface, linear grooves forming a cross, plus a single cup mark.	Private survey notes 2002–2004 G. Chappell P. Brown.	Discovered under burnt vegetation Sept 2003. G. Chappell, P. Brown.

No	Site	Location	OS Grid Ref	Description	References	Notes
87	05p	Brow Moor Map E	NZ 96433 01322	Flat rock single cup mark.	Private survey notes 2002–2004 G. Chappell P. Brown.	Discovered under burnt vegetation Jan 2004. P. Brown, G. Chappell.
88	05q	Brow Moor Map E	NZ 96409 01269	A small boulder (0.5 x 0.5 x 0.3m) with a pecked curved channel(natural?). Carved surface was originally face down. Located on west side of sheep fold.	Private survey notes 2002–2004 G. Chappell P. Brown.	Discovered under burnt vegetation Sept 2003. G. Chappell, P. Brown.
89	05r	Brow Moor Map E	NZ 96386 01343	A wedge-shaped boulder (90 x 60 x 35cm) on the front vertical side are cups and grooves that form a series of linked square motifs.	Private survey notes 2002–2004 G. Chappell P. Brown.	Discovered under burnt vegetation Jan 2004 G. Chappell, P. Brown.
90	05s	Brow Moor Map E	NZ 96239 01256	A flat stone (0.7 x 0.3 x 0.05m) has on its uppers surface, two deep cup marks. Alongside 5r.	Private survey notes 2002–2004 G. Chappell P. Brown.	Discovered under burnt vegetation Nov 2003 P. Brown, G. Chappell.
91	05t	Brow Moor Map E	NZ 96239 01256	A flat stone (1 x 0.6 x 0.05m) has on its upper surface, three cup marks- two deep. Alongside 5q.	Private survey notes 2002–2004 G. Chappell P. Brown.	Discovered under burnt vegetation Nov 2003. P. Brown, G. Chappell.
92	05u	Howdale Map E	NZ 96176 01238	A large, ridge-shaped boulder (1.6 x 1.0 x 0.5m) has on its north facing side, a series of deep linear grooves. Possibly natural or may be eroded motifs. Close to 5t 3m souh-west.	Private survey notes 2002–2004 G. Chappell P. Brown.	Discovered under burnt vegetation Oct 2003. G. Chappell, P. Brown.
93	05v	Howdale Map E	NZ 96173 01240	A large flat slab (2 x 1.2 x 0.2m) has on a raised section of its upper surface, six cup marks in a 'domino' motif linked by two parallel grooves to a second six cup mark domino motif. Motifs are on southern part of rock only.	Private survey notes 2002–2004 G. Chappell P. Brown.	Discovered under burnt vegetation Oct 2003. P. Brown, G. Chappell.
94	06a	Brow Moor Map E	NZ 96738 01253	A flat topped boulder (1.5 x 1 x 0.15m) has on its upper surface, an eroded rosette of cup marks enclosed by two rings which are crossed by a short channel from the central cup mark.	Private survey notes 2002–2004 G. Chappell P. Brown.	Discovered under burnt vegetation Oct 2003. P. Brown, G. Chappell.

No	Site	Location	OS Grid Ref	Description	References	Notes
95	06b	Brow Moor Map E	NZ 96714 01184	A flat rock (1.2 x 0.8 x 0.2m) has on its upper surface, approximately 12 cup marks. Possibly the 'damaged' stone noted by Stuart Feather (SMR).	Private survey notes 2002–2004 G. Chappell P. Brown.	Discovered in deep heather July 2003. P. Brown, G. Chappell. close to L-shaped bank a few metres to the west.
96	06b*	Brow Moor Map E	NZ 967 012	Rock outcrop, 5ft. by 3ft.(1.5 x 0.9m) at ground level. Cups with channels, damaged. Possibly 6b? (1.2 x 0.8m).	Private survey notes 2002–2004 G. Chappell P. Brown YAJ 41 (1966), 557.	Reported by S. Feather (1966). Not located during recent fieldwork.
97	06c	Brow Moor Map E	NZ 96615 01163	A rounded boulder (1 x 1 x 0.2m) has on its upper surface a single cup mark.	Private survey notes 2002–2004 G. Chappell P. Brown.	Discovered in deep heather July 2002. P. Brown, G. Chappell.
98	06d	Brow Moor Map E	NZ 96647 01142	A small flat stone (0.6 x 0.5 x 0.1m) has on its upper surface a single cup mark. Several rocks in this area appear to have a single cup marks. NZ 96620 01150 – two stones (2m apart) NZ 96616 01190.	Private survey notes 2002–2004 G. Chappell P. Brown.	Discovered in deep heather July 2002. P. Brown, G. Chappell.
99	06e	Brow Moor Map E	NZ 9668801174	Flat rock single 4cm cup and lines (67 x 60 x 5cm) covered by heather.	Pers. comm. Brian Smith.	Found under heather Sept 2004 Brian Smith.
100	06f	Brow Moor Map E	NZ 9672201150	Cigar-shaped boulder (45 x 34 x 10cm) 3 cup marks.	Pers. comm. Brian Smith.	Found under heather Sept 2004 Brian Smith.
101	06g	Brow Moor Map E	NZ 96800 01372	A quarried stone block (0.65 x 0.37 x 0.22m) has on one flat surface, two curving channels joining at the edge of the stone. Possible motifs or related to quarrying?	Private survey notes 2002–2004 G. Chappell P. Brown.	Discovered Nov 2003. G. Chappell, P. Brown.
102	07a	Brow Moor Map E	NZ 96702 01057	A low rock (1.1 x 0.4 x 0.15m) has on its upper surface, thirteen cup marks.	Private survey notes 1992–2002 G. Chappell	Located by G. Chappell (Dec 1994).
104	07b	Brow Moor Map E	NZ 96699 01013	A low, flat rock (1.8 x 1.4 x 0.3m) has on its upper surface, 16 cup marks, some being surrounded by an arrangement of channels. Two sides of the rock have been quarried away.	Private survey notes 1992–2002 G. Chappell.	Located by G. Chappell (Dec 1994).
103	07c	Brow Moor Map E	NZ 96684 00963	A low rock (1.6 x 0.6 x 0.5m) has on its upper surface, 3 adjacent cup marks in a line.	Private survey notes 1992–2002 G. Chappell.	Located by G. Chappell (Dec 1994).

No	Site	Location	OS Grid Ref	Description	References	Notes
105	08a	Howdale moor Map F	NZ 95608 01235	A low flat rock (1.6 x 1.2 x 0.2m) has on its upper surface, 30 eroded cup marks. A better preserved section has two cup marks each with a single concentric ring, a small 'comb' motif, a large cup mark/basin and a rectangular pecked area.	Private survey notes 1992-2002 G. Chappell.	Located by G. Chappell (Dec 1994) Identified as S. Feathers ★site removal of more vegetation revealed further motifs.
106	08a★	Howdale moor Map F	NZ 96100 01200	Flat rock 5ft by 4ft by 7ins.(1.5 x 1.2 x 0.17m) many cups. Probably 8a? (1.6 x 1.2 x 0.2m).	YAJ 41 (1966), 557.	Reported by S. Feather (1966). Not located during recent fieldwork.
107	08b	Howdale moor Map F	NZ 95610 01225	A small boulder (0.6 x 0.55 x 0.15m) has on its flat sloping surface, a horizontal channel with two vertical channels attached Possibly start of 'comb' motif or maybe natural erosion? together with three cup marks and erosion hollows	Private survey notes 2002-2004 G. Chappell P. Brown.	Discovered under burnt vegetation Nov 2003. G. Chappell. P. Brown.
108	08b2	Howdale Moor Map F	NZ 95681 01205	A small rounded boulder (0.8 x 0.6 x 0.2m) has on its upper surface, six or more cup marks and an oval depression. An adjacent small stone has a single cup mark on its upper surface.	Private survey notes 1992-2002 G. Chappell.	Located by G. Chappell (Dec 1994). Stones are located on a small mound.
109	08c	Howdale moor Map F	NZ 95616 01247	A small flat boulder (0.6 x 0.6 x 0.1m) has on its upper surface, 12 cup marks and some natural depressions.	Private survey notes 2002-2004 G. Chappell P. Brown YAJ 41 (1966), 557.	Discovered under burnt vegetation Nov 2003. G. Chappell. P. Brown.? This is★ stone two of Feathers lost sites!!
110	08c★	Howdale moor Map F	NZ 96100 01200	Flat rock 2ft by 1ft 10ins. by 4ins (0.6 x 0.5 x 0.1m) Cup marked. Probably 08c (0.6 x 0.6 x 0.15m).	YAJ 41 (1966), 557.	Reported by S. Feather (1966). re located during recent fieldwork.
111	08d	Howdale moor Map F	NZ 95621 01250	Large rectangular slab (0.8 x 0.6 x 0.2m) the motifs consist of three pecked oval depressions.	Private survey notes 2002-2004 G. Chappell P. Brown.	This rock forms part of a group found by Stewart Feather The burning of vegetation exposed further motifs relocated during recent fieldwork. G. Chappell and P. Brown Sept 03

No	Site	Location	OS Grid Ref	Description	References	Notes
112	08d★	Howdale moor Map F	NZ 96100 01200	Flat rock 2ft 10ins. by 2ft by 2ins (0.8 x 0.6 x 0.5m) Single oval depression. Probably 08d (0.8 x 0.6 x 0.2m).	YAJ 41 (1966), 557.	Reported by S. Feather (1966). re located during recent fieldwork.
113	08e	Howdale moor Map F	NZ 95615 01275	A large boulder (1.3 x 0.6 x 0.3m) has on its sloping flat surface, at least 6 cup marks. cup type depressions on adjacent stone?	Private survey notes 2002–2004 G. Chappell P. Brown YAJ 41 (1966), 557.	Re discovered under burnt vegetation Nov 2003. G. Chappell, P. Brown. This is stone forms part of a group found by★ Stewart Feathers.
114	08e★	Howdale moor Map F	NZ 96100 01200	Triangular rock, 3ft 3ins. by 2ft by 1ft. (1.0 x 0.6 x 0.3m) Cup marks mainly on large (3 x 2ft) sloping side. Probably 08e(1.3 x 0.6 x 0.3m).	YAJ 41 (1966), 557.	Reported by S. Feather (1966).
115	08f	Howdale moor Map F	NZ 95603 01288	Flat slab (57 x 52 x 10cm) two cup marks.	Private survey notes 2002–2004 G. Chappell P. Brown.	Discovered under burnt vegetation P Brown and G. Chappell Nov 004.
116	08g	Howdale Moor Map F	NZ 95676 01261	A triangular-shaped stone (0.55 x 0.5 x 0.1m) has on its flat upper surface, at least 10 cup marks. three surrounded by faint single rings. Stone is located near the remains of a large cairn.	Private survey notes 2002–2004 G. Chappell P. Brown.	Discovered under burnt vegetation Nov 2003. G. Chappell. P. Brown.
117	08h	Howdale Moor Map F	NZ 95679 01204	Rounded boulder two cup marks and large natural oval depressions.	Private survey notes 2002–2004 G. Chappell P. Brown.	Discovered under burnt vegetation Nov 2003. G. Chappell. P. Brown.
118	08i	Howdale Moor Map F	NZ 95695 01204	A low flat rock (0.7 x 0.6 x 0.2m) has on its flat upper surface, two cup marks and many faint hollows possible eroded cups.	Private survey notes 1992–2002 G. Chappell.	found by Brian Smith Feb 2004.
119	08j	Howdale Moor Map F	NZ 95616 01183	A large loose boulder located on a cairn. Stone has possible eroded cup marks on its upper surface and pecked grooves on north sloping side of stone.	Private survey notes 1992–2002 G. Chappell.	Located by G. Chappell (Dec 1993). Stone is located on a small mound/cairn.

No	Site	Location	OS Grid Ref	Description	References	Notes
120	08k	Howdale Moor Map F	NZ.95683 01174 95684 01176	A low flat rock (1.0 x 1.0 x 0.15m) has on its upper surface, 12 cup marks, including one surrounded by a single pecked concentric ring. Also a channel arrangement connecting two of the cup marks. Possible traces of five other eroded cup marks.	Private survey notes 1992–2002 G. Chappell.	Noted for the Ordnance survey (1970s). Located again by G. Chappell (Nov 1994). 3 small cairns nearby?.
121	08L	Howdale Moor Map F	NZ 95775 01178	A low flat rock (1.0 x 0.7 x 0.1m) has on its flat upper surface, a single cup mark.	Private survey notes 2002–2004 G. Chappell P. Brown.	Found July 2003. P. Brown, G. Chappell. A small cairn is located a few metres to the south-west
122	08m	Howdale moor Map F	NZ 95793 01136	Irregularly-shaped rock has on its flat surface, three eroded cup marks. .	Private survey notes 2002–2004 G. Chappell P. Brown.	Found July 2003. P. Brown, G. Chappell.
123	08n	Howdale Moor Map F	NZ 95793 01135	Flat slab two metres South of 08e eight cups the slab is enclosed by small cobbles these may be the remains of a small cairn or field clearance.	Private survey notes 2002–2004 G. Chappell P. Brown.	Found P. Brown, G. Chappell. July 04 covered over with a dense matt of vegetation
124	08o	Howdale moor Map F	NZ 95609 01130	Small flat stone (0.35 x 0.35 x 0.1m) has on its upper surface a single cup mark. Stone located on remains of cairn.	Private survey notes 2002–2004 G. Chappell P. Brown.	Discovered under burnt vegetation Nov 2003. G. Chappell, P. Brown.
125	08p	Howdale moor Map F	NZ 95551 01124	Small, marked stone single cup (34 x 29 x 10cm).	Private survey notes 2002–2004 G. Chappell P. Brown.	Discovered under burnt vegetation Nov 2003. P. Brown, G. Chappell.
126	08q	Howdale moor Map F	NZ 95544 01192	Small flat stone (1.0 x 0.8 x 0.05m) has on its upper surface a two cup marks plus natural fracture lines.	Private survey notes 2002–2004 G. Chappell P. Brown.	Discovered under burnt vegetation Nov 2003. P. Brown, G. Chappell.
127	08r	Howdale moor Map F	NZ 95518 01231	A large dome-shaped boulder (3.15 x 1.7 x 0.7m) has on its upper surface a shallow dished depression, and on its south facing side, several linear grooves. several forming dumbbell motifs.	Private survey notes 2002–2004 G. Chappell P. Brown.	Discovered under burnt vegetation and silt, the large boulder is located the stream bed, removal of the silt and stone debris reveled dumbbell motifs. G. Chappell. P. Brown. Feb 2004.

No	Site	Location	OS Grid Ref	Description	References	Notes
128	08s	Howdale Moor Map F	NZ 95559 01209	A large boulder (1.1 x 1.0 x 0.2m) has on its upper surface, an oval depression and one deep cup mark and one shallow cup mark.	Private survey notes 2002–2004 G. Chappell P. Brown.	Discovered under burnt vegetation Nov 2003. P. Brown, G. Chappell.
129	08t	Howdale Moor Map F	NZ 9557801594	Smooth slab protruding from bank side of water course(87 x 80 x 25cm) motifs consist of two cup marks one surrounded by a penannular and the remaining cup by circular grooves forming a kidney-shaped motif both are linked by a serpentine groove.	Pers. comm. Brian Smith.	B Vyner and S Sherlock EH Survey March 2004
130	09a	Howdale Moor Map F	NZ 95440 01062	A large boulder (1.1 x 1.2 x 0.6m) has on its upper surface several cup marks (some linked by channels). South side of rock has a cup mark and connecting channel.	Private survey notes 2002–2004 G. Chappell P. Brown.	Discovered under burnt vegetation Sept 2003. G. Chappell. P. Brown.
131	09b	Howdale Moor Map F	NZ 95513 01060	A flat rock (1.2 x 0.9 x 0.05m) has on its upper surface, at least four cup marks and a series of parallel linear grooves (large comb type motif?). surface is badly damaged.	Private survey notes 2002–2004 G. Chappell P. Brown.	Discovered under burnt vegetation Sept 2003. P. Brown, G. Chappell.
132	09c	Howdale Moor Map F	NZ 95465 01037	A Large boulder (1.3 x 0.9 x 0.5m) has on it sloping east face, several cup marks (some linked by channels), a P-shaped groove, and at least eight parallel lines in a comb like motif. North side of stone also has cup marks and channels. A cairn is located 3m south of this stone.	Private survey notes 2002–2004 G. Chappell P. Brown.	Discovered under burnt vegetation Sept 2003. G. Chappell, P. Brown.
133	09d	Howdale Moor Map F	NZ 95514 00967	A large ridge-shaped boulder (2.3 x 1.5 x 0.7m) has on its east sloping face, two faint pen annular ring marks, plus four cup marks and possible traces of five more eroded cup marks. Also deep 'naturally' eroded depressions on top of the rock.	YAJ 41 (1966), 557. Private survey notes 1992–2002 G. Chappell.	Reported by S. Feather (1966). Located again by G. Chappell (June 1996).
134	09f	Howdale Moor Map F	NZ 9549801037	Small rounded boulder (59 x 30 x 20cm) two cups.	Private survey notes 2002–2004 G. Chappell P. Brown.	Discovered under burnt vegetation April 2004. P. Brown, G. Chappell.

No	Site	Location	OS Grid Ref	Description	References	Notes
135	09g	Howdale Moor Map F	NZ 9549401045	Small rounded boulder(49 x 30 x 19cm) two cups.	Private survey notes 2002–2004 G. Chappell P. Brown	Discovered under burnt vegetation April 2004. P. Brown, G. Chappell
136	09h	Howdale Moor Map F	NZ 9549401037	Small rounded boulder (56 x 27 x 13cm) four cups.	Private survey notes 2002–2004 G. Chappell P. Brown.	Discovered under burnt vegetation April 2004. P. Brown, G. Chappell.
137	09i	Howdale Moor Map F	NZ 9544101036	Small rounded boulder(49 x 35 x 8cm) one cup.	Private survey notes 2002–2004 G. Chappell P. Brown.	Discovered under burnt vegetation April 2004. P. Brown, G. Chappell.
138	10a	Howdale Moor Map G	NZ 94996 01192	A small stone (40 x 30 x 10cm) has a single cup on one face and plough scars. Stone located on the western side of a large barrow in field.	Private survey notes 2002–2004 G. Chappell P. Brown.	Found by P. Brown, G. Chappell June 2003. Stone from barrow material. plough scarred.
139	10b	Howdale Moor Map G	NZ 95103 01210	large rounded slab close to farm gate on the north side of farm track (95 x 90 x 30cm) large deep cup and three shallow cups.	Private survey notes 2002–2004 G. Chappell P. Brown.	Found under vegetation April 2004 Barbara Brown.
140	10c	Howdale Moor Map G	NZ 94941 01093	A large boulder (1.3 x 0.7 x 0.2m) has on its upper surface, a large (14cm dia) cup mark/ shallow basin. A channel on the sloping side of the rock connects to the cup mark. Traces of two more cup marks and another channel on sloping face of the rock.	Private survey notes 2002–2004 G. Chappell P. Brown.	Discovered under burnt vegetation Jan 2004. G. Chappell. P. Brown.
141	10d	Howdale moor Map G	NZ 94990 01079	Small cobble with one cup mark located on the south side of a robbed-out barrow (27 x 22 x 11cm).	Private survey notes 2002–2004 G. Chappell P. Brown.	Discovered under burnt vegetation Jan 2004. G. Chappell. P. Brown.
142	10e	Howdale moor Map G	NZ 94990 01079	A small stone (0.6 x 0.3 x 0.2m) has on its flat sloping surface, two cup marks. Stone is located in south west section of cairn kerb. Cup like depression on smaller stone 10d in kerb material 2m to north.	Private survey notes 2002–2004 G. Chappell P. Brown.	Discovered under burnt vegetation Jan 2004. G. Chappell. P. Brown.

No	Site	Location	OS Grid Ref	Description	References	Notes
143	10f	Howdale moor Map G	NZ 94990 01079	Boulder located on the south side of large robbed-out barrow three cups (60 x 44 x 22cm).	Private survey notes 2002-2004 G. Chappell P. Brown.	Discovered under burnt vegetation Jan 2004. G. Chappell. P. Brown.
144	10g	Howdale moor Map G	NZ 95056 01110	Quarried boulder 3 cups (80 x 45 x 25cm).	Private survey notes 2002-2004 G. Chappell P. Brown.	Part quarried stone south-east of robbed-out Barrow Nov 2003 G. Chappell. P. Brown.
145	10h	Howdale moor Map G	NZ 95056 01110	Quarried boulder two cups.	Private survey notes 2002-2004 G. Chappell P. Brown.	Part quarried stone south-east of robbed-out Barrow 1m from 10g Nov 2003 G. Chappell. P. Brown.
146	10i	Howdale moor Map G	NZ 95163 01149	A wedge-shaped boulder 5 cups (57 x 38 x 18cm).	Private survey notes 2002-2004 G. Chappell P. Brown.	Discovered under burnt vegetation. Nov 2003 G. Chappell. P. Brown.
147	10m	Howdale moor Map G	NZ 95153 01183	Rounded boulder (1.0 x 0.90 x 0.12m) four cups two deep and two shallow.	Private survey notes 2002-2004 G. Chappell P. Brown.	Discovered under burnt vegetation June 2004 Brown and Chappell.
148	10k	Howdale moor Map G	NZ 95139 01181	Wedge-shaped boulder cup with single ring and a small tri -radial motif	Private survey notes 2002-2004 G. Chappell P. Brown	Discovered under burnt vegetation June 2004 Brown and Chappell.
149	10L	Howdale moor Map G	NZ 95139 01188	rounded boulder two cups close to farm track (86 x 56 x 17cm).	Private survey notes 2002-2004 G. Chappell P. Brown.	Discovered under moss and turf Brown and Chappell. April 2004
150	10J	Howdale moor Map G	NZ 9519 01188	A ridge-shaped boulder (64 x 43 x 10cm) three cups and two shallow depressions on the sloping side, near farm track.	Private survey notes 2002-2004 G. Chappell P. Brown.	Discovered under burnt vegetation April 2004 Brown and Chappell.
151	10n	Howdale moor Map G	NZ 95174 01171	Small rounded stone (46 x 31 x 10cm) on the top surface a pecked ring.	Private survey notes 2002-2004 G. Chappell P. Brown.	Discovered under burnt vegetation June2004 Brown and Chappell.
152	10o	Howdale moor Map G	NZ 9513001202	Flat rounded slab(1.0 x 0.75 x 0.10m) two cup marks on the northern edge.	Private survey notes 2002-2004 G. Chappell P. Brown.	Discovered under vegetation April 2004 B Brown, P. Brown, G. Chappell.

No	Site	Location	OS Grid Ref	Description	References	Notes
153	10p	Howdale moor Map G	NZ 95134 01202	Flat rectangular slab (1.05 x 0.60 x 0.10m) one large cup, two oval pecked depressions and a triangular motif with attached cup.	Private survey notes 2002–2004 G. Chappell P. Brown.	Discovered under vegetation April 2004 P. Brown, G. Chappell.
154	10q	Howdale moor Map G	NZ 95158 01204	Flat slab, two cup marks, close to track.	Private survey notes 2002–2004 G. Chappell P. Brown.	Discovered under vegetation April 2004 P. Brown, G. Chappell.
155	10r	Howdale moor Map G	NZ 9504501023	Boulder (64 x 48 x 25cm) one 4cm cup mark.	Private survey notes 2002–2004 G. Chappell P. Brown.	Found exposed by fire sept 2004 Brown and Chappell.
156	10s	Howdale moor Map G	NZ 94968 00957	Rough-shaped boulder on two levels (84 x 55 x 15cm) single cup mark.	Private survey notes 2002–2004 G. Chappell P. Brown.	Located partly exposed under burnt heather Sept 2004 Brown and Chappell.
157	10t	Howdale moor Map G	NZ 9505701068	large sloping boulder damaged by fire (1.0 x 0.72 x 0.36m) two cups 9cm and 6cm.	Private survey notes 2002–2004 G. Chappell P. Brown.	Found exposed by fire Sept 2004 Brown and Chappell.
158	10u	Howdale moor Map G	NZ 9523501312	Large rock protruding from bank side close to gorse(1.9 x 1.9 x 0.90m) the motifs on the exposed northern side almost eroded away the removal of land slip revealed a number of chevron motifs one deeply incised an oval two cups with single rings and grooves many of the motifs are linked by grooves.	Pers. comm. Barbara Brown Private survey notes 2002–2004 G. Chappell P. Brown.	Discovered by Barbara Brown April 2004.
159	10v	Howdale moor Map G	NZ 95321 01387	Large rock protruding from bank side close to burnt tree single cup mark	Private survey notes 2002–2004 G. Chappell P. Brown.	Large rock protruding from bank side November 2004 Brown and Chappell.
160	11a	Stony Marl Moor Map G	NZ 95203 00892	A small ridged rock (1.3 x 0.7 x 0.2m) has on its upper surface, at least 6 cup marks and other eroded depressions. Grey horse Standing stone 50m to east.	Private survey notes 2002–2004 G. Chappell P. Brown.	Discovered under burnt vegetation Oct 2003. G. Chappell, P. Brown.

No	Site	Location	OS Grid Ref	Description	References	Notes
161	11b	Stony Marl Moor Map G	NZ 95140 00837	A large, ridge-shaped rock (2.7 x 1.0 x 0.3m) has on its north sloping face, a circle and groove connected to a split serpentine channel. The groove meanders over the top surface to a large cup and ends in a double ring 'Spectacles' motif. a further ring motif on the eastern edge.	Photograph in Whitby Museum archive. Private survey notes 2002-2004 G. Chappell, Brown.	Noted by Whitby Naturalists Club 1937. Located again Dec 2002. P. Brown & G. Chappell.
162	11c	Stony Marl Moor Map G	NZ 95235 00842	A ridge-shaped rock (1.0 x 0.6 x 0.3m) has on its sloping west side, a shallow dished depression with connecting groove. A second groove spans apposing faces of the rock. The west face of the stone also has 2 cup marks and other irregular depressions, plus a serpentine groove and pick marks.	Private survey notes 2002-2004 G. Chappell P. Brown.	Discovered under burnt vegetation Jan 2004. P. Brown, G. Chappell.
163	11d	Stony Marl Moor Map G	NZ 95217 00777	A large rock (1.35 x 0.8 x 0.15m) has on its upper surface, a single cup and ring mark and several more cup marks and irregular depressions.	Photograph in Whitby Museum archive. Private survey notes 2002-2004 G. Chappell, P. Brown.	Noted by Whitby Naturalist Club 1937. Located under burnt vegetation Oct 2003. G. Chappell, P. Brown.
164	11e	Stony Marl Moor Map G	NZ 95176 00805	A low, flat stone (0.7 x 0.5 x 0.15m) has on its sloping upper surface, a single cup and ring mark (Ring is a 'keyhole' motif?).	Private survey notes 2002-2004 G. Chappell P. Brown.	Discovered under burnt vegetation Jan 2004. G. Chappell, P. Brown.
165	11f	Stony Marl Moor Map G	NZ 95192 00831	A low, rounded rock (1 x 0.8 x 0.15m) has on its upper surface nine cup marks (six in a line).	Private survey notes 2002-2004 G. Chappell P. Brown.	Discovered under burnt vegetation Jan 2004. G. Chappell, P. Brown.
166	11g	Stony Marl Moor Map G	NZ 95180 00864	A low, rounded rock (0.88 x 0.55 x 0.17m) has on its sloping north face, 5 wide vertical grooves linked to a shallow depression, plus a second irregularly-shaped depression.	Private survey notes 2002-2004 G. Chappell P. Brown.	Discovered? under burnt vegetation Jan 2004. G. Chappell, P. Brown. White peg here Jan 2004.

No	Site	Location	OS Grid Ref	Description	References	Notes
167	11h	Stony Marl Moor Map G	NZ 95244 00844	A split section of a large stone (1.24 x 0.42 x 0.26m) has on its flat upper surface, two large cup marks. Second half of split stone (1.25 x 0.58 x 0.37m) has three large cup marks on upper surface.	Private survey notes 2002–2004 G. Chappell P. Brown.	Discovered under burnt vegetation Jan 2004. G. Chappell, P. Brown.
168	11i	Stony Marl Moor Map G	NZ 95243 00848	Second half of split stone (1.25 x 0.58 x 0.37m) has three large cup marks on upper surface.	Private survey notes 2002–2004 G. Chappell P. Brown.	Discovered under burnt vegetation Jan 2004. G. Chappell, P. Brown.
169	11J	Stony Marl Moor Map G	NZ 95089 00793	Sloping boulder(86 x 63 x 29cm) two cups linked by groove.	Pers. comm. Brian Smith.	Discovered by Brian Smith May2004.
170	11k	Stony Marl Moor Map G	NZ 95068 00770	A loose flat stone (0.4 x 0.3 x 0.1m) has on its upper surface four parallel ruts or grooves – possibly natural? Stone is located near a cairn.	Private survey notes 2002–2004 G. Chappell P. Brown.	Discovered under burnt vegetation Mar 2004. G. Chappell, P. Brown.
171	11L	Stony Marl Moor Map G	NZ 9535 0093 ??	Reported site of cup and ring marked stone. Possibly 11d?	SMR.	Not located during recent surveys wrong map reference recorded.
172	11m	Stony Marl Moor Map G	NZ 95002 00792	Round boulder (57 x 57 x 10cm) large cup 10cm and two 4cm cups three parallel lines on the sloping side are possible plough marks.	Private survey notes 2002–2004 G. Chappell P. Brown.	Discovered under burnt vegetation Mar 2004. G. Chappell, P. Brown.
173	11n	Stony Marl Moor Map G	NZ 94945 00842	Round boulder (76 x 54 x 25cm) seven cups with protracting grooves five of which are in parallel following the rock profile.	Private survey notes 2002–2004 G. Chappell P. Brown.	Stone in line with group of three barrows east–west Discovered under burnt vegetation Brown and Chappell April 2004.
174	11o	Stony Marl Moor Map G	NZ 94912 00792	rounded boulder (1.0 x 0.72 x 0.25m) four cups and a area of pick marks close to stream gully.	B Viner and S Sherlock EH Survey 2004.	Stone beside track.
175	11p	Stony Marl Moor Map G	NZ 95218 00979	Flat Slab protruding from small cairn single cup mark and an area of pecking. (54 x 35 x 10cm)	Private survey notes 2002–2004 G. Chappell P. Brown.	Located North West of Grey Horse stone in small cairn.

No	Site	Location	OS Grid Ref	Description	References	Notes
176	11q	Stony Marl Moor Map G	NZ 95148 00925	Rounded boulder (80 x 60 x 20cm) one single cup mark.	Private survey notes 2002-2004 G. Chappell P. Brown.	Stone located beside footpath under burnt vegetation. Brown and Chappell 2004.
177	11r	Stony Marl Moor Map G	NZ 95050 00810	Flat slab (117 x 65 x 5cm) two cups.	Private survey notes 2002-2005 G. Chappell P. Brown.	Discovered under burnt vegetation May 2005. G. Chappell, P. Brown.
178	12a	Stony Marl Moor	NZ 95605 00811	Round cobble single cup mark possible from nearby barrows.	Private survey notes 2002-2004 G. Chappell P. Brown.	Stone close to track located within the vicinity of the Stony Marl Howe's G. Chappell, P. Brown.
179	1m	Fylingdales	NZ? Information by application to the SMR officer.	Flat slab(99 x 79 x 16cm) org (80 x 29 x 14cm) exposed The motifs consist of lightly pecked linear lines forming triangles and lozenge shapes. PROTECTED MONUMENT all stones conserved under English Heritage Protection.	Discovered by Paul Frodsham 8th April 2004 site visit with National Parks team. Recorded by Brown & Chappell during excavation May 2004.	Site dug into to reveal motifs by enthusiastic member of the public two days later! Uncovered during EH. excavation May 2004 details B Vyner & S Sherlock EH Contract.
180	2m	Fylingdales	NZ? Information by application to the SMR officer.	1m south-west of 1m excavation revealed circular flat slab (81 x 79 x 16cm) a deep groove following the outer edge two deep parallel grooves projecting from the lower edge one ending in a rosette of three linked cups surrounded by a cluster of six additional cups.. PROTECTED MONUMENT.	Brown & Chappell survey notes April 2004 Recorded by Brown & Chappell during excavation May 2004	Discovered by P. Brown and G. Chappell. April 2004 SMR/ EH informed uncovered during excavation May 2004 details B Vyner& S Sherlock EH Contract.
181	3m	Fylingdales	NZ? Information by application to the SMR officer.	A square-shaped boulder (47x40x27cm) on the flat surface an area smoothed and polished and randomly pockmarked enclosed by two parallel incised lines resembling plough scars. PROTECTED MONUMENT.	Recorded by Brown & Chappell during excavation May 2004.	Found face down in cairn material resting on top of unmarked kerb stone between 001m and 002m Uncovered during excavation May 2004 details B Vyner and S Sherlock. EH Contract.

No	Site	Location	OS Grid Ref	Description	References	Notes
182	4m	Fylingdales	NZ? Information by application to the SMR officer.	Rectangular slab (58x47x15cm) lightly pecked design forming linked rectangles crossed by irregularly-shaped lines . PROTECTED MONUMENT.	Recorded by Brown & Chappell during excavation May 2004.	Found during excavation face down in front of 002m Uncovered during excavation May 2004 details B Vyner and S Sherlock EH Contract.
183	5m	Fylingdales	NZ? Information by application to the SMR officer.	Small cobble (20x15x10cm) one 3.5cm cup. PROTECTED MONUMENT.	Recorded by Brown & Chappell during excavation May 2004.	Found during excavation to the south-east within the outer edge of cairn material Uncovered during excavation May 2004 details B Vyner and S Sherlock EH Contract.
184	6m	Fylingdales	NZ? Information by application to the SMR officer.	Rectangular slab (50x26x11cm) single 5cm cup face up one metre north of 001m. PROTECTED MONUMENT	Recorded by Brown & Chappell during excavation May 2004.	Uncovered during excavation May 2004 details B Vyner and S Sherlock EH Contract.
185	7m	Fylingdales	NZ? Information by application to the SMR officer.	Small rounded cobble (23x20x9.5cm) one 3cm cup found face up 0.5 m north of 006m. PROTECTED MONUMENT	Recorded by Brown & Chappell during excavation May 2004 May 2004.	Uncovered during excavation May 2004 details B Vyner and S Sherlock EH Contract.
186	8m	Fylingdales	NZ? Information by application to the SMR officer.	Triangular-shaped cobble (20x17x5) one 4cm cup in cairn material one metre south on kerb. PROTECTED MONUMENT.	Recorded by Brown & Chappell during excavation May 2004.	Uncovered during excavation May 2004 details B Vyner and S Sherlock EH Contract.
187	9m	Fylingdales	NZ? Information by application to the SMR officer.	Round-shaped stone (22x20x12cm) one 3cm cup. PROTECTED MONUMENT.	Recorded by Brown & Chappell during excavation May 2004.	Uncovered during excavation May 2004 details B Vyner and S Sherlock EH Contract.
188	Rem 02	Howdale Moor	removed from moor location unknown.	Small stone (0.15 x 0.13 x 0.08m) Has one surface covered, (apart from the edges) with a continuous pecked area.	YAJ 41 (1966), 557.	In possession of the estate (Late S. Feather).

ALLAN TOFTS, GOATHLAND

No	Site	Location	OS Grid Ref	Description	References	Notes
01	ALL 1a	Allan Tofts. Goathland.	NZ 83140 03086	A partly turf covered slab (75 x 78 x 10cm) with two cup marks linked by a short channel.	Authors' research notes.	This marked stone is located to the east of a small cairn. Reported by P. Brown 2003.
02	ALL 2a	Allan Tofts. Goathland.	NZ 82939 03084	Stone (90 x 80 x 15cm) with a cluster of seven cup marks, six of which are inter-connected by short channels.	Authors' research notes.	This marked stone is located near several small cairns. Reported by G. Chappell June 1996.
03	ALL 2b	Allan Tofts. Goathland.	NZ 83005 03083	Stone (110 x 60 x 10cm) with five cup marks (two having traces of eroded concentric rings) and an elongated depression. An irregularly-shaped channel around the edge of the stone encloses the motifs.	Authors' research notes.	This marked stone is located near several small cairns. Reported by G. Chappell June 1996.
04	ALL 2c	Allan Tofts. Goathland.	NZ 83005 03050	Stone (130 x 120 x 38cm) with four cup marks and a series of linked and roughly parallel channels across the surface of the stone.	Authors' research notes.	This marked stone is located near several small cairns. Reported by P. Brown 2003.
05	ALL 2d	Allan Tofts. Goathland.	NZ 83035 03047	Stone (60 x 47 x 43cm) with three cup marks linked by a channel.	Authors' research notes.	This marked stone is located on a small cairn. Reported by P. Brown 2003.
06	ALL 2e	Allan Tofts. Goathland.	NZ 82989 03016	Stone (70 x 40 x 0cm) with five cup marks, four of which are linked by a channel.	Authors' research notes.	This marked stone is located near several small cairns. Reported by P. Brown 2003.
07	ALL 2f	Allan Tofts. Goathland.	NZ 82936 03015	Stone (60 x 45 x 10cm) with four cup marks on its upper surface (a short channel connects two of the cups).	TSDAS No.15 (1972) p39. SMR 7721.00003	This marked stone is located near several small cairns. Pick-marks are visible in the cups. Reported by D Smith 1972.
08	ALL 2g	Allan Tofts. Goathland.	NZ 82949 03016	Stone (90 x 60 x 15cm) with nine cup marks, (several connected by a deeply eroded channel) and four roughly parallel pecked lines.	Authors' research notes.	This marked stone is located near several small cairns. Reported by G. Chappell Oct 1996.

No	Site	Location	OS Grid Ref	Description	References	Notes
09	ALL 3a	Allan Tofts. Goathland.	NZ 83075 02980	Stone (65 x 50 x 5cm) with three cup marks on its upper surface.	Authors' research notes.	This marked stone is located near the remains of a large cairn. Reported by G.. Chappell Nov 1996.
10	ALL 3b	Allan Tofts. Goathland.	NZ 83060 02918	Stone (60 x 46 x 8cm) with a single cup mark and three smaller depressions, plus natural grooves.	Authors' research notes.	This marked stone is located near a small cairn. Reported by P. Brown 2004.
11	ALL 4a	Allan Tofts. Goathland.	NZ 82817 02955	Stone (75 x 50 x 6cm) with 15 cup marks (several linked by two channels) on its flat upper surface.	Authors' research notes.	This marked stone is located near several cairns. Reported by P. Brown 2003.
12	ALL 4b	Allan Tofts. Goathland.	NZ 82830 02928	Stone (60 x 55 x 13cm) with six cup marks one having three concentric rings, another having a single concentric ring. A series of channels connect to the cup marks.	Authors' research notes.	This marked stone is located near several cairns. Reported by P. Brown 2003.
13	ALL 4c	Allan Tofts. Goathland.	NZ 82829 02921	Stone (77 x 54 x 5cm) with five cup marks and several smaller depressions. Two short channels link to three of the cup marks.	Authors' research notes.	This marked stone is located near several cairns. Reported by P. Brown 2003.
14	ALL 5a	Allan Tofts. Goathland.	NZ 82669 02875	Stone (80 x 52 x 10cm) with 10 cup marks on its upper surface. A concentric ring encloses one large cup mark, alongside a rectangular 'grid' pattern with six sectors.	Authors' research notes.	This marked stone is located near several cairns. Reported by P. Brown 2003.
15	ALL 5b	Allan Tofts. Goathland.	NZ 82640 02848	Stone (70 x 25 x 10cm) with 10 cup marks on its upper surface.	Authors' research notes.	This marked stone is located near several cairns. Reported by P. Brown 2003.
16	ALL 5c	Allan Tofts. Goathland.	NZ 82655 02816	Stone (150 x 120 x 34cm) with approx. 25 cup marks and a series of interlinked channels forming an intricate pattern.	First published P. Brown 2002 www.Y.R.A. photograph c.1968 S. Feather, noted in Archive 2005	Stone discovered under vegetation close to small cairn P. Brown 2002
17	ALL 6a	Allan Tofts. Goathland.	NZ 82957 02905	Stone (70 x 55 x 10cm) with a single cup mark connected to a roughly circular channel.	Authors' research notes.	This marked stone is located near the Boggle Bield. Reported by P. Brown 2003.

No	Site	Location	OS Grid Ref	Description	References	Notes
18	ALL 7a	Allan Tofts. Goathland.	NZ 82945 02747	Stone (100 x 90 x 10cm) with three large cup marks, each enclosed by a single concentric ring. An arrangement of channels connect the cup and ring marks. Possible traces of two further cup marks.	TSDAS No.15 (1972) p39. SMR 7721.00001	This marked stone is located 10m to the north of a large cairn. Pick marks visible in the large cups. Reported by Hayes and Hollings 1939.
19	ALL 8a	Allan Tofts. Goathland.	NZ 83045 02780	Partly exposed flat slab on bank side. (86 x 76 x 10cm) with two cup marks.	Authors' research notes.	Uncovered from under dead bracken Barbara Brown 2002
20	ALL 9a	Allan Tofts. Goathland.	NZ 83169 02842	Stone (80 x 70 x 15cm) with three cup marks, each surrounded by a single penannular ring. Also two smaller cup marks connected by a short pecked channel.	TSDAS No.15 (1972) p39. SMR 7721.00002	Reported by Hayes and Hollings 1939.
21	ALL 10a	Allan Tofts. Goathland.	NZ 83045 02655	Large upright slab in a field wall with over 60 rough depressions (some cup-like) on its east side and the letters ww on the west side.	Whitby Museum records.	The markings on this stone are of uncertain origin, they may be natural or the result of gun shot etc.
22	ALL 11a	Allan Tofts. Goathland.	NZ 8317 0264	Roughly-shaped gatepost with a series of meandering lines on one surface. Possible cup marks at the top of the stone.	Whitby Museum records.	This stone is located in a private garden.
23	ALL 12a	Allan Tofts. Goathland.	NZ 83365 02830	Stone (80 x 60 x 14cm) with an arrangement of faint lines on its upper surface.	Authors' research notes.	The markings on this stone may be a natural feature? The stone is located 20m west of a small cairn. Reported by Chris Evans, June 1997.
24	ALL 12b	Allan Tofts. Goathland.	NZ 82975 02661	Stone (52 x 38 x 5cm) with two shallow depressions (15cm dia.) one smoothed, one with possible pick marks) on its sloping surface.	Authors' research notes.	Reported by Chris Evans, June 1997.
25	ALL 13a	Allan Tofts. Goathland.	NZ 82535 02340	Short standing stone (80 x 40 x 20cm) with a rectangular 'grid' like pattern on its sloping north edge.	Whitby Museum records.	This marked stone is known as 'Pennock's Puzzle Stone' (after a local farming family). The eroded grid pattern may have parallels with ALL 5a.

EAST

No	Site	Location	OS Grid Ref	Description	References	Notes
01	DUN 1	Barrow. Swarth Howe. Dunsley Moor. Newholm cum Dunsley.	NZ 8430 0891	Reference to a cup marked stone in a cist under the east side of the barrow mound. (No further details available).	Anderson MSS. Spratt 1982, 146.	Anderson notes a stone found in the barrow had similar marks to those on the standing stones to the west of the barrow (see DUN2). Spratt notes this was a cupstone in the barrow cist.
02	DUN 2	Standing Stones. Dunsley Moor. Newholm cum Dunsley.	NZ 8429 0891	Reference to markings on two large stones located alongside a destroyed barrow. (No further details available).	Anderson MSS. Young 1817, 725.	Anderson notes these stones were the remains of a line of large stones located between two barrows (see DUN1). Young notes the folklore that the markings on one stone were the result of a giant throwing the stone.
03	Galley Hill Stone	Galley Hill. Aislaby.	NZ 8608 0902	A stone (70 x 40cm) with four cup marks on one surface. (Three of the cup marks having partial concentric rings).	Browne 1940, 65. Whitby Museum records. SMR 7554	This stone was found in a field wall. Stone now in Whitby Museum.
04	AIS 2	Aislaby Moor. Aislaby.	NZ 850 088	Reference to 'two cup marked rocks'. (No further details available).	Feather 1970, 387. SMR 7547	Reported location is in the vicinity of a destroyed cairn (NZ 8456 0888), possibly the source of the marked stones.
05	A01	Moorcock Farm. (Aislaby Moor) Egton.	NZ 8427 0836	Stone (55 x 40 x 20cm) with six cup marks on its upper surface, one cup having a concentric ring.	Authors' research notes.	This stone is located on the northern edge of the Esk Valley escarpment. On a low earth bank adjacent to a small quarry. Possibly saved from quarrying or field clearance from fields to north.
06	HAW 1	Hawsker	Unknown	A photograph of a lost stone appears to show an arrangement of linked channels on one face of stone.	Whitby Museum Records.	Current location of stone unknown.

No	Site	Location	OS Grid Ref	Description	References	Notes
06	RAM 1	Latter Gate Hills. Ramsdale. Sneaton.	NZ 9275 0420 Rem = removed from site	Rem 08 2004/16.2 (30 x 21 x 18cm) with five cup marks on one face and a small 'dumb-bell' motif on the opposing face. Rem 09 2004/16.1 (30 x 19 x 14cm) with a single cup mark. Rem 10 2004/16.3 (31 x 26 x 12cm) with two cup marks on one face and two 'dumb-bell' motifs (two small cup marks connected by a short groove), plus three small cup marks on the opposing face. Rem 11 2004/16.4 (26 x 28 x 19cm) with a single cup mark.	Whitby Museum records. Authors' research notes.	Four small cup marked stones found in a drystone boundary wall. Stones may have originated in cairns cleared from fields to the south (as marked on the first edition OS map). The stones were donated to Whitby Museum.
07	KIR 1	Kirkmoor Farm. Fylingdales.	NZ 9236 0295	A stone (40 x 30cm) marked with a cup-and-ring mark (single concentric ring), along with two smaller cup marks on the same surface. Two shorts channels lead from the ring to the edge of the stone.	National Park records. Whitby Museum records (ARC1144). SMR 9069	This stone was found in a field wall on Kirkmoor Farm. The stone is in Whitby Museum.
08	KIR 2	Kirkmoor Farm. Fylingdales.	NZ 9249 0312	Reference to a flat topped boulder with three linear grooves (approx. 100cm long) on its upper surface. (No further details available).	National Park records. SMR 9070	The markings were reported by the owners of Kirkmoor Farm, who suggested the grooves might have been arrow straighteners.
09	FOU 1	Foulsike Farm. Fylingdales.	NZ 918 020	A stone (65 x 40cm) with eight cup marks on one surface.	National Park records. Whitby Museum records (ARC 1143). SMR 7650.00001	This stone was found in the vicinity of the barrow group to the south-east of Foulsike Farm.
10	FOU 2	Foul Sike. Fylingdales.	NZ 913 024	Reference to a cup-and-ring stone. (No further Details available).	National Park records. SMR 12307	This stone was found in a wall near Foul Sike, exact location not known.
11	FOU ARC 11 53-56	Foulsike Farm? Fylingdales.	Unknown	ARC 1153. (35 x 25cm) with two cup marks on one surface. ARC 1154. (27 x 20cm) with two cup marks on opposing sides. ARC 1155. (35 x 30cm) with single cupmark. ARC 1156. (27 x 24cm) with two cup marks on one surface.	Whitby Museum records (ARC1153) (ARC1154) (ARC1155) (ARC1156)	Four small cup marked stones deposited in Whitby museum after being found during wall repairs – possibly on Foulsike farm.

No	Site	Location	OS Grid Ref	Description	References	Notes
12	LOW 1	Robbed Howe. Low moor. Goathland.	NZ 8682 0197	Possible cup marks on the kerb stones on the west side of this barrow.		Reported by Blaise Vyner.
13	SLE 1	Sleights Moor. Eskdale Ugglebarnby.	NZ 84639 04718 NZ 84664 04712 NZ 84641 04702	Three stones marked with grooves and channels, creating patterns of meandering lines and circles.	Whitby Museum records. Authors' research notes.	The markings on these stones may be natural (trace fossils?). The stones are located in the vicinity of the High and Low Bridestones, but the stone in the area appears to have been quarried.
14	ALL 1	Allan Tofts. Goathland.		See separate table for Details.	Authors' research notes.	
15	PUR 1	Purse Moor. Egton.	NZ 8095 0162	Stone (70 x 55 x 20cm) with seven cup marks on its upper surface.	Authors' research notes.	This marked stone is located along side the Park Dike earthwork. There are possible remains of small cairns 100m to the north. Reported by Chris Evans Sept 2000.
16	FYL	Fylingdales Moors. Stoupe Brow, Howedale, Stoney Marl Moors.		Approximately 200 marked stones in this area. See separate table for details.		
17	ROB REM 1/P1	'in the moor above Robin Hood's Bay'		REM 1/P1. Reference to the location of a cup-and-ring marked outcrop, part of which was split off and taken to Pickering. Split section of stone (140 x 70 x 20cm) with 12 cup marks on one surface. Six cup marks having concentric rings (max three rings). A channel links two of the cup-and- ring marks.	Simpson 1866, 51	Thomas Kendall removed this section of decorated stone to his home in Pickering, where it was later seen by Sir James Simpson (president of the Society of Antiquaries of Scotland). The Stone is still located in a garden in Pickering. Reported by Chris Evans, Sept 1998.

No	Site	Location	OS Grid Ref	Description	References	Notes
18	ROB 2	'in the neighborhood of Robin Hood's Bay'		ROB 2. Reference to the original location of 'two fine cup and ring marked stones'. (No further details available).	Annual Report of the Yorkshire Philosophical Society. 1896.	Two stones purchased for the YPS antiquities collection, which later passed to the Yorkshire Museum in York. One of the marked stones is thought to be still located in the Museum Gardens (carved surface is currently face down). These stones may have come from Raven Hall, possibly the stones found by Marshall.
19	PEA 1	Peak Moors. Fylingdales.		Reference to the location of several cup marked boundary stones, including one upright slab with 15 cup marks on one side. (No further details available).	Mortimer 1896, 146.	These stones were noted by J.R. Mortimer on a visit to the area in 1890.
20	RAV 1	Raven Hall Hotel. Ravenscar.	NZ 9805 0195	PH1. A flat piece of sandstone (32 x 28cm) with a shallow central cup mark surrounded by three concentric penannular rings, forming a keyhole-shaped motif.	Greenwell 1890, 39. Knox 1855, 198.	Possibly one of the eight marked stones mentioned by Greenwell as being located at the hall (possibly collected by a Mr. Marshall referred to in Knox). This stone is cemented into the walling alongside the grotto in the hotel garden.
21	RAV 2	Barrow 1. Raven Hill. Ravenscar.	NZ 9795 0104	Stone RH2. (25 x 20 x 18cm) with an oval depression on one face and two cup marks on opposing side. Stone B. marked with a spear-shaped cavity on one surface and four lines in a double 'V' formation (chevron). Stone C. marked with five cup marks. Stone D. marked with two cup marks. Stone E. No details.	Tissiman 1851, 2. Scarborough Museum records. SMR 7640.42002	These stones were associated with several collared urns found within the mound of this Kerbed barrow.

No	Site	Location	OS Grid Ref	Description	References	Notes
22	RAV 3	Barrow 2. Raven Hill. Ravenscar.	NZ 9809 0121	RH1. A large sandstone slab (115 x 70 x 15cm) with a cup-and-ring mark (three concentric rings) located at one end of the slab.	Tissiman 1852, 3. Knox 1855, 198. Scarborough Museum records. SMR 7640.85122	This stone formed the western side of a cist. (This may also be the stone described in Knox, 1855). This stone is on display in the Rotunda Museum, Scarborough.
23	RAV 4	'about two furlongs southwards from the Peak or Raven Hall'. Ravenscar.	NZ 980 012	Reference to a 'stone marked with a circle, crossed with a horizontal and perpendicular line'. (No further details available).	Knox 1855, 198.	Found in the vicinity of Raven Hill barrow 2 by George Marshall in 1852. This stone may be one of two marked stones bought by the Yorkshire Philosophical Society in 1896 (See ROB1&2).
24	RAV 5	'about two furlongs southwards from the Peak or Raven Hall'. Ravenscar.	NZ 980 012	Reference to a 'stone marked with four cup and ring marks, having one, two, three and four concentric rings respectively'. (No further details available).	Knox 1855, 198.	Found in the vicinity of Raven Hill barrow 2 by George Marshall in 1852. This stone may be one of two marked stones bought by the Yorkshire Philosophical Society in 1896 (See ROB1&2).
25	RAV 6	'about two furlongs southwards from the Peak or Raven Hall'. Ravenscar.	NZ 980 012	Reference to a 'large block of blue granite having a surface-area of about a yard, with a saucer like cavity cut in it (not worn) six inches wide'. (No further details available).	Knox 1855, 201.	Found buried in the vicinity of Raven Hill barrow 2 by George Marshall in 1852.
26	STA 1	Barrow. Rudda Howe. Staintondale.	SE 9768 9975 or SE 9773 9973	Reference to two roughly-shaped sandstones: Stone A. (35 x 18cm) encircled by two worn grooves. Stone B. (27 x 15cm) encircled by a single groove.	Tissiman 1852, 447.	These stones were associated with two collared urns and Tissiman suggested they may have been anchor stones (See also Seamer Moor barrow 1).

No	Site	Location	OS Grid Ref	Description	References	Notes
27	HAR I	Bloody Beck. Harwood Dale.	SE 9500 9765	Reference to a cup-and-ring stone in this area. (See notes).	Harland 2001,5. Scarborough Museum records.	This site may refer to three large circles (150cm dia.) carved on a slab near Castlebeck Farm in Harwood Dale. Probably related to millstone manufacture.
28	CLO I	Cairn Circle. Standingstones Rigg. Cloughton Moor.	SE 9825 9698	Stone C1. (76 x 53cm) with twenty-six cup marks, ten having concentric rings (max four rings). Stone C2. (84 x 56 x 10cm) with fourteen cup marks, seven surrounded by single concentric rings. Stone C3. Sandstone (58 x 30 x 18cm) with six cup marks. Stone C5. Sandstone (38 x 38cm) with three cup marks.	Tissiman 1852, 447. Knox 1855, 164. Scarborough Museum records. SMR 7883.08001	These marked stones may have formed part of cist structure. A stone on south side of the circle also has a cross marked on it (C4). The listed stones are part of the Scarborough Museum collection.

SOUTHERN REGION

No	Site	Location	OS Grid Ref.	Description	References	Notes
01	WHE I	Barrow 1. Wheatcroft. Scarborough.	TA 0460 8645	Reference to 'Two large stones', one with 'numerous cup marks' the other with 'a few cup marks'. (No further details available).	Crossley 1911, 111. Knox 1855, 197.	These marked stones were possibly part of a cist structure.
02	SEA I	Barrow 1. Seamer Moor.	TA 0196 8617	A small piece of rough limestone (11 x 9 x 7cm) encircled by a groove, crossed by a second groove on one face.	Brewster & Finney 1995, 25.	This stone was found in the western section of the kerb. Grooves on stone suggest its use as a weight or net sinker. (See also Rudda Howe site).
03	IRT I	Barrow 2. Irton Moor.	TA 0065 8768	'A large stone with tool sharpening scores'. (No further details available).	Brewster & Finney 1995, 10.	Stone had been placed over a pit covered by the cairn.

No	Site	Location	OS Grid Ref.	Description	References	Notes
04	IRT 2	Barrow 5. Irton Moor.	TA 0051 8765	Reference to a cup marked stone. (No further details available).	Simpson 1974, 32. Smith 1994, 150.	Stone from a double kerbed cairn, covering food vessel sherds and a plano-convex knife. Cairn also covered a Neolithic pit surrounded by two concentric ditches.
05	IRT 3	Barrow 6. Irton Moor.	TA 0070 8755	Reference to a cup marked stone. (No further details available).	Coombs 1974, 31. Smith 1994, 152.	Stone found in the outer kerb of this barrow, which had three concentric kerbs. food vessel sherds also found.
06	WES 1	Barrow. Way Hagg. West Ayton Moor.	SE 9657 8840	Stone 1. (46 x 51 x 23cm) with oval depression and three cup marks. Stone 2. (58 x 36 x 33cm) with five cup marks on one face. Stone 3. (84 x 56 x 25cm) with four cup marks. Stone 4. (69 x 60 x 25cm) with 13 cup marks and three parallel lines on the edge of the stone.	Tissiman 1851, 1. SMR 3648.253 SMR 3648.254	Four marked stones found associated with a collared urn in this barrow.
07	HUT 1	Barrow 2. Hutton Buscel.	SE 9595 8720	Stone A. (110 x 55cm) with two cup marks and a 'comb like' arrangement of lines, plus a smoothed depression. Stone B. (77 x 45cm) with two cup marks and a series of channels forming an 'anthropomorphic' face-like pattern. Stone C. (115 x 45 x 25cm) with five cup marks and a linear groove. Stone D. (40 x 35cm) with six cup marks. Stone E. (45 x 35cm) with 10 cup marks. Stone F. (45 x 35cm) three cup marks.	Brewster & Finney 1995, 6. SMR 3656.0331	13 marked stones found in the kerb of this barrow. 10 were cup marked and three had incised lines. Stones were distributed around the kerb with a cluster in the north sector. Stones deposited in Scarborough museum.
08	HUT 2	Barrow Site. Hutton Buscel.	SE 9492 8908	A small piece of limestone (17 x 14 x 9cm) marked with two cup marks.	TSDAS 1972, 40.	Stone was found on the site of a barrow. Stone deposited in Scarborough museum.

No	Site	Location	OS Grid Ref.	Description	References	Notes
09	WYK 1	Unidentified Barrow. Wykeham Moor.	SE 94 86?	'Colonel A. Lane Fox has two cup marked stones from a barrow on Wykeham Moor'. (No further details available).	Greenwell 1877, 342.	A footnote in Canon Greenwell's book, British Barrows. These stone is not listed in the Pitt Rivers (Lane Fox) collection at Oxford.
10	SAW 1	Barrow 1. Sawdon Moor.	SE 9350 8590	Stone 1a. Limestone (12 x 13 x 7cm) with a single cup mark and several pick marks on one face. Stone 1b. Sandstone (10 x 8 x 3cm) with a small cup mark on one face.	Brewster & Finney 1995, 11.	Both stones from eastern sector of Kerb. Finds of Grimston and Peterborough Ware pottery, indicated early Neolithic activity on the site.
11	SAW 2	Barrow 2. Sawdon Moor.	SE 9365 8555	Stone 2a. A small piece of limestone (19 x 15 x 7cm) with a single cup mark on one face.	Brewster & Finney 1995, 11.	Stone from eastern sector of kerb. Finds of Grimston and Peterborough Ware pottery, indicating early Neolithic activity on the site.
12	BLA 1	Barrow 1. West Farm. Blandsby Park.	SE 8141 8652	Stone A. (20 x 19 x 7cm) with a single cup mark. Stone B. (17 x 9 x 8cm) with two cup marks on opposing sides of stone.	Rutter 1973 16. Smith 1994, 124. SMR 8143.33001 SMR 8143.3314	Single cup marked stone came from a central burial pit. The second stone was found on the barrow surface. Sherds from Beaker, collared urn and Peterborough Ware also found on the site.
13	CRO 1	Cross Dykes Earthwork. Lockton.	SE 838 879	Cup marked stone. (No further details available).	Spratt 1982, 261.	Stone found on surface of earthwork, may have been field clearance.
14	APP 1	Barrow. Appleton Common. Appleton Le Moor.	SE 7256 8604	Three marked stones from the barrow kerb, one with a straight groove and a possible cup-and-ring mark and two more stones with possible cup marks. (No further details available)	Smith 1994, 117.	Unpublished excavation report by V. D'Andria in YAS library.

No	Site	Location	OS Grid Ref.	Description	References	Notes
15	LIN 1	Barrow 1. Lingmoor Farm. Hutton Le Hole.	SE 713 883	Stone 1. (34 x 15 x 11cm), single cup mark. Stone 2. (18 x 14 x 5cm), two cups. Stone 3. (20 x 20 x 10cm), two parallel "pocked" lines. Possible trace fossil. Stone 4. (22 x 14 x 12cm), single cup mark. Stone 5. (22 x 19 x 17cm), single cup mark. Stone 6. (20 x 30 x 14cm), "pocked line". Possible trace fossil. Stone 7. (24 x 19 x 9cm), single cup mark.	Hayes 1978, 3. Smith 1994, 112. SMR 2118.04	Six marked stones from barrow excavation. Stones 1,2 found in south and west side of barrow kerb. 7, 5, 3 associated with cremation pits under internal cairn. Stone 4 identified as part of saddle quern, ploughed up from mound. Finds in Ryedale Museum.
16	BYL 1	Barrow 1. Byland Moor. Byland with Wass.	SE 5429 8056	Stone A. Sandstone (20 x 15 x 11cm) with two grooves forming a cross. Stone B. Sandstone (27 x 15 x 8cm) with three cup marks on one face. Stone C. Sandstone (15 x 11 x 9cm) with two cup marks on opposing faces.	Greenwell 1877, 341. Smith 1994, 109. SMR 1140.03001 SMR 1140.03002	Greenwell describes finding more than 20 marked stones on this site, the stones having up to six cup marks, some connected by grooves. Listed stones are in the British Museum.
17	BYL 2	Barrow 2. Byland Moor. Byland with Wass.	SE 5432 8064	Stone A. Sandstone (18 x 13 x 8cm) with two cup marks located on opposing faces. Stone B. (55 x 65 x 20cm) with a single cup mark, found in depression on top of barrow.	Greenwell 1877, 340. Smith 1994, 109. SMR 1140.01001	Stone B noted by Hayes, photograph in Smith 1994.
18	Misc 1	Barrow site. 'Two miles North of Pickering'.		Reference to a '...large sandstone, with a cup-shaped cavity, 2.5in diameter, worked in it' (No further details available).	Bateman 1861, 213.	An unidentified barrow opened by James Ruddock in 1850.
19	Misc 2	Barrow Site. '3 miles from Pickering'.		Reference to several 'peculiarly shaped stones' one having peck-marks around a natural hollow in the stone. (No further details available).	Bateman 1861, 213.	An unidentified barrow opened by James Ruddock in 1850.
20	Misc 3	Barrow site. '4 miles north-east of Pickering'.		Reference to a small rectangular piece of sandstone (approx. 20 x15cm) with two cup marks, one on each face. (No further details available).	Bateman 1861, 224.	An unidentified barrow opened by James Ruddock in 1851.
21	Misc 4	Barrow site. '6 miles north-east of Pickering'.		Reference to a rectangular stone (approx. 15 x 11cm) with two cup marks, on opposing faces. A second stone 'irregularly-shaped sandstone, near six inches long, with neatly-wrought round holes in it'.	Bateman 1861, 230.	An unidentified barrow opened by James Ruddock in 1851. Stones were found in the fill of the grave pit under the mound.

No	Site	Location	OS Grid Ref.	Description	References	Notes
22	Misc 5	Barrow site. '11 miles east of Pickering'.	Scamridge area	Reference to a flat piece of sandstone (19cm in length) with one face divided into squares like a 'draught board'. Two small sandstone balls, one smooth, one with a pecked surface. A piece of sandstone (10 x 5cm dia.) with encircling pecked lines.	Bateman 1861, 225.	An unidentified barrow site investigated by James Ruddock in 1852. Stone items were found in a grave pit containing an inhumation with a bronze dagger.

WESTERN SITES

No	Site	Location	OS Grid Ref	Description	References	Notes
01	BMP 1	Ring Cairn. Bumper Moor. Hawnby.	SE 5545 9265	Reference to a marked stone in a ring cairn. (No further details available).	Pearson 1995, 164.	This ring cairn was excavated in 1967 by A. Fleming. The site was part of a larger group of cairns and earthworks.
02	HOO 1	'Druids Altar'. Hood Hill. Kilburn.	SE 5037 8125	Reference to a foot-shaped cavity on top of large isolated block of stone. (No further details available).	Bogg 1909, 140. SMR 12498	A legend connected this stone with a missionary and the devil's footprint. The stone was broken up by a plane crash on the site in 1954.
03	T01	Thimbleby Moor. Thimbleby.	SE 46396 95988	Earthfast boulder (100 x 50 x 50cm) with a single cup mark and an eroded oval depression.	Authors' research notes.	This marked stone is located to the east of a small cairnfield. Reported by B. & P. Brown. Feb 2003.
04	T02	Thimbleby Moor. Thimbleby.	SE 46525 95928	Boulder (300 x 200 x 100cm) with 10 cup marks on the upper surface and a further 13 cup marks on the sloping south side.	YAJ 49 (1977), 4.	This marked stone is located to the east of a small cairnfield. The original report confused the location of this stone. Relocated by B & P. Brown. Feb. 2003.
05	T03	Thimbleby Moor. Thimbleby.	SE 46563 95961	Stone (150 x 75 x 25cm) with four cup marks on upper surface (north-west end).	Authors' research notes.	This marked stone is located to the east of a small cairnfield. Reported by P. Brown, G. Chappell. March 2003.

No	Site	Location	OS Grid Ref	Description	References	Notes
06	T04	Thimbleby Moor. Thimbleby.	SE 47008 95837	Boulder (90 x 60 x 20cm) with 10 cup marks (three having single concentric rings, and one having two concentric rings) plus a number of linking grooves.	Authors' research notes.	Discovered by Barbara Brown. Feb 2003.
07	THI 5	Thimbleby Moor. Thimbleby.	SE 475 957	Reference to a stone with 15 small depressions (10p size). (No further details available).	Stanhope White 1997, 17.	
08	SCA 1	Scarth Wood Moor. Whorlton.	NZ 47073 00300	Stone (25 x 25 x 10cm) with five cup marks on one face of the stone.	Batey 1995. 176.	This marked stone was noted by Mrs C. Cook (Swainby). The stone was later stolen.
09	NEA 1-12	Near Moor. Worlton.		See separate list for details.		
10	LIV 1	Live Moor.	NZ 5054 0136	Stone A – flat slab with three cup marks in a line. Stone B – stone with seven cup marks. Stone C & D two millstone rough outs with faint cup marks.	Authors' research notes.	Close to a large prominent cairn Reported by B. Smith and P. Brown.
11	LOR 1	Lordstones Café.	NZ 52380 03170	Stone 1a (68 x 38cm) with nine cup marks on its upper surface. Stone 1b (75 x 27cm) with four cup marks and eroded depressions.	Authors' research notes.	These marked stones a located in the vicinity of several cairns/barrows. Discovered by B. Smith.
12	CRI 1	Drake Howe. Cringle Moor.	NZ 5380 0290	Reported site of a cup-and-ring marked stone. (No further details available).	Authors' research notes.	This marked stone may be associated with the Drake Howe cairn. Reported by a local gamekeeper.
13	COL 1	Cold Moor.	NZ 5440 0340	Large stone slab with four cup marks and eroded depressions	Authors' research notes.	This marked stone is located between two track/hollow ways. Reported by B. Smith and P. Brown.
14	WAI 1	Garfit Gap. Wain Stones. Bilsdale Midcable.	NZ 55626 03590	1a Large block of stone (5.6 x 3.9 x 1.2m) with three cup-and-ring marks (single concentric rings) and approx. 25 cup marks, some located in natural hollows within the rock surface. A number of channels connect to the recessed cup marks.	Smith 2003.	This marked stone is part of a cluster located around the prominent Wain Stones outcrop. The cup marks within hollows appear to be a significant feature of this site.

No	Site	Location	OS Grid Ref	Description	References	Notes
15	WAI 2	Garfit Gap. Wain Stones. Bilsdale Midcable.	NZ 55990 03467	2a Large boulder (5 x 3.6 x 0.84m) with seven heavily eroded cup-and-ring marks (single concentric rings) on its upper surface. A cluster of six cup marks are located on the north side of the boulder.	Smith 2003.	This marked stone is part of a cluster located around the prominent Wain Stones outcrop.
16	WAI 3	Garfit Gap. Wain Stones. Bilsdale Midcable.	NZ 55592 03403	3a Large boulder (4 x 3 x 0.8m) with a cluster of four cup marks enclosed by a circular groove.	Smith 2003.	This marked stone is part of a cluster located around the prominent Wain Stones rock outcrop.
17	WAI 4	Garfit Gap. Wain Stones. Bilsdale Midcable.	NZ 55594 03517	4a Large boulder with cup marks in natural hollows on the upper surface of the stone linked to a linear groove on the sloping south side.	Authors' research notes.	This marked stone is part of a cluster located around the prominent Wain Stones rock outcrop. Reported by B. Smith.
18	WAI 5	Garfit Gap. Wain Stones. Bilsdale Midcable.	NZ 55793 03636	5a Large boulder with a pecked linear channel (2.3m long).	Authors' research notes.	This marked stone is part of a cluster located around the prominent Wain Stones rock outcrop. Reported by B. Smith.
19	WAI 6	Garfit Gap. Wain Stones. Bilsdale Midcable.	NZ 55838 03338	6a large stone slab with three cup marks, one having three concentric rings, another having a single concentric ring. The motifs are located within an arrangement of linear grooves creating interlinked rectangles.	Authors' research notes.	This marked stone is part of a cluster located around the prominent Wain Stones rock outcrop. Reported by B. Smith.
20	WAI 7	Wall stones. Garfit Gap. Wain Stones. Bilsdale Midcable.	NZ 55545 03580	7a Stone with five cup marks in a curving line. 7b Stone (40 x 31x 9cm) with two deep cup marks on one surface.	Authors' research notes.	These marked stones form part of a drystone wall. The stones are part of a cluster located around the prominent Wain Stones rock outcrop. Reported by B. Smith and P. Brown.
21	URR 1	Urra Moor. Bilsdale Midcable.	NZ 5781 0002	Reference to three cup marks on the north face of a stone. (No further details available.)	National Park records. Stanhope White Survey. SMR 12440	

No	Site	Location	OS Grid Ref	Description	References	Notes
22	URR 2	Urra Moor. Bilsdale Midcable.	NZ 58841 01119	Upright slab with a small cup-and-ring mark (6cm dia.) and three other cup marks, above which there is an 'eye brow' like groove creating a 'spectacles' motif.	Stanhope White 1987, 17.	This upright slab is located on a stony earthwork. The markings are on the south face of the stone. There are other stones with possible markings alongside the earthwork.
23	BATT 1	Battersby Moor. Ingleby Greenhow.	NZ 609 068	Reference to a large 'man-made' basin (approx. 60cm dia.) in bedrock.	Stanhope White 1987, 16.	This large rock-cut basin is located in the vicinity of the Cross Dyke earthwork and cairns. Stanhope White noted several more basins in this area.
24	WES 1	Crown End. Westerdale Moor. Westerdale.	NZ 6692 0700 (possible site)	Reference to a cupstone in a field wall. (No further details available).	Elgee 1930, 142. Authors' research notes.	A single cup mark has been noted on a slab at the base of the drystone wall at the noted grid ref.
25	WES 2	Crown End. Westerdale Moor. Westerdale.	NZ 6662 0736	Stone (90 x 60 x 60cm) with an irregular ring-shaped marking on its north face.	Whitby Museum records. Authors' research notes.	The marking on this upright stone is probably a natural feature. The stone is located in an area of enclosures and cairn fields.
26	HOG 1	Little Hograh Moor. Westerdale.	NZ 65043 06679	Stone HM1 (55 x 55 x 40cm) with two cup marks on one side (east). Cup marks are either side of a vertical crack in the rock.	Stanhope White Survey, National Park records.	This marked stone may be located alongside a small cairn.
27	HOG 2	Little Hograh Moor. Westerdale.	NZ 65062 06697	Stone HM2 (110 x 90 x 20cm) with a single cup- mark on its upper surface.	Authors' research notes.	This marked stone may be located alongside a small cairn.
28	HOG 3	Little Hograh Moor. Westerdale.	NZ 65447 06973	Stone HM3 (110 x 60 x 20cm) with an intricate pattern of interconnecting lines on its flat upper surface.	Authors' research notes.	The markings on this stone are possibly a natural feature. Reported by G. Chappell 1997.
29	HOL 1	Holiday Hill. Baysdale. Westerdale.	NZ 632 068	Reference to a 'flat stone in the moor marked with two deep cups and incised lines forming an intricate pattern'. A sketch of this stone (70 x 30cm) shows two cup marks with single concentric rings, and a series of concentric semi-circles.	YAJ 41 (1964), 163. SMR 807	This marked stone was reported by Roland Close in 1961 but was noted as being 'obscured' in 1970 (YAJ 43, 191) and has not been relocated since.

No	Site	Location	OS Grid Ref	Description	References	Notes
30	WAR 1	Park Pale. Warren Moor. Kildale.	NZ 61189 08417	Stone 1a (30 x 25 x 18cm) with a single ring marking. Adjacent stone (70 x 50 x 35cm) in walling has a T-shaped mark.	Authors' research notes.	These marked stones form part of the Park Pale drystone wall (east side). Possibly part of a medieval boundary marking system. Reported by G. Chappell 1996.
31	WAR 2	Park Pale. Warren Moor. Kildale.	NZ 6124 0836	Stone 2a (65 x 50 x 22cm) with two single ring markings on one face (east side). A small central 'cup' in the upper ring.	*YAJ* 41 (1964), 171. Stanhope White 1987, 17. SMR 779.03	This marked stone forms part of the Park Pale drystone wall (east side). Adjacent stones have letter-like markings 'R' 'W' (see WAR 1).
32	WAR 3	Park Pale. Warren Moor. Kildale.	NZ 61214 08386	Stone 2c with a group of four parallel incised lines (10cm long) and a second group of three lines below this.	Authors' research notes.	This marked stone is located at the junction of an earthwork bank and the Park Pale wall. Reported by Paul Brown.
33	WAR 4	Park Pale. Warren Moor. Kildale.	NZ 61475 07955	Stone 3a with a single 6cm cup mark on its flat upper surface.	Authors' research notes.	This marked stone is located in a collapsed section of the Park Pale drystone wall. Reported by Paul Brown.
34	AYT 1	Iron Age site. Great Ayton Moor. Great Ayton.	NZ 59859 11340	Reference to a stone (45 x 35 x 15cm) with a single cup-and-ring mark (one concentric ring) on its upper surface.	Tinkler & Spratt 1978, 49. SMR 1621.04001	This marked stone was found in the paved floor area of an Iron Age hut. The stone was located between the doorway and the hearth.

NEAR MOOR

No	Site	Location	OS Grid Ref	Description	References	Notes
01	NEA 1a	Near Moor. Whorlton.	NZ 47658 00139	Stone 1a (120 x 60 x 15cm) with three cup marks on its upper surface.	Authors' research notes.	This marked stone is located near two small cairns. Reported by B. Smith.
02	NEA 1b	Near Moor. Whorlton.	NZ 47658 00142	Stone 1b (135 x 90 x 25cm) with several eroded cup marks and a number of natural depressions on its upper surface.	Authors' research notes.	This marked stone is located near two small cairns. Reported by B. Smith.
03	NEA 2a	Near Moor. Whorlton.	NZ 47623 00132	Stone 2a (95 x 85 x 30cm) with four cup marks plus eroded channels and depressions on its upper surface.	Authors' research notes.	This marked stone is located 20m west of a small cairn.
04	NEA 2b	Near Moor. Whorlton.	NZ 47598 00117	Stone 2b (120 x 80 x 20cm) with four cup marks on its flat upper surface.	Authors' research notes.	This marked stone is located 7m to the north of a small cairn. Reported by G. Chappell and P. Brown, Nov 2004.
05	NEA 2c	Near Moor. Whorlton.	NZ 47582 00139	A large rounded boulder within the wood. (150 x 80 x 50cm) one 20cm basin and 8cm cup and the letters FWL.	Authors' research notes.	Reported by G. Chappell and P. Brown, May 2005.
06	NEA 3a	Near Moor. Whorlton.	NZ 47933 00084	Stone 3a (77 x 26 x 17cm) with a single cup mark on its upper surface. (Portable stone).	Authors' research notes.	This marked stone is located near Rain drip Well. The stone is distinctive orange/red sandstone. Reported by G. Chappell, Jan 1997.
07	NEA 3b	Near Moor. Whorlton.	NZ 47903 00151	Stone 3b (60 x 35 x 10cm) with a single cup mark on its upper surface.	Authors' research notes.	This marked stone appears to be located on a small cairn (part of a group of four cairns). Reported by G. Chappell, Sept 1996.
08	NEA 4a	Near Moor. Whorlton.	NZ 47842 00057	Large boulder 4a (200 x 150 x 60cm) with seven large cup marks/shallow depressions on its uppers surface. Possible traces of other eroded markings.	Authors' research notes.	Reported by G. Chappell, Sept 1996.
09	NEA 4b	Near Moor. Whorlton.	NZ 47842 00055	Stone 4b (126 x 100 x 50cm) with four cup marks on the upper surface.	Authors' research notes.	Reported by G. Chappell, Sept 1996.

No	Site	Location	OS Grid Ref	Description	References	Notes
10	NEA 4c	Near Moor. Whorlton.	SE 47668 99923	Stone 4c (35 x 20 x 15cm) with a single cup mark.	Authors' research notes.	This marked stone is located on a small cairn. The stone is distinctive orange sandstone. Reported by G. Chappell, Sept 1996.
11	NEA 5a	Near Moor. Whorlton.	SE 47554 99989	Stone 5a (210 x 90 x 10cm) with seven cup marks on its upper surface, (six grouped in two lines of three). One cup mark is linked by a groove to an irregularly-shaped depression. Possible traces of several more eroded cup marks.	YAJ 52, (1980), 189. Spratt 1982, 154.	This marked stone was noted during field survey work by Goddard, Inman and Spratt.
12	NEA 5b	Near Moor. Whorlton.	SE 47478 99932	Stone 5b (120 x 50 x 20cm) with two small cup marks on its upper surface.	Authors' research notes.	Reported by Brian Smith 2004.
13	NEA 6a	Near Moor. Whorlton.	SE 47628 99909	Stone 6a (100 x 50 x 40cm) with 12 cup marks on its upper surface.	Brown & Smith field survey notes.	This marked stone is located at the head of a dried up stream gully. Reported by Brian Smith, 2004.
14	NEA 6b	Near Moor. Whorlton.	SE 47661 99877	Stone 6b (95 x 45 x 20cm) with three cup marks and a series of smaller cup-like depressions.	Authors' research notes.	This marked stone is located within an area of quarrying. Reported by Brian Smith 2004.
15	NEA 6c	Near Moor. Whorlton.	SE 47699 99864	Stone 6c (70 x 55 x 35cm) with a single cup mark and a natural (?) depression on its upper surface.	Authors' research notes.	This marked stone is located alongside a linear stone bank. Reported by G. Chappell 1996.
16	NEA 7a	Near Moor. Whorlton.	SE 47650 99761	Stone 7a (42 x 24 x 16cm) with a single cup mark on its upper surface.	Authors' research notes.	This marked stone is located on a linear stone bank. (1m west of 7b). Reported by G. Chappell, 1996.
17	NEA 7b	Near Moor. Whorlton.	SE 47650 99761	Stone 7b (105 x 43 x 16cm) with a line of five eroded cup marks on its upper surface.	Authors' research notes.	This marked stone is located on a linear stone bank. (1m west of 7b). Reported by G. Chappell, 1996.
18	NEA 8a	Near Moor. Whorlton.	SE 47376 99928	Stone 8a (70 x 40 x 20cm) with a V-shaped groove.	Authors' research notes.	This marked stone is located in an area of quarrying and may not be prehistoric. Reported by P. Brown 2004.

No	Site	Location	OS Grid Ref	Description	References	Notes
19	NEA 9a	Near Moor. Whorlton.	SE 47301 99887	Stone 9a (27 x 14 x 11cm) with a single cup mark. (Portable stone).	Authors' research notes.	This portable marked stone may derive from one of the nearby cairns. Reported by P. Brown 2004.
20	NEA 9b REMD 01	Near Moor. Whorlton.	SE 4740 9980	Stone 9c (67 x 49 x 20cm) Very eroded surface with at least six cup marks, four of which have double concentric rings, the rings merging with grooves to form an intricate pattern across the surface of the stone.	YAJ 52 (1980), 189. Dorman Museum records 1982.866.1 SMR 210.01002.	This marked stone was discovered by Mrs. C. Cook (Swainby). Found on a small cairn in field system. Stone is now in the Dorman Museum.
21	NEA 9b REM 02	Near Moor. Whorlton.	SE4740 9980	Cup mark surrounded by two penannular rings and a number of short grooves radiating from the outer ring. On the opposite face of the stone there is a second cup mark with a single concentric ring and short grooves connected to it.	(1980) 189. Dorman Museum records 1982.866.2 SMR 210.01002.	During field survey work by Goddard, Inman and Spratt. Stone is now in the Dorman Museum.
22	NEA 9c	Near Moor. Whorlton.	SE 47410 99782	Stone with a single cup mark (and possible traces of one other) on its upper surface.	Authors' research notes.	This marked stone is located near a group of three cairns.
23	NEA 9d	Near Moor. Whorlton.	SE 47656 99733	Stone (160 x 90 x 15cm) with six large cup marks/shallow depressions. Possible traces of further eroded cup marks.	Authors' research notes.	This marked stone is located approx. 20m to the north of a large cairn. Located By G. Chappell and P. Brown, Nov 2004.
24	NEA 10a	Near Moor. Whorlton.	SE 47358 99599	Stone 10a (133 x 64 x 10cm) with three cup marks on its upper surface.	Authors' research notes.	This marked stone is located in an area of stone quarrying. Reported by Brian Smith 2004.
25	NEA 10b	Near Moor. Whorlton.	SE 47384 99612	Stone 10b (60 x 28 x 15cm) with two cup marks on its upper surface.	Authors' research notes.	This marked stone has been partly quarried. Reported by G. Chappell 1996.
26	NEA 10c	Near Moor. Whorlton.	SE 47403 99644	Stone 10c (133 x 83 x 5cm) with three cup- marks and an eroded depression, plus a series of eight small cup-like depressions.	Authors' research notes.	This marked stone is located in an area of stone quarrying. Reported by Brian Smith 2004.
27	NEA 10d	Near Moor. Whorlton.	SE 47498 99665	Stone 10d (77 x 66 x 18cm) with two eroded cup marks on its upper surface.	Brown and Smith Field notes.	Flat slab located the East side of the moorland track

No	Site	Location	OS Grid Ref	Description	References	Notes
28	NEA 10e	Near Moor. Whorlton.	SE 47470 99591	Stone 10e Flat slab (68 x 55 x 15cm) with one large cup mark and an eroded depression on its upper surface.	Authors' research notes.	This marked stone is located close to a small cairn.
29	NEA 10f	Near Moor. Whorlton.	SE 47435 99539	Stone 10f (60 x 33 x 10cm) with a 'Domino' pattern of 12 cup marks (arranged in two rows of six) on its upper surface.	Authors' research notes.	Reported by Brian Smith, Sept 2004.
30	NEA 11a	Near Moor. Whorlton.	SE 47918 99544	Stone 11a (41 x 35 x 12cm) with three cup marks (one with traces of a single concentric ring) on its upper surface. Possible traces of a groove or channel around edge of stone.	Authors' research notes.	This marked stone is located 10m to south of a small cairn and a rectangular setting of low stones. Located by P. Brown and G. Chappell, Nov 2004.
31	NEA 12 a,b,c.	Pamperdale Moor. Osmotherley.	SE 47464 98952	Stone 12a (95 x 80 x 15cm) with a line of four cup marks and several natural (?) depressions on its upper surface. 12b with a single cup mark (1m south-west of 12a). 12c with a single cup mark (2m south-east of 12a).	Authors' research notes.	These stones are located among an area quarried for stone. Located by P. Brown and G. Chappell, Nov 2004.
32	NEA 12d	Pamperdale Moor. Osmotherley.	SE 47248 98973	Stone 12d (40 x 35 x 15cm) with four cup marks and several natural (?) depressions on its upper surface.	Authors' research notes.	This marked stone is located in a collapsed stonewall. Reported by Mrs. S. Lane.
33	NEA 12e	Near Moor	SE 47665 99332	Stone 12e (100 x 90 x 20cm) with four eroded cup marks/ depressions.	Authors' research notes.	This marked stone is located alongside Crabdale Beck. Located P. Brown 2005

ESTON HILLS

No	Site	Location	OS Grid Ref	Description	References	Notes
01	EST 1 (1a-e)	Drystone wall. Eston Moor.	NZ 569 182	Stone 1a (30 x 22 x 9cm) with six cup marks on one face and three on the opposing face. Stone 1b (28 x 23 x 11cm) four cup marks, one with a single concentric ring. Stone 1c (30 x 20 x 12cm) with six cup marks (one having a single concentric ring) Stone 1d (40 x 35 x 20cm) with seven cup marks on one surface. Stone 1e – reference to a fifth cup marked stone in this group.	*YAJ* 46 (1974), 141. *YAJ* 63 (1991), 25. Dorman Museum records. 1a. (1967.252.1) 1b. (1967.252.2) 1c (1967.252.3) 1d (1967.252.4)	These marked stones were discovered in a drystone wall 200m to the south-east. of the Eston Nab enclosure.
02	EST 1 (1f)	Cairn. Wilton Moor.	NZ 5743 1840	Stone 1f (15 x 15 x 7cm) with one central cup mark.	Crawford 1980, 51. Goddard, Spratt & brown. 1978, 15. Dorman Museum records.	This cupstone was found in the N.E sector of a small barrow covering a rock cut grave pit. A fragment of a saddle quern was also found near the cupstone.
03	EST 1 (1g)	Cairn. Wilton Moor.	NZ 5750 1838	Reference to a cup marked stone. (No further details available).	Crawford 1980, 47.	This marked stone was noted on the surface of the cairn during Crawford's barrow survey.

No	Site	Location	OS Grid Ref	Description	References	Notes
04	EST 2 (2 a–m)	Pallisade Enclosure /Hillfort. Eston Nab.	NZ 567 183	2a. (50 x 30 x 25cm) with one cup mark. 2b. (65 x 35cm) with seven cup marks on one face. 2c. With a single cup mark. 2d. (35 x 29 x 17cm) with one cup mark. 2e. (38 x 28 x 10cm) with three cup marks on one face. 2f. With a single cup mark. 2g (30 x 30 x 15cm) with a single cup mark enclosed by a concentric ring. 2h. (39 x 31 x 18cm) one cup mark on opposing sides 2i. (37 x 25 x 22cm) with eight cup marks. Seven on one face, plus a single cup mark on reverse. 2j. (110 x 55cm) with approx. 33 cup marks on the upper surface of stone. 2k. (28 x 22 x 14cm) with a single cup mark enclosed by two concentric rings. 2l with two cup marks. 2m with two cup marks on opposing faces.	Vyner 1989, 83. Tees Archaeology records.	Stone 2g & 2j (ENH85 B66) came from the rampart boulder wall. Stone 2c (ENH85 A10) came from a small pit on the south side of the palisade. Stone 2a & 2i (ENH85 A6) were found in the backfill of the palisade trench. Others stones (ENH85 B34) came from the outer rampart ditch. Stone 2J is on display in the Margrove Heritage centre.
05	EST 2 (N)	Pallisade Enclosure /Hillfort. Eston Nab.	NZ 567 183	Stone 2n (36 x 28cm) with three large cup marks on one surface.	Elgee 1930, 156. Vyner 1989, 83. Dorman Museum records (1928.78.1).	This marked stone was found during Elgee's 1920s excavation of the enclosure ditch.
06	EST (O)	Eston Moor area.	Unknown	Stone 2o with a single cup mark.	Dorman Museum records.	This marked stone has the words 'Eston Moor 1924' on it. May relate to Hornsby's digging at Court Green Howe in 1923. Stone in Dorman Museum.
07	EST 2 (misc)	Pallisade Enclosure /Hillfort. Eston Nab.	NZ 567 183	Reference to a number of cup marked stones in the enclosure boulder wall.	Vyner 1989, 83.	Aberg's 1960s excavation also uncovered three quern fragments in the boulder wall.

No	Site	Location	OS Grid Ref	Description	References	Notes
08	EST 3 (3a)	Boulder. Eston Moor.	NZ 5629 1727	Stone 3a (82 x 58cm) with four cup marks on upper sloping surface.	Authors' research notes.	This marked stone is located to the east of a possible pond barrow/ enclosed cremation cemetery (NZ 5619 1732).
09	EST 3 (3b)	Boulder. Eston Moor.	NZ 5630 1727	Stone 3b (190 x 55cm) with 17 cup marks on the upper surface.	Tees Archaeology records.	See above notes (EST3a).
10	EST 5	Stone. Eston Moor.	NZ 564 174	Reference to a cup marked stone. (No further details available).	Heslop Unpublished	
11	EST 4 Fig 107a	'Ord' Barrow 2. Eston Moor.	NZ 5691 1802	Reference to: Stone A. (50 x 30cm approx.) marked with a pattern of intersecting straight lines, creating a series of triangles. (No further details available).	Ord 1864, 72.	Stone A. covered a cremation burial in a collared urn. The marked surface was facing downwards. This stone was lost after its removal from the barrow. (See next record).
12	UNP 1 Fig 107b	Stone Slab. (unprovenanced) Tees Archaeology Store.	N/A	Stone (43 x 29 x 9cm) marked with a pattern of intersecting straight lines, creating a series of triangles within a square outline.	Tees Archaeology records.	It seems probable that this unprovenanced stone may be the lost marked slab from the barrow excavated by Ord in 1843 (See EST4 above).
13	OSB 1 (4a)	Field Wall. Osbourne Rush. Barnaby Side.	NZ 5710 1660	Stone (25 x 15cm approx.) with a single cup mark. (No further details available).	Tees Archaeology records.	This marked stone was found in a collapsed section of drystone walling in 1963.
14	NOR 1 (5A)	Barrow. Mount Pleasant. Normanby Moor.	NZ 5582 1654	Reference to cup-and-ring marked stone. (No further details available).		

On site stone (60 x 50 x 20cm) with three cup-like depressions on one side. | Socket 1971 Crawford 1980, 42. Vyner 1991, 36. | This marked stone had been placed over the remains of a Beaker vessel. Originally reported as cup-and-ring marked, however it appears the stone bore cup marks only. A cup marked stone has been noted on the site. |

NORTHERN SITES

No	Site	Location	OS Grid Ref	Description	References	Notes
01	ERR 1	Barrow. Errington Wood. Upleatham.	NZ 6212 1999	Stone 01a. (85 x 75 x 25cm) with six cup marks (four being linked by three short grooves) on one surface. Stone 02a. (80 x 40cm) with 19 cup marks (some connected by grooves) on its upper surface.	Tees Archaeology records. Authors' research notes.	Stone A. is possibly part of the barrow kerb, being located on the south-east perimeter of the mound. Relocated P. Brown. Stone B. is possibly a cist cover removed from the barrow. Located by G. Chappell.
02	AIR 1 01	Barrow. Airy Hill. Skelton.	NZ 6443 1675	Stone (75 x 40 x 20cm) with six cup marks on one surface.	Crawford 1980, 64. Atkinson 1864, 20.	This marked stone is possibly part of the barrow kerb, being located on the southern perimeter of the barrow mound, with the markings facing outwards.
03	AIR 2 02	Stone wall. Airy Hill. Skelton.	NZ 6445 1655	Stone (20 x 20 x 8cm) with a single cup mark and an area of pecking on the reverse.	Private research records P. Brown 2003.	This cupstone was found in a field wall 200m to the south south-west of the Airy Hill barrow (AIR1).
04	KEM 1	Barrow. Kemplah Top. Guisborough.	NZ 6075 1413	Reference to a cist cover with three cup marks, plus a single cup mark on the southern side slab of the cist. (No further details available).	Hornsby MSS, Dorman Museum. Crawford 1980, 36.	These marked stones were found during the excavation of a kerbed cairn, which had already been opened The barrow also contained a cremation and fragments of a Beaker.
05	GUI 1	Unprovenanced. Guisbrough area.		Stone (25 x 13 x 9cm) with two cup marks on one face.	Dorman Museum records. 1951.27.	Deposited in the museum by K Woodsworth, Guisborough in 1951. Found on moor close to Guisborough.

No	Site	Location	OS Grid Ref	Description	References	Notes
06	SPA 1	Field clearance. Spa Wood. Guisborough.	NZ 6380 1552	Boulder (81 x 72 x 27cm) with nine cup marks (two having a single concentric ring). A series of grooves link the cup marks. Two cup marks are also located on the opposite face of the boulder.	Annis 1996, 6. research notes Ros Nichol & Tom Gledhill.	This marked stone was found among a heap of field clearance stones along side the Cleveland Way footpath. The stone is now on display in the Margrove Heritage Centre.
07	02	Barrow. Dimmingdale Farm. Moorsholm.	NZ 6910 1199 (Present location NZ 6941 1175)	Boulder (100 x 60cm) with approximately 50 cup marks, several linked by short grooves. A longer groove connects six cup marks and terminates in a square-shaped depression with a cup mark in each corner.	YAJ 48 (1976), 2. Crawford 1980, 44.	This marked stone was originally located on the south-east corner of a barrow, possibly being part of the kerb. After 1975, the stone was lost having being removed from the site. Relocated by P. Brown 2003.
08	01	Boulder. Moorsholm Rigg. Moorsholm.	NZ 6862 1192	Earth fast boulder (60 x 35cm) with five cup marks on its upper surface.	Crawford 1980, 43.	This marked stone is located near several cairns and to the north of an oval enclosure thought to an enclosed cremation cemetery.
09	MOO 2	Field walking find. The Knoll. Moorsholm.	NZ 689 136.	Smooth round stone (12 x 4cm) with worked hollow in centre (3.5cm dia.). (No further details available).	YAJ 41 (1964), 172.	This marked stone was found near a stone axe and flints, in a field to the north of Freebrough Hill. (F. Tindell of Moorsholm.)
10	NEW 1	Barrow. Newton Mulgrave Moor.	NZ 7712 1380 (Suggested barrow location).	Reference to 'A variety of curious figured stones' plus a 'curiously marked stone'. (No further details available).	Anderson MSS. Smith 1994, 80.	A barrow excavation in 1852-3 uncovered the 'curiously marked stone' covering a cremation burial. The other marked stones were found near the centre of the mound within a concentric circle of walling. Two food vessel's were also found within the barrow.

CLEVELAND COAST

No	Site	Location	OS Grid Ref	Description	References	Notes
01	WHI 1	Barrow. Whinny Hill. Lythe.	NZ 8329 1450	Piece of sandstone (24 x 23 x 15cm) with three cup marks (two on opposing faces, the third being on the edge of the stone).	Greenwell 1890, 43.	This marked stone was found in the barrow mound, which covered a central cist containing a food vessel and jet pieces. This stone is in the British Museum.
02	BAR 1	Barrow 1. Barnby Howes. Barnby.	NZ 8302 1381	Small block of stone (18 x 18cm approx.) with a single, roughly squared, cup mark on its upper surface.	Ashbee & ApSimon 1956. Whitby Museum Records.	This stone was located in the southern section of the barrow kerb.
03	BAR 2	Barrow. Butter Howe. Barnby.	NZ 8273 1513	Reference to ripple markings on the underside of sandstone slabs forming a paved area within this barrow. (No further details available).	Hornsby & Laverick 1918, 50.	These marked slabs formed an area of paving within the barrow mound, which also contained a grave pit and later Anglian cremation.

No	Site	Location	OS Grid Ref	Description	References	Notes
04	HIN 1	Barrow. Hinderwell Beacon. Hinderwell.	NZ 7933 1780	7.3 Stone (27 x 21 x 11cm) with two small cup marks connected by a straight 'v' cut groove plus two cup marks and small comb-like mark on opposing face of stone. 7.4 Stone (17 x 15 x 9cm) with V-shaped groove. 7.5 Stone (21 x 16 x 11cm) with two cup marks plus oval depression on opposing face. 7.6 Stone (19 x 16 x 9cm) with a single cup mark. 7.7 Stone (20 x 20 x 8cm) with a single cup mark. 7.8 Stone (20 x 15 x 10cm) with a single cup mark. 7.9 Stone (13 x 11 x 7cm) with a single cup mark and an adjacent short groove. 7.10 Stone (20 x 15 x 13cm) with a single cup mark. 7.11 Stone (31 x 27 x 24cm) with large cup mark surrounded by a single concentric ring with grooves radiating to edge of stone. 7.12 Stone (28 x 18 x 10cm) with an oval depression. 7.13 Stone (25 x 25 12cm) with a single cup mark. 7.14 Stone (32 x 22 x 12cm) with two large cup marks and two smaller cup marks. 7.15 Stone (27 x 24 x 14cm) with a single cup mark. 7.16 Stone (19 x 18 x 12cm) with crossed grooves. 7.17 Stone (40 x 30 x 18cm) with three cup marks and a linear groove. 52.2 stone with incised lines. 52.3 stone with incised lines.	Hornsby & Laverick 1920, 446. SMR 2772.02001.	These marked stones were found above and around a group of seven cremation burials associated with food vessels. Part of an estimated 300 marked stones found in this barrow, around 50per cent were cup marked, others had incised lines or grinding /polishing marks. One was described as a 'sinker', and another as the 'Ship Stone'. The stone listed here are in the Dorman Museum, 1914.7.3 etc.
05	HIN 2	Barrow. 'Slightly NE of the Beacon'. Hinderwell.	NZ 7935 1782	Reference to a cupstone. (No further details available).	Hornsby & Laverick 1920, 445. SMR 2772.01003	This marked stone was associated with food vessel fragments in the upper part of a barrow covering an empty grave pit.

No	Site	Location	OS Grid Ref	Description	References	Notes
06	BOU 1	Barrow 1. Boulby Barns. Boulby.	NZ 7496 1943	Reference to several cupstones. (No further details available).	Hornsby & Laverick 1918, 48.	These marked stones were associated with an internment below a deposit of cremated bone and fragments of a collared urn located in the centre of the cairn.
07	BOU 2	Barrow 3. Boulby Barns. Boulby.	NZ 7494 1918	Reference to a flat stone (60 x 30cm) 'with peculiar markings on the underside'. (No further details available).	Hornsby & Laverick 1918, 49.	This marked stone was found placed above a burial in a grave pit cut into the sandstone bedrock below the barrow. Elsewhere the excavators refer to a cup and grooved stone as being 'peculiarly marked'.
08	BOU 3 1914 7.1	Barrow 4. Boulby Barns. Boulby.	NZ 7496 1913	Reference to a large stone used for grinding/polishing. Possibly stone (40 x 32cm) with straight groove cut into a flat and smoothed surface.	Hornsby & Laverick 1918, 49.Dorman Museum records (1914/7/1).	This stone was located in the outer of two concentric circles of stones within the barrow mound.
09	BOU 4	Barrow 5. Boulby Barns. Boulby.	NZ 7515 1919	Reference to a stone with 'pittings upon one side and a deep groove at the end'. (No further details available).	Hornsby & Laverick 1918, 50.	This stone was found incorporated into a rectangular paved area within the barrow mound.
10	BOU 5 1914 7.2	Barow 6. Boulby Barns. Boulby.	NZ 7539 1920	Stone (20 x 15cm) with five cup marks on one surface. Reference to a second stone (45 x 18cm) with a single cup mark on one surface and a series of 12 parallel grooves on an adjacent side. Rem 3	Hornsby & Laverick 1918, 50. Dorman Museum records (1914.7.2).	These marked stones were found associated with a cremation burial placed adjacent to the southern end of a cist at the centre of the barrow.
11	BOU 6	Barrow 7. Boulby Barns. Boulby.	NZ 7564 1895	Reference to two cupstones. (No further details available).	Hornsby & Laverick 1918.	These marked stones were found in the mound material of this kerbed barrow, which covered a central cremation burial in a collared urn. A second cremation associated with a food vessel was located in the south-west part of the mound.

No	Site	Location	OS Grid Ref	Description	References	Notes
12	SHC no. 1–6	Cairn. Street House. Loftus.	NZ 7365 1962	Stone 1. (40 x 20cm) with two or three cup marks. Stone 2. (40 x 35 x 17cm) with an oval-shaped hollow on one face and two cup marks on the opposing face. Stone 3. (45 x 40cm) with three shallow cup marks. Stone 4. (48 x 24cm) with a single cup mark. Stone 5. (28 x 22 x 8cm) with three cup marks on one face and one on the opposing face. Stone 6. (40 x 28 x 13cm) with three shallow cup marks.	Vyner 1984, 175. Tees Archaeology records.	Stones 1-4 were found in the surviving north section of a round barrow kerb, which overlay an earlier Neolithic long cairn and mortuary structure. Stones 5 & 6 found as plough stones on the adjacent hedge bank.
13	SHW no 1-12	'Wossit'. Street House. Loftus.	NZ 7390 1892	12 marked stones (largest 30 x 18cm), eight having a single cup mark. Four having two cup marks, located on opposing surfaces. Detailed listing on website	Vyner 1988, 189. Tees Archaeology records.	These marked stones were found in a capping layer of stones covering the site of a dismantled, palisaded ritual enclosure. A cremation in a collared urn was also associated with this phase. Three broken saddle querns plus an axe polishing stone and two net sinker stones were also found on the site.
14	BRO 1	Barrow. Howe Hill. Brotton.	NZ 6950 1887	Stone (70 x 55cm) having 25 cup-marks (five having single concentric rings) plus a single cup mark on the opposing face of the stone. Reference to eight stones, (four with a single cup mark, two with two cups, one with three cups, one with four cup marks). Reference to 17 stones (10 with a single cup mark, two with two cups, four with three cup marks. One with a V-shaped groove).	Hornsby & Stanton 1917. Dorman Museum records 1914.17.8	Eight stones found in a cairn above a central grave pit under the barrow mound. 16 stones found above a second grave pit containing a tree trunk coffin. The cup-and-ring marked stone was located between the two burials, with the carvings face down. Cup marks were usually face down.
15	KIL 1	Iron Age site. Kilton Thorpe. Lockwood.	NZ 6917 1855	The 'Lattice Stone'. A stone (36 x 19 x 14cm) with a series of pecked lines forming a criss-cross or lattice pattern on one surface of the stone.	Vyner 2001. Kirkleatham Museum records (KTL01).	This marked stone was found buried in a pit associated with a structure on an Iron Age site. The carved surface was face down.

No	Site	Location	OS Grid Ref	Description	References	Notes
16	FOX 1	Iron Age site. Foxrush Farm. Dormanstown. Redcar.	NZ 586 230	Stone (41x 35 x 12cm) with cup-like depressions.	Tees Archaeology records.	This marked stone was found during the excavation of an Iron Age site. The stone was 'sandwiched' between two stone slabs in a ditch terminal on the site.

Locations map

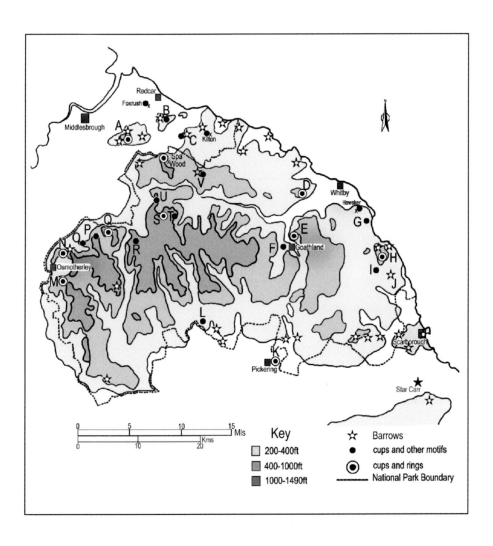

Key

Barrows ☆
cups and other motifs ●
cups and rings ◉
National Park Boundary --------

200-400ft
400-1000ft
1000-1490ft

(A Eston Moor (B Errington Wood (C Airy Hill (D Aislaby Moor
(E Allan Tofts (Allan Tops) Goathland (F Purse Moor (G Ramsdale
(H Fylingdales CP lands common to parishes of Fylingdales and Hawsker Cum-Stainsacre,
 sites on Stoupe Brow, Brow, Howdale, Stony Marl moors
(I Castle Beck Farm (J Standing Stone Rigg (K Pickering
(L Hutton-le-Hole Photograph only! site to be confirmed
(M Thimbleby Moor (N Near Moor, Whorlton (O Live Moor
(P Cringle Moor (Q Wain stones (R Urra Moor (S Holiday Hill, Baysdale
(T Little Hograh Moor (U Warren Moor (V Dimmingdale, Moorsholme

141 Rock art sites location map

References

Aberg, F.A. (1970), Archaeological Register. *Yorks. Archaeol. J.* 42

Aberg, F.A. and Spratt, D.A. (1974), Archaeological Register. *Yorks. Archaeol. J.* 46

Beckensall, S. (1983), *Northumberland's Prehistoric Rock Carvings*. Rothbury: Pendulum Publications

Beckensall, S. and Laurie, T.C. (1998), *Prehistoric Rock art of County Durham Swaledale and Wensleydale*. County Durham Books

Boughey, K.J.S. and Vickerman, E.A. (2003), *Prehistoric Rock Art of the West Riding. WYAS*

Brown, P. (1999), 'In Search of the Howgill Stone'. Journal of the Teesdale Record Society 3rd Series, 7, 23-6

Brown, P. and Chappell, G. (2005), *Prehistoric Rock Art in the North York Moors*. Stroud: The History Press

Brown, P., Brown B. and Rowe P. (2008), 'New Discoveries of Prehistoric Rock Art in the Eston Hills'. Teesside Archaeological Journal No. 13 2008, 3-12

Brown, P. and Brown B. (2009). *Prehistoric Rock Art in the Northern Dales*. Stroud: The History Press

Brown, P. and Brown B. (2009). 'Recording Prehistoric Rock Art in North Yorkshire'. *YAS Prehistory Research Bulletin* 46 2009, 29

Brown P. and Brown B. (2010). 'New Discoveries of Rock art Around the Wainstones North York Moors'. *YAS Prehistory Research Bulletin* 47, 2010, 25-31

Brown, P. and Brown, B. (2010). 'Prehistoric Rock Art Within the Valleys and Tributaries of the River Burn in Colsterdale'. *YAS Prehistory Research Bulletin* 47, 2010, 32-44

Brown P. and Brown B. (2010). 'New discoveries of Prehistoric rock art around the Wainstones'. *Teesside Archaeological Journal* 15, 2010, 3-9

Brown P. and Brown B. (2011). 'Newly-Discovered Prehistoric Rock Art in Swaledale'. *YAS Prehistory Research Bulletin* 48, 2011, 65-69

Brown P. and Brown B. (2011). 'Newly-discovered prehistoric rock art in the North Riding of Yorkshire'. *Teesside Archaeological Journal* 16, 2011, 14-25

Burl, A. (1973). *The Stone Circles of the British Isles.* New Haven

Crawford, G.M. (1980). *Bronze Age Burial Mounds in Cleveland*. Cleveland County Council Archaeology Section

Elgee, F. (1930). *Early Man in North Eastern Yorkshire*. Gloucester: John Bellows

Elgee, F. and Elgee, H.W. (1932) *The Archaeology of Yorkshire*. London: Methuen & Co. Ltd

Feather, S. (1979), *Yorkshire Archaeological Journal* 52, 179

Feather, S. (1981), *Yorkshire Archaeological Journal* 53, 137

Feather, S. (1966), *Yorkshire Archaeological Journal* 41, 557

Feather, S. (1967), Archaeological Register. *YAJ* 42, 2-3, III, 395

Feather, S. (1968), *Yorkshire Archaeological Journal* 43, 4

Goddard, R.E., Brown, D.R. and Spratt, D.A. (1978). Excavation of a Small Bronze Age Barrow on the Eston Hills. *Bulletin of the Teesside Archaeol. Soc. Cleveland Local History Soc.* xxxiv

Greenwell, W. (1877). *British Barrows*. Oxford: Clarendon Press

Heslop, D. (1978). 'Later Prehistoric Settlement and Land Use in Cleveland'. Unpublished BA dissertation, University of Leicester

Hornsby, W. *Unpublished manuscript (268)*. Middlesbrough: Dorman Museum

Laurie, T.C. (1985). 'Early Land Divisions and Settlement in Swaledale and on the Eastern Approaches to the Stainemore Pass over the Pennines', in *Upland Settlement in Britain: The Second Millennium B.C. and After*, ed. D. Spratt and C. Burgess, BAR British Series 143

Laurie, T.C. (2003). 'Researching the Prehistory of Wensleydale, Swaledale and Teesdale', in *The Archaeology of Yorkshire. Yorks. Archaeol. Soc.* Occasional Papers, 3, Oxford BAR 143

Macellan Mann, L. (1915). 'Archaic Sculpturings of Scotland', in J.W. Ord *History and Antiquities of Cleveland*. London: Simpkin and Marshall

Ridley, M. (1971). *The Megalthic Art of the Maltese Islands*. The Dolphin Press

Spratt D, Burgess C. (eds) (1985). *Section in Upland Settlement in Britain*. Oxford BAR 143 Spratt D.A. (1993) 'Prehistoric and Roman Archaeology of North East Yorkshire'. CBA Research Report 87 Simpson, Sir J. (1866/7). *Archaic Sculpturings*. Edinburgh

Smith, M.J.B. (1994), 'Excavated Bronze Age Burial Mounds of North-East Yorkshire'. *Archit. and Archaeol. Soc. Durham and Northumberland Res. Rep.* 3

Sockett, E.W. (1971). 'A Bronze Age barrow at Mount Pleasant, Near Normanby, North Riding'. *YAJ* 43

Spratt, D. A. (ed.) (1993). *Prehistoric and Roman Archaeology of North-East Yorkshire*. Oxford BAR 104

Tate, George (1865) 'Ancient British Sculptured Rocks of Northumberland'. Alnwick

Tissiman, J. (1852). 'Celtic Remains from a Tumulus near Scarborough'. *Archaeologia* 34

Van Hoek, M.A.M. (1993). 'The Spiral in British and Irish Neolithic Rock Art'. *Glasgow Archaeological Journal* 18

Van Hoek, M.A.M. (1995). *Morris Prehistoric Galloway*. Private publication, Oisterwijk

Vyner, B.E. (1989), 'The Hill-fort at Eston Nab, Eston, Cleveland'. *YAJ* 145

Vyner, B.E. (1991), 'Bronze Age Activity on the Eston Hills, Cleveland'. *YAJ* 63

Index

Numbers in **bold** refer to illustrations.